third edition

ASIAN ART

John D. La Plante
Stanford University

Boston, Massachusetts Burr Ridge, Illinios Dubuque, Iowa
Madison, Wisconsin New York, New York San Francisco, California St. Louis, Missouri

FOR TOM

McGraw·Hill
*A Division of The **McGraw·Hill** Companies*

Book Team

Editor *Meredith M. Morgan*
Developmental Editor *Elizabeth Robbins*
Production Coordinator *Jayne Klein*
Photo Editor *Laura Fuller*
Permissions Editor *Gail Wheatley*

President *G. Franklin Lewis*
Vice President, Publisher *Thomas E. Doran*
Vice President, Operations and Production *Beverly Kolz*
National Sales Manager *Virginia S. Moffat*
Group Sales Manager *Eric Ziegler*
Executive Editor *Edgar J. Laube*
Director of Marketing *Kathy Law Laube*
Marketing Manager *Kathleen Nietzke*
Managing Editor, Production *Colleen A. Yonda*
Manager of Visuals and Design *Faye M. Schilling*
Production Editorial Manager *Julie A. Kennedy*
Production Editorial Manager *Ann Fuerste*
Publishing Services Manager *Karen J. Slaght*

President and Chief Executive Officer *Mark C. Falb*
Chairman of the Board *Wm. C. Brown*

Cover photo © Gerard Champlong/The Image Bank

Cover design Kay D. Fulton

Copyedited by Laura Beaudoin

CONTENTS

.

PREFACE

In the twenty-five years since the first edition of this book, our view of Asian art history has expanded considerably. The unprecedented and spectacular finds of the pottery army of the Qin emperor Shi Huang Di or the jade burial suits of the Western Han Dynasty are but two of the more extraordinary examples revealed by new excavation in China. In India and Japan the finds have been less startling, but they have confirmed or broadened the views tentatively held previous to excavation. In the area of prehistory particularly, both the Indian and Japanese material have been reviewed and somewhat rewritten in light of recent discoveries and new interpretations.

This text is an introduction to the arts of India, China, and Japan. In this brief space it is not possible to present more than the broad outlines of the major developments of the art of these countries. Southeast Asia is not included.

Asia remains a vast subject and it has been necessary to be very selective in choosing what to present and how much attention to give to it. The intention has been to provide insight and information; insight into why various aspects of Asian art appear as they do and information about what they meant to those for whom they were made.

Both India and China have acted as centrifugal centers, disseminating ideas, styles, and objects of material culture into those areas that fell under their influence. From time to time, they too have received fresh cultural and ideological stimulation from outside their borders, but when these stimuli had served their purpose they were more often than not modified by the deeper-lying traditions of each country into which they came. After lying dormant, sometimes for centuries, these older native concepts reemerged and absorbed the foreign influences.

The purpose of this book is twofold: to suggest why the works of art were made and to reveal the relationships between one period and another as well as between one culture and another. The art objects to be discussed have been selected with these aims in mind. They are but milestones along the pathways that half the world's population has traveled through five thousand years of history.

The most representative forms have been selected from each country. For example, a greater emphasis is given to architecture and sculpture in India than in China and Japan, where painting and the arts of daily life are more fully discussed. This principle has also been followed within each culture. Thus, this is not a

"survey" of Asian art. The text does not give equal space to all aspects of the arts of the cultures with which it deals. It carefully selects those arts that best exemplify the contributions of each culture and, within that framework, it emphasizes those forms that have been the highest achievements for Asia as a whole. Thus, because the city plan and the development of symbolic religious architecture reached their greatest fulfillment in India, these concepts are dealt with at greater length in that country than in the others. And because the finest products of the Neolithic Age and the Bronze Age were produced in China, these aspects of cultural development are given more detailed coverage in that country than in the others. Of course, some of the art forms, such as painting, flourished in all of the countries, and effort has been made to indicate this. But, even then, not all periods have been covered equally within one culture. In China, for example, the earliest remaining Buddhist painting has been shown, but in Japan the emphasis has been on the later, more secular styles of painting.

Those examples that are considered to have been formative are emphasized over those that are derivative. For example, although there are many beautiful examples of teahouses in Japan, only the first example is included, because it is both beautiful and formative, and all later ones derive from it; porcelain is treated most fully in China because that is where it was invented and where the finest examples were made. The Japanese teabowl is included because it is so typical of the characteristic Japanese aesthetic sensitivities and so unlike those of India or China.

The criteria of choice have been as follows: (1) *quality*—only the outstandingly finest examples were selected; (2) *characteristic*—only those forms and examples that are considered to be the finest examples of the best periods of each culture are included; (3) *formative*—only those examples that are the best indicators of the most important formative periods in any one culture and, further, in all of Asian art, are included.

Three entirely new chapters have been added to cover the significant aspects of the transition into the twentieth century in each culture. In addition, some of the earlier chapters have been enlarged to include examples from earlier periods that are relevant to the later periods or that were simply not able to be included in earlier editions for lack of space. Almost fifty new figures have been added.

A "Comparative Time Line: Asia and the West" permits the reader to see at a glance the time span for periods of development in India, China, Japan, the Middle East, and Europe from prehistory to today. The chronologies for each section have been retained, as have the glossaries at the end of each chapter. Sixteen new colorplates have been added.

Although some of the most colorful objects are the ceramics of China and Japan, these objects really require being seen "in the flesh" to be fully appreciated. Rather than do them less than justice, the reader is encouraged to experience them by visiting a local museum. Almost every large city in America has outstanding examples on display. This is also true of many of the other categories as well, and the reader is urged to take advantage of the opportunities available to meet firsthand such remarkable representatives of the Asian spirit.

The works of art included in this book may be approached on several levels: (1) the sensory, or formal, level, in which the works are examined on compositional as well as other purely visual grounds; (2) the iconographic, or signification, level, in which the meaning of the piece is sought; (3) the cosmologic, or philosophic, level is the larger thought/belief system of which the iconographic is the visual expression. For those readers outside the Asian religious traditions, these works may be seen as documents of cultural history or of anthropology. For those within the belief system, they may be viewed as aids to further spiritual development. It is within this last category that most of the works in this book were made and experienced within their own time.

An attentive study of these works of art can reveal much about the people who created them. It can expand our horizons of aesthetic perception and enrich our lives through a better understanding of the religious and philosophical frames of reference within which these works were produced.

ACKNOWLEDGMENTS

I again wish to express my sincere gratitude to those museums, institutions, and collectors whose kind co-operation has permitted photographs of objects in their collections to be reproduced in this text. Thanks are also due to the many temples and shrines in India and Japan for their kind permission to photograph works of art owned by them, and to the Ford Foundation, Board for Overseas Training and Research, who sponsored my study in Asia.

Time has not dimmed my gratitude to Mr. Chozo Yamanouchi, who so generously secured the photos of Japanese art and architecture, and to Dr. Grace L. McCann Morley and Dr. C. Sivaramamurti, National Museum, New Delhi, for their like efforts in obtaining the photos of Indian art and architecture reproduced here.

In addition to those persons and foundations for whose help and kindnesses I remain grateful, I wish to acknowledge the assistance of the Center for International Research, the Center for East Asian Studies, the Ruth Levison Halperin Fund, and the Department of Art at Stanford for funding my tour to the People's Republic of China in 1982, and the Committee for Art at Stanford for providing the opportunity to visit Japan in 1983. Grateful appreciation is hereby expressed to the Bureau of Cultural Relics and to the Institute of Archaeology of the Chinese Academy of Sciences, Beijing, and to the directors and staffs of the various museums of the People's Republic of China whose objects are reproduced here.

I wish to express my thanks to the editors and staff of the Wm. C. Brown Publishing Company and, most especially, to Dean Robbins, who so patiently and kindly guided me through the difficult days of revision. Thanks also to reviewer, William Hoar, copyeditor, Laura Beaudoin, and production coordinator, Jayne Klein, for their patience and help in preparing this edition.

For assistance in locating illustrations of the Dunhuang caves and the plan of the White Horse Temple in China, and for helpful suggestions and corrections of some aspects of the chapters on Japan, I am grateful to my friends and colleagues, Professor Albert Dien and Professor Melinda Takeuchi, respectively.

I am indebted to the authors listed in the bibliography at the end of this text and, of course, to hundreds of others who cannot be named here. For the new chapters in this edition on modern art in India I have depended heavily upon the catalogs of exhibitions

by Laxmi P. Sihare, Director of the National Museum of Modern Art, New Delhi, and upon the excellent book by G. H. R. Tillotson dealing with Indian architecture from the Victorian Age to the present.

For the chapter on modern art in China, I am especially grateful to Joan Lebold Cohen for her work on recent Chinese painting.

I remain grateful to my friends David Fridley, William Hurlbut, Per-Owlow Leijon, Carol Rudolph, and Peter Rushton, who permitted me to use their photos in the second and third editions. Thomas Lee Robertson did the final proofing and turned the manuscript into readable English. For these services and for his continued inspiration and encouragement, I express my gratitude.

I dedicate this book to the memory of Schuyler V. R. Cammann and to Alfred Salmony, who taught us to see beyond borders.

John D. La Plante
Palo Alto, California

.

INTRODUCTION

PHYSICAL GEOGRAPHY OF ASIA

Since physical geography, latitude, and climate help to determine the development of cultures, it will serve well to describe these aspects of Asia briefly. The Asian landmass covers very nearly all the upper half of the Eastern Hemisphere. By superimposing a map of Asia over that of North America so that the latitudes (distances from the equator) coincide (fig. A), it can be seen that Beijing, China, is as far north as Philadelphia; Kyoto, Japan, is as far north as Oklahoma City; and Bombay, India, is as far south as Vera Cruz, Mexico. Thus a great range of climate can be expected, from sub-arctic to tropic.

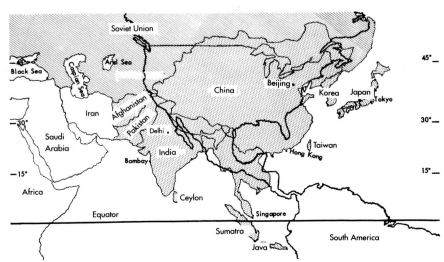

Figure A Comparative map: America superimposed on map of Asia.

Like the rest of the world, Asia is made up of mountains and valleys, rivers and plains. The great rivers of Asia all flow outward from the high Tibetan Plateau (above 12,000 ft) through tortuous routes and tremendously deep gorges to empty into the lowlands, where they have, through thousands of years, formed vast alluvial plains by depositing the silt brought down from the uplands.

The most formidable mountain range in the world, the Himalaya, forms the border between India and Tibet. As the prevailing westerly wind, bearing moisture from the Arabian Sea, reaches these peaks it is forced upward into a cooler atmosphere, where it loses its moisture in the form of snow deposited upon the peaks. Summer weather causes some of it to melt and form streams, which unite to form the great rivers that water the plains, enriching them by depositing fertile silt. This process provides the two necessities for agriculture: water and fertile soil.

FIRST HUMANS IN ASIA

Humans first appeared in Asia more than 200,000 years ago, but they did not begin to settle into an agricultural life until about 3000 to 2500 B.C. The oldest remains of agricultural communities have been found, as might be expected, in the richly fertile river valleys. Humankind emerged from the older nomadic and hunting way of life into a settled life in the Indus River and Yellow River valleys, building permanent homes and raising food. This period is called the Neolithic after the "New Stone" tools that replaced the "Old Stone" tools of the preceding Paleolithic Age. These new tools were highly polished, specialized, and efficiently designed to work well, feel good to the hand, and look attractive to the eye. The laborious fashioning of such implements required time, but this could be provided only by humans' new ability to raise more than needed and store the surplus. Once humans "knew where their next meal was coming from" they could begin to express their aesthetic preferences; this meant the beginning of art.

Food storage also permitted division of labor so that some degree of specialization could take place. Those who farmed could trade with those who made implements or pottery or clothing, and the needs of each group could be better satisfied. Without some degree of specialization, the next step in technological evolution could not have occurred. The Bronze Age, which

began rather soon after the Neolithic period in India and China, required the gathering or mining of the ore, refining of the metal, and the preparation of molds for casting, as well as the casting process itself—all specialized activities. The rapidity with which the Neolithic, Bronze, and Iron ages followed one another in Asia is significant. It is a clue to succeeding events.

Technological improvements, stylistic motifs, and even philosophical ideas were accepted almost unhesitatingly, and yet, fundamental change was resisted. In other words, the utilitarian or visually attractive objects of material culture found easy acceptance; profound religious and philosophical concepts, however, met more resistance. Those aspects that coincided with indigenous attitudes were accepted, while those that did not were either rejected or modified until they were reconcilable with the native tradition. This sifting process, which was often long and frequently unconscious, was determined by a search for meaning. Most of the objects we will discuss were not considered by their makers to be "art" at all; they were simply objects that fulfilled a function, sometimes utilitarian, sometimes spiritual, but always meaningful. They worked within a broadly accepted tradition that usually determined (sometimes very rigidly) the style in which the works were executed. These traditions changed as the more fundamental concepts that they reflected evolved and defined stylistic sequences.

Nothing illustrates the process of reforming foreign elements in terms of the indigenous cultures of India, China, and Japan so well as does Buddhism. It is the only common meeting ground of Asian cultures, for it is the only philosophy that has been shared by all and, at the same time, it is the yardstick by which the differences in these cultures can be most surely measured.

Buddhism originated in India but its doctrine was foreign to the two thousand years of thought and faith that preceded it and that had come to form the foundation of Indian culture. In China and Japan Buddhism met equally well-established, but quite different, bodies of belief. We shall see that these cultures would encounter and be converted to Buddhism and eventually modify or even reject those aspects that could not be reconciled to the primeval world view held by each. Our study can be divided into three phases: pre-Buddhist, Buddhist, and post-Buddhist, when native concepts reemerge and modify Buddhism, reinstating the pre-Buddhist philosophical and aesthetic premises.

Western Hemisphere Chronology

B.C.		A.D.	
2400–1600	EGYPT: Old Kingdom	100	
1800	BABYLONIA: King Hammurabi	200	SYRIA: Palmyra
1600	EGYPT: New Kingdom Queen Hatshepsut	300	ROME: Constantine makes Constantinople the new capital of the Roman Empire
1500		400	St. Augustine
	CRETE: Knossos	455	Rome is sacked by the Vandals
1300	EGYPT: Karnak and Luxor	500	
1200		600	
1000		700	
800			
700			The Book of Kells
	Destruction of Nineveh	800	Charlemagne (ca. 742–814)
	BABYLONIA: New Empire	900	EGYPT: Cairo established (A.D. 970)
600		1000	ENGLAND: Battle of Hastings (1066)
	PERSIA: Achaemenid Empire founded by Cyrus the Great	1100	FRANCE: Chartres Cathedral west facade begun
500			
	GREECE: The Parthenon	1200	ENGLAND: Salisbury Cathedral
400		1300	ITALY: Giotto (1267–1337)
	Alexander the Great		SPAIN: The Alhambra
300		1400	FRANCE: Battle of Agincourt (1415)
	PERSIA: Parthian Empire		FLANDERS: The Van Eyck brothers
200	CARTHAGE destroyed by Rome (149–146 B.C.)		ITALY: Leonardo da Vinci (1452–1519)
			Michelangelo (1475–1564)
100			Discovery of America by Christopher Columbus
	EGYPT: Mark Anthony and Cleopatra		GERMANY: Dürer (1471–1528)
		1500	ITALY: Palladio (1508–80)
			FLANDERS: Rubens (1577–1640)
		1600	ITALY: Bernini (1598–1680)
		1700	ENGLAND: Hogarth (1697–1764)
			SPAIN: Goya (1746–1828)
			ENGLAND: Constable (1776–1837)

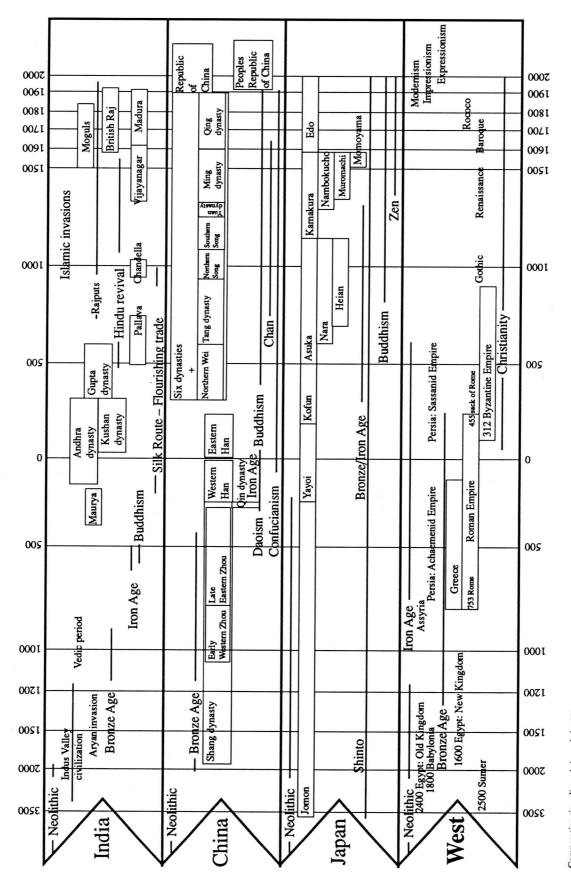

Comparative time line: Asia and the West.

INDIA
PART ONE

CHRONOLOGY

B.C.

2400	INDUS CIVILIZATION: Mohenjo Daro and Harappa
1400	Decline of Indus Valley Civilization
1200	
1000	VEDIC PERIOD
500	The Buddha
400	
	Alexander the Great Conquest of Taxila (327)
	MAURYA DYNASTY (322–185)
	Capital at Pataliputra
300	Chandragupta Maurya (323–300)
	Ashoka (273–236)
200	SHUNGA DYNASTY (185–172)
	Bhaja
100	ANDHRA DYNASTY (73 B.C.– ca. A.D. 50)

A.D.

100	
	Karli
	KUSHAN DYNASTY (first century A.D.–320) Winter capital at Mathura; summer capital at Taxila
200	LATE ANDHRA DYNASTY in the south (first century A.D.–320) Capital at Amaravati
300	GUPTA DYNASTY (A.D. 320–600) Capital at Pataliptura
400	
	Colossal Buddhas at Bamiyan
500	PALLAVA DYNASTY in the south (ca. 500–850) Capital at Kanchipuram
	Late Gandhara style at Fondukistan
600	CHALUKYA DYNASTY (ca. 550–750) Capital at Pattadakkal
	Ellura: Kailasanatha
700	RASHTRAKUTA DYNASTY (ca. 753–973)
	Purashurameshvara Temple at Bhuvaneshvar, Orissa
900	
	CHANDELLA DYNASTY (950–1050) Capital at Khajuraho

1000	CHOLA DYNASTY in the south (907–1053) Capital at Tanjore
	HOYSALA DYNASTY in the south
1200	
	Orissa: Surya Deul (1238–64)
1300	Muslim conquest of the Deccan (1306–26); Vijayanagar founded (1336)
	Tamerlane's sack of Delhi (1398)
1400	Rise of vernacular poetry; paper introduced by Arab traders
1500	1526 Babur defeats Ibrahim Lodi at the Battle of Panipat
	MOGUL DYNASTY (1526–1857)
	Babur (r. 1526–30)
	Humayun (r. 1530–40 and 1555–56)
	Akbar (r. 1556–1605)
1565	Tomb of Humayun
1569	Fatehpur Sikri
1584	Agra Fort
	Jahangir (r. 1605–27)
1613	Tomb of Akbar at Sikandra
1615–1619	Sir Thomas Roe seeks trade concessions for British
	Shah Jahan (r. 1627–58)
1630	Tomb of Itm-ud-Daula
1632–1648	Tomb of Mumtaz Mahal (the Taj Mahal)
1700	Aurangzeb (r. 1658–1707)
1739	The invasion and sack of Delhi by Nadir Shah of Persia
1765	Lord Clive given power to collect taxes for the Mogul
1803	The British East India Company became protector of the Mogul
1813	British parliament legislates its sovereignty over the British East India Company, thus making India a British possession
1857	Sepoy Mutiny against British rule
1858	Bahadur Shah II exiled to Burma
1947	India becomes independent of Britain

Pronunciation of Indian Words

In this book diacritical marks have been omitted from Indian words and additional letters substituted so that *s* (pronounced *sh*) is spelled as pronounced—*sh; c* (pronounced *ch*) is spelled *ch*. The vowels are pronounced as in Italian. The diphthong *th* does not occur so the juxtaposed letters *th* are pronounced as they are in the word ho*t*house.

1

THE DAWN
The Indus Valley Civilization

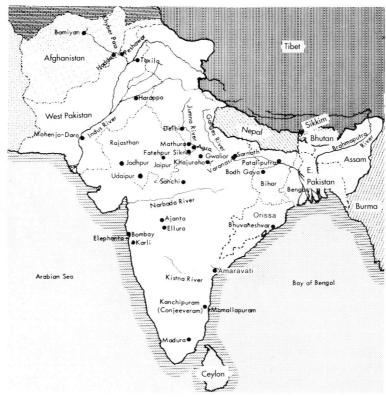

Indus Valley (West Pakistan) and India.

A Neolithic culture existed in the Indus Valley at least as early as the fourth millenium (about 3000) B.C. Those who lived there at the time are known to archaeologists as the **Dravidian people,** and they were the prevalent native Indian stock at the time. These people were short and dark skinned, with low nose bridges, in contrast to the Aryan stock, who were taller and lighter and who had the high-bridged nose characteristic of the Caucasian race who invaded the Indus Valley later on.

The Metal Age began sometime around 2000 B.C., by which time several very large cities had developed into metropolitan centers, with paved streets laid out in grids, blocks of houses, large public buildings, and fortifications. Walls of buildings at Mohenjo-Daro and Harappa were of fired brick, but there appears to have been a singular lack of architectural ornamentation. It seems clear that society was organized in terms of efficiency and mutual protection into urban compounds, with little change from generation to generation, for almost one thousand years.

Floods from the rivers carrying the spring runoff from the Himalayas made it necessary to erect flood-walls against the river, and the end of the culture may have largely resulted from the increasing flooding of the Indus and its tributaries. The Indus Valley civilization was an urban society but one that depended very closely upon farming of the irrigated fields that lay outside the cities. It was, in many ways, the equal of its neighbors to the west, in the Tigris-Euphrates and in the Nile valleys. A system of writing was developed but has not so far been deciphered, and there seems to have been a strong central government that maintained control over business and other aspects of life.

EARLY AESTHETIC LIFE

The aesthetic life of the Dravidians appears to have been meager when compared with that of ancient Mesopotamia or Egypt. Pottery, carved seals, and small stone sculptures are all that remain of artistic interest. The funerary pottery is handsomely painted in black against a rust red clay (fig. 1.1).

Pottery Figures

Pottery figures and miniature versions of utilitarian objects, such as wheeled carts and vessels, have been excavated (fig. 1.2). By far the greatest number are female figures believed to represent a mother goddess (fig. 1.3). These pottery pieces are simply made, with the details formed from small pellets of clay stuck onto the roughly modeled body.

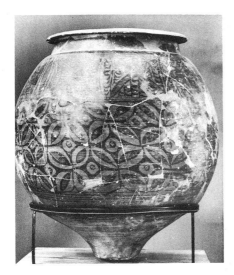

Figure 1.1 Jar. Painted and fired clay. Harappa (2500–1500 B.C.). H. 24½″. National Museum, New Delhi, India.

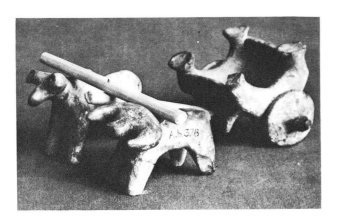

Figure 1.2 Wheeled cart with oxen. Baked clay. Indus Valley civilization (2400–1200 B.C.).

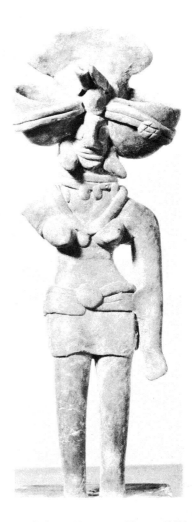

Figure 1.3 Female figure. Terra-cotta. Harappa (2500–1500 B.C.). H. 8½″. National Museum, New Delhi, India.

Carved Seals

Numerous small seals carved in steatite have been found (fig. 1.4*a*). They were carved in **reverse relief** (*intaglio*) so that when pressed against a damp clay surface they would make a relief impression. Their designs are almost exclusively animal; only a few indicate human figures. Real animals, especially humped bulls and a whole series of fantastic animals, some made up from parts of other beasts, decorate these seals, which bear inscriptions in the semi-pictographic Indus Valley script.

The carving on these seals is truly remarkable. The largest are not more than two inches square, yet within this tiny space the artists have expressed, in energetic and naturalistic form, the very essence of the animal

depicted. The choice of stance as well as the precise manner in which the head is held indicates an intimate knowledge and a great love for these animal subjects. A few of the seals bear human images. One in particular is of interest for several reasons (fig. 1.4*b*). It shows a figure full-front, seated flat on a low bench with his legs bent into what might be called a *yoga* posture (to use a word from much later Indian terminology). His hands are extended over his knees, and he appears to be dressed in a rather tight-fitting garment that is striated (perhaps to indicate a pattern on the cloth or armlets and heavy necklaces). The most remarkable aspect of this figure is the head; there seems to be one face looking straight forward and at each side another in profile, making a total of three. From later Hindu art we know of multiple-headed and multiple-armed

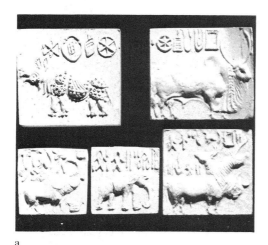

a

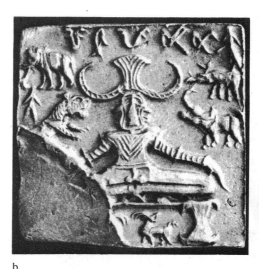

b

Figure 1.4 *a*. Impressions from Indus Valley seals (from casts). Indus Valley period (2500–1500 B.C.). (largest) 1½″. Original, National Museum of Pakistan, Karachi. *b*. Seal from Mohenjo-daro. White steatite. H. 1½″. National Museum, New Delhi. Courtesy of the Department of Archaeology.

deities, and it is entirely possible that this seal represents one of the very ancient deities from the Indus Valley period.

This human representation, when compared with the animal representations, expresses a fact of Indian art better than words can: that the human figure tends to be treated in abstract simplified terms, while animals tend to be treated with great attention to the anatomical detail of bone and muscle. This curious fact remains true throughout the long history of India, and it signifies a major difference in attitude between the art of our Western tradition, where humans have been most important, and that of India, where humans have shared an equality with all other forms of life.

Sculpture

A small group of white limestone sculptures in the round include two seated figures and a bust of a man broken off at the waist. This figure has been called the high priest or priest-king (fig. 1.5). In view of the very few stone sculptures that have come to light it seems likely that it was in some way connected with the Indus Valley religion or government, or both, but it was probably not meant to be a portrait in our sense of the word. It is a very highly abstract and simplified representation of a man. Its very geometry is so massive and powerfully organized that it fills us with awe. The direct and almost startling geometrical simplicity has a magical power so often met with in "primitive" art, where the artist is concerned not with what humans look like but with what they are, which is after all rather magical or at least mysterious.

Another example of Indus Valley stone sculpture is a small torso of a figure that appears to be dancing (fig. 1.6). The left leg, broken at the thigh, was extended straight forward, while the right supported the weight of the body. The torso is twisted into a spiral movement, and all the composure and static monumentality of the "priest-king" has disappeared in the wild abandon of a frenzied dance. This figure is headless, but on the stump of the neck there are a series of holes that formed, it is supposed, attachments for the head or heads; for, since these holes are so numerous, it seems likely that this figure may have had several heads. The pose of the figure is almost identical with that of figures made some three thousand years later that depict the god Shiva as Lord of the Dance, the Cosmic Dance of Creation and Destruction.

POLITICAL BOUNDARIES

The Indus Valley excavations indicate a culture of surprising unity and imposed standardization. This, in turn, implies a strong centralized government. Since the fall of the Indus Valley civilization India has existed as a series of kingdoms, rarely unified into a single nation, until the twentieth century. The local village has been the hub of social and political organization and the paradigm for cosmic and symbolic projections beyond its own boundaries.

Political unity, encompassing all of the subcontinent, did not occur even in the dynasties which exerted enough central control to dominate, although not to subdue, all parts of geographical India. The usual condition has been one in which small kingdoms rose to

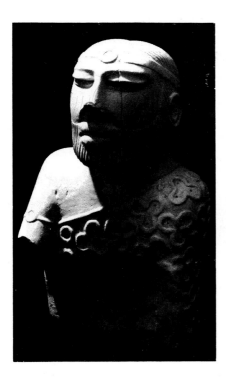

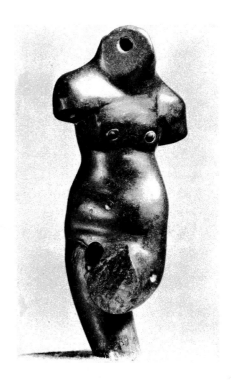

Figure 1.5 Male bust. Limestone (cast). Mohenjo-Daro (2500–1500 B.C.). H. 7″. Original, National Museum of Pakistan, Karachi.

Figure 1.6 Torso. Black stone. Harappa (2500–1500 B.C.). H. 4″. National Museum, New Delhi, India.

positions of strength by conquering smaller or weaker ones and then, if they were not themselves overcome by a rival state, went on to dominate a region or a larger portion of the land. It was normal for other kingdoms to coexist within the larger political boundaries of almost any dynasty, or at least to exist as contiguous entities. These kingdoms ultimately formed the present states of India. The lack of a process of standardization of the whole country under a single ruler may be one of the factors that has caused India to be one of the least homogenized cultures in the modern world. At the same time it has contributed to the complex localization and individuality of the many separate strains in India today.

In ancient India the concept of geography was ideal and symmetrical rather than actual and particular. This means that India was not thought of by its people as the triangular peninsula that we know from maps. Instead it was conceived of as a great World Mountain floating upon the World Ocean. On the sides of this mountain people and gods had their abodes; the people lived near the shore and in the lower hills and the lesser gods in the foothills, while the great gods lived at the summit, an idea very like that of the Greeks regarding Mount Olympus.

THE ARYAN INVASION

The Indus Valley civilization came to an end sometime around 1500–1200 B.C. Its decline appears to have coincided with a slow invasion of peoples from the Northwest who are known to history as the **Aryans.**

The Aryans were Caucasians who moved in successive waves out of the region of the Caucasus Mountains, between the Black and the Caspian seas. One migration apparently turned southwest and descended into pre-Homeric Greece. Another moved southeast into the Indus Valley and North India. The Aryans brought to India several cultural concepts that were to play a significant role in the development of Indian philosophy and religion and thus to affect Indian art. They also brought a new language, *Sanskrit,* to India.

The Aryans appear to have been **an-iconic**—that is, they did not make images; they did not embody their deities in visual form. For almost a thousand years following the coming of Aryan culture to India (ca. 1500–ca. 1200 B.C.) we have very little visual art of any consequence.

THE VEDIC PERIOD (1200–500 B.C.)

The period from about 1200 B.C. to about 500 B.C. is known as the **Vedic period.** It was the time when native beliefs were dominated by those introduced by the Aryan peoples. During these centuries many of the basic concepts about humanity, life, the world, and the universe were formulated. At first these concepts were passed on verbally from generation to generation, but gradually they were written down and formed the basis for the Hindu scriptures. These writings are called the **Vedas,** and they were written in Sanskrit, which has been the classical language of India since that time.

SUMMARY

The Indus Valley culture constructed well-planned cities made of brick along the Indus River and its tributaries. Life was agricultural, with the fields lying outside the cities in a well-designed network of irrigation canals. The people seem to have been rather efficiently organized, with a strong centralized government.

The only writing that has been discovered is found on small, beautifully carved seals, probably used in commerce. Otherwise there is little evidence of a very highly developed aesthetic life. Many small female figures simply made in baked clay may attest to a mother-goddess cult. A few toys and other small clay objects have been found.

Sculpture in stone numbers only a few examples. The best known is that of the male bust.

For a period of almost one thousand years, life appears to have been very standardized. A movement from the west of a people called the Aryans occurred sometime between 1500 B.C. and 1200 B.C. They may have helped to bring about the decline of the Indus Valley culture. But natural phenomena such as floods seem to have also been responsible. Whatever negative effects the immigrant peoples may have had, they introduced a new language, Sanskrit, and a new belief system. This sytem, incorporated with native concepts and beliefs, became the basis for what has been the major religion of India ever since. It is called Hinduism.

GLOSSARY

An-iconic Non-image. (p. 7)

Aryans Caucasians who moved in successive waves out of the region of the Caucasus Mountains into India around 1500–1200 B.C. (p. 6)

Dravidians Prevalent native Indian people before the Aryan invasion. (p. 4)

Reverse relief Incised carving, as opposed to carving in relief. By pressing a seal thus carved against a damp clay surface, a relief impression is obtained. (p. 5)

Vedas The Indian writings on the basic concepts of humanity, life, the world, and the universe forming the basis for the Hindu scriptures, 1500–1200 B.C. The Vedas also contained hymns and prayers addressed to various gods along with detailed prescriptions for ritual offerings. (p. 8)

Vedic period Time period when native Indian beliefs were dominated by those introduced by the Aryan peoples, 1500–1200 B.C. (p. 8)

2

BUDDHISM

THE BUDDHA: THE AWAKENED ONE

In the sixth century B.C., two centuries before the founding of Rome, about a century before the Greeks completed the Parthenon in Athens, and in the same generation in which Confucius was born in China, a prince was born in a small kingdom in the southern foothills of the Himalaya. His ideas would eventually revolutionize the patterns of philosophic thought in India, China, and Japan. This prince was Siddartha Gautama (ca. 563–483 B.C.), of the Shakya clan, who was to become the **Buddha.**

The Buddha was born a Hindu because all Indians of the period followed that cultural and religious system. Hinduism was an amalgamation of native Indus Valley religious practices and the system of thought brought by the Aryans. By the time of the Buddha many sub-systems of Hinduism had developed, but the fundamental belief for all was that the unity of being had been fractured into many tiny units that human beings thought of as their individual selves. But individuality is an illusion. This realization was the goal, because it freed the "individual" from illusions, such as time and space and personality, and permitted the being to flow back to its source.

Until he was twenty-nine, so the story goes, Gautama was sheltered by his father and prevented from seeing the world outside the palace precincts. One day he cajoled his tutor into taking him out. On the way they met a sick man, an old man, a dead man, and an ascetic, or holy man. The prince was so shocked that he determined then and there to discover the cause of pain in the world. Leaving the palace at night, without bidding farewell to his young wife and infant son, he fled into the forest, cut off his hair, and took up the life of a **yogi,** or *sadhu,* a wanderer in search of reality.

But after six years of self-mortification and of study with various great **gurus** (teachers of Hinduism), he knew he was no closer to the answer than when he had started. Meanwhile, he had gained five friends with whom he had shared his search. Sadly he bid them farewell and set off on his own to the city of Bodh Gaya (see map, p. 4). There, beneath the great tree that stood at the center of the crossing of the two main roads he determined to sit until he discovered the answer he sought. After forty-nine days and nights the god of evil, Mara, seeing that Gautama was close to learning the truth about existence, tried to terrify and then to tempt him with the wiles of his beautiful but evil daughters. Nothing availed; Gautama stuck resolutely to his post. Finally, in desperation, Mara accused Gautama, saying that in one of his former existences he had refused to give alms. Gautama, seated in his pose of meditation, touched the earth with his right hand and said: "I call

upon Mother Earth to witness that I did give alms." At this the earth shook, Mara's band evaporated, and the answer that he had sought so long became blindingly clear. At that moment Gautama became truly "awake." He had become the Buddha, the "Awakened One."

Gautama then went to the holy city of the Hindus, Benares (Varanasi), on the banks of the Ganges. Just outside the city, in the Deer Park, called Sarnath, he came upon his five former companions. As he approached they could see that this was not the emaciated fellow they had known through years of privation. They decided to have nothing to do with him, but as he came near them his spiritual power was so strong that they could only bow down and revere him. They begged to be told what he had discovered. In the shade of the trees in the Deer Park he quietly preached his first sermon (Turning the Wheel of the Law) to the five companions who became his first disciples.

THE BUDDHA'S FIRST SERMON

The essentials of the First Sermon are known as the **Four Noble Truths.**

1. To be is to suffer.
2. The cause of suffering is desire.
3. To eliminate suffering one must eliminate desire.
4. The way to eliminate desire is to follow the Noble Eightfold Path, which consists of right
 (1) views;
 (2) inclinations;
 (3) sayings;
 (4) conduct;
 (5) livelihood;
 (6) endeavor;
 (7) mindfulness;
 (8) meditations.
 When all desire has been eliminated one realizes clearly and immediately the bliss of Buddhahood.

The Buddha preached throughout the Ganges Valley until he was eighty years old, when he entered into **Nirvana,** that state in which he would be released from *Samsara* (the **Wheel of Life,** or reincarnation) and would not be born again.

THE KEY: SELF

The key to the Buddhist doctrine is *self*-endeavor and *self*-awakening; there is no source outside oneself from which enlightenment can come. A system that required hard work and self-discipline was bound to be modified, and it was not long after the Buddha that sectarian differences arose, stemming from various

interpretations of what the Buddha had meant. These differences led to the fundamental split into two camps: **Theravada** (School of the Elders) and **Mahayana.** The former retained the idea that each person must work out his or her own salvation, while the latter felt that the Buddha was divine and could in some way save them from the endless wheel of rebirths. Thus the Buddha began to be looked upon as a deity. Among Mahayanists this idea continued to grow until finally the Buddha was seen as a kind of messiah, one of nine: seven Buddhas of the past (to correspond to the seven previous ages of the world, or *Kalpas*), Gautama, and a Buddha of the Future, yet to be born.

SUMMARY

Eventually many schools of philosophy developed to accommodate differing interpretations of the old traditions. One of the new teachers of the late sixth and early fifth centuries B.C. had determined to discover the cause of pain in the world. His discoveries formed the basis of a new system of thought and practice called Buddhism. Buddhists believed in reincarnation, but the Buddha taught that one could become awake now, in this very lifetime, and not need to go through countless rebirths to attain release.

A great division within Buddhism separated those who believed they must do as their founder had done and those who believed that faith in him would somehow save them. Eventually the historical Buddha was seen as but one of nine Buddhas, to coincide with the Indian view of the world cycles of time.

GLOSSARY

Buddha The "Awakened One," Siddartha Gautama, ca. 563–483 B.C. (p. 10)

The Four Noble Truths The essentials of the Buddha's first sermon: (1) to be is to suffer; (2) the cause of suffering is desire; (3) to eliminate suffering one must eliminate desire; (4) the way to eliminate desire is to follow the Noble Eightfold Path. (p. 10)

Guru Teacher of Hinduism. (p. 10)

Theravada School of Buddhism that believes each person must work out his or her own salvation. (p. 11)

Mahayana School of Buddhism that believes Buddha is divine and can intervene in human salvation. (p. 11)

Nirvana That state after a person is released from the cycle of reincarnation. (p. 10)

Wheel of Life Cycle of reincarnation, *Samsara.* (p. 10)

Yogi A wanderer in search of reality. (p. 10)

3
.

EARLY BUDDHIST ART
Maurya and Kushan Dynasties

THE MAURYA DYNASTY (322–185 B.C.)

Before Mahayana Buddhism had fully developed, another man entered the Indian scene; while he had no spiritual effect upon the country, he did have a decided political and cultural impact.

Alexander the Great became the ruler of Macedon and Greece when he was twenty years old. Endowed with extraordinary physical, intellectual, and moral virtues, he had been trained by the famous philosopher Aristotle and his favorite book was the *Iliad,* the story of the Trojan wars. Partly inspired by this book (his personal hero was Achilles) and partly to avenge the Persian invasion of Greece 150 years earlier, he turned his attention to the preventing another such disaster.

In 334 B.C. Alexander crossed the Hellespont into Asia and conquered Persia four years later. He went on to subdue the great Indian king, Poros, in 326 B.C. at Taxila, only about two hundred miles due north of the ancient Indus Valley city of Harappa (see map, p. 4). He had intended to return to Greece but died of a fever in Babylon in 323 B.C. Alexander had conquered the known world in a career that lasted only thirteen years.

Meanwhile a great Indian warrior, Chandragupta Maurya, was inspired by Alexander's strategy and amalgamated the local rulers of the eastern Ganges Valley. The year after the death of Alexander, he succeeded in having himself crowned king and established the Maurya dynasty (322–185 B.C.) with the capital at Pataliputra (Patna).

Ashoka Adopts Buddhism

Chandragupta's grandson, Ashoka (ca. 273–236 B.C.), adopted Buddhism as the state religion. In order that all the people of his realm might know and follow the *Dharma* (the Law of the Buddha), he had exhortations engraved on stone outcroppings or on monolithic stone pillars (edict columns) set up throughout the Maurya Empire.

Ashoka is best remembered for his strong support of Buddhism. He sent missionaries in the four directions to convert all beings. Just how far they actually got is uncertain, but they did reach Syria, Egypt, Ceylon, and probably central Asia and China.

The court at Pataliputra was the first in Indian history to receive ambassadors from foreign lands. They came from Persia (Iran), the Greco-Roman Empire, and Egypt as well as Asia. The Maurya kings were ardent admirers of the Hellenized cultures of the Middle East and had the works of Homer translated and Greek plays and music performed at the court. This influence was also reflected in the Hall of a Hundred Columns erected in admiration of the Persian palace at Persepolis.

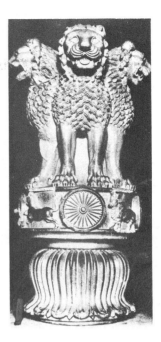

Figure 3.1 Lion capital from Ashoka column, Sarnath. Polished sandstone. Maurya, reign of Ashoka (273–236 B.C.). H. 7'. Archaeological Museum, Sarnath. Photo: Archaeological Survey of India.

Animal Sculptures Symbolize Cosmology

Ashoka also set up **memorial pillars** at those sites associated with events in the life of the Buddha. Like the edict columns, they were monolithic shafts topped by animal capitals. The best preserved is that from the site of the First Sermon (now in the Archaeological Museum, Sarnath) (fig. 3.1). It consists of four large lions facing outward and joined at the shoulders. Only the front legs are shown. These animals are first cousins of the Persepolitan animal style. They are hieratically arranged and organically stylized, conveying a sense of vigorous controlled energy. Like their Persian counterparts, they were highly polished, even though made of sandstone. The four lions originally supported a huge wheel, symbolizing the First Sermon, the Turning of the Wheel of the Law. Both wheel and lions are ancient sun symbols and imply the Buddha illuminating the spiritual world as the sun illumines the physical world. The lions rest upon a circular base around which four small animals follow one another; they are a bull, an elephant, a horse, and a lion. Between them are four miniature wheels repeating the form of the great wheel originally supported by the lions. Below the circular section a bell-shaped base in the form of a lotus with hanging petals makes the transition from animals to the smooth shaft of the column.

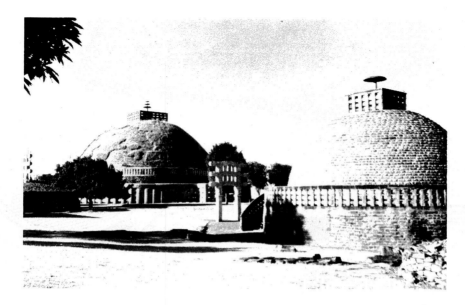

Figure 3.2 Sanchi. *Left,* stupa I; *right,* stupa III (third century B.C. to first century A.D.). View looking southwest. H. (stupa I) 54'. Photo: author.

The symbolism of this capital with its column is complex. According to Hindu cosmology, the world is in the form of a **World Mountain** (Mount Sumeru, or Meru) at the top of which is Lake Udaya. From this lake four rivers flow toward the four directions through animal-headed outlets: the bull, elephant, horse, and lion. From the center of this lake a shaft emerges at dawn and rises with the sun until it supports it at high noon; it descends with the sun and, at sundown, disappears into the waters again. The Sarnath shaft symbolizes the central universal axis, symbolizing time as well as space; the four smaller wheels may well have stood for the four planets that are in conjunction with the sun at the four divisions of the year. The large lions represent the planar extension of space from the center outward in the four directions.

The wheel, the horse, and the elephant were ancient symbols of the **Chakravartin** (Turner of the Wheel, i.e., World Ruler). When Gautama was born, the palace priests cast his horoscope and foretold that the child would become either a Chakravartin or a Buddha. The Sarnath column symbolically fuses the two ideas: the Buddha turned the Wheel of the Law and thus proved himself to be the Ruler of the World Rulers—a super-Chakravartin. The bull is the zodiacal sign under which the Buddha was born.

Thus pre-Buddhist cosmological concepts were used to explain the Buddhist message in the Maurya Dynasty, as seen in the Sarnath pillar.

Three Architectural Forms Evolve

The Maurya dynasty saw the development of the three fundamental Buddhist architectural forms: *stupa, chaitya-hall,* and *vihara.*

The Stupa

The **stupa** is a burial mound. After the physical death of Gautama, his body was cremated and his ashes given to the eight cities in which the most important events of his life took place. The ashes were entombed in hemispherical mounds and became sites of pilgrimage for the faithful.

The best preserved of all Indian stupas is that at Sanchi in central India (fig. 3.2). This site seems never to have been visited by the Buddha but it may be the place where Mahendra, the son of Ashoka, stopped on his way to convert Ceylon, in the third century B.C. The site of Sanchi is a small hill with two stupas on the top and one lower down on a shoulder of the west slope. The larger of the upper stupas, called stupa 1 (they have been numbered according to size) was established in the Maurya period. It was a simple hemisphere of brick, possibly enclosed by a wooden railing. The solid brick mound is today not visible, since it was covered over with stone, cut in the shape of bricks, during the Shunga dynasty (185–172 B.C.). In the next period, the Early Andhra (73 B.C.–ca. A.D. 50) the four large gateways were added (fig. 3.3).

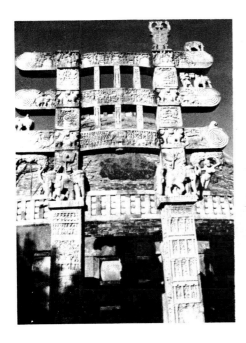

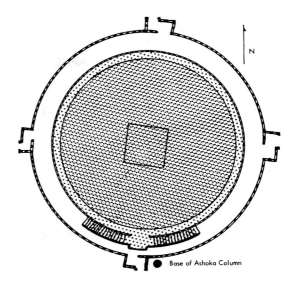

Figure 3.4 Sanchi, stupa I, ground plan.

Figure 3.3 Sanchi, stupa I, east gateway. Stone. Early Andhra (first century A.D.). H. 35'. Photo: author.

The stupa, like the Sarnath pillar, embodies a union of pre-Buddhist and Buddhist ideas. The mound is called the *anda* (egg), referring to the story of creation when a golden egg fell through the void and finally separated, the upper half becoming the dome of the heavens and the lower the support of the oceans (the white of the egg) and the land (formed from the yolk). The land was in the form of the great World Mountain, Mount Meru, on the sides of which lived men and animals and at the top was the palace of the gods.

The stupa and all its parts were determined by very rigid sets of "magical" geometrical proportions in order to insure its proper functioning as a miniature replica of the universe, a microcosmic three-dimensional diagram of the macrocosm. Just as the universal axis springs from Mount Meru, the shaft of the umbrella rises from the top of the stupa. The umbrella indicates the royalty of the Buddha at the same time that it symbolizes the tree at the center of the old Aryan village. In addition it implies the realm of the gods. It will be noticed that in plan the stupa is made up of even numbers: four gateways, an even number of pillars in each quadrant of the railing, and so forth (fig. 3.4). In cubic extension, upward into space, the numbers are always uneven: three horizontal beams between the pillars of the railing, three main levels of the stupa, and three umbrellas. Later stupas become more elaborate, but the

system is always the same, even numbers for two-dimensional space in one plane and uneven for three-dimensional extension in volume.

The mound of the Sanchi stupa is placed upon a cylindrical drum, and between its base and the enclosing outer railing is a broad path. Between the base of the dome and the outer edge of the top of the drum is a secondary walkway, access to which is gained by a stairway on the south side of the stupa. This secondary path, approximately twelve feet above ground level, is enclosed by a simple railing of the same type as the larger outer railing. The gateways are arranged so that one must turn to the left upon entering; that is, they are offset so that they form a **swastika,** one of the most ancient sun symbols. The pilgrim moved around the stupa in a clockwise manner, keeping the right shoulder toward the stupa, in the same way in which the sun was thought to revolve about the earth. By doing so, pilgrims set themselves in harmony with the universal motion of the physical cosmos, at the same time meditating on the Buddhist Dharma the Four Noble Truths, and the Eightfold Path, the universal movement of the spiritual cosmos.

In addition to being a miniature universe, the stupa recalled the plan of the ancient Aryan village with its four gateways and its double pathway surrounding it (although the ancient village plan was square rather than circular). The literature tells us that when a king visited a village he made a double circumambulation, entering each of the four gateways twice; thus the Eightfold Path of the Buddha is a symbolic reenactment of the eight entrances to the Aryan village. Each

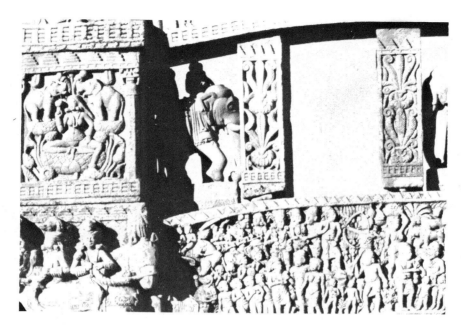

Figure 3.5 Sanchi, stupa I, detail, south face of north gateway. Early Andhra (first century A.D.). Photo: author.

village had two main streets, north–south and east–west. Where they crossed, at the center of the village, a small square contained in its center a Tree of Knowledge (*chaitya*). Under this tree the village elders met to legislate and to discuss religion and matters of council. It was under just such a tree at Bodh Gaya that Gautama had become the Buddha. Thus the Vedic Tree was seen to be the symbolic goal of Buddhism; it was the vertical shaft by which one could leave the entanglement with material existence and rise to a higher plane of awareness—to the awareness that material reality is illusory.

Thus the pilgrim might, through a kind of sympathetic magic, harmonize not only with the cosmos in its physical aspect but with that higher invisible cosmos beyond the realm of the senses and thus beyond the realm of desire. Walking around the stupa on the ground level was a preparation for the ascent of the World Mountain (which the dome of the stupa also represented) to the second level of existence. In both Hindu and Buddhist thought there were three realms: the senses, form, and idea. The goal was to rise from attachment to the senses and forms through the realm of idea and even beyond thought to the realm beyond everything—to existence in its essence, unconditioned by time and place. This last realm was the goal, but it could not be reached by the physical body (and thus did not require a third level of circumambulation) but only by that which was beyond, before, and after the

physical life, that which never dies but that may be reborn countless times in as many forms. By reaching the goal, the Buddhist was released from rebirths into Nirvana (unconditioned existence) beyond time and place.

The carvings of the Sanchi gateways depict stories of the previous lives of Gautama (Jataka stories) as well as allusions to his mortal life (fig. 3.5). No human form of the Buddha is found here. He is represented only symbolically by the lotus, the wheel, the tree, and the small stupa—all an-iconic references to his presence.

Many small-scale figures are crowded into the compositions and strictly respect the architectural structure of the gateways. Where the **architraves** (horizontal arches) are intersected by the two vertical pillars of each gate, square spaces are filled with larger figures (pairs of riders on animals). The reliefs are carved in detail, presenting a closely packed pattern of light and shadow in the clear Indian sunlight. Human figures are shown in a variety of poses, but they are slightly stiff and impersonal when compared with the masterful depictions of animals, particularly the elephant, whose form and character is admirably rendered.

The largest sculptures are the Yakshis (female tree and fertility spirits), which formed brackets between the pillars and the outer ends of the lower architraves on the gates. Because of their size they were the first to be recognized as one approached, and they were also

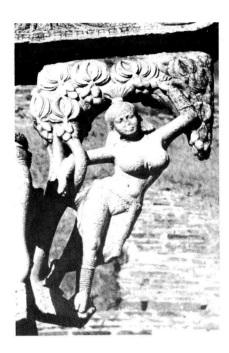

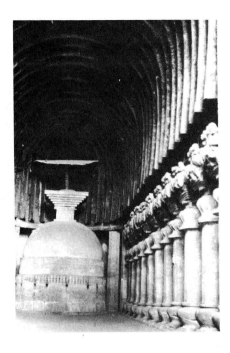

Figure 3.6 Sanchi, stupa I, detail of female figure, north side of east gateway. Early Andhra (first century A.D.). H. (figure only) 4′. Photo: author.

Figure 3.7 Karli, chaitya-hall, interior. Rock cut; ceiling ribs and stupa umbrella wood (A.D. 100–125). H. 45′; W. 46½′; L. 124′. Photo: author.

the most familiar, tracing their ancestry all the way back to the Indus Valley mother-goddess cult (fig. 1.3). The Yakshi of the east gate stands languidly embracing a mango tree and seems to be filled with the same vegetative rhythm, forming with the tree an inseparable unit of visual grace (fig. 3.6; see also fig. 3.3, right side). This motif also refers to the legend of the birth of Gautama. One day as his mother, Queen Maya, was passing through the Lumbini garden, she reached up and touched a tree, which burst forth into bloom and immediately Gautama was born miraculously from her right side.

This figure illustrates a characteristic of Indian sculpture: it is composed of convex forms one against another. These rounded bulging shapes, unrelieved by concavities, express a different attitude from that of the sculpture of the classical European tradition with which we are familiar. The forms seem not only to exist in space but to be actively displacing it in expanding volumes.

The Chaitya-Hall

The second Buddhist architectural form, the **chaitya-hall,** was originally a building constructed with wooden pillars and a barrel-vaulted roof. It was about three times as long as it was wide with a door at one end. At the other end the wall was curved, like the *apse* behind

the altar of a Gothic church. In the center of this rounded end a small stupa was built, and space was left between it and the curved wall for circumambulation around the stupa.

About a dozen chaitya-halls were carved into solid rock; they give us a good idea of what the inside of the wooden chaitya-halls was like, since they imitate very faithfully the wooden architectural style.

The largest and finest of all chaitya-halls is that at Karli (fig. 3.7). It has a ribbed ceiling and in this case the actual wood ribs, which were fastened into the stone, remain. The interior has two rows of columns running the length of the room and forming two side aisles between the columns and the plain walls (fig. 3.8). At the end of the hall the stupa, carved entirely from stone except for the umbrella, which is the wood original, stands as the focal point.

Such stone-carved chaitya-halls indicate a fundamental idea that continues throughout Indian history: that the "living" rock is the matrix that contains within it the potential of all forms but that is itself as yet unformed. This concept of unformed potency behind visible form is essential to the understanding of Indian imagery. In addition, the rock *is* the World Mountain; what better place to reenact the cosmic cycle than around a stupa at the "center" of this mountain?

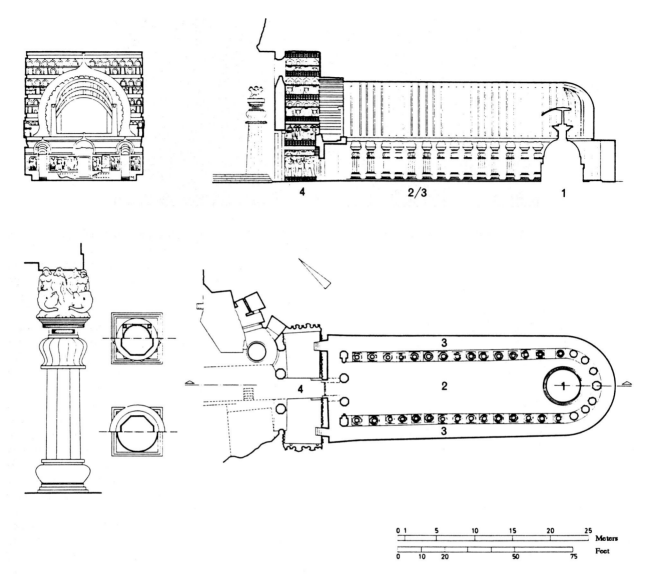

Figure 3.8 The Buddhist chaitya-hall at Karli. Ground plan and vertical section 1:500 and details of a pillar 1: 80. 1 stupa; 2 nave; 3 aisles; 4 vestibule. From Andreas Volwahsen, *Architecture Universelle: Inde.* Copyright © 1968, Office du Livre. Reprinted by permission of Compagnie Du Livre D'Art, Lausanne, Switzerland.

The capitals of the Karli columns are composed of Mithuna (happy couples) on kneeling elephants (fig. 3.9). They are more voluminously developed than the figures at Sanchi. Their forms seem almost to bubble out of the stone. The same gentle child-like expression in the faces of these couples is seen in the standing couples flanking the doorways (fig. 3.10). (At Karli there are three doorways from the vestibule, which precedes the hall; a large central one and one at each side connecting with the aisles.) These relief figures are slightly greater than life size and are the very embodiment of youthful promise. Un-self-consciously they stand, gently poised, unaware of that vitality with which their bodies swell, as though they have paused momentarily in a dance—the dance of life. This quality of almost bursting tension in the surfaces, achieved by convex forms, is an ideal that was to remain in Indian sculpture.

The Vihara

The third of the Buddhist architectural forms, the **vihara,** was a dwelling place for monks. In its simplest form it is only a rectangular room with small cells accessible through narrow doorways on three sides. The

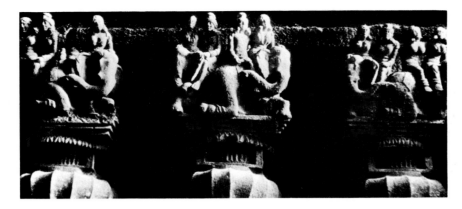

Figure 3.9 Karli, chaitya-hall, capitals of columns. Rock cut (A.D. 100–125). H. (couples plus elephants) 3′. Photo: author.

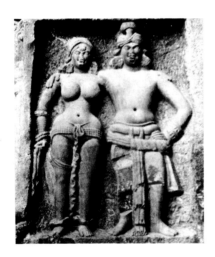

Figure 3.10 Karli, facade of chaitya-hall, pair of figures. Rock cut. H. approx. 6′6″. Photo: author.

monks slept in the cells, while the larger room served as both lecture hall and dining hall. Over time the viharas became more elaborate. The climax is seen at Ajanta (see chapter 4), where not only were the architectural embellishments more complex but the walls and ceilings were covered with paintings depicting scenes from the Jatakas (the stories dealing with the 550 previous incarnations of Gautama) or from Gautama's last life in our own historical time.

THE KUSHAN DYNASTY (ca. A.D. 50–320)

Migratory Patterns Become Trade Routes

After the dissolution of the Maurya dynasty in 185 B.C., India again broke up into a series of local units quarreling among themselves and harried by pressures from the northwest border tribes.

One of these, the **Kushans,** had left the western borders of China (where they had been called the Yuezhi by the Chinese) just as the Maurya throne fell. These people entered India through Afghanistan in the first century B.C., having already displaced the Persian conquerors of what remained of the kingdom of Bactria established by Alexander the Great. The Yuezhi were Caucasian and nomadic. Their migratory habit probably meant that when they had crossed the Tarim Basin, which forms the heart of central Asia, they had moved slowly, keeping to the low foothills, where grass was plentiful for their flocks. Furthermore, they must have moved intermittently; that is, one group would move ahead and others would follow behind, depending upon the foraging of their animals. This meant that they were apt to rest or remain in one area for long periods of time. They might find high summer pastures, then move on to lower winter pastures, or they might move back toward the east whence they had come. It is important to remember that the Yuezhi were not *going* anywhere; they were *leaving;* they did not *plan* to become the rulers of India. Thus, from their point of view, it was equally desirable to disperse or to stay together, so long as they were safe. They were apt to continue moving back and forth along the route they had come.

By the time the Yuezhi were established as the Kushan dynasty in India, it was probably common for many to visit relatives in the high country in the summer and for their relatives to visit them in the low country in the winter. The same pattern was followed by the court, which saw no reason not to cross the formidable Khyber Pass in order to summer in Afghanistan when the weather of their summer capital at Peshawar was too warm for their northern sensibilities.

The Kushans set up two capitals, a summer one at Peshawar, near Taxila, and a winter capital at Mathura on the Jumna River (see map, p. 20). The most important Kushan ruler was Kanishka I, the third king of the dynasty. He was crowned, probably in A.D. 128,

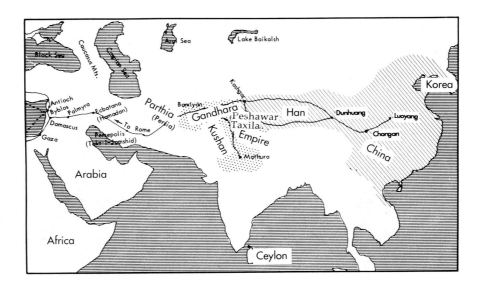

Figure 3.11 The Silk Route linking Rome and China through the Kushan Empire and the Middle East.

at Peshawar. The Kushans established trade and cultural relations with the Roman colonies that were set up in the wake of Alexander's march to India. By the second century A.D. these colonies formed the western section of the Silk Route from China to Rome (fig. 3.11). From Bamiyan, the great oasis city in Afghanistan, a secondary route connected with Peshawar through the Khyber Pass. In the Gandhara region, thanks to the importation of artisans who worked in the late Roman style of Asia Minor, a local Gandhara style developed that is the eastern relative of the provincial styles of Romanized Europe.

At Mathura a more purely Indian style arose. No Kushan architecture remains at this site, but excavations have revealed foundations of a kind of hall of ancestors in which stone portrait sculptures of the Kushan kings were placed. These are inscribed in the reign of Kanishka, and the most imposing is that of Kanishka himself (fig. 3.12). The arms and head are missing, but its massive triangular composition indicates the Kushan desire for monumental stability in sculpture. The forms are rigid and geometrical (see fig. 3.10). The Kushan boots, loose pants, tunic, and a long, fitted coat covered all the body but head and hands, making it difficult to see bodily forms beneath this cold-weather garb, well suited to the cold winters of the Kushan homeland but hardly ideal for the Indian summers. However, this basically triangular composition is retained even when figures in Indian clothing are depicted.

Figure 3.12 King Kanishka, Mathura. Red sandstone. Kushan (second century A.D.). H. 5'4''. Archaeological Museum, Mathura. Courtesy of the Archaeological Museum, Mathura.

Buddha Images

During the Kushan dynasty the first images of the Buddha in human form were made. The earliest dated stone image is inscribed as having been made by (or for) the monk Bala and is dated in the third year of the reign of Kanishka (fig. 3.13). The inscription calls the figure a bodhisattva, a designation at first used to refer to Gautama, the Buddha, but later taking on a quite different meaning (see chapter 4). This large figure

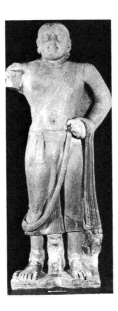

Figure 3.13 Standing Buddha. Red sandstone. Inscribed and dated A.D. 131 (or 147). H. 8'1½". Archaeological Museum, Sarnath.

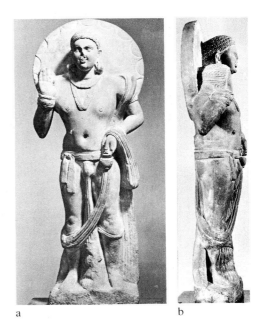

a b

Figure 3.14 *a.* Maitreya (Buddha of the Future). Red sandstone. Kushan (second to third century A.D.). H. 26". National Museum, New Delhi, India. *b.* Side view.

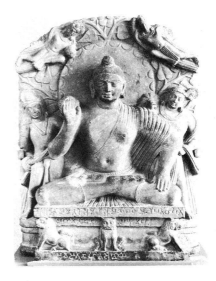

Figure 3.15 Seated Buddha with attendants, from Katra Mound, Mathura. Red sandstone. Kushan (mid-second century A.D.). H. 27¼". Archaeological Museum, Mathura. Courtesy of the Archaeological Museum, Mathura.

stands with feet apart, forming the base of the triangle. The rounded head and broad shoulders are typical of the Mathura Kushan style. The drapery clings to the body as if wet, and the stone between the feet remains, as though the sculptor feared that the legs would not support the weight unless reinforced by the massive base. A small figure of Maitreya (Buddha of the Future) is just as massive, and there is the same hesitancy to cut away too much stone (fig. 3.14a). Those parts that should stand free are left connected to the mass. The detail of the raised right hand indicates this technical characteristic. From the side it can be seen that the hand is connected to the shoulder; the stone between is decorated with an incised pattern (fig. 3.14b). Mathura sculpture was made of a local red sandstone often mottled with cream-colored spots but, since the sculpture was originally painted, the color of the stone was not important.

A seated Buddha is one of the earliest representations of the Buddha with two attendants (fig. 3.15). It is a relief sculpture against the simple unbroken silhouette of the stone block. Above the Buddha's halo, two celestial beings come to worship. At either side stand male attendants wearing royal turbans. The left figure carries a fly-whisk over his right shoulder. The fly-whisk bearer and a lotus bearer were standard attendants of kings, and their presence here implies the royal character of the Buddha.

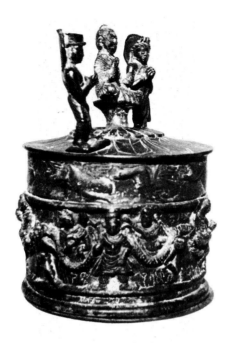

Figure 3.16 Kanishka relic casket, from the great stupa, Peshawar. Bronze. Kushan. Inscribed and dated A.D. 128 (or 144). H. 7¾″. Archaeological Museum, Peshawar, Pakistan. Photo: author.

The seated position, with ankles crossed and soles upward, is now considered a *yoga* pose, that is, one adopted by a *yogin,* or holy man, during meditation. It provides stability and balance. It is much like the body position represented on a few seals from the Indus Valley period (fig. 1.4*b*). It might also be noted that the hand on knee is shared by both images. The robe is worn over the left shoulder like the male bust (fig. 1.5). The Buddha sculpture has a small circle between the eyebrows, perhaps echoing the circle on the headband of the male bust. Motifs in Asian art often last through centuries, and it is interesting to see such visual similarities in objects separated by some two thousand years. Whether there is any symbolic similarity in the relation of leg positions, robes, and forehead circles we have no way of knowing. But some of the conventions seen in those earlier pieces may have endured and may have been adopted by the early Buddhist sculptors for their own purposes.

The Buddha with attendant figures is found on the lid of a small bronze container, the **Kanishka relic casket,** made to hold the Buddhist relics placed in the immense stupa built by Kanishka at Peshawar (fig. 3.16). It is inscribed in the first year of his reign and was perhaps made in Mathura. In the center of the lid, the Buddha is seated between two Hindu gods, Brahma and Indra. Buddha's right hand is raised. The hand po-

sitions (called **mudras**), communicate, by a kind of sign language, a particular meaning. The raised right hand is the "fear not" (*abhaya*) mudra. The attendant gods hold their hands in the *anjali* (worship) mudra. An incised pattern of lotus petals radiates from the lotus pod upon which the Buddha sits. On the sides of the lid, below the rim, an encircling band of flying geese indicates the presence of Brahma. The goose is the vehicle by which this deity was thought capable of traveling to all places, an idea approaching omnipresence. Running children carrying a garland encircle the casket. Above the loops of the garland are images of the Buddha and, between figures representing the sun and the moon, a full-length figure in the same pose as the large stone sculpture of King Kanishka from Mathura (see fig. 3.12).

The Kanishka relic casket is the earliest work to combine the Hindu deities as attendants of the Buddha, with the adaptation of purely classical motifs. The garland-bearing children are lifted intact from Roman art, where they were symbolic of victory. Here they express the victory of Buddhism, which extends to all parts of the cosmos.

In Gandhara the meeting of Buddhist thought and Roman sculptural Greco-style resulted in a style that gave the features of Apollo to Gautama, but the surfaces seem harder and the drapery more geometrically regimented into parallel ridges. Gandhara Buddhas wear Roman style robes. The **Gandhara style** figures, with their oval faces, long straight noses, high-arched eyebrows, cupid's-bow lips, and hard drapery, are very different from the round faces, broad noses, round eyes, and body-revealing "wet" Indian drapery of the **Mathura style** (compare fig. 3.17 and 3.14*a*).

The Gandhara bodhisattva type is well seen in figure 3.18. It is also a spendid example of the meeting of Roman realism and Indian conceptualization. Before the strong Western influence, there were no images of Buddhas or bodhisattvas, but in the Kushan dynasty Indian ideas were given visualization through Roman forms. The bodhisattva stands with his weight on his left foot, his right knee slightly bent. His face is that of the Apollo ideal but with the addition of a moustache. His hair is tied in a bow, a Greek hairstyle like that of the Apollo Belvedere in the Vatican collections. Except for jewelry, he is nude above the waist. The jewelry is both Western and Eastern. His earrings are Hellenistic, and his wide, flat necklace across his upper chest is Roman. His necklace with confronted figures is a Middle Eastern type, and the cords across his chest to his right shoulder and down to his waist on his right

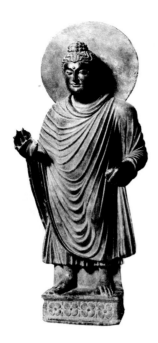

Figure 3.17 Standing Buddha, Gandhara. Stone. Kushan (second to third century A.D.). H. 23¾″. Asian Art Museum of San Francisco, the Avery Brundage Collection.

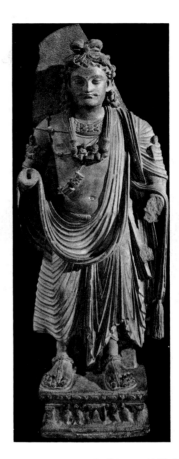

Figure 3.18 Standing Gandharan bodhisattva. N.W. Pakistan. Gray schist. Late second century. H. 43″. Helen and Alice Colburn Fund. Courtesy, Museum of Fine Arts, Boston. ACC. 37.99.

side are Indian. Prayers and amulets would have been contained in the little boxes on real cords of this type. The upper arms have heavy armlets and, on the left arm, a completely non-Indian illusion of the material of the upper garment (the long scarf) gives us the sense that the armlet shows through the cloth that covers it. Something of the same illusionism occurs at the waist, where the belt shows through, and at the kneecap. On the other hand, the material itself appears to lack the pull of gravity upon it. The folds are rigid, too insistent upon their regimentation. The lower garment (*dhoti*) seems to take satisfaction in maintaining its own autonomy, and it defies gravity by splaying its folds like fans. The rigidity of the material is characteristic of the tendency in Asia to linearize and make geometric the sculptural style of the classic West. The left arm is bent at the elbow and the broken hand probably held a small water bottle in the manner of the bodhisattva in figure 3.14*a*. This would identify him as the same bodhisattva, Maitreya, the Buddha of the Future. A comparison of these two figures reveals the basic Indian and the Westernized versions of the bodhisattva.

Gandhara sculptures were placed against walls and formed part of the architectural adornment of stupa bases or of viharas. Both sculpture and architecture were painted and gilded. Remaining stupa bases show sculptures between half-round pillars of the Corinthian type used in the Roman Empire. With the decline of the Kushan power (third century), stucco replaced stone, since it was cheaper and faster. Stucco figures, or parts of them, especially heads and hands, could be made in molds and attached to bodies modeled directly on the walls (fig. 3.19).

In the middle of the third century (ca. 250) an invasion by the Iranian king, Shapur I, brought an end to the Kushan control of Gandhara. Buddhism continued, however, until the White Huns invaded in the early sixth century and stamped out Buddhism forever from this region by their merciless persecution of the populace and their wholesale destruction of stupas and monasteries.

In their finest examples the Gandhara representations of the Buddha achieved a fusion of Indian thought and Hellenized techniques, which was to have a profound effect on Buddhist art.

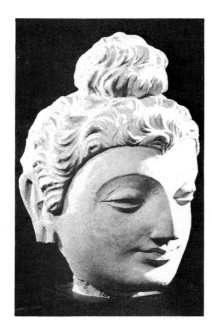

Figure 3.19 Head of a Buddha, Hadda, Afghanistan. Stucco; painted lips, eyes, and eyebrows. Kushan (third to fourth century A.D.). H. 8''. Stanford University Museum, Mrs. Frank E. Buck.

SUMMARY

Alexander's conquest of India brought it into contact with Middle Eastern cultural influences. For the first time ambassadors from these countries came to India. The Maurya emperor, Ashoka, adopted Buddhism as the state religion and accepted much of the Hellenized culture, which had grown up after Alexander and which was nourished by ambassadorial contacts with the Western countries.

To mark important sites in the life of the Buddha, Ashoka set up memorial pillars topped with animal capitals. They combined motifs and styles drawn from both India and the West to express Buddhist concepts. Ashoka also established or renovated many stupas throughout northern India.

Early Buddhism developed three major architectural forms: the *stupa* for the burial of the ashes of the Buddha, the *chaitya-halls* for use as chapels during the rainy season, and the *vihara*, which usually adjoined them and were the living quarters for the monks. The stupas were of brick construction, but the chaitya-halls and viharas were established in caves. At first these caves were probably left natural but, as time went on, it was normal that the monks would wish to embellish them with painting and carving. The early cave temples of western India preserve the styles of wooden architecture of the region.

When the Kushan became rulers of India they established two capitals, a summer one in the north at Peshawar and a winter capital in the south at Mathura.

Under their rule two styles of sculpture developed, a Romanized style in the north and a more native Indian type at Mathura. The northern style flourished in Gandhara, the region around Peshawar and the upper Indus closest to the cities established by Alexander and to the subsequent Roman settlements along the Silk Route. In this style it seemed consistent that the figure of the Buddha should have the face of Apollo and wear a Roman robe. These figures stand gracefully in the realistic manner of Roman sculpture. The Buddha figures from Mathura are less free and stand rigidly frontal, bending neither to right nor left in their monumental and geometric pose.

GLOSSARY

Architraves Horizontal arches. (p. 16)

Chaitya-hall A hall containing a *chaitya,* that is, a *stupa;* a fundamental Buddhist architectural form constructed with wooden pillars and a barrel-vaulted roof. (p. 17)

Chakravartin "Turner of the Wheel" or "World Ruler"; symbolized by the wheel, the horse, and the elephant, as well as a woman, a minister of state, a parasol, and money (the 7 Jewels). (p. 14)

Gandhara style Sculpture showing oval faces, long straight noses, high-arched eyebrows, cupid's-bow lips, and hard drapery. Strongly influenced by the Roman Empire styles. (p. 22)

Kanishka relic casket A small bronze container made to hold the Buddhist relics placed in the stupa built by Kanishka at Peshawar. The earliest work to combine Hindu deities, as attendants of Buddha, with purely classical motifs. (p. 22)

Kushans Caucasian, nomadic rulers of India. It was during the Kushan dynasty that the first images of Buddha in human form were made. (p. 19)

Mathura style Sculpture showing round faces, broad noses, round eyes, and body-revealing "wet" drapery. (p. 22)

Memorial pillars Monolithic columns with animal capitals erected during the Maurya dynasty at sites associated with Buddha. (p. 13)

Mudras Hand positions, each communicating a particular meaning. (p. 22)

Stupa A burial mound; for the ashes of the Buddha or his disciples; a fundamental Buddhist architectural form; a miniature replica of the universe determined by rigid sets of geometrical proportions. (p. 14)

Swastika An ancient sun symbol. The four gateways to a stupa are sometimes arranged in a swastika to prevent circumambulation to the right. (p. 15)

Vihara A basic Buddhist architectural form constructed as a large dwelling place divided into cells housing monks. (p. 18)

World Mountain According to Hindu cosmology the world is in the form of a great mountain at the top of which is Lake Udaya and the palaces of the gods. (p. 14)

4
.

THE ELABORATION OF
MAHAYANA IN INDIA

THE LATE ANDHRA DYNASTY
(ca. A.D. 50–320)

While the Kushan dynasty had reigned in northern India and had dominated Afghanistan and central Asia, the later Andhra kingdom (ca. 50–320) had ruled the south. Stretching across India from sea to sea, this sophisticated dynasty had attracted Roman trade through its ports on both its west and its east coasts. As the royal house of Andhra grew and flourished, it gave patronage to the Buddhist centers of learning that sprang up in the area of Amaravati, the capital (see map, p. 4). This patronage was more specifically carried on by the Andhra queens, many of whom were related to the Kushans in the north and were thus Buddhist, while the Andhra kings retained the Hindu faith.

At first the Buddhism of the Andhra south was Theravadan, but as early as the late second to early third century A.D. a great preacher, Nagarjuna, converted the region to Mahayana. This required remodeling and renovation of the stupas and viharas in the area. The stupas were expanded in size, and faced with white limestone quarried locally. These slabs were covered with low-relief carvings of Buddhist themes (fig. 4.1a). Some of them were miniature depictions of the great stupas themselves, and these casing slabs give a good idea of what the stupas looked like (fig. 4.1b). The carving is full and rich, while the figures are handled with graceful ease, and perspective is convincingly indicated. The crowding of many figures reminds us of the reliefs of Sanchi; the development in the Amaravati area is the continuation of the Sanchi style of the Early Andhra dynasty. The comparison of the Sanchi reliefs with those from Amaravati shows how much

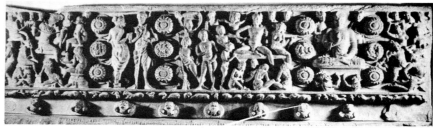

a

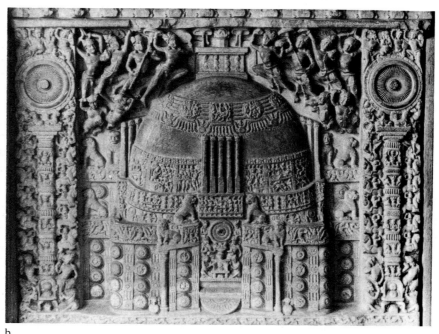

b

Figure 4.1 *a.* Casing slab from a stupa at Amaravati; various scenes; seated Buddha at right. Limestone. Later Andhra (ca. third century). H. 13″. *b.* Casing slab from Amaravati stupa depicting the great stupa. Limestone. Later Andhra (ca. third century). H. 6′2¾″. Madras Government Museum, Madras, India. Photos: Archaeological Survey of India.

more fluid the later figural style had become. At Amaravati the Buddha was shown in human form, perhaps under the influence of the Romanized Gandhara style.

It is, however, possible that there was a Roman influence in the south as well as in Gandhara. On the east coast, not far south of Amaravati, in the vicinity of Virampatam (Poindicherry), fragments of Roman pottery vessels, including wine jars, bowls, and dishes, as well as Roman coins, have been found. These items probably indicate the presence of a Roman colony in conjunction with a trading port, which would have received spices from southeast Asia and prepared them for transshipment across India to the west coast for the next leg of the journey by ship through the Red Sea to the Roman Empire.

One kind of Roman ware found in this area is called Arretine (after Arezzo, the Italian town where it was produced). It was made in molds and imitated very faithfully the kinds of relief designs found on Hellenistic silver bowls. These exquisitely cast low-relief figures may have influenced the figurative relief stone sculptures in the Amaravati region. In any case, the Late Andhra style outstrips the contemporaneous Kushan styles of the north in its suave and sophisticated handling of anatomy and subtle variety of pose and in the illusion of spatial depth.

THE GUPTA DYNASTY (A.D. 320–600)

During the Gupta dynasty, which succeeded the Kushans in the north and which located its capital at the ancient Maurya city of Pataliputra, Mahayana doctrine continued to evolve until by the end of the dynasty it was scarcely distinguishable from Hinduism. This evolution was of course unconscious and represents the fundamental needs of the people rather than any intentional subversion.

A Fusion of Styles

With the collapse of the Roman Empire India lost contact with the Roman West. But before the destruction of Gandhara in the sixth century influences from that region had already found their way to the southern Kushan capital of Mathura. At both Mathura and at Sarnath important centers for the production of Buddhist stone sculpture developed. This new style was in part a fusion of the Gandhara and Mathura styles of the Kushan dynasty and in part influenced by the attenuated body proportions of the Late Andhra period.

The difference between the two Gupta styles is slight but significant: the **Mathura style** retains the Kushan folds in the drapery but makes them so geometrical that they seem to be a series of strings hanging over the figure (fig. 4.2*a*); the **Sarnath style** treats the drapery as perfectly smooth without folds except at the extreme edges (fig. 4.2*b*). The Mathura "string-folds" derive from the Gandhara draperies of the Kushan period, but they indicate how little the Indian sculptors were concerned with imitating natural materials; they have become regimented into highly arbitrary patterns. The proportions of the Gupta style are equally unrealistic. The figures are much taller and more svelte than their Kushan predecessors, reminding us of Late Andhra influence. The gentle swelling of the body that we saw in the figures at Karli has, by the Gupta dynasty, evolved into a pneumatic style that gives a puffed look and a stretched quality to the "skin."

A comparison with figures 3.6 and 3.10 reminds us of the incipient tendency to pneumatic, slightly swollen, or at least full-bodied, figure styles in the Early Andhra dynasty. But, while the views are convincingly three-dimensional, from the side there is no transition between them and the blockiness of the stone, which dominates and diminishes the effect of a convincingly full-round figure.

The tendency merely to put a front and back together without a realistic transition from one set of forms to the other is continued in the Kushan style at Mathura, where it is hard to believe that the awkward side view of figure 3.14*b* belongs to the same sculpture seen from the front (fig. 3.14*a*).

By studying these examples it becomes clear that a deeply felt yoga concept, that of *prana*, or breath control, was unfolding from about the first century to its culmination in the late fourth and early fifth centuries A.D. In this concept, the control of breathing gave strength, both physical and spiritual, because, like the Latin West, the Indians believed that breathing in (*in*spiration) brought life and spirit to the body and that breathing out (*ex*piration) diminished it. From these Latin words we also get *inspire*, to be strongly in-spirited, and *expire*, to die, indicating a similarity of this concept in East and West.

The sequence of these sculptures shows how, almost unconsciously, an aspect of artistic style may develop over many generations and through the work of hundreds of individual artists. It suggests that in many societies the specific aesthetic choices of each artist are not, after all, made in a vacuum. They reflect a broader preference; they are group choices gradually accepted and molded and passed along in the continuity of the societal memory.

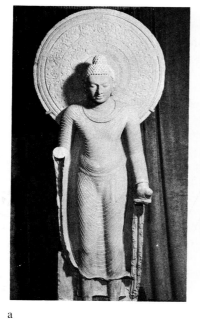
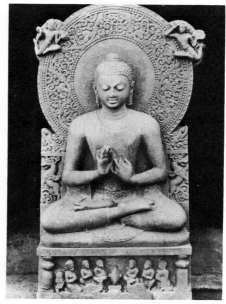

a b

Figure 4.2 *a.* Standing Buddha, Mathura. Red sandstone. Gupta (late fourth century A.D.). H. 7'. Rashtrapati Bhavan, New Delhi. Photo: National Museum, New Delhi, India. *b.* The First Sermon, Sarnath. Tan sandstone. Gupta (fifth century). H. 5'3''. Archaeological Museum, Sarnath. Photo: Archaeological Survey of India.

Buddha's Divine Nature

By the time of the Gupta dynasty many ideas that earlier had been only partially articulated became codified, and among them were the prescriptions for the making of images. According to tradition the physical body of Gautama bore several signs that marked him as a Buddha. On the top of the skull a bony protuberance (*ushnisha*), between the eyes a mole (*urna*), webbed fingers, wheels (*chakra*) on palms and soles, and arms long enough to allow the fingers to touch the knees when he stood are but a few of the more obvious signs.

In addition, it was felt that to base the bodily form of the Buddha upon mere physical anatomy would be inappropriate. He was therefore given metaphorical idealized forms drawn from the natural world: the "torso of a lion," the "legs of the gazelle," the "eyebrows like a double bow," the "chin like a mango," and "eyes like lotus petals" (fig. 4.2a). All these are but attempts to idealize—to raise the physical form of the Buddha out of our realm and to see him as a manifestation of all the most perfect elemental forms in nature. This is an art that is less concerned with depicting biological function than with the abstract expression of the divine nature.

The tightly coiled ringlets covering the head are the abstracted form for the indication of short hair, which must have come into India from the Middle East, where it is frequently found in Achaemenid art. The severely arched brows of the Gupta style along with the oval face, straight nose, and cupid's-bow lips are obvious derivations from the Gandhara style. But now all the Roman illusionism has been sifted out and we are left with a superbly abstracted expressive style, which was best suited to convey the essential message of Buddhism: inner peace and contemplation. It was in fact so well suited to convey this message that the Gupta style has remained the norm for representation of the Buddha figure for centuries throughout Buddhist Asia, Java, Burma, Thailand, and Nepal as well as China and Japan.

The Gupta was a period of unprecedented splendor, at least in courtly circles. But this luxurious enrichment is out of place in images of the Buddha, which are clothed in the simple monastic robe; however, it is hinted in the embellishment of some of the halos of the period. The round head halos, which in Kushan images had only simple scalloped edges, in the Gupta period became areas where the artist was free to invent marvels of complex curvilinear ornamentation based upon the lotus flower and undulating rhythmic stems. Both

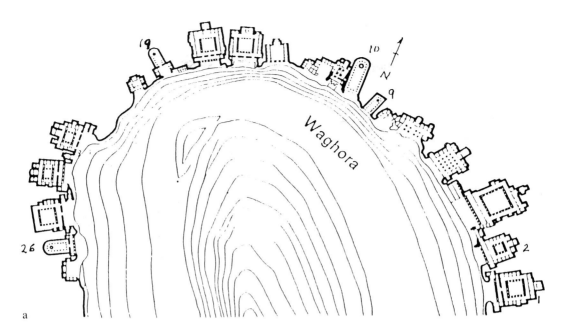

Figure 4.3 Buddhist monastery of Ajanta. *a.* Site plan. Chaitya caves: 9, 10, 19, and 26; remainder: Vihara caves. Carved into lava rock (second century B.C. to sixth century A.D.). From Andreas Volvahsen, *Architecture Universelle: Inde.* Copyright © 1968, Office du Livre. Reprinted by permission of Compagnie Du Livre D'Art, Lausanne, Switzerland.

the standing Buddha from Mathura and the seated Buddha from Sarnath have such halos. They are almost twice the size of the Kushan halos and, in addition to the floral motifs, set off by beaded borders, they retain the scallops, reduced in size, on the outer perimeter.

The seated Sarnath Buddha is shown preaching the First Sermon, a most appropriate representation for Sarnath, where this event took place (fig. 4.2*b*). The hands are in the Turning the Wheel of the Law (Dharmachakra) mudra, as though an invisible wheel is being turned between the fingers. He sits on the Lion Throne as shown by the two small-winged lions at either side. Seven small figures, kneeling below the throne flanking the Wheel, are the five companions and at the far left a woman and child. This is an unreal, hieratic arrangement in which the importance of the Buddha makes him much larger than the other figures. It indicates how the historical Gautama was evolving toward a divinity in the minds of his Mahayana followers. This image became extremely popular, and copies of it were probably made in every Buddhist country. We shall see an example from China that is a close imitation. As a major pilgrimage site, Sarnath attracted travelers from many Asian cultures, and this image seems originally to have been housed in a temple (now destroyed) that stood in the Deer Park. In this setting, with its original color and gold, it must have made a deep impression on the pilgrim.

The Gupta Court

The luxurious richness of the Gupta court is best seen in the wall paintings at Ajanta, a cave-monastery complex carved into the volcanic stone of the Waghora River valley (see map, p. 4). The almost unbelievable intricacy of actual objects of personal adornment, the crowns, necklaces, bracelets, and richly patterned cloth with which the figures are provided, have all disappeared, for the Indians, whether Hindu or Buddhist, cremated their dead, leaving no tombs that might yield (as in China) objects of material culture. All twenty-nine caves at Ajanta (four chaitya-halls and twenty-five vihara, as shown in fig. 4.3*a* and *b*) were at one time painted. Now only two retain much of their original decoration (fig. 4.4). The scenes of the wall paintings merge into one another, and the crowded compositions flow in unceasing variety and richness over the walls. The drawing is of the highest order, the line alone implying volume aided by only very slight shading. While the ostensible subjects portrayed are Buddhist, what is really of importance here is that the artists have provided us with detailed views of courtly elegance of this golden age of Buddhist art in India (fig. 4.5).

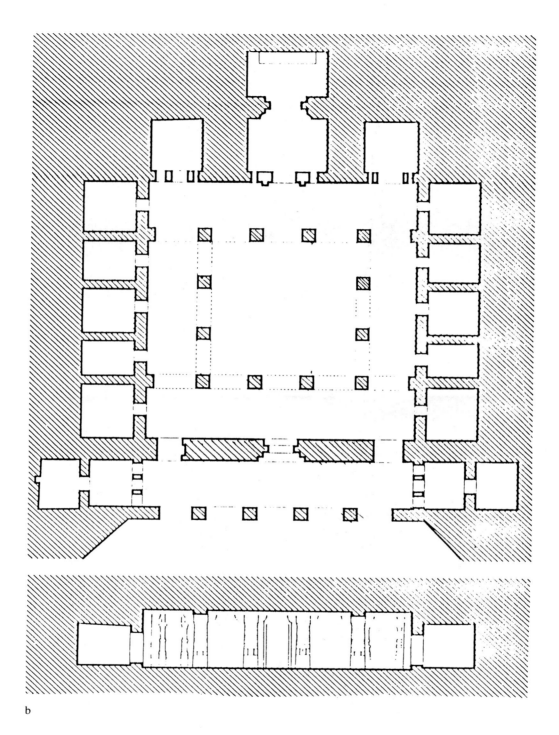

b

Figure 4.3 *b*. Ground plan and section of cave 2, Ajanta. Andreas
Volvahsen, *Living Architecture: Indian,* © 1969 Grosset and Dunlap,
N.Y. From Andreas Volwahsen, *Architecture Universelle: Inde.* Copyright
© 1968, Office du Livre. Reprinted by permission of Compagnie Du
Livre D'Art, Lausanne, Switzerland.

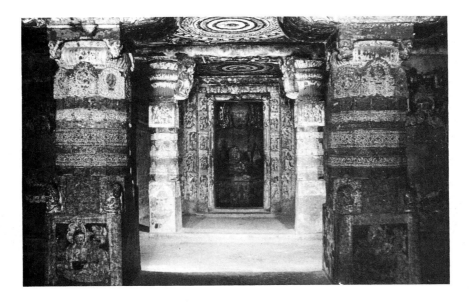

Figure 4.4 Ajanta, cave 1, Vihara, interior. Rock cut; pillars, ceilings, and walls painted. H. of ceiling about 13'. Photo: author.

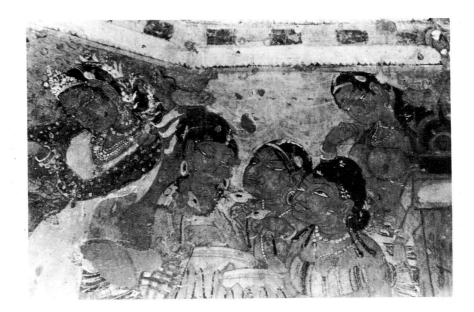

Figure 4.5 Ajanta, cave 1, detail of wall painting: palace scene; dancer at left. Gupta (ca. sixth century). Painted figures about half life size. Photo: author.

Changes in Buddhism

During the Gupta dynasty Buddhism underwent profound changes hinging upon the evolution of ideas about Gautama. The concept of the **three bodies of the Buddha** had developed. In his Body of Magic Transformation he was born. Before his birth he existed in his Body of Bliss in the "heavens of the gods," whence he came into the world. But if he existed before his birth, and since he will not be reborn again, having attained Nirvana, he is eternal. Gradually both the Body of Magic Transformation and the Body of Bliss were seen to be but emanations of the Body of Essence, which is self-existent, unchangeable, and eternal, beyond the realms of form and conditioned existence. The Body of Essence, the great Buddha, **Vairochana,** is enthroned in the center of the universe, upon a lotus whose base was said to be made up of a thousand (i.e., an infinite number) petals and in each petal, a world like our own with its own Buddha. Sometimes the Thousand Buddhas were depicted, but more often four Buddhas of the Four Directions were shown to stand for the universal cosmic power of Vairochana.

These changes in doctrine naturally inspired their expression in art. Shortly the idea that the stupa equaled the World Mountain, which equaled the dome of heaven, which equaled the cosmic mandala which expressed the concept of symbolic equation. If these aspects were somehow mystically equal, then the categories of being could themselves be equated. If the physical remains, the relics, of the historical Buddha could make him present at the eight great stupas that contained them, then—as he was a kind of emanation from Vairochana—the center of the stupa became equatable with the center of the universe, just as the mortal Buddha was equal to the immortal Vairochana. The Buddhas of the Four Directions, including the historical Buddha, were emanations into our time and space.

At Ajanta, these concepts are seen in the last two chaitya-halls to be built there, caves 19 and 26. In cave 26 the Buddha sits enthroned in the projecting portico in front of the stupa (fig. 4.6). He is visible *as though* we see him within the stupa or *as though* he has manifested himself from inside the stupa.

Here the equation–image equals relics–is the important concept, and it was to have far-reaching effects upon Buddhist art in Asia. It would permit memorial stupas, that is, stupas without relics, to achieve a functional, if not actual, equality with relic stupas.

The figurative reliefs that came to be added to stupa bases, as well as the walls of vihara and other ecclesiastical buildings, exemplified in Gandhara,

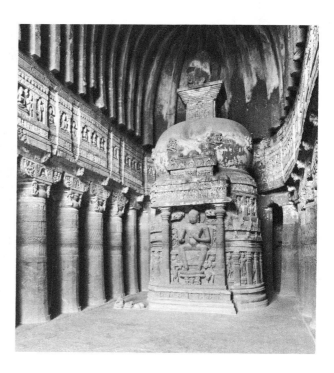

Figure 4.6 Ajanta, cave 26, interior. Rock cut. Late sixth to seventh century. Photo: Eliot Elisofon. Life Magazine © Time Warner Inc.

Amaravati, and central Asia, indicate the subtle modification that took place within Mahayana Buddhism. The image became as important as the relic in reminding the faithful of the purpose of their visit. Without this shift the stupa would have continued as a place where visitors might set themselves right with the Law and the way of the Buddha, but it would have remained a do-it-yourself situation. With this change, stupas became places where the faithful could not only be reminded of the Buddha and his law but could also experience a personal identification with any of a number of Buddhas and bodhisattvas. Although its founder might not have regarded this personalization as a welcome development, in North Asia, Buddhism in its Mahayana form, was to be increasingly permeated by this devotional attitude.

The round stupa base changed into a squared one, and the single level changed into a proliferation of bases, one atop the other, in uneven numbers of stories reflecting the realms of existence. And finally, at the very top, the tiny stupa may be found. Thus architecture reflected the developing religion. The new form of stupa was developing in Gandhara and central Asia as well as in India proper.

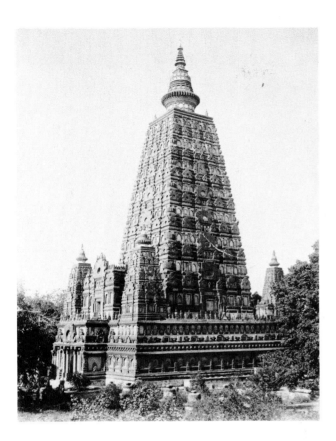

Figure 4.7 Mahabodhi Temple, Bodh Gaya. Stone. Originally painted and gilded. Built during Kushan dynasty. Rebuilt during Gupta dynasty and restored last in the nineteenth century. H. 230′. Courtesy of The British Library.

The best-preserved large Buddhist stone architecture of the Gupta dynasty is the famous stupa/temple, the Mahabodhi Temple at Bodh Gaya (fig. 4.7). Built in front of the sacred Bo tree marking the site where the Prince Gautama became the Buddha, it was renovated in the Gupta dynasty. It consists of a solid, truncated pyramidal tower made up of nine stories, square in plan, which have slanting faces that recede in size from the lowest to the uppermost, which is topped by a large bell-shaped *stupa*. There were four small plain stupas, one at each corner of the top, as well. The ground story has a single large room, in the west end of which sits a large stone sculpture representing the Buddha at the moment of awakening.

A courtyard preceding the entrance was constructed probably at the time of the Gupta remodeling, and the smaller towers of the ground floor were added. The shape of the large stupa on the central tower and those on the corner towers was altered, probably in the twelfth century, when the building was again renovated by monks from Burma, the site having fallen into dis-repair by then. The last major work was done in the nineteenth century. At that time, the original Bo tree having died, a slip from the one that had been taken to Sri Lanka in the third century B.C. was brought back and planted.

This building is important because it is the only preserved example of the tower form of the stupa in India, although the form is preserved in China and Japan as the pagoda (see chapters 11 and 19).

Instead of relics, the Mahabodhi Temple contains the image. Additional images in niches adorned each story of the tower, manifesting an epiphany or showing forth of the presence of the Buddha within, an idea to be further developed in Hindu architecture of the post-Gupta period.

Bodhisattvas

The **four Dhyani** (meditation) **Buddhas** reigned over four paradises, where the faithful would enjoy a purified material existence. The attendants of the Buddhas of the Four Directions were **bodhisattvas,** beings who could enter Nirvana but who have given up this goal to help others. The compassionate character of the bodhisattva indicates the humanism that transformed Mahayana Buddhism which spread from India throughout North Asia.

The bodhisattvas bridged the gap between man and the Buddha Essence, which, like Brahman of Hinduism, was indescribable and unapproachable except through the gods, who were manifestations of that essence. The bodhisattvas quite naturally were embodiments of the virtues of the Buddha Essence. Thus there was the Bodhisattva of Mercy (Avalokiteshvara), of Wisdom (Manjushri), of Auspicious Excellence (Samantabhadra), and even an aspect of Brahma, omnipotence, became the Bodhisattva Mahasthamaprapta. Of these, Avalokiteshvara and Manjushri became the most popular, since they typified the doctrine as being one of mercy and wisdom.

Two figures on a stele from Sarnath depicting scenes from the life of Gautama are among the earliest representations that can with some degree of certainty be identified as bodhisattvas (fig. 4.8). They stand, one on either side of the seated Buddha; one holds the fly whisk and the other the lotus. Their position is clearly that of the palace attendants who accompany Kushan Buddhas (fig. 3.15), but by now they were thought of as embodiments of virtues to whom special homage was due.

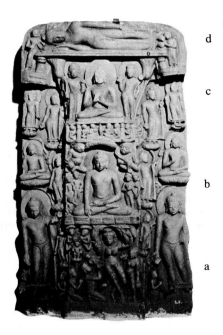

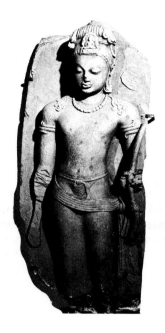

Figure 4.8 Stele from Sarnath showing scenes from the life of the Buddha. Tan sandstone. *a.* Birth of Gautama; *b.* temptations of Mara; *c.* the First Sermon; *d.* death of the Buddha. Gupta dynasty. H. 3'5''. Indian Museum, Calcutta. Photo: author.

Figure 4.9 Bodhisattva, Sarnath. Tan sandstone. Late Gupta (sixth century). H. 4'. Indian Museum, Calcutta. Photo: author.

There are several life-size sculptures from the very end of the Gupta dynasty that indicate that the cult of the bodhisattva was practiced in the Sarnath area (fig. 4.9). They are graceful, gentle beings, humanized and compassionate; gazing down at the supplicant with very human understanding. The "thrice-bent" (tribhanga) position of the body is very different from the Kushan style of Mathura, which maintained a stiffly erect body with widespread feet supporting the weight equally, but it recalls that of Gandhara; its Roman-inspired interest in natural anatomy allowed the body weight to be supported more naturally on one foot and balanced by the other. But it is the yearning for comforting compassion that seems to be embodied in such figures and the expression of this feeling is new in the Gupta dynasty.

By the end of the sixth century the final phases of Mahayana Buddhism in India had begun. By the mid-seventh century it was probably difficult for the layperson to see Buddhism as anything more than another yoga system of Hinduism because so many Hindu concepts had been accepted into Buddhism over the centuries, including the major Hindu deities. Only in the two northeastern provinces of Bihar and Bengal did Buddhism continue, and even here it was in its Hinduized forms of Vajrayana (Lightning Vehicle) and the Dhyani (meditation) cults centering on the Buddhas of the Four Directions (who could be said to be avatars of the Buddha Essence, Vairochana) that Buddhism prevailed.

From about 750 A.D. to the end of the twelfth century, during the Pala and Sena dynasties (730–1197), Buddhism survived in this area, which had been most intimately connected with the life of Gautama. Many stone and metal images have been recovered from this period (see chapter 6). They are rather rigid versions of the Gupta ideal, a repetitious formula hard and dry in form, providing us with a clue to the religion that produced them. Late Indian Buddhism developed into a labyrinth of ritualistic magic formulas stressing the letter of the law but seemingly unconcerned with its spirit.

SUMMARY

During the Gupta dynasty Buddhism reached a more complex level of development. Concepts evolved, as did the imagery of Buddhas and bodhisattvas. Iconographic details became codified and, in an effort to maintain clear identification, corporal attributes and hand positions became standardized.

Based upon an amalgamation of the Kushan and Early Andhra styles, the Gupta developed the serene and contemplative countenance as well as the bodily proportions and accoutrements for the figures of the Buddhas and the bodhisattvas that were to become the classic model in all lands where Buddhism took root.

GLOSSARY

Avatar Descent of a deity into our time and space.

Bodhisattvas Beings whose essence is intelligence and who could become a Buddha but have made a vow not to enter Nirvana until all other beings have done so. (p. 33)

Four Dhyani Buddhas These meditation Buddhas of the Four Directions reigned over four paradises, where the faithful would enjoy a purified material existence. (p. 33)

Mathura style (Gupta) Sculpture showing folds in drapery styled so geometrically that they seem to be a series of strings hanging over the figure; little imitation of natural materials. (p. 27)

Sarnath style (Gupta) Sculpture treating drapery as perfectly smooth without folds except at the extreme edges. (p. 27)

Three bodies of the Buddha Questions: (1) Where was the Buddha between his 550 deaths and rebirths (when he was born as a great variety of beings from a monkey to a man)? (2) How could he be born into our world? (3) Where did he come from in the beginning? Answers: (1) He was in heaven (Body of Bliss). (2) He took on the Body of Magic Transformation to be born into our world. (3) He is an emanation of the Body of Essence, which exists in the center of the universe. (p. 33)

Vairochana The Body of Essence; the Universal Buddha. (p. 33)

5
.

THE INDIAN TRADE
Its Effects in Europe and Asia

East and West met for the first time under the impact of Alexander's conquering armies (fourth century B.C.). Two centuries later his dream of a cultural fusion began to bear fruit, but probably not as he would have imagined.

After Alexander's death, commerce began to develop among the several cities he had founded as well as with a whole chain of oasis centers farther to the east. By the second century B.C., these trade routes through the Middle East and central Asia extended all the way from China to Rome. This was the **Silk Route** (fig. 3.11).

Among the dozen and a half cities founded by Alexander across the Middle East (the best known today being Alexandria, Egypt) the most relevant to this study was that of Bactria in present-day Afghanistan. It was the most important center in the trade system that developed between the major centers after Alexander's death. The city flourished for several centuries and exerted a strong Greek influence in the area. It was populated by many Greeks, Macedonians, and others from Alexander's army, following his method of establishing city-states as homes for any of his soldiers who wished to settle down and marry local women.

Greek culture predominated until replaced by Roman Empire styles in the early centuries of the present era. Inscriptions referring to Greeks have been found in Afghanistan and northwest India suggesting descent from the soldiers of Alexander. In the region of Bactria, at least one local tribe still believes even their horses to be descended from Alexander's famous mount, Bucephalus.

The arts of central Asia, Afghanistan, Pakistan, and northern India all reflected Alexander's dream of fusing Asian and classical culture. The Mauryan kings welcomed ambassadors from the city-states throughout the middle East as well as Egypt, where Cleopatra herself was the Macedonian descendant of Ptolemy I, one of Alexander's generals who became king of Egypt when Alexander's empire was divided up after his death.

KUSHAN COMMERCE

Commercial Routes

The trails of the Yuezhi herds across Central Asia gradually developed into one of the greatest commercial roads in the history of the world. During the Kushan dynasty, Indian cultural influences began to accompany Indian commerce northeastward along these trade routes into central Asia and China and also southeastward into the Indonesian Archipelago. Sea routes brought spices from this island region to India, and from there they were sent by sea or overland routes westward to the Roman Empire. Europe had developed a taste for two exotic products of Asia, and this taste changed the history of the world. One of these products was pepper; the other was silk, which became such a rage that in A.D. 16 the Roman senate ruled that it could not be worn by men. At the time, silk was worth twelve ounces of gold per pound.

Rich Cargoes and Safe Oases

There were many other commodities as well as silk in the packs of the Bactrian camels that carried the trade. In India spices were sent to join the silks in Afghanistan or Samarkand, and exotic scents such as musk from China and incense and aromatic woods from India and Southeast Asia as well as a host of other luxury items made up extremely rich cargoes. On the return, glass from Syria and silver vessels from Alexandria joined the gold bullion from Rome in exchange. India grew rich from the trade. But so did the individuals through whose territories the Silk Route went (fig. 3.11).

Inspired by religious zeal or gratitude for a safe journey the merchants and caravan masters were generous in their endowments and support of religious establishments at the oasis centers. In spite of climate and the terrors of the road, the **caravanserai**, the area where the caravans rested, offered the weary traveler a surprisingly high level of comfort and care. In central Asia the East and West not only met, they mingled. The transient clientele fared well. But the permanent residents of the business community maintained an even higher standard of living. They seem to have partaken of the best of both worlds. The wealthier could furnish their homes with silver dining services from Alexandria, glass from Syria, wood and ivory furniture from India, silks and lacquers from China, and wall paintings by itinerant Indian or Iranian painters. They could dine on Indian-style curries, dried figs and dates from Asia Minor, and melons, grapes, and pomegranates from Afghanistan, as attested a thousand years later by Marco Polo as being the best in the world; and they could wash down their food with a choice of wines from China or the Mediterranean. The cities of the Silk Route appear to have partaken of the material bounty as well as the ideological and aesthetic richness of both the East and West, combining them to form a complex and vibrant new culture. Alexander would have been pleased.

a

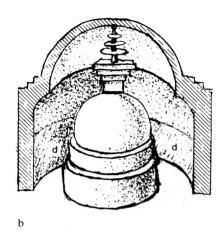

b

Figure 5.1 Circular shrine. Miran, Central Asia (third century A.D.). *a.* Plan of stupa inside square building; *b.* sectional view. Conjectural reconstructions based upon descriptions by Sir Mark Aurel Stein. The paintings reproduced here came from the dado (*d*) around the interior of the building where the pilgrim could see them during pradakshina around the stupa.

CENTRAL ASIAN ART

Architecture

The Indian architectural style for Buddhist buildings spread into central Asia and was adapted to suit each locality as it went from oasis to oasis. Stupas, viharas, and, in some places, even cave temples were established. But the use of stone, common in India, was replaced by sun-dried brick, little of which has survived. The stupa continued to be built on higher and higher bases, so that the eventual effect was that of a tall narrow pyramid composed of clearly defined stories; these were marked by heavy cornicing and fitted with chaitya window-type niches in which figures of Buddhas modeled in stucco were to be seen. On the uppermost story sat the tiny stupa-mound, almost forgotten as the real purpose of the edifice. Often the four corners of the building at the first level supported four additional towers, which were smaller replicas of the central one similar to the Temple at Bodhgaya; these were complete, with miniature stupas and umbrellas at their tops. Usually buildings so constructed had an interior room and doorway, so that they differ radically from the Indian stupa and in fact may be called temples instead, since the stupa has been relegated to a minor role. The interior held images of the Buddha and bodhisattvas in sculptured form, while the walls would have been painted, often with scenes from the life of the Buddha. The exterior of the building was also painted and gilded, presenting a colorful contrast to the normally unpainted domestic mud-brick architecture of the region. The chaitya-hall took on a new form where there were no suitable cliffs for carving cave temples. At Miran the remains of a square building

topped originally by a large dome were found. The exterior plan was square, but the interior was round, and in the center was a large mud-brick stupa. The circular passageway around the stupa allowed for the ritual circumambulation, and on the circular walls of the room murals were painted, reminding the visitor of the previous lives of the Buddha and of 'is victory over pain in the world (figs. 5.1, 5.2, and 5.3).

In some places great cliffs could be carved into cave temples. At Bamiyan hundreds of such caves were carved into the face of a cliff, which is also the site of the largest sculptures of the Buddha (fig. 5.4). These caves were sculpted and painted inside, but they have suffered a great deal over time and only fragments remain.

Sculpture

The colossal sculptures at Bamiyan are also not well preserved, but they are so large that they seem to retain more of their original grandeur. These sculptures stand flanking the ends of the cliff, as though bracketing the cave temples. The smaller is probably fourth century A.D. and the larger (fig. 5.5) perhaps late fourth or early fifth century A.D. They are Gandharan in style. The smaller, earlier sculpture is more Kushan in feeling, while the larger is more closely related to Gupta sculpture of the Mathura school (fig. 4.2*a*). The string-folds of that style are here rendered literally. They were made by drilling holes in the smooth stone, inserting pegs, and attaching rope to form the folds of the Buddha's robe. A thick layer of stucco plaster was then applied and the entire figure was covered with gold leaf.

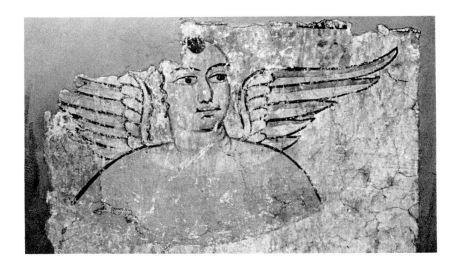

Figure 5.2 Wall painting. Figure of a Victory, from the Circular
Shrine Miran, central Asia (third century A.D.). National Museum, New
Delhi, India. Photo: author.

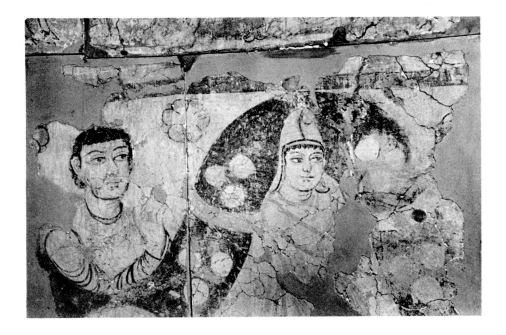

Figure 5.3 Wall painting from the Circular Shrine, Miran, Central
Asia (third century A.D.). Figures carrying a victory garland with busts of
deities. National Museum, New Delhi, India. Photo: author.

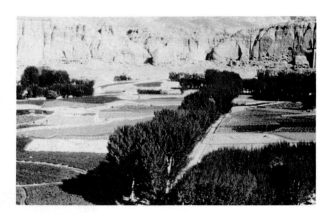

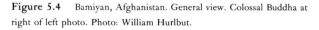
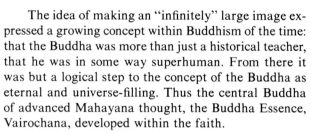

Figure 5.4 Bamiyan, Afghanistan. General view. Colossal Buddha at right of left photo. Photo: William Hurlbut.

The idea of making an "infinitely" large image expressed a growing concept within Buddhism of the time: that the Buddha was more than just a historical teacher, that he was in some way superhuman. From there it was but a logical step to the concept of the Buddha as eternal and universe-filling. Thus the central Buddha of advanced Mahayana thought, the Buddha Essence, Vairochana, developed within the faith.

Of all the concepts and forms that passed along the Silk Route, the **Universal Buddha** may have had the most impact upon the imagination of the inhabitants in northern Asia. In both China and Japan enormous images were later carved in the faces of cliffs or cast in bronze, but none ever equaled in size the colossal Buddha of Bamiyan, which is more than three times as high as the tallest of these. The overpowering experience of having seen the figures at Bamiyan was indelibly impressed upon the memory of pious pilgrims and merchants, and fame of these images was unmatched. Later, ruling families of China and Japan personally erected similar monuments to the Buddha Essence, from whom all Buddhas emanate. From them descend the Eight Great Bodhisattvas as emissaries of the Buddhas of the Four Directions; who are themselves envoys from the Universal Buddha into this world.

Even in their ruined state these great figures are impressive. Here is the very form of the space-filling Buddha. The sun in the heavens forms his halo; he is the universal axis which runs through the World Mountain to support the sun, as symbolized by the Sarnath capital (fig. 3.1). It is no accident that these figures are carved in the "living" rock. The significance of the vertical figure encased within the mass of the cliff completes the circle that began when the relics of the Buddha were first enshrined within a stupa. When stupas later came to be carved within the interior of

the World Mountain itself, in the chaitya-halls (fig. 3.7), the symbolism was enhanced by identifying the axis of the umbrella shaft with that of the universal axis. The stupa was vivified by the relics, the "physical trace" of the Buddha. Gradually the presence of the Buddha was interpreted as more spiritual than physical; thus it became evident that an image of the Buddha was as powerful a reminder of his presence as were the relics, concealed from view within the stupa. The increasing numbers of stupas were already exceeding the possibility of providing each with suitable relics. This situation was alleviated by replacing the equation "relic equals Buddha" with the equation "image equals Buddha." At Bamiyan, this emphasizes the fact that the image does, indeed, have the power to remind one of the Buddha; not just the historical Buddha but his very source, the Universal Buddha, Vairochana, thus precluding the need of both relic and symbol.

The colossal Buddhas at Bamiyan date from about the fourth century, the period that witnessed the tendency of Roman emperors to express the universal character of their power by increasing the size of their portrait sculptures set up at strategic spots around the empire as reminders to the people.

Painting

The manner of transmission of stylistic impulses along the Silk Route was somewhat wave-like. This was true of painting as well as of architecture and sculpture. It may be that in the early stages of the Kushan dynasty in India a style of painting that developed in the Gandhara region was fairly well distributed across central Asian sites with a fair amount of consistency. All that is left of a Kushan style in central Asia are the fragments in the National Museum in New Delhi (see

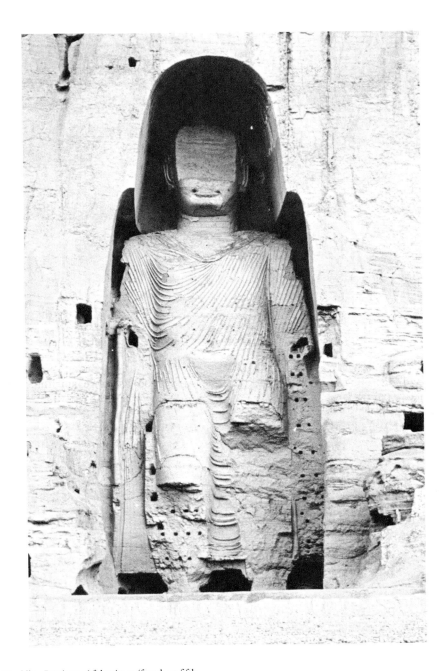

Figure 5.5 Colossal Buddha, Bamiyan, Afghanistan (fourth to fifth century). H. 175'. Borromeo/Art Resource, N.Y.

map and figs. 5.2 and 5.3). This style is clearly provincial Roman; even the name of the man in charge of painting the series of murals from which these bits and pieces were retrieved had a Roman name, Titus. The painting is applied in a broad manner, depicting form by indicating warm lights and cool shadows.

As wave after wave of new influence arrived from India and Persia they mingled with or entirely replaced the earlier arrivals. Thus, within one city some temples

might, by the seventh or eighth century, retain the older Kushan style, while others might have been painted in a combination of Kushan and Gupta styles; still others might have been recently remodeled in the then-current styles, incorporating more or less Sassanian or Persian influences. The remains of Central Asian painting are too few to provide detailed evidence, but one can perceive that numerous variations existed, ranging from the Romanized style of the Kushan period

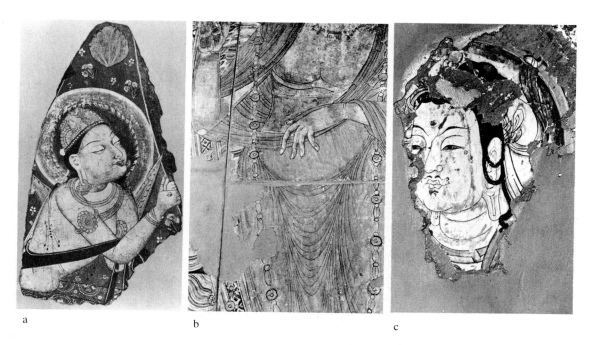

a b c

Figure 5.6 Wall paintings. *a.* adoring figure, probably from Balawaste, central Asia; *b.* standing Buddha, Bezeklik, central Asia (eighth century); *c.* head, from Turfan, central Asia (eighth to ninth century). National Museum, New Delhi, India. Photos: author.

at Miran, through a combination of influences from Gupta India and Persia (fig. 5.6*a*), to the complex style seen in fragments of murals from Bezeklik (fig. 5.6*b*).

Until the ninth century the stylistic movement seems to have been from west to east; but by that century Chinese influence had penetrated as far west as Turfan (fig. 5.6*c*), extending earlier Chinese influences at sites between Turfan and Dunhuang to the east.

SUMMARY

The development of international trade during the ascendancy of the Kushan dynasty led to the spread of Indian culture along the trade lines. Since the Kushan had been largely responsible for the development of the Silk Route, at first as wanderers across central Asia, later as the rulers of India, it was to be expected that they would play a dominant cultural role in the subsequent trade. The importation of spices and other exotic items from Southeast Asia and their transshipment through the Ganges Valley to join the Silk Road in Afghanistan brought Indian culture to the southeast as well. Indian colonization transmitted Buddhism and Hinduism, and with them came the need for religious architecture and images.

Over the years the Indian styles were gradually modified by local traditions and artistic preferences. In central Asia the original Kushan style was largely lost due to renovations and remodeling, generation after generation, but the few fragments that remain indicate that the Gupta Indian style of the fourth and fifth centuries continued to influence works in Afghanistan and sites farther to the east. Often a strongly Persian flavor is evident in the emphasis upon linear rhythms and flat patterns in bright colors. Sometimes, as at Bezeklik, these are combined somewhat anachronistically with the shading style of Ajanta.

GLOSSARY

Caravanserai Inns for camel caravans. Large buildings surrounding a court where the caravans would rest and replenish supplies. (p. 37)

Silk Route Trading route connecting China, India, the Near East, and Europe. (p. 37)

Universal Buddha Vairochana, the Buddha of Essence. Depicted in colossal sculpture in Afghanistan, Central Asia, China, and Japan. (p. 40)

6
.

THE HINDU REVIVAL
The Decline of Buddhism

POST-GUPTA INDIA (A.D. 600–1200)

By the end of the Gupta dynasty the changes that had taken place in Buddhist thought in India were, simply stated, modifications of Buddhism by Hinduism. In assimilating Hindu deities into Buddhism, Buddhists had unconsciously accepted Hindu concepts as well. Eventually these ideas blossomed within Buddhism; thus we have seen such concepts as the three bodies of the Buddha and the bodhisattva cult, both of which owe a great deal to Hinduism.

The supreme deity of the Aryans was Indra, omnipotent ruler of the universe. Other lesser gods were more or less vaguely described in the Vedas, which were hymns of praise, prayers and supplications, and charms and incantations addressed to the various gods and powers. The Vedas also contain detailed prescriptions for ritual offerings to these beings; it appears that for a long time they were worshipped and praised by word and ritual act. Gradually (by ca. 500 B.C.) the pre-Aryan desire to depict in visible form the power being worshipped re-emerged and led to the production of cult images. By this time the amalgamation of pre-Aryan (Dravidian or native Indian) and Aryan concepts was fairly complete, and, while retaining the Vedas, the Hindu religion that resulted revived the embodiment of divinity in visible form as an object for worship, since it contained within itself at least a spark of the divine by virtue of its representation of the divinity. Both levels, the highly abstract and the intensely concrete, have continued as complementary aspects of Hinduism.

HINDUISM

In theory Hinduism is simple. In practice it is extremely complex. Its basic tenet is that the only real existence is **Brahman,** and that existence as we know it is illusory. Our separate selves seem to exist individually only because we have not learned that "we" do not exist. Thus the aim of Hinduism is the discovery of the true nature of the self (*atman*) and the true nature of the undifferentiated eternal principle of existence, which is Brahman. When these two realities are fully grasped they are seen to be one, without separateness or differentiation, and at once we are aware that Brahman is us as well as everything else that is.

Aspects of Brahman

Brahman is self-existent, changeless, and eternal—all qualities that the Judeo-Christian tradition attributes to God. There is a significant difference: God is a personality, Brahman is not. In Hinduism there are many gods, which represent the various aspects of Brahman. There is the aspect of creation, expressed through the creator god, *Brahma;* the aspect of sustaining life, expressed through the sustainer god, *Vishnu;* and the aspect of decay or destruction, expressed through the god of destruction, *Shiva.* Like the Greek gods, the Hindu gods had wives, and like them they often exhibited very human frailties.

At its lowest level of practice Hinduism may indeed be little more than "idol worship," but at its highest the well-informed Hindu worships not the multitude of images but what lies beyond them, what gives existence its being, the undifferentiated unity that is called Brahman. The goal is the reunification of that small seemingly separated splinter of being, the individual (which is only an illusion), with Brahman. Physical death does not end the quest. The self (*atman*) may be reborn over and over again until it discovers that it and Brahman are one. Release (*moksha*) from this **cycle of rebirths,** *samsara,* is then achieved. The condition of the self in its next reincarnation is determined by the consequences of one's life (*karma.*). If one leads a good life, he or she may be released from the wheel of rebirths at its close; if not he or she may be reborn in a lower state—a fish, a tortoise, a monkey, a cow—and move slowly from life to life, up the evolutionary scale toward humans. In the end, however, all will find their way back to Brahman no matter how many lives it may take. There is no reward but eventual release, and no punishment but regression.

Hindu Revival

Hinduism enjoyed a revival beginning in the later years of the Gupta dynasty. The Hindu renaissance centered around devotion to Vishnu and, in particular, his **avatar,** Krishna, the romantic hero of poetry and song. This cult of avatar is a parallel to that of the bodhisattva in Buddhism; both were expressions of a new humanism that brought divinity within the reach of everyday actuality.

Elephanta

The idea of the emergence of form from the stone matrix that holds within itself all potential of form is best seen in the cave temple of Elephanta on a small island in the Bay of Bombay. The date of this site is uncertain, but it can probably be assigned to sometime around the sixth century. It is a large, square, flat-ceilinged room approximately ninety feet on a side, plus narrower extensions forming open porches on the north, east, and west. On the south the extension forms a recessed niche. On the central east-west axis, just inside the west porch, is the square cella containing the *lingam* (the phallic emblem of Shiva).

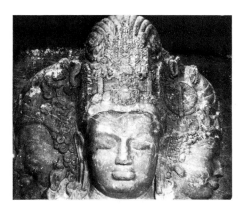

Figure 6.1 Elephanta cave temple, south wall, Shiva Mahadeo. Rock cut (ca. sixth–seventh century). H. (floor to top of head) 24′; face only 9′. Photo: author.

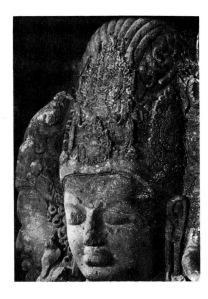

Figure 6.2 Detail, central head.

The female aspect of the divine is expressed in Hinduism by the concept of Devi, the goddess, counterpart of the male Deva. In Shaivism, Devi has three forms of being. In the static form, she simply is in her essential aspect. In this form she is Uma, the Great Mother. In her active form she is Parvati, the daughter of the Himalaya and the wife of the god Shiva, a role dear to the heart of the Shaivite. In her destructive role Devi is Durga, the terrifying goddess form created by all the great gods in desperation to overcome the Buffalo demon. As Kali, Devi is the destroyer of time and, thus, is the goddess of death.

High-relief carvings inside the cave temple depict episodes in the life of Shiva and Parvati. Two of these flank the central sculpture on the south wall. The central sculpture is by far the most striking feature of Elephanta, partly because of its huge scale (fig. 6.1). It is an almost full-round bust of Shiva in three forms (*Trimurti*): benign in the central head; terrifying in the head on the spectator's left, and on the right in female form. Another relief in the cave depicts him as half Shiva and half Parvati. We see here an expression of the concept that, although there may appear to be multiple gods and even goddesses, they are all really only one—Shiva Mahadeo—Shiva the Great God.

A peculiar feature of the carving is the lack of definition of eyelids, as though the eyes look inward (fig. 6.2). This feature coupled with the darkness of the cave emphasizes the character of the forms; they actually seem to be emerging out of the stone as one becomes accustomed to the gloom. The downcast eyes support the illusion that the figures are just beginning to stir in a slow majestic movement that is only apparent, not real, with their attention fixed on inner essence. Thus, the quality of the unmoved essence of being behind action is powerfully conveyed at Elephanta in the majestic grandeur of these ample forms evolving from the living stone. In the quivering light of the uncertain illumination provided by butter lamps, these sculptures, in their original painted and gilded condition, must have been even more awe inspiring than as we see them now.

THE PALLAVA DYNASTY (A.D. 500–850)

Sculpted Temples

The rise of the Kushan in the north displaced the Andhra, whose successors set up the Later Andhra kingdom in the region of Amaravati on the southeast coast. Both the Kushan and the Andhra were subsumed under the Gupta power in the early fourth century. By the sixth century a new and important dynasty began to emerge to the south of that region. It was the Pallava.

The Pallava capital was at Kanchipuram (Conjeeveram) some thirty miles inland (see map, p. 4). On the coast, at the site of Mamallapuram, during the reign of Narasimhavarman (630–68), some of the most remarkable works of the period were created. The coast is strewn with huge boulders and rounded outcroppings of granite, which were carved into sculptured temples. The style is that of wood buildings, none of which have survived. The engaged pilasters with their elongated shafts and brackets are clearly derived from a tradition of wood construction. In wooden buildings they would probably have been fully rounded pillars, but in stone they seem too thin to support the superstructure of the tiered roofs so they have been treated as pilasters. The

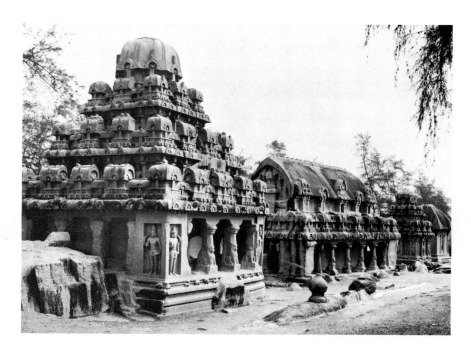

Figure 6.3 Mamallapuram, general view of temples carved from
granite boulders. Pallava, reign of Narasimhavarman (630–68). Photo:
Archaeological Survey of India.

temples are raised on short bases, and the silhouette of
these roofs forms a straight line from the corner to the
spire. When the plans are rectangular rather than
square, the roofs are not straight-sided but rather
curved so as to reflect the exterior shape of the barrel-
vaulted interiors. These latter go back to the early
Buddhist chaitya-halls for their inspiration. The most
complete is the group known as the "Five Chariots"
(*Raths*) (fig. 6.3). Several others were begun, but all
were left more or less unfinished, and none seems ever
to have been dedicated for use, since work on them was
abandoned upon the death of Narasimhavarman. They
are significant because they sum up Indian architec-
ture before their time and forecast its evolution after
their time. Four of them are rectangular in plan with
differing kinds of roofs. The fifth is an apsidal chaitya-
hall of the type we have seen earlier at Karli.

One of these temples has the long barrel-vaulted
roof that in later centuries would be seen as the roof of
the extremely tall gateways to South Indian Hindu
temples (fig. 6.4*a*). Another has a pyramidal roof with
rows of carved miniature buildings that repeat the
barrel-vaulted building (fig. 6.4*b*). At the corner of each
row is a miniature building with a four-sided curved
roof looking very like a small squared-off stupa; this
repeats the motif of the crowning element, which is
more rounded by having eight sides. This element is

called the **stupika** ("little stupa") and seems to have
been derived from the Later Andhra Buddhist stupas,
which must have been known to the Pallavas, whose
kingdom lay just south of Amaravati. The repetition in
miniature of the shape of the larger elements is very
significant, for it is the device by which later Indian
temples, no matter how large or complex, retain an
overall sense of unity. It is seen here at Mamallapuram
in one of its earliest expressions.

Hindu Deities

Between the tall thin pillars of these carved temples
stand images of Hindu deities (fig. 6.5). They are
slender like the Amaravati figures but less active. The
poses seem in some cases to be purposely stiff. The god-
dess Durga is of special interest.

Durga, Mother Goddess Triumphant

Recall that originally the Indus Valley culture wor-
shipped a mother goddess. The Aryans suppressed this
cult and gradually installed their own male deity, Indra,
as the supreme god. Finally this deity was exalted to
rule over the Heaven of the Thirty-Three Gods. By
about the second century the fusion of Aryan and pre-
Aryan (Dravidian) concepts produced the triumvirate
Brahma, Vishnu, and Shiva as the three great deities

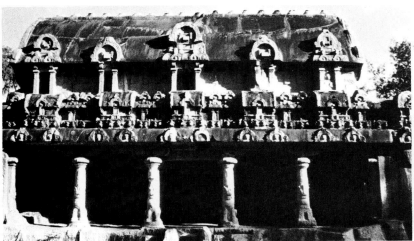

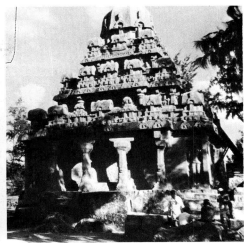

a

b

Figure 6.4 *a.* Bhima Rath, Mamallapuram. Rock-cut temple. Pallava (630–68). Height about 30′. *b.* Dharmaraja Rath, Mamallapuram. Rock-cut temple. Pallava (630–68). H. about 40′. Photos: author.

of Hinduism. By the time of the Gupta dynasty Brahma had begun to lose favor, and eventually only Shiva and Vishnu remained as co-equal. Those who followed Vishnu claimed him to be supreme, with Brahma and Shiva as his creations, while the followers of Shiva claimed Brahma and Vishnu as his creations. Toward the end of the Gupta period a new concept arose (or rather a very old concept re-emerged). The story goes that during the time of the gods, a terrifying buffalo-demon, Mahisha, was running berserk throughout the universe destroying everything in his path. All the Thirty-Three Gods tried in vain to quell this monster. Finally, in desperation, they came together and, in their wrath, breathed out their power in the form of flames. The flames came together and fashioned a new deity, the goddess Durga. She was given the attributes (i.e., powers) of all the gods and went off to attack the demon. With the sword of Vishnu she cut off his head, but as soon as this was done the blood spurted onto the ground and from each drop sprang up another demon of the same kind. Durga called upon the Sapta-matrikas (Seven Mothers) to assist her and they fell to lapping up the blood before it could reach the ground. Thus eventually did Durga destroy the demon and set the universe back in order.

This story is most revealing as indicating the manner in which the primordial concept of the mother goddess reemerged, after many centuries, victorious. The Aryan idea of male supremacy was overcome and Hinduism was reestablished at its more comfortable level.

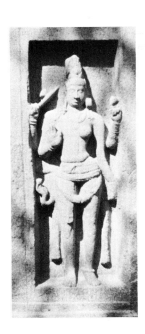

Figure 6.5 Shiva Ardhinari. Combined form. Shiva and Parvati. Dharmaraja Rath, Mamallapuram. H. 6′. Photo: author.

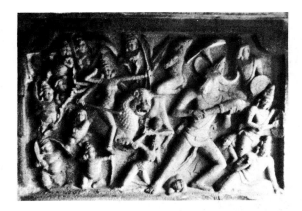

Figure 6.6 Durga attacking buffalo demon. Mamallapuram, Mahisha Mandapam. Rock-cut relief. Palava (seventh century). H. 10'. Photo: author.

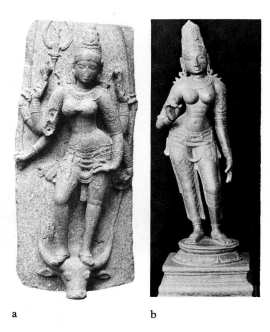

a b

Figure 6.7 *a.* Durga victorious. Mamallapuram. Granite. Pallava (seventh century). H. 4'11''. Museum of Fine Arts, Boston, Ross Collection. *b.* Chola queen as devi. Bronze. Chola (ca. 907–1053). H. 32¾''. National Museum, New Delhi, India.

Illusion and Drama

Regardless of how many deities are worshipped in countless forms, the sophisticated Hindu knows that form itself is only an illusion (*maya*) and that the divinity in these countless forms, taking on one role after another, is but playing out the drama of the gods (*lila*). What lies behind these innumerable and shifting roles is always the same unchanging unity, Brahman, which, in the realm of form, takes on the appearance of men and gods but which, beyond the realm of form, lies eternally unaffected by the conditioned existence of the world of men and gods.

It is this concept of the unformed beyond form—the unconditioned beyond the conditioned existence—that the sculptures of Mamallapuram express. When Durga, seen wielding in her eight hands the powers of the gods and riding on her lion, charges the buffalo demon, we expect a facial expression compatible with this terrifying engagement (fig. 6.6). This is not the case. In neither this active phase of the story nor in the final victory, when she stands triumphantly upon the head of the demon, is there the slightest hint in her expression that she is actually involved (fig. 6.7). She seems almost to be unaware of her acts, thus indicating the ultimate truth about the gods: that they exist only as illusion. When this is properly understood, the illusion of separateness among humans is also clear; it follows that the only true existence is Brahman.

The Buddhist story concerning the attacks of Mara revolves around this same point. Why did Mara fear that Gautama would awaken? Because he knew that the Buddha would then realize the gods are but part of *maya,* illusion, and that, should he succeed in informing others, it would be the end of the gods. In short: the Hindu gods came to be regarded not as creations

of a supreme creator, but contrariwise, creations of a deluded humanity. Nevertheless, as long as humans believe in them, the gods will exist in the realm of forms. When humans are so attached to the realm of the senses that they do not perceive the realm of form, the gods have no being for them. When humans are aware of the world of form but fooled by the play of the gods into believing it is the final realm, they remain unaware of the realm beyond form; when humans perceive the realm beyond form, the gods (like the armies of Mara) are immediately dissolved. But, if properly approached, the gods can be stepping stones from the world of the senses to the world beyond form.

The **Pallava sculptural style** evolved without a break into that of the succeeding Chola dynasty (ca. 907–1053). Chola style stone and cast bronze images (fig. 6.7*b*) reflect the same swelling forms and easy pose seen in the Durga in Boston, made some three centuries earlier (fig. 6.7*a*).

Form from Stone: Descent of the Ganges

At Mamallapuram a gigantic carved boulder represents the descent of the Ganges River (fig. 6.8). Originally the goddess Ganga flowed in heaven. Sagara, the king of Ayodhya, by means of the intervention of a great sage, had one son by one wife and by the other a gourd

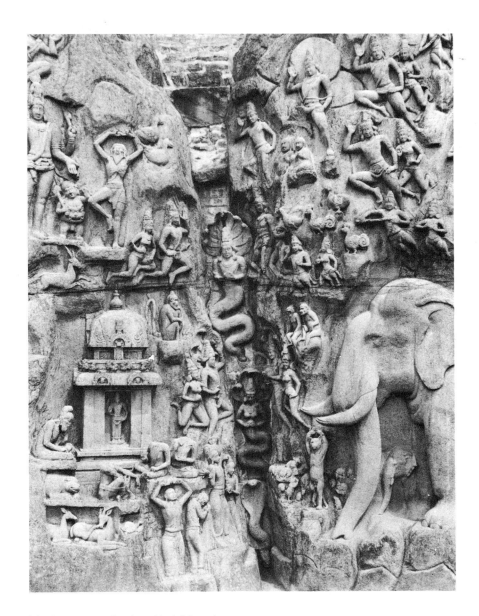

Figure 6.8 Descent of the Ganges, *central section,* with cleft in rock down which water descends, Mamallapuram. Carved granite. Pallava (630–68). H. about 35'; length of entire composition is about 90'. Archaeological Survey of India.

that produced sixty thousand sons. When they became adults the king was tempted by pride to try to overthrow the great god Indra. But Indra, learning of his intention, thwarted his desire. As a result, the sage Kapila was accused by the sons of stealing the horse that Sagara had set loose as a means of establishing his superiority by claiming all the land encompassed by the horse in his wandering. Kapila, disturbed in his meditation by their accusation, opened his eyes and, looking at them in wrath, reduced them to ashes.

King Sagara meantime had sent his grandson to search for his uncles. Kapila, pleased with his humility, told him that they could be restored to life if Ganga could be induced to descend from heaven and flow over their ashes, but both Sagara and his grandson died without succeeding in bringing Ganga to earth. Finally the great-grandson of Sagara, Bhagiratha, performed severe penances until Brahma at last agreed to order the goddess to come down. But, fearing she would destroy the earth by her force, he told Bhagiratha to beseech the god Shiva to break her fall. After more severe penances, Shiva agreed to assist (fig. 6.9).

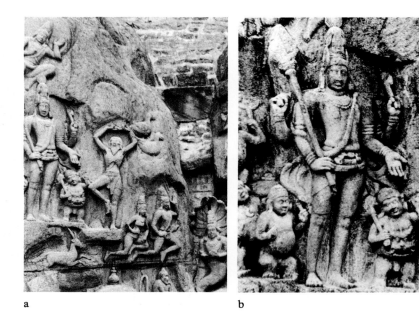

a b

Figure 6.9 *a.* Descent of the Ganges, *upper left section,* Shiva and Arjuna. Photo: Archaeological Survey of India. *b.* Shiva. Photo: author.

Ganga rushed down in terrifying torrents, but Shiva caught her in his hair and eventually Bhagiratha led her to the place where his ancestors' ashes lay. When her life-giving waters flowed over them, the sons of Sagara were restored to life.

The dozens of divine beings are portrayed in two large groups turning toward the center, where a cleft in the rock allowed water to descend in a cascade. In the cleft may be seen a pair of cobra-hooded water-spirits (Naga and Nagini), but in this representation Shiva does not catch the water in his hair; he simply stands to one side with the same impassive expression, indicating his true being behind his actions—moving but unmoved (fig. 6.9*b*). This, the grandest assembly of Pallava sculpture, was also left unfinished following the death of Narasimhavarman.

CHOLA DYNASTY (907–1053)

After almost a half century of warfare among the contenders, following the fall of the Pallava, the Chola dynasty dominated all of South India and the island of Shri Lanka (formerly Ceylon) from the early tenth to the mid-eleventh century. The architecture as well as sculpture of the Chola period is a natural consequence of the Pallava style. The temples were placed on bases so that they resembled the pyramidal temples at Mamallapuram (figs. 6.1 and 6.2*b*) but multiplied, so that the great temple built at Tanjore, the Chola capital, at

the beginning of the eleventh century, is fifteen stories high and more than five times the width of its predecessor at Mamallapuram, which is only three stories high, measuring forty feet, whereas the Tanjore Temple is over two hundred feet high.

Ellura

At Ellura, in western India, the same profound reverence for the living stone is seen in the greatest of all the Indian rock-cut temples, the Kailasanatha, dedicated to Shiva (fig. 6.10). This enormous building was entirely carved out of the stone cliff. The form of the spire above the sanctuary is clearly derived from the Pallava style. It is the World Mountain, enshrining Shiva in the lingam. The sanctuary is surrounded on three sides by five smaller shrines; on the exterior the base is supported by life-size elephants, recalling the ancient Indian belief that the World Mountain was supported by elephants facing in the four directions. Walls are carved in relief representations of the legends of Shiva and Parvati.

THE NAGARA STYLES

Ganga Kingdom of Orissa

The sanctuary at Ellura is almost swallowed up in the massing of the **mandapam** (porch) that precedes it and by the five shrines that surround it. A quite different

Figure 6.10 Ellura, Kailasanatha, looking southeast. Rock cut. Rashtrakuta (753–ca. 900). Kailasanatha carved between 756–853. H. 100′; L. 280′. Photo: Archaeological Survey of India.

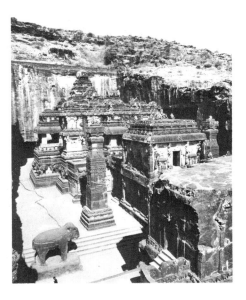

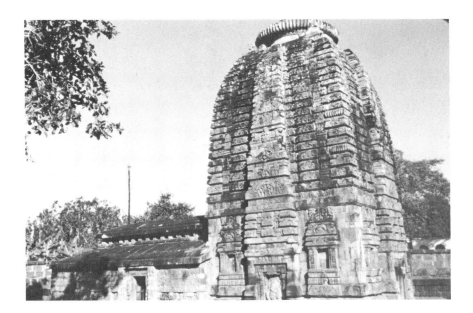

Figure 6.11 Bhuvaneshvar, Purashurameshvara Temple. Sandstone construction (ca. 750). H. 44′. Photo: author.

relationship is seen in the Hindu temples of Orissa. At Bhuvaneshvar in eastern India (see map, p. 4) a temple of almost the same date as Ellura exhibits a very clear distinction between the two elements: the porch, long, low, and horizontal, and the tall tower (**shikhara**), with no transition between them, as though two separate buildings had been joined together (fig. 6.11).

The Chandellas of Khajuraho (A.D. 950–1050)

This simple plan became more elaborate by adding more halls and porches, until by the eleventh century a complex series of roofs build up from the entrance to the tower. At Khajuraho, northwest of Orissa, a subtly related style prevailed. Here the temples are on high platforms and each of the several roofs of the porches and halls preceding the tower over the sanctuary build

up gradually to a crescendo of form in the spire itself (fig. 6.12). This is again the World Mountain in temple form, the roofs, like the foothills, preparing us for the inspiring height of the peak. Each of the twenty temples remaining at Khajuraho is different in details, but they all share this architectural relation of a series of smaller roofs building up to the main spire. The sides of the spires expand in the four directions in a repetition of the form of the whole spire. This device, repeating in miniature the form of the whole, preserves unity amid an otherwise overwhelming variety of detail. These temples have open porches facing in three directions around the sanctuary (fig. 6.13). Their bases as well as the lower sections of the spires have high-relief carvings depicting the Hindu deities to whom they were dedicated. The style of carving is supple and elegant. Dancing girls, musicians, and loving couples (fig. 6.14) depict the realm of the senses above which the spire rises in pure geometric, nonrepresentational grandeur.

The transition from figurative and sensual to abstract and spiritual in these temples reflects a fundamental conception in Indian religion and thus in religious art.

The suggestion of a sexual union as a symbol of union with the divine; of atman with Brahman, is very old in India. To see the evolution of the increasingly voluptuous treatment of the female form, as a reminder of the mundane/spiritual relationship, one need only refer back to earlier examples (see figs. 3.6, 3.10, 4.5). In this connection it must not be forgotten that the pre-Aryan deity of the Dravidian peoples of the Indus Valley was the mother goddess, represented by the hundreds of clay figurines that have come down to us.

The Khajuraho sculptures represent an extremely high level of formal organization of line and volume that is so finely tuned that it not only describes in detail but, by its abstract organization of these details, moves far beyond description to a tremulous moment when the whole structure of the temple and, by extension, the whole world is transported to the higher reaches of aspiration, in which the human reveals itself as already divine.

SUMMARY

From the confluence of the old native beliefs and those introduced by the Aryan immigrants into the Indus Valley, the Indian people formed a faith based upon the powers of nature and imbued them with anthropomorphic qualities.

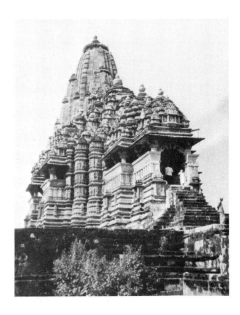

Figure 6.12 Khajuraho, Kandariya Mahadeo Temple. Sandstone construction (ca. 1000). H. (including platform) 116′. Photo: author.

The body of thought that the Aryans brought with them was at first an oral tradition but gradually came to be written down and was known as the Vedas, primarily spells and incantations for propitiation of the gods and directions for the conducting of services and sacrifices due to them. Other literature grew up dealing with the relationship of the individual to the supreme principle of existence. Later on came the multitude of myths and legends telling the stories of the major gods. It is from these that artists drew their inspiration when an image of a deity came to be needed.

The latter half of the first millenium witnessed the revival of Hinduism. It was also the most creative period for the expression of Hindu ideals in art. The form of the Hindu temple underwent a variety of changes, from the simple cubic sanctuary with minimal spire and porch to its full maturity. At the end of the millenium, the principal of microcosmic miniaturization of the World Mountain macrocosm was resonantly reflected in an almost endless elaboration of form; this culminated in the abstraction of the upper reaches of the spire, beyond the realm of form and idea: the goal of Hindu religious art.

GLOSSARY

Avatar The incarnation of a Hindu deity; Krishna is one of the incarnations of Vishnu. (p. 44)

Brahman The only real existence acknowledged by the Hindu religion. (p. 44)

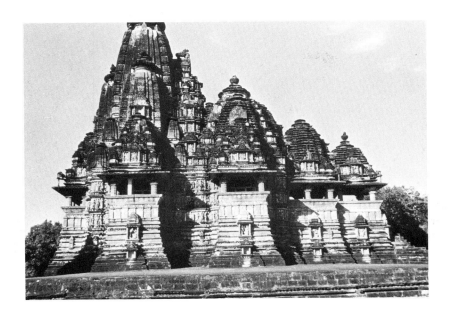

Figure 6.13 Khajuraho, Vishvanatha Temple. Sandstone construction (inscribed dedication dated 1002). H. 60′. Photo: author.

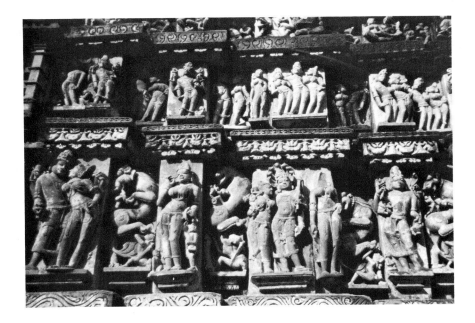

Figure 6.14 Khajuraho, Parshvanatha Temple. Sandstone construction. Detail of sculpture (eleventh century). H. (lower figures) 2′. Photo: author.

Cycle of rebirths In the Hindu religion, the self continues to be reborn until it discovers that it and Brahman are one; samsara. (p. 44)

Mandapam Porch. (p. 50)

Pallava style Primarily known from stone sculptures in high relief. Figures seem to "emerge" from the stone and are elongated in body proportions with oval faces. Found in southeastern India and date from the seventh through the eighth centuries. (p. 49)

Shikhara Tower or spire. (p. 51)

Stupika "Little stupa," a miniature building with a round or octagonal roof at the summit of the Pallava temples. Also a four-sided curved roof found at the corner of the row of miniature buildings on the sculptured temples of the Pallava dynasties, A.D. 630–668 (p. 46)

7

.

THE MOSLEM CONQUEST OF INDIA
The Mogul Dynasty
(Sixteenth to Eighteenth Century)

Moslems, or Muslims ("believers"), are followers of Islam, which was established by the Arab prophet Mohammed (ca. A.D. 570–632). The sacred book of Islam is the Koran. It is a record of visions and spiritual experiences spoken by Mohammed over a period of years.

Islam is monotheistic, with the belief that "there is no god but Allah and Mohammed is His prophet." Prayers, almsgiving, and fasting as well as pilgrimage to the holy city of Mecca are the principal aspects of the faith.

The Islamic culture gradually absorbed the best aspects of those countries through which it swept. It creatively adapted the best of all the lands from Spain to China and preserved many of the values and technologies of the Greco-Roman tradition, which were lost to Europe until the late Middle Ages, when they were re-introduced through trade with the Orient.

As early as the eighth century Moslems from Afghanistan began to penetrate Northwest India. In the thirteenth century the Sultanate of Delhi was set up to consolidate the conquests of the north and central Indian kingdoms. However, the Delhi Sultanate lost control in less than a century and broke up into a series of local contending factions. Unity was restored when the Mogul leader Babur (r. 1526–30) conquered most of northern India in 1527.

Mogul is the Persian pronunciation of the word *Mongol,* which refers to the tribes of fierce nomads from Mongolia who had already devastated Asia in the thirteenth century (see chapter 17 for the Mongol conquest of China).

MOGUL RULERS

The Mogul dynasty consisted of a succession of six fathers and sons, beginning with Babur and, in effect, ending with Aurangzeb (r. 1658–1707). These rulers were descended, through Babur, from Timur (Tamerlane, or Timur the Lame because of one short leg) on one side and Genghis Khan on the other. They were also distant cousins of the Persian Princes who ruled at Herat and, like them, were Moslems.

Unlike Genghis, who wanted land for his people and his flocks, Timur was bent as well on improving and beautifying his capital city at Samarkand, from which he terrorized and destroyed much of the area between central Asia and the Mediterranean.

Timur was a Muslim and a Turk and so were his people. They were raiders who lived off those around them by pillage. Under Timur the people raided for valuables but also for craftsmen, artists, and men of letters from Persia, Syria, Turkey, and India, which was devastated by a raid on Delhi and surrounding territory in 1398.

In the century between the time of Timur and the birth, in 1483, of his descendent, Babur, who would become the first Mogul ruler of India, a great culture had developed around Samarkand, and it is named Timurid after Timur, who instigated it. It was Islamic and inevitably eclectic, based as it was on kidnapped talent from the Middle East and borrowed motifs from China and the Silk Route oasis. Samarkand was the richest and most renowned trading center of all. When the Portuguese ambassador, Ruy Gonzales de Clavijo, arrived a year before the death of Timur he was astonished at the size and grandeur of Samarkand.

At Shiraz, Isfahan, and Tabriz in Persia (present-day Iran) great schools of miniature painting and calligraphy flourished during and after Timur's domination of the area. Unlike their Mongol ancestors, the Mogul rulers of India were among the world's most aesthetically minded rulers. Their language was Persian and they brought with them a Timurid culture. But transplanted to Indian soil it soon flowered into the hybrid Mogul style. Persian artists, imported by Babur's son, Humayun (r. 1530–40 and 1555–56), trained Indian painters, who produced the finest Mogul miniature paintings under the reign of Akbar (1556–1605), the third Mogul ruler.

Persian and Indian Art Concepts Create Mogul Art

Akbar was the real founder of Mogul art. During his reign the Persian style was modified by Indian concepts and emerged as distinctly Mogul. Although illiterate, Akbar was highly intelligent and cosmopolitan. After leaving Agra (fig. 7.1) and building his new capital, Fatehpur Sikri, in 1569 (abandoned 1584), he tried to synthesize the Moslem faith (Islam) with Zoroastrianism and Hinduism into a new religion in order to overcome the religious differences in his empire. His intense intellectual curiosity made him happy to receive foreign visitors and ideas. Christian Portuguese missionaries provided him with an illustrated copy of the Bible and European paintings of Christian subjects. His large staff of court painters studied these avidly and made copies of them, which Akbar enjoyed showing side by side with the original and challenging visitors to detect which was the copy. The European methods of shading and indicating depth were of particular interest and were incorporated into Mogul painting.

Something of the splendor of Babur's court is implied by the painting in figure 7.2. But what is actually displayed is an imagined scene painted twenty years after his death. Babur's lineage is reflected here because he was part Turk and part Mogul and lived in

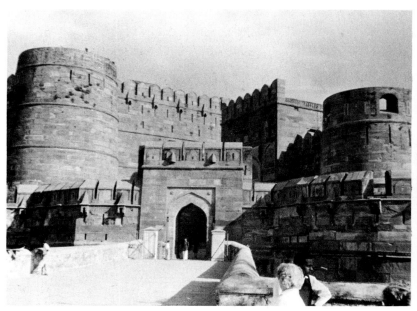

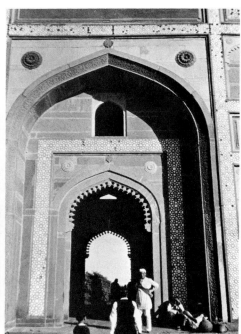

a

b

Figure 7.1 *a.* Agra Fort. Red sandstone. Moghul (built 1564). Photo: author. *b.* Fatehpur Sikri, Buland Darwaza (victory gate) to Mosque. Red sandstone inlaid with white marble (1575). Photo: author.

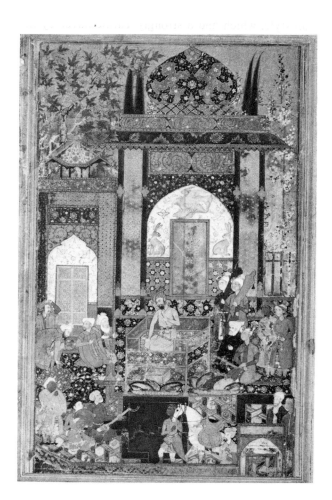

Figure 7.2 Babur receives a courtier. Attributed to Farrukh Beg. From a *History of Babur.* Opaque watercolor and gold on paper. Mogul period (ca. 1589). H. 10⅛″ × 5¹⁵⁄₁₆. Courtesy of the Arthur M. Sackler Gallery, Smithsonian Institution, Washington, D.C. Accession No. s1986. 30.

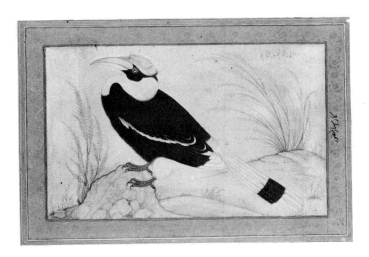

Figure 7.3 A black and white hornbill, by Ustad Mansur. Colors on paper (ca. 1615). H. 6″. The Metropolitan Museum of Art, Purchase, Rogers Fund and the Kevorkian Foundation Gift, 1955.

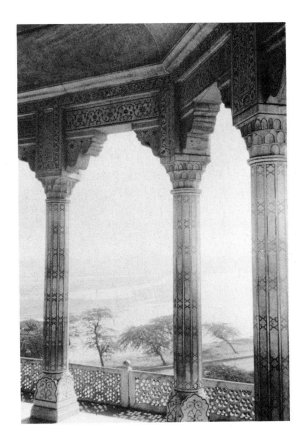

Figure 7.4 Diwani Khas (Hall of Private Audience), Red Fort, Delhi. White marble inlaid with semiprecious stones. Reign of Shah Jahan (1627–58). Photo: author.

the splendid city of Samarkand, which he had conquered as a child. The Timurid style in which it is painted is the result of the artist's training in the Persian style, which had a strongly Turkic flavor by that time. It all seems perfectly appropriate, and one cannot wonder if Akbar, Babur's grandson, who had it painted to illustrate a new translation of his grandfather's memoirs of his reign, chose painter Farrukh Beg because of his style as much as for the fact that he was one of the greatest artists of the day.

Mogul style painting brought India a realism unknown before. Portraiture became an important field, perhaps best expressed in the Darbar (Public Audience) scenes where each face is a specifically treated individual (colorplate 1).

Jahangir (r. 1605–27) was very fond of painting and continued to employ both Persian and Indian painters at his court. He was a passionate collector, and he gathered whatever he could into his menageries and gardens and palaces. What could not be collected he had painted, and these paintings were preserved in his huge painting album collection (fig. 7.3).

Unsurpassed Architecture

Jahangir's son, Shah Jahan (r. 1627–58), was the glory of the Mogul rule. His court was the most sumptuous of all. His palaces and audience halls of white marble set with semi-precious and precious stones provided a setting unsurpassed in sheer magnificence (fig. 7.4). In formal gardens flowers gleamed like jewels set among the emerald green of lawns and dark green of cypress

trees, while rubies, diamonds, sapphires, and emeralds sparkled not only on the walls of the palaces but on the person of the emperor, as well as on members of his court. Shah Jahan loved architecture, gardens, and precious stones. He was less fond of painting; the portraits, so revealing in the reigns of Akbar and Jahangir, became stiff and official. Shah Jahan was always portrayed with a halo, in regal glory (fig. 7.5). In his reign, architecture and the minor arts arrived at a perfect balance of harmony and proportion.

The Taj Mahal

Outwardly the reign of Shah Jahan was one of formality, but at its core lay an intense romanticism, which is best expressed in the tomb of his wife, the Taj Mahal at Agra (colorplate 2). This monument to love employed twenty thousand workmen for twenty years. Set in a formal garden on the bank of the Jumna River, this miracle in marble seems to float in the mists of dawn, to radiate the noonday sun, and to shimmer in the cool

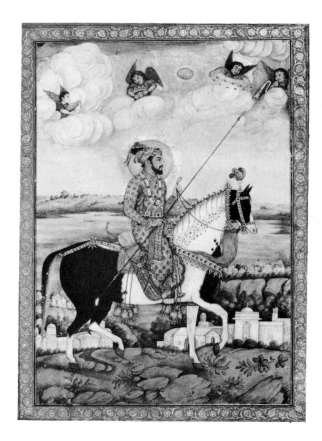

Figure 7.5 Shah Jahan on horseback. Colors on paper (ca. 1635). The Freer Gallery of Art, Washington, D.C.

light of the moon. The first view through the great arched gate of this immense edifice is an unforgettable experience.

THE MOGUL DECLINE

Although they had conquered by the sword, the Moguls ruled with autocratic justice. Their ancestral ferocity may have been softened by their Indian wives or mothers. The personality traits that had made Timur and Genghis Khan the scourge of Asia did not really show themselves until the birth of Aurangzeb, the son of Shah Jahan. He usurped the throne, killed his brothers, and imprisoned his father in the fort at Agra. His rigid and bigoted character alienated his court and particularly the Rajput princes of western India, who refused to support him as they had his predecessors. As he grew older he banned the making of images as being contrary to the teaching of the holy book of the Moslems, the Koran. He shut down the painting studios, dismissed musicians and poets, and even banned the weaving of gold cloth.

Aurangzeb was responsible for the decline of Mogul power and culture. Almost everything he undertook resulted in failure, often on a grand scale. His resources were drained away in ceaseless attempts to overcome opposition by the local Rajas, who declared their independence. In 1793 Nadir Shah of Persia sacked Delhi.

The once-great Mogul painting style remained only as a dim reflection in the work of the later Indians, who recorded their families and homes as memoirs for the newly arrived Europeans or as mementos to be sent back to European families—the equivalent of today's snapshots. These painters are often referred to as the Company School, because the East India Company workers were the first to employ the services of such artists, although the fad soon took hold with other foreign residents as well. Conversely, by the late nineteenth century, the rulers of the cultural centers of India, particularly the Rajput princes of the Punjab, but many others as well, began to acquire a British veneer, importing furnishings, paintings, and all manner of Victorian bric-a-brac of the most expensive kind to embellish their palaces. Many had their portraits done in European style and began to travel through Europe, where they were seen to be impressive and enchanting. In short, India and Europe found themselves to be mutually attractive in an exotic sense.

Figure 7.6 was painted at the height of the East India Company period. It is of great interest because its subject is the Private Audience Hall of the Red Fort, the palace built by Shah Jahan in Delhi. The painting was done two centuries later but before the serious damage caused to the palace after the Mutiny of 1857. It gives us an intimate view of the way the building must have looked when it was a vital part of the Mogul habitation. It is a view happily different from the deserted and largely despoiled Mogul palaces as seen today at Agra, Delhi, and Lahore and in Kashmir, where they remain only as empty shells largely shorn of the multitude of appointments that in their prime made these palaces the most opulent of their day. The wide colorful awnings, so necessary to the Indian summer heat, and the lush, thick, and priceless Persian and Indian carpets, so necessary to the cold, North Indian winters, are no longer to be seen. Nor are the fabulous silks, ranging from transparent films of summer to multi-hued brocades heavy with gems and embroidery, which were used as winter hangings to protect against drafts. It was in this building that Shah Jahan met with his ministers of state and important officials. When he held private audience, he was seated on the fabulous Peacock Throne, made of gold and set with thousands of rubies, emeralds, sapphires, and diamonds. The throne was the most valuable item taken

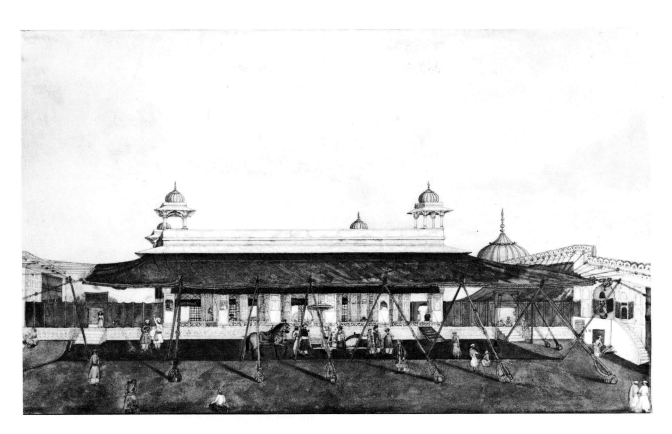

Figure 7.6 The Hall of Private Audience (Diwani-Khas) in the Red Fort, Delhi. Colors on paper (ca. 1820–25). H. 10″. North Indian artist from Agra or Delhi. Collection of India Office Library and Records, London. © The British Library.

from the palace among the tons of loot taken back to Persia by Nadir Shah in the eighteenth century after his terrible sack of Delhi.

We must try to envision art works of the past in their original condition. This is particularly true of architecture and nowhere is it more important than in Mogul architecture. Even if every precious item were magically restored to its place in the Red Fort, the recreation would still be incomplete without the people in their stunning dress, sewn with precious stones and embroidered with gold and silver, and the pounds of pearls, emeralds, and rubies worn by the Moguls. The living environment would still need the beautiful borders of flowers and lawns and the flowering fountains and channels of fresh water in the gardens. In some interior rooms fountains of colored and scented water played, appealing to the senses of sight, sound, smell, and hearing as well as coolness. Then there was the food—sumptuously and lavishly appealing to the combined senses of sight, taste, and smell. An inscription in the Hall of Private Audience states, "If there be a paradise on earth, 'Tis here, 'Tis here!" It is believable when one considers the entire ensemble of life in these halls.

One effect of Aurangzeb's iconoclasm and of Nadir Shah's destruction of Delhi was the dispersal of artists from the court to work for the local Rajas. Many artists had come from Rajputana in the west and from the Punjab area in the north. Now they returned home and others joined them, bringing a strongly Mogul court flavor to the provincial styles of painting.

SUMMARY

Mogul art was firmly established under the reign of the third ruler in the line, Akbar. He built new palaces, renovated the capitals of his father and grandfather, and brought Indian painters to the court to undertake great projects of illustrating Muslim texts and to make paintings of all the important events in his reign.

Under the Moguls Indian painting took on a greater realism, inasmuch as the Moguls preferred detailed visual descriptions to the Indian tradition of stylized abstraction. This preference was aided by the increasing numbers of Europeans who came to trade and who brought European paintings with them. These were much admired and often copied at the court.

Painting reached its height under Akbar and his son, Jahangir, but began to decline under the reign of Shah Jahan, the grandson of Akbar. On the other hand, architecture enjoyed a special flowering under this ruler, and the magnificent Taj Mahal was built by him for his beloved wife. It stands like a poem to the glory of the Mogul taste and creativity. It is the zenith of Mogul architecture.

After Shah Jahan little more was erected in architecture. His son was penurious and mean, and although the family was to remain in power through several more reigns until the nineteenth century, the Mogul sun passed its zenith with Shah Jahan.

8
.

NORTH INDIAN PAINTING
South Indian Temples

In the fifteenth century two events occurred in India that were especially important for the encouragement of painting. Through trade, paper-making was introduced from China through Arabia, and a vernacular literature developed. This meant that everyone could understand the great epics and legends of India as expressed in everyday language and that these stories could be presented and illustrated in book form.

In Rajputana (now Rajasthan) in western India, the use of the written vernacular meant that books were available to castes other than the Brahmin, who had previously held a monopoly on literature, since only the Brahmin caste could read Sanskrit, the traditional classical language. The writing of books of popular stories in a language everyone could read led to a desire for illustrations and this, in turn, led to the development of local schools of painting. In the Punjab other styles developed. From these areas painters were drawn to Delhi to work at the court of Akbar, where they were trained in the Mogul style.

RAJPUT PAINTING

Rajput painting is fundamentally conceptual. It is less concerned with imitation of objects than with the expression of ideas in an appropriate form. In colorplate 3, the figures are arranged parallel to the picture plane. The setting is minimal and is seen straight-on. No attempt is made to show depth within an object by shading or space between objects by foreshortening or perspective.

The *Rasikapriya,* from which this illustration comes, was written in 1591 by the renowned poet Keshava Das. Both the *Rasikapriya* and the fourteenth-century *Rasamanjari,* by Bhanu Data, were essentially classifications and descriptions of the various states of Mystical Union, which were represented by the *Nayika* (Heroine) and the *Nayaka* (Hero), who are perceived metaphorically as the union of the soul with the divine. The use of erotic figures to stand for the soul lost in love for its source was a familiar theme as early as the *Karli Mithuna* (fig. 3.10). In later times the metaphor of **Nayika-Nayaka** representing soul-god was so widely accepted and understood that Krishna, and his lover, Radha, were often interchanged for hero and heroine, both in the minds of the readers and of the painters who illustrated such works of literature. Here they seem to be hero and heroine, but compare to colorplate 4, where *A Nayika and Her Lover* seem clearly to depict Radha and Krishna. This theme of love is so deeply a part of India that, even today, brides and grooms are often dressed in the regal attire of Krishna and his love.

Although the Rajput princes lived at their various courts in Rajasthan, they dominated the local rulers of the hill states of the Punjab, which forms a transitional region between Rajasthan and Kashmir to the north. Each of the hill states developed its own style, although some were interrelated and quite naturally show affinity with certain of the Rajput styles.

In Basohli, one of the ancient centers of the Punjab, a particularly colorful style was practiced. Intense fiery reds, hot vibrant mustard yellows, scintillating red-violets in combinations with whites set off by brilliant turquoise, blue-violet, and deep blue are standard combinations in this wondrously sophisticated style. Intricate patterns of architecture and rugs enhance the dazzling visual experience, which, in figure 8.1, is heightened by the use of gold leaf in some of the draperies and by the addition of irridescent green beetle wings to depict large emeralds in the necklaces and crowns.

INTERRELATED ARTS

The themes of this sensuous style were frequently the heroes and heroines, who were sometimes required to endure terrifying dangers and hardships to find the hero-beloved, and at other times, the most profound loneliness in the beloved's absence. Such themes were further elaborated in the systematization of the various "flavors" of mood and sensation associated with love, called **Ragamala.** These were also musical modes that expressed the same themes in six **Ragas,** or masculine modes, and thirty **Raginis,** or feminine variations. Only a few notes are involved as a fixed beginning, and the musician may depart as far as he or she wishes in the subsequent development of the theme so long as it is, from the musician's viewpoint, appropriate to the particular Raga or Ragini and provided that he or she returns to the original set pattern of notes at the end. Paintings, poems, and music were often identified as appropriate to certain hours of the day and seasons of the year. The hours in the cycle of days and the seasons in the yearly cycle were fundamental considerations in a culture based upon a cosmological system that employed astrology and the zodiac to determine everything from the destiny of the newly born to the rituals accompanying death, including the proper times and places for the major ritual events of life.

The siting and orientation of cities as well as palaces were also governed by these considerations, as well as comfort, beauty, and convenience. When they could, rulers established more than one palace, especially to escape the dry heat of North India. These were always built near water to take advantage of its cooling effect.

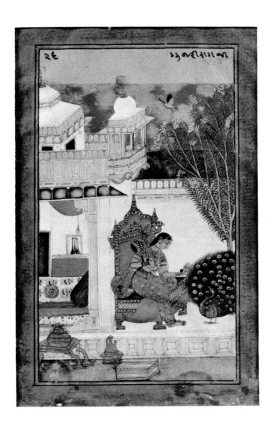

Figure 8.1 Musical mode Dipaka (Dipaka Raga). Page from a
Ragamala. Colors on paper. H. 7½″. Rajasthan, Bundi (ca. 1725).
Museum of Fine Arts, Boston, gift of John Goelet.

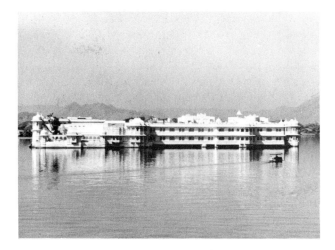

Figure 8.2 The Lake Palace (Jag-Mandir), in Lake Pichola, Udaipur.
Sandstone and white marble. Begun seventeenth century, remodeled
several times. Photo: author.

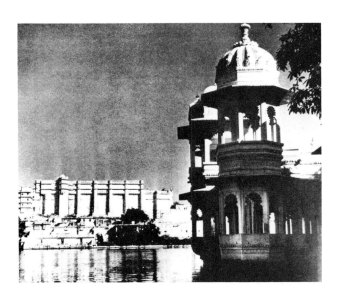

Figure 8.3 The City Palace from the Lake Palace in Lake Pichola,
Udaipur, Mewar, Rajasthan. Tan sandstone. Built in the sixteenth and
seventeenth centuries.

Perhaps the loveliest small palace in India is the
Lake Palace at Udaipur, constructed primarily of white
marble (fig. 8.2). It was built and rebuilt in several
stages from the early seventeenth century into the
twentieth century and is today a fine hotel. Through
most of its life it functioned as a retreat and play-
ground for the Maharanas of Udaipur. The young
Mogul, Prince Khurram, took refuge here in 1626 with
his friend the Maharana Karan Singh, who ruled
Mewar from 1620 to 1628. Khurram fled from the
wrath of his father, the Mogul emperor Jahangir, to the
Rajput court of Udaipur. Khurram must surely have
preferred this palace to the solid, closed, and massive
sandstone City Palace on the shore of Lake Pichola.
The contrast of architectural styles may be seen in
figure 8.3, where the differences are readily apparent.
The open lightness of the Lake Palace follows the Is-
lamic tradition of open rather than closed volumes. It
may be that this small palace inspired in Khurram a
love of white marble, for when he became the Mogul
emperor Shah Jahan in 1627 he built the famous and
beautiful white marble palaces at Agra and Delhi. The
marble for them came from quarries near Udaipur.

A delightful painting by a local artist, probably one
attached to the court, has preserved for us his concep-
tion of the Udaipur Lake Palace at the time of Karan
Singh's successor (fig. 8.4). It is submitted here not only
as a delight in itself but also to show a more accurate
view of it at the time the young Mogul prince resided
there. In addition, a comparison between figures 8.2 and
8.3 and this painting will indicate the difference be-
tween the objective reality of photography and the sub-
jective reality of Rajput painting. The unknown painter

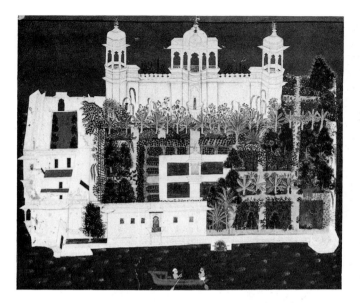

Figure 8.4 The Rana's Lake Pavilion. Rajasthan, Mewar, Udaipur. Opaque watercolor on paper (mid-eighteenth century). H. 15½″. Collection of Stuart Cary Welch.

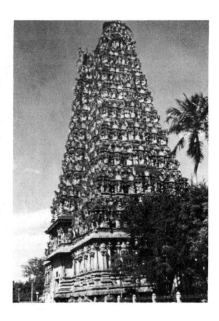

Figure 8.5 Minakshi Temple, Great South Gate, Madura. Stone construction. Nayak (seventeenth century). H. 208′. Photo: author.

has depicted the palace as he knew it to be. He knew the gardens to be flat and walls to be vertical, and so he has presented it as plans and elevations—like architectural drawings—where there are no converging lines or vanishing points and, at first glance, one might suppose the painter to be inept. But is the reality of the photo any more real than that of the painting? The photo cannot show the garden plan and, in fact, it only shows one side of the palace accurately. Two sides cannot be seen at all and the third side (to the right in the photo) is foreshortened. In other words, the photo gives us a one-eyed view of a three-dimensional building group. The painting gives up the reality of the photo for a different kind of reality—one in which the plan and elevation system of drawing gives us a better knowledge of the subject. All of the plants in the garden are clearly defined; none obscures the other as they would if the artist had painted what he saw. Instead, he painted what he knew.

Beyond the historical and technical considerations, this painting is a wonderfully suggestive memoir of the Lake Palace with its architecturally varied sections and the wonderful foil they provide for the gardens. The whole is like an imagined fairyland palace. That it really does exist is a tribute to the sense of Rajput splendor and delight.

TEMPLES IN THE SOUTH

Although the Moguls ruled at Fatehpur Sikri, Agra, and Delhi, the south of India escaped their domination. Here there developed a unique style of temple construction that is the last great manifestation of Indian sacred architecture. At the same time it makes a fitting conclusion to our study of the native tradition, since it goes all the way back to the ancient village for its inspiration. The ancient memories were better preserved in the deep south, and under the last great Dravidian dynasty, the Vijayanagar (1336–1675), long covered galleries were added to existing temples in the form of large concentric quadrangles.

The typical plan is an immense rectangle enclosed by two high stone walls. Both walls are pierced by gates at the cardinal points. These gates are topped by gigantic rectangular stone towers and overlaid with multitudes of carved and painted deities (fig. 8.5). The enclosure is covered over and supported by long arcades of pillars forming concentric quadrangular galleries (fig. 8.6). Somewhere in the center of these galleries, concealed from outside view, is the sanctuary containing the image of the deity. Whereas the northern style had taken as its inspiration the World Mountain, the southern Hindu style is a reconstruction of the basic Aryan village plan with its double walls and eight gateways. Even the name of the towers is a memory from

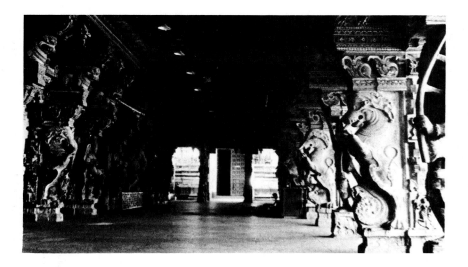

Figure 8.6 Minakshi Temple. Main corridor. Stone columns, carved and painted. Nayak (seventeenth century). H. 20'. Photo: author.

the Vedic past. They are called Gopura—that is, towers for watching over cattle as they grazed outside the Aryan village.

In the South Indian temple the arts of architecture, sculpture, and painting are combined as a setting for the live performing arts of music and dance, transfused by flickering flames of butter lamps and the incense of sacrifice, for the delectation of the god within and for the edification of the faithful. It is a profound and living union.

SUMMARY

The many tales of heroes, gods, and romantic lovers that were so much a part of the Indian tradition were transmitted orally until the introduction of paper making in the fifteenth century, as well as the development of a vernacular language, made it possible to write them down in a language of the common person. Sanskrit, the classical Indian language, had been restricted to the Brahmin caste; moreover, it did not utilize the kinds of subjects of the vernacular literature.

The result was a rapid flowering of Indian miniature painting, which continued in a highly creative production until the nineteenth century. This native painting is called Rajput after the region of western India where the best of its schools developed. It is a highly abstract art, simplifying shapes and flattening out volumes. It stands at the opposite pole from the style favored by the Moguls and developed by them at their courts. Rajput painting is conceptual whereas Mogul is perceptual. Rajput conceives the idea to be conveyed, then invents the clearest style or form to express it,

unencumbered by any requirement to imitate a subject outside the space of the painting. Thus, Indian miniature painting is more like music in the immediacy of the experience.

The most famous theme of Rajput painting is the love of Krishna and Radha, which symbolized the love of the soul for the god Vishnu, of whom Krishna was an avatar or manifestation, in human form. Other themes include the heroes and heroines, as well as musical modes. They are closely interrelated in their development and are intensely sensuous visual counterparts to musical themes based upon a few notes with variations. The fact that both the musical modes and the paintings were equated with times of days and seasons of the year indicates the richly sensuous nature of life in traditional India, where sound, color, ritual, and fragrance combine to enhance the daily experience of life.

Nowhere is this tradition better preserved than in South India, where the great temples are vibrant with color, imagery, scent, and sound, where the temple is both home for the god and haven for the people. It is notable that this last manifestation of Indian temple architecture should recall one of the very earliest architectural plans: that of the Aryan village. Both village and temple share the rectangular plan, with walls and high gates at the cardinal points of the compass, and in both plans the most sacred spot was at the very center, where the main roads crossed in the village and where the shrine houses the image of the god in the temple. It seems to prove the idea that India absorbs everything and forgets nothing.

GLOSSARY

Nayika-Nayaka Indian metaphor depicting the soul lost in love; hero-heroine or Krishna-Radha. (p. 62)

Ragamala The Indian system of various "flavors" of mood and sensation associated with love; musical modes expressing these themes, fifteenth century. (p. 62)

Ragas Six Indian masculine modes of music expressing love themes, fifteenth century. (p. 62)

Raginis Thirty Indian feminine modes of music expressing love themes, fifteenth century. (p. 62)

Rajput painting Fundamentally conceptual, less concerned with imitation of objects than with the expression of ideas in an appropriate form, fifteenth-century India. (p. 62)

9

MODERN ART IN INDIA

ARCHITECTURE

The treaties initiated by the British East India Company with the maharajas in the early nineteenth century maintained peace between themselves (and with the crown when Victoria took India to herself as its empress in 1858). With peace came leisure and financial savings. The maharajas had the time and the means to consider the improvement of their domains. Architecture loomed large as a means for indicating their superiority to neighbors, since they could no longer do so on the battlefield. The maharajas were also anxious to impress their new empress, through her minions, with their culture and breeding. In more immediate and personal terms, they wished to provide those accoutrements familiar to the life-style of their British guests who made official visits of state. During this period, the tastes of the maharajas became increasingly Anglicized, and in the late nineteenth and early twentieth centuries, European styles had a profound impact upon Indian palace architecture. While the British saw India as exotic, this was no less true in reverse.

The many "Indian-style" buildings added to English noble garden architecture at this time bear evidence of the effect of Indian architecture on the British. The most extravagant of them all, the Royal Pavilion at Brighton, was designed by John Nash in 1815 for the Prince of Wales. An almost equally elaborate endeavor on the Indian side was the great Rajput palace at Gwalior, which contains, for example, the world's largest chandeliers (fig. 9.1). Each is forty-two feet high and weighs three tons. Such extravagance was fitting for a maharaja. But what now seems to be touchingly true is that such extravagances were the maharajas' way of defending the ancient way of life they sensed to be threatened by foreigners, even as they were succumbing to the cultural onslaught, at least superficially. The Rajput princes, the maharajas, professed a longer heritage than either the dead Moguls or their new British empress, and they were not to be outdone in splendor. The Jai Vilas has Italian Renaissance pillars and arches and is topped by a terrace with towers and squared domes. In its original state it must have been a magnificent environment fit for a maharaja. Its designer was a lieutenant colonel in the British Army, chosen by Maharaja Jayaji Rao Scindia because of his acquaintance with European architectural styles.

It is entirely fitting that the first guest at the Gwalior palace of Jai Vilas was the very son of the empress of India, His Royal Highness, Albert Edward, Prince of Wales, who became emperor of India as Edward VII in 1901. The Jai Vilas must be compared to a more typically Rajput palace (figs. 8.2, 8.3, and 8.4) to see the difference between the traditional Rajput style and that of intruding European architecture.

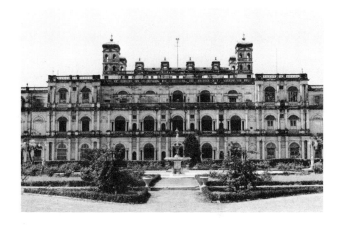

Figure 9.1 Jai Vilas. Built by Maharaja Jayaji Rao Scindia (r. 1843–86). Gwalior (1874). Designed by Lt. Col. Sir Michael Filose. Photo: G. H. R. Tillotson.

Traditional Rajput Style and the New Mubarak Palace

Jaipur (City of Victory) was established by Maharaja Sawai Jai Singh II (1693–1743) in 1728, when he moved his court from the heights of the Amber Palace to the plain below, where it would be less vulnerable to siege. The city was laid out in classic Hindu **mandala** style, in the form of a nine-square plan with the palace occupying the central square.

Sawai Jai Singh II's ancestor, Raja Man Singh, had been the commander in chief of Akbar's army. In 1568–69, Akbar captured two Rajput city-states (kingdoms), thus bringing all Rajput princes into the Mogul fold through treaties guaranteeing them imperial partnership, high honors, and autonomy as rewards for their allegiance. The system was maintained throughout the Mogul and succeeding British periods. The strong bond between the Rajputs and Moguls brought Mogul influences in architecture as well as painting to Jaipur, and the new palace was laid out in Mogul style.

Almost two hundred years after this "city palace" (so-called to distinguish it from the Amber Palace located in the hills northeast of Jaipur) was built the Mubarak Palace was added, about 1900. Many buildings were added in the years between these two buildings, but the Mubarak is special. It was built as a guest house near the city palace, and, like the city of Jaipur itself, its plan is a square made up of nine smaller squares, eight of which mark rooms on both the ground floor and second floor (fig. 9.2). The central square is left open as a court, which extends from bottom to top through both floors. The plan of the building is extended in four directions following this ubiquitous Indian convention, forming porches on the ground floor

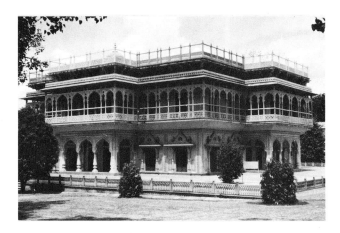

Figure 9.2 Mubarak Mahal, Jaipur (ca. 1900). Supervising architect, Chiman Lal. Photo: G. H. R. Tillotson.

the second (fig. 9.3). The proportions and details of this building recall milennia of Indian architectural concepts as a kind of delightful reprise. The open two-story central court is an important Rajasthani detail of building. The heat of Rajasthan inspired its architects to devise a natural air conditioning system. Houses built wall to wall around the courtyards (**havelis**) gained cool air from their awning-shaded street sides. When the warmer air in the courtyard rose, it sucked in the cooler air from the ground floors and maintained a cooler breeze running through the buildings.

For all its native beauty, the Mubarak Palace is, in a way, a British inspiration. It is possible it would be no more attractive to us than many other turn-of-the-century Indian buildings, which tend to be heavy in effect, if it had not been for one Samuel Swinton Jacob. Jacob was a member of one of the British military families of several generations in Jaipur. He became the executive engineer to the maharaja in 1867. In 1866 a school of arts and crafts had been established to revive the dying craft traditions of the state. The British art schools focused chauvinistically upon teaching Indians to paint like Britons, but the Jaipur art school encouraged them to learn the practical arts of architecture and local ceramics and metal working. A military surgeon, Dr. de Fabeck, was put in charge of the art school. As executive engineer, Jacob was in charge of all new buildings and designed the new Albert Hall Museum (opened 1887), named for the Prince of Wales, who had visited the maharaja in 1876. Jacob also published a five-volume set of books of plates devoted to architectural details in Jaipur and tried to encourage the public works department (to no avail) to be sensitive to native

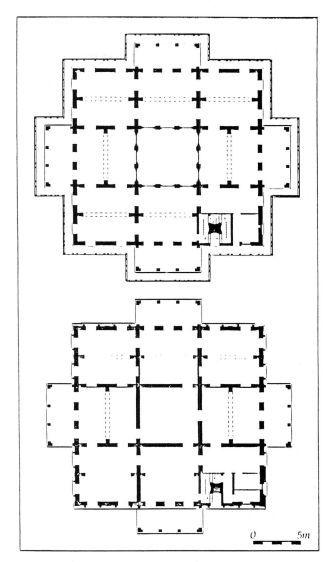

Figure 9.3 Mubarak Palace. Plan of figure 9.2. *Bottom,* ground floor with projecting porches; *top,* upper floor with veranda. Drawing of the Mubarak Mahal by Sarah Tillotson is from G. H. R. Tillotson, *The Tradition of Indian Architecture: Continuity, Controversy, Change Since 1850.* Copyright © 1989 Yale University Press, London. Reprinted by permission of the artist.

architectural styles as they built vast numbers of buildings throughout the country, including pastische bungalows combining Roman columns and Gothic windows. T. H. Hendley, another English military engineer, was appointed curator of the museum. It exhibited the best of local crafts and was also a place where craftsmen could be seen at work. Pieces could be ordered if desired by the visitors.

A new gate was built between the Mubarak Palace and the inner courtyard at the same time (colorplate 5).

It reflects the modified Mogul style of the palace. It has no borrowed Western motifs. Its purpose was to connect the new guest house with the Hall of Private Audience in the inner courtyard. It must be remembered that the guests of a maharaja of Jaipur were heads of state or their emissaries, who had come for the purpose of conferring with the maharaja upon matters of importance. The generous hospitality of Indian rulers is legendary, and this layout continued the tradition of providing ample provision for visiting friends and casual ranking visitors. The proportions of the gateway express a sturdy but sensitive presence perfectly in keeping with Indian culture. The fine details of the floral patterns inlaid with semi-precious stones on the white marble reflect the delicacy of the pierced screens above in the same material. An arch of the Hall of Private Audience may be seen through the gateway. The buildings of the palace are all painted brightly except for the white marble details. The miniature white marble elephants may recall a pair of life-sized elephants flanking one of the gateways in the palace of Shah Jahan in the Red Fort at Delhi.

Thanks to the enlightened views of Maharaja Sawai Ram Singh II, who saw the need to save Jaipur's traditional arts in the face of Western influences, and the three British Indian army officers he hired to do so—de Fabek, Jacob, and Hendley—the tradition was saved. The architect for the Mubarak Palace, Chiman Lal, had been a student of Samuel Swinton Jacob. Through Lal's sensitivity to Indian architectural style, the Mubarak Palace preserved the tradition, with just a tiny bow to the West, in grateful homage (one likes to think) to his Western teacher. On the second floor balcony, for example, one can see spiral columns with grape-leaf cluster capitals that are purely Romanesque (fig. 9.4). It is pleasant to consider the possibility that Jacob enjoyed this witty reference, as he was still in Jaipur in 1902 and was still active in Delhi in the second decade of the twentieth century.

The New Capital of India—New Delhi

There were other instances in other areas of British efforts to diminish the demise of native architectural crafts. Rudyard Kipling, for example, came to the defense of craftsmen against the public works department, and E. B. Havell, superintendent of the Calcutta School of Art, fought against the attempts by the government to give Indian arts a British flavor. The truth was the majority of the British government workers simply found India and Indian ways of life unacceptable—it was not, after all, British. Finally, in 1911, they solved the problem. They built a new city to house the British government of India, and the capital was moved from Calcutta to New Delhi.

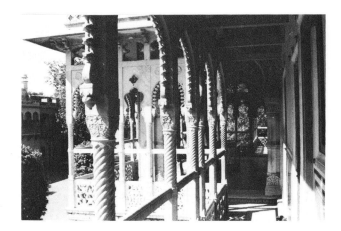

Figure 9.4 Mubarak Mahal, Jaipur (ca. 1900). Detail of figure 9.2. Upper veranda showing Romanesque style columns and capitals. Photo: G. H. R. Tillotson.

The viceroy, and even the king, expressed the desire to make the new city Indian in style. But the architect, Edwin Lutyens, and his collaborator, Herbert Baker, had their own ideas. Lutyens despised Indian architecture, and a long debate, revolving around the supposition that Indian craftsmens' guilds were incompetent to work on the new city's architecture, involved government workers in India and at home for years. It is ironic that Samuel Swinton Jacob was appointed consultant to Lutyens and Baker, who were so set against what Jacob spent so much of his time trying to revive: Indian architecture for India.

Finally, New Delhi was officially opened in 1931, twenty years after its inception. The government had been moved from Calcutta and housed in temporary quarters since 1912. Despite their insensitivity, both Lutyens and Baker incorporated into their buildings elements of native architecture. In the design of the Viceroy's House Lutyens, in effect, lifted the Sanchi stupa (fig. 3.2) some eighty feet into the air and set it down on the roof of a Roman temple, complete with the stupa railing (fig. 9.5). One cannot help but be amused by the idea that Lutyens took the solid hemisphere of the ancient Buddhist burial monument, hollowed it out, and represented it as a kind of Roman dome! If nothing else, the wit by which he satisfied both his patrons' insistence upon Indian style and his own preference for classical architecture is impressive. One must also wonder what Indians thought of a stupa atop the British Viceroy's House.

In 1947, India at last gained independence, and the field of architecture was left to Indians. But by now the guilds had become defunct and most of the craftsmen were gone. A few had been re-trained in the British

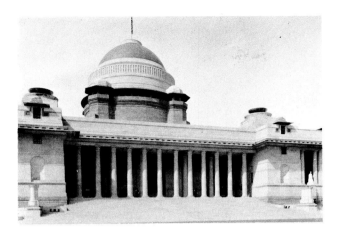

Figure 9.5 Viceroy's House, New Delhi. Red and tan sandstone (1913–31). Designed by Sir Edwin Lutyens. © *Country Life Library*.

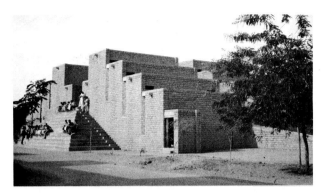

Figure 9.6 Lecture theaters, University of Jodhpur (1968–72). Designed by Uttam Jain. Photo: G. H. R. Tillotson.

system and risen in the civil service to supervisory positions, but their rise had depended precisely upon how thoroughly their "Indianness" had been trained out of them.

In fact, the ruling class of India had been caught, as surely as the craftsmen, in the British system. When, in 1953, Prime Minister Nehru decided to build a new capital, Chandigarh, for the state of Punjab, the world-famous French architect, Le Corbusier, was chosen. The city was finished in 1960. There is nothing about it that is Indian, and it is totally without national character. Cast concrete technology has conquered and obliterated tradition, just as surely as Lutyens and Baker had obliterated the guild system of architectural craftsmen earlier. Between New Delhi and Chandigarh architectural tradition died. New young architects were, like Nehru, convinced that "modern" meant Western. They were trained in Western methods and learned Western aesthetics, often in Western countries, since there was no place left in India where they could learn architecture.

**The New Indian Architects:
A Return to Old Sources**

Chandigarh has had an unexpected effect on India. Although, at first, it was not stormed and destroyed by an outraged public, as de Fabeck, Jacob, and Hendley might have hoped, some younger architects began to seek alternatives to the modern (i.e., Western) movement in Indian architecture.

In 1968, Uttam Jain designed new lecture halls for the University of Jodhpur (fig. 9.6). Jodhpur is located in western India on the edge of the Great Indian Desert.

Jain chose local yellow sandstone as the material and used it in the manner of brick. The buildings are minimal, without cornice or visible roof. Only light slits and drain spouts break the outer wall surface. The buildings have the look of Southwest American Indian pueblos in their simplicity, but they are much more like brick buildings of the cities of the ancient Indus Valley, just west of Jodhpur.

The stepped roofs derive from the interior function of the buildings, which are arranged in stepped tiers. This pattern is repeated in the steep entrance steps. Jain has maintained an integrity between the interior and exterior aspects of the building. If he had made the roof in two large planes, meeting in the center above the entrance, it might have shed water better, but its visual uninterrupted mass would have given an aggressive bulk to the building. Adding to the stepped elevation, the wall is enlivened by the functional light slits and drain spouts. The repetition of the same vertical widths varied in height give a strong sense of unity, which includes a rhythmical variety as well. And, above all, it keeps the buildings on a scale to which people can relate.

Several leading Indian architects claim to have moved beyond the modern movement and to have found the essence of Indian architecture by emphasizing the planning and definition of space. But, as art historian G. H. R. Tillotson tells us, that kind of emphasis is, in itself, a modernist, not an Indian, view of architecture. He goes on to say that "the character of form and detail is a subject of proper concern to the architect—but architects in India have almost ceased discussing it."* Thus, the legacy of Le Corbusier lies heavy on the architecture of India. Tillotson goes on to point out that traditional Indian architecture has been characterized

* G. H. R. Tillotson, *The Tradition of Indian Architecture Continuity, Controversy and Change since 1850* (New Haven and London: Yale University Press, 1989), 141.

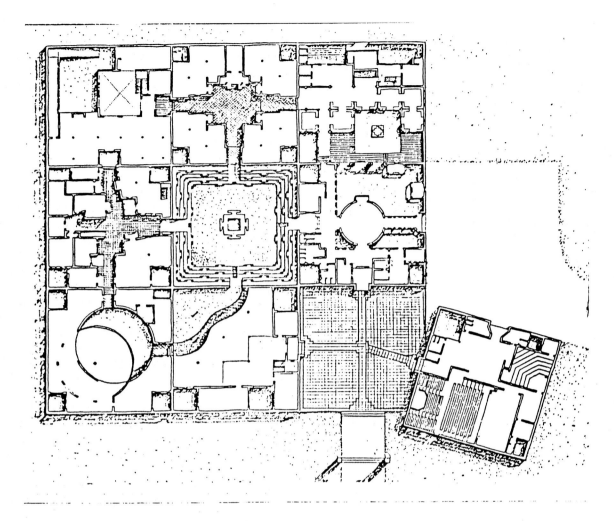

Figure 9.7 The Jawahar Kala Kendra, cultural center, Jaipur. Plan by
Charles Correa (1988 revision). Designed by Charles Correa. From
G. H. R. Tillotson, *The Tradition of Indian Architecture: Continuity,*
Controversy, Change Since 1850. Copyright © 1989 Yale University Press,
London.

by great balance between form and detail. Recall the
temples of Mamallapuram (figs. 6.3 and 6.4) and of
Bhuvaneshvar and Khajuraho (figs. 6.11 and 6.12), as
well as the Muslim-inspired architecture of the Mogul
period, and realize that the traditional Indian archi-
tectural concept is one of strong volumes embellished
by details, which are subordinate to the whole form of
the building but which enliven and—very often—
inform and inspire.

 It is interesting to consider the plans for a new cul-
tural center for Jaipur designed by Charles Correa (fig.
9.7). Like the eighteenth-century city itself, it is based
on a *mandala* of nine squares. The lower right square
has been left open and its block of lecture halls has been
shifted on an angle to the southeast. That is because,

in the original plan of Jaipur, the northwestern square
of the mandala was interrupted by the cliffs supporting
the Nahargarh Fort, so the maharaja extended the plan
to the south and east in order to compensate (fig. 9.8).
However odd Correa's plan may seem to us, it indicates
the century-long concern about reviving the essentials
of Indian architecture. It is refreshing to see the inten-
tion to go deeper than the modern movement and to
give the international style a real Indian identity.

 India must recover from its colonialization. It con-
tinues to suffer the self-conscious uncertainty that ac-
companies release from aesthetic and intellectual
subjugation. That it will recover seems now a certainty,
and architecture may well become the leading expo-
nent of its new age.

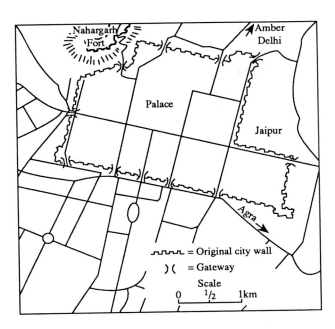

Figure 9.8 City of Jaipur, simplified plan showing original walled city and palace surrounded by modern city. After Fodor, *Guide to India*.

PAINTING

The British East India Company was organized by a small group of Englishmen who backed a trading ship to India in the seventeenth century. Two hundred years later, the trade was so profitable (mainly the same items of the ancient India trade, see chapter 5) that, in 1858, Queen Victoria took over the subcontinent of India from the East India Company. To administer and protect this highly profitable trade, hundreds of Englishmen were sent to India as company officials and military officers. By the end of the eighteenth century, these Englishmen had established colonial outposts of British culture and tradition, particularly in the larger commercial centers such as Calcutta, Madras, and Bombay.

Between the late nineteenth century and early twentieth century, a schism developed in which historical India was left behind in the villages and modern India was born among a few intellectuals in a few of the great cities. Gradually increasing migrations of farmers from villages to the urban centers, lured by the spreading industrialization and rumors of work for unskilled laborers, swelled the floating populations of unemployed poor. The ancient traditions were disrupted. The integral factor, the village, the center and focus of the family and community, could not be maintained in the midst of urban sprawl. At the same time, among the high-caste wealthy intellectuals at the opposite end of the human scale, a new phenomenon was stirring.

Urban growth had tended to diminish religious beliefs and practices, and a new Anglo-Indian culture was impinging upon those same beliefs and practices. These disruptions of tradition were seen most vividly in Indian painting, or rather not seen, for Indian painting was dying in the urban centers.

The Bengal School

In the first decades of the twentieth century, a rising sense of national consciousness among a few Indian intellectuals led eventually to the revival of earlier traditions, which were more truly Indian than the Anglo-Indian culture imposed by the British Raj. The movement began in Calcutta with the first modern Indian painter, Abanindranath Tagore (1871–1951). Tagore came from an old and high-caste family and was educated at the Sanskrit College in Calcutta. He studied painting under English and Italian painters residing in Calcutta as well. He created a synthesized style, amalgamating several aspects of Asian and Western traditions. His eclectic paintings were important because they broke with the dead or dying Indian schools of his day. They looked back to earlier myths and legends for subjects, and they incorporated aspects of Mogul linear delicacy and even Japanese two-dimensional spacing and techniques of color and watercolor washes, a medium he had espoused before he encountered the repetitive overlapping wash technique in the work of two visiting Japanese painters (fig. 9.9). It was this technique, adapted by Tagore, which was to become a major characteristic of his successors in the Bengal school.

Members of the Tagore family were famous as international hosts. Many of the greatest artists, thinkers, aesthetes, and mystics of the day, English, Russian, French, Japanese, and German, were visitors. The whole family seemed bent on recovering the lost India and retrieved in bits and pieces fragments of dying crafts and techniques, as well as poetry and music. The motto of the family might have been: "Save India." Given the increasing British control, the significance of the Tagore family is more apparent. In 1858, Queen Victoria issued an edict, made known in every state in India, that she was taking over the government of India from the British East India Company, which had increased its powers with British encouragement since the seventeenth century. In 1877, she was proclaimed the empress of India, making India a nation of vassals to Britain. In this increasing stranglehold the tendency of the upper classes was to become as British as fast as they could. The Tagore family, with remarkable insight, integrity, and courage, made every effort to save Indian culture in the face of the onslaught.

Figure 9.9 Illustration from Omar Khayyam, by Abanindranath Tagore (1871–1951). Watercolor on paper. Indian Museum, Calcutta.

Expressionism

Abanindranath Tagore's greatest influence on modern Indian art came through his pupils, who came to study with him after his retirement from public teaching. The next generation of art school directors throughout India were largely these pupils, who retained the Tagore desire to find an Indian art.

Muhammad Abdur Rahman Chugtai (b. 1897) came from an ancient family of artists of Iranian origin. One of his ancestors, Ahmed Chugtai, was the chief architect to the Mogul emperor Shah Jahan. His paintings in ink and opaque watercolor on paper have some of the sensitivity to line and space of the Iranian tradition and share an eclectic synthesis like Tagore's, though synthesized from different sources (fig. 9.10). He presents classical Indian and Iranian themes treated in a nostaligic and sentimental manner. But the effect, at least to modern Western eyes, is rather like a theatrical production, elegantly presented but not entirely convincing—as though the participants will return to their street clothes as soon as the curtain falls. Oddly, the actors seem not really to be Indians or Persians but

Figure 9.10 *Charm of the East,* by M. A. Rahman Chugtai (b. 1897). Drawing with tempera. H. 15¾". Prince of Wales Museum, Bombay, India.

British. And the paintings remind one more of the nineteenth-century English illustrator, Aubrey Beardsley, than of fully Asian traditions—although admittedly they recall a touch of Ajanta (fig. 4.4).

Rabindranath Tagore (1861–1941) was the uncle of Abanindranath Tagore and an inheritor with him of the long Tagore family cultural tradition. He was educated in Calcutta and London and he was a world famous poet and was awarded the Nobel Prize in Literature in 1913. Unlike his nephew, Rabindranath Tagore had no formal training in the visual arts and did not start painting until he was in his sixties. Even then he never really arrived at a point where he was able to think of himself as a painter (fig. 9.11). This was because his visualizations grew out of his words. In writing poetry he would sometimes, when the right word was not to be found, resort to "doodling" and found that he often supplied the visual equivalent of the word he was after. In this way he went from the

Figure 9.11 *Brooding,* by Rabindranath Tagore (1861–1941).
Colored inks on paper. H. 11″. Courtesy of the National Gallery of
Modern Art, New Delhi.

visual to retrieve the sought-after word. As time passed, he became interested in these tiny exercises for themselves and began to enlarge and modify them.

The significance of this is that Rabindranath Tagore became involved in a visual art process entirely on his own—without any precedent model—at the most primary level. His images were a language of their own without any illustrative aspect to them. They depended neither on literary sources nor upon painterly sources for their being. They are images that express feelings instead of ideas because they arise from the subconscious and, therefore, subliteral region of being. Once enlarged and modified these images might be accepted as "pictures," but in their essence they are more like visual words than representations.

Rabindranath Tagore, although he follows his nephew Abanindranath (who was ten years his senior) by almost fifty years stands with him side by side in the formation of modern Indian painting. Abanindranath created a new independent style and Rabindranath created a new depth of artistic activity, parallel to but not so cerebral as Vassily Kandinsky in Europe at about the same time. In India their work led to an interest in making a new art and to an investigation and experimentation in the realms of visualization of psychic states or emotions. It was a mode that was only one step away from expressionist art.

Jamini Roy (b. 1887) was trained as a portrait artist, an art that he practiced quite successfully for some thirty years, before he decided to return to a more native and primitive style. Whereas Rabindranath Tagore was never quite able to command his medium to his satisfaction, a situation that led him to experiment with manifold methods of applying paint, Roy's problem was that he had to unlearn everything he had known and used in the sophisticated techniques of European-style portrait painting (fig. 9.12). He eventually made his own pigments and sized his canvas with cow dung to avoid any aesthetic or technical contamination from the Western tradition in his work. He found his aesthetic inspiration in the lively patterns of the primitive folk art of his native Bengal and became a leading figure in the Calcutta art world.

All this strikes us now as too self-conscious; as lacking universal meaning and communication. It seems to be introverted, without relevance to anyone other than the artist and his circle. Nevertheless, caught up in an intellectual and political revival, these artists felt they were helping to fulfill the destiny of modern India. Roy was by far the most successful of his contemporaries, and perhaps it was not so much due to the quality of his work as to its political implications. He appeared on the scene just as the desire to revive Indian culture was waxing, and, indeed, it may be said that he himself was a product of that revival, which had started quietly amidst intellectuals such as the Tagores. Roy is the perfect example of what the entire situation was about. He, like many other Indians, had grown up, culturally speaking, in a house divided. The land was still Indian, but its control and cultural veneer were sharply British. It was not until he was a fully mature painter that he consciously decided to abandon his European-style portrait painting and "became Indian."

Roy's conscious shift in the 1930s and 1940s from the European style to the simple primitive style of painting found in Indian villages, with its simple, strong, flat, patterned symbols, had a strong impact. The effect, to the Western eye, is rather like the poster style of American plane or train posters of the 1920s and 1930s,

Figure 9.12 *Offering,* by Jamini Roy. Opaque watercolor on paper. Collection. Nalanda Publications, Bombay.

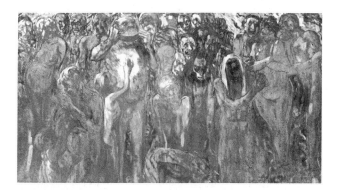

Figure 9.13 *Pavement dwellers,* by K. C. S. Panikar (1912–77) Indian. Oil on board (1951). H. 33″. Courtesy of the National Gallery of Modern Art, New Delhi.

but to upper-caste Indians it spelled INDIA in capital letters and was seen as the fulfillment of the desire for a cultural renaissance separate and divorced from the colonial culture imposed on India by England.

In such a climate it was natural that the urban painters should look increasingly far from home for aesthetic companionship. The latest news of art movements and exhibitions in Madrid or Chicago was avidly awaited in Madras and Calcutta. Magazines, books, catalogs, and even colored postcards and prints found their way to India, somewhat like the East India Company paintings of the eighteenth century found their way home to Europe. But their twentieth-century corollaries had a profoundly greater impact on India than these earlier works had had on Western culture.

It was at the suggestion of Rabindranath Tagore that the first exhibit of German Expressionists took place in Calcutta in 1922. Many of the major artists were represented, including Kandinsky and Klee. It is no surprise that Indian painters took to expressionism, since it is the traditional mode of Indian art in all forms.

Indian art has always been more conceptual than perceptual. And Indian painters have always been more concerned with the symbolic and expressive aspects of being than those of objective appearance.

Twentieth-century Indian art arises not in the palaces (for in many cases the rulers moved away) nor in the new temple centers (because they were provided their artworks when they were built, often many generations earlier) nor in the old temple centers (because the populations themselves have moved away). Modern art in India arises, as in most countries, in the great urban centers, the economic metropolises. New Delhi, Calcutta, and Bombay are the leading cultural centers today, with Madras and Baroda close behind.

Regional Schools

Some painters of the 1940s responded to European painting in an intellectual manner, recalling the earlier years when Jamini Roy made an intellectual decision to acquire a truly Indian style. In 1947, a group of Bombay painters formed the Progressive Artists Group and wholeheartedly welcomed the styles of Europe, especially Expressionism.

The new expressionist painting found in India a resonant response. In New Dehli, the **Silpi Chakra** (Artists' Circle) was formed in 1949 by artists and collectors. Such associations of artists were formed in all the larger urban centers. In 1950, the Progressive Painters' Association of Madras was formed, led by K. C. S. Panikar (b. 1912), who later became the director of the government school of arts and crafts. In one painting, Panikar shows us the street people, probably of the Madras region in southeastern India, where he lived and went to art school (fig. 9.13). He was forty years old when he painted this work, and all the desperation and hopelessness of such victims of society is

Figure 9.14 *Agony,* by Arup Das (b. 1927). Oil on canvas (1969). H. 34". Courtesy of the National Gallery of Modern Art, New Delhi.

present in its dark, moody, and depressing appearance. It is as though the individuals join together in one forlorn request: help us. The only action depicted is that of the child reaching hesitantly toward the watermelon being eaten by the man next to him. But neither the child nor his companions in agony seem to hate us who have escaped their pitiful fate. They merely stand mute in the shadows. Perhaps it is the passive acceptance of their lot that makes the painting so haunting. It is interesting to speculate on how much this acceptance may have to do with the doctrine of karma as an aspect of modern life.

In *Agony,* by Arup Das (fig. 9.14), the artist has presented a figure reminiscent of the dead Christ familiar in European Christian iconographic presentations of the Pieta, in which the body of Christ is held by his mourning mother. Here the figure lies instead across the top of what may be a tomb, with its yawning black door. Symbols that reinforce the Christian allusion are the small cross, as well as the strong verticals and horizontals, which suggest a larger cross, and the name of Jesus referred to in the large letters above his pendant right hand. But other symbols appear as well, some evident and some only vaguely suggested. These include the cloth, hanging from the top right of the door, which may represent the rending of the veil of the temple in Jerusalem at Christ's death or his shroud, a suggestion heightened by the gray soles of feet reminiscent of dead bodies. The standing figure in tan with white arms and the vague white form of a figure with a hand to its head emphasizes death. The large head rising from the center of the bottom of the painting expresses the stark horror felt in the face of death. The gray light on its face seems to radiate from the dead, as though in recognition that it shares death with all

men. The eyes of this figure are blank white, echoing those pupilless eyes in the standing figure just above—perhaps remembering the Lazarus story—on the left, below the head of the Christ figure. One first sees the head as crowned with thorns but, at second look, in the ambiguously painted hair, stands the traditional menorah, the Jewish candelabrum, recalling the story of the Macabees and their bravery in maintaining the light in the temple.

The whole painting may be seen to be a Christian subject; however, there are no wounds on the body of Christ, and the letters in Jesus' name are ambiguous, as is the cross and the letter *A* (alpha) which should be accompanied by the Greek letter Ω (omega) instead of what appears to be the letter *H* (for Hindu?). The visual relationship of the cross to the letter *A* brings to mind a scale and, all in all, the painting shifts its meaning from the agony of Christ to the agony of the world. The great symbol of Christ's suffering is appropriated to stand for all humankind. But, perhaps, with the message that the spiritual light, represented by the menorah, will in the end vanquish the whiteness of death, which is not light.

The expressive aspect of the painting is very powerful, partly because of the symbolism but also in its purely formal aspects, which are the two-dimensional shapes of the parts of the composition, the largest of which, the dead body, lies in the upper third of the canvas with the long arm and legs hanging down across the bottom two-thirds of the painting. This produces a sense of the awkward immobility of death, which is reenforced by the muted earth tones—yellow, tan, browns, grays, white, and black. But the purely sensory aspects of shape and color and detail relate to each other with such consistency that the viewer responds by becoming immediately involved. This sensory involvement leads to the recognition of the symbols and then to their interrelationship in the historical event portrayed, and finally a widening circle of awareness may lead to the possibility that the painting suggests more than it depicts specifically, depending upon the viewer's own experience, sensitivity, and awareness of these realms of perception. It may seem a strange painting for India, but it expresses the traditional tolerant acceptance and the fundamental meaning of the word *Hindu,* which means to accept as one's own the sufferings of others. The sophisticated patterning and coloring make this painting a very attractive and involving visual experience. On the fundamental level of the sensory aspects of color and composition, the painting attracts and leads us on to the symbolic level of meaning and ideas, and, perhaps, eventually to the level of spiritual experience—the goal of traditional Indian art, brought up to date.

Figure 9.15 *Hamamkhana,* by Bhuphen Khakhar (b. 1934). Oil on board (1968). H. 49". Courtesy of the National Gallery of Modern Art, New Delhi.

Eclectics and Surrealists

In some segments of Indian society, myth is playing itself out. Individuals have lost faith in their inherited world view, and their painters are turning their attention to urbanism itself as the myth-hero and myth-demon—the old gods in new guises. A leader of this movement is Bhuphen Khakhar (b. 1934) who in the 1970s depicted common urban dwellers as their own protagonists/antagonists, producing canvases recognizably modern but not so recognizably Indian, except in subject. The eclectic influences present in Khakhar's work are seen in figure 9.15, where the garden is almost completely a plan view but the pools are in perspective. A comparison with figure 8.4 reveals the difference. Khakhar's painting has trees one behind the other on each side, but they may also be seen as a pair of pruned trees of the topiary kind popular in Europe in the eighteenth century. The whole painting seems less a real garden than a garden as seen in a dream. It is somewhat like the European surrealist painters, particularly the work of Rene Magritte in uneasy suggestions. Although European surrealism developed in the 1920s and 1930s, Indian painters did not espouse it until the 1970s, although, in its emphasis upon the subconscious mind, and altered states of perception, it was not very different from some of the expressionists.

Another strangely eclectic painting is shown in figure 9.16 by R. S. Gill (b. 1938). On a dark gray beach a seashell seems to be receiving the contents of

Figure 9.16 *Ahier Bhairav,* by R. S. Gill (b. 1938). Oil on canvas (ca. 1960). H. 56". Courtesy of the National Gallery of Modern Art, New Delhi.

the ocean, represented by bright blue, green, and golden waves as though seen in an unearthly light. This same light suffuses the sky on the right and fades into a dark and foreboding gray on the left. The color scheme and dark and light patterning is strongly reminiscent of the Spanish surrealist painter Salvador Dali, but the subject seems to be entirely Indian. The theme seems to be that of the end of the cosmos, when everything will go back into its source.

Tantric Painters

Outside the mainstream of Indian representational painting, which takes as its subjects recognizable subjects, are a few modern artists who have been grouped together as new **Tantric** painters. Their paintings are based upon the long Tantric tradition, which is still alive in parts of India as a belief system of universal complementary principles of cosmic symbolism. The tradition developed around Hinduism and Buddhism beginning in the seventh to the eleventh century and was a complex system involving forms of mystical magic and secrecy. Overall, these painters base their paintings upon visual symbols and conceptions associated with Tantric imagery, which are usually geometric. They are, of course, painters, not religious practitioners, so they are free to modify both form and content. Painting is their purpose, and as painters they are free to absorb stimuli and influences from outside sources as well. While Tantric symbolism is profound and complex, its goal is unity and peace. The approach may be through the intellect, through the word, or through intuitive meditation. The aesthetic goal is resonant response.

The painting by G. R. Santosh indicates the subjective aspect of the artist's response (colorplate 6). It

Figure 9.17 *Surya,* by Prafulla Mohanti (b. 1936). Watercolor, ink, and guache on paper (1980). H. 30″. Courtesy of the National Gallery of Modern Art, New Delhi.

is non-objective and, like music, means whatever the observer finds in it. Prafulla Mohantis' painting is perhaps more expressionistic than non-objective since it is titled *Surya* and Surya is the sun-god (fig. 9.17). The third example, by K. V. Haridasan, is somewhere between non-objective and expressive (fig. 9.18). The subject is the story of the god Brahma, which includes his function as creator-god. This group of paintings may be more attractive to the Western observer than some of the earlier examples because they do not present us with specifics of time or place or forms derived from our immediate experience. Those who have found Indian painting and sculpture a little hard to appreciate may take refuge in these paintings, realizing that whether the outer forms suit their own specific aesthetic sensitivities or not, the inner conceptualizations are, as with all art, universal expressions of the fundamental level of the being of all humanity.

Figure 9.18 *Brahma sutra,* by K. V. Haridasan (b. 1937). Acrylic on canvas (1982). H. 39″. Courtesy of the National Museum of Modern Art, New Delhi.

SUMMARY

When Queen Victoria appropriated the role of Empress of India, British tradesmen had been in India for over two hundred years. The British East India Company had dominated the European trading companies since the beginning and became the virtual owners of most of India. The result was good for England and bad for India, in economic terms. In the cultural realm there was a two-way trade with England and other European countries, but the European influence in India was more profound than that of India in Europe.

Because of the British-imposed peace among the maharajas, wars among them were halted. This meant more time and money for the maharajas' own internal affairs. Since they could no longer conquer each other militarily, they turned to displaying their status in cultural terms. The highest status symbol was Europeanization. The late nineteenth and early twentieth centuries saw the importation of European styles in architecture and other arts. Buildings designed by European architects were to be found in many Indian states as additions to older palaces.

As it became clear that Indian architectural traditions were in danger of disappearing, the maharaja of Jaipur enlisted a group of officers of the British Army stationed in India to try to preserve the arts and crafts of Indian architecture. But the British Raj saw things differently. They, as in all their colonial holdings, were trying to make India British. Members of the British commercial enterprises built classical-style European houses. They totally ignored Indian architectural tradition to the point of hiring two English architects to design the new capital (which the British had decided India needed) at New Delhi. These architects created a style of architecture for the major government buildings that combined European classical structures with ancient Indian motifs. When the same idea of building a new capital for the state of Punjab was initiated, apparently in the belief that new government buildings could solve old government problems, they decided on the French architect Le Corbusier. Contemporary Indian architects are closer to the heart of the Indian architectural tradition, with its rich conceptual and symbolic approaches to building.

The story of Indian painting in the modern period follows the same basic scenario. Attempts at revival led back to Mogul styles and to the primitive village arts. Then European influences, especially the Post-Impressionist and Expressionist schools of painting, were accepted as compatible with the Indian aesthetic but led to a more or less derivitive period. More recently a group of painters identified as Tantric have emerged. Tantric painters are not necessarily believers in the Tantric schools of Hindu or Buddhist religious systems, but they are painters of mandala-like images that recall the old Tantric schools of religious painting. What was once a belief system has become an aesthetic system. This is rather indicative of the aesthetic dilemma of India, and of the world at large, in the modern period. Without a significant symbolism modern painting has tended to become insignificant except for those schools that accept and promote the idiosyncratic aesthetic experiences of the painter. Attempts to expropriate symbol systems from the past and a deeper understanding of the condition of modern life may eventually lead to a new and vigorous aesthetic.

GLOSSARY

Havelis Houses that adjoin in a quadrangle, with a courtyard in the center to permit a natural air conditioning system. (p. 69)

Mandala A circle or square microcosmic image of the universe; usually divided into quadrated sections and oriented to the cardinal points. (p. 68)

Silpi Chakra Literally "artists' wheel." In usage, a circle of artists in the social professional sense. (p. 76)

Tantric A psycho-magical form of Hinduism or Buddhism. (p. 78)

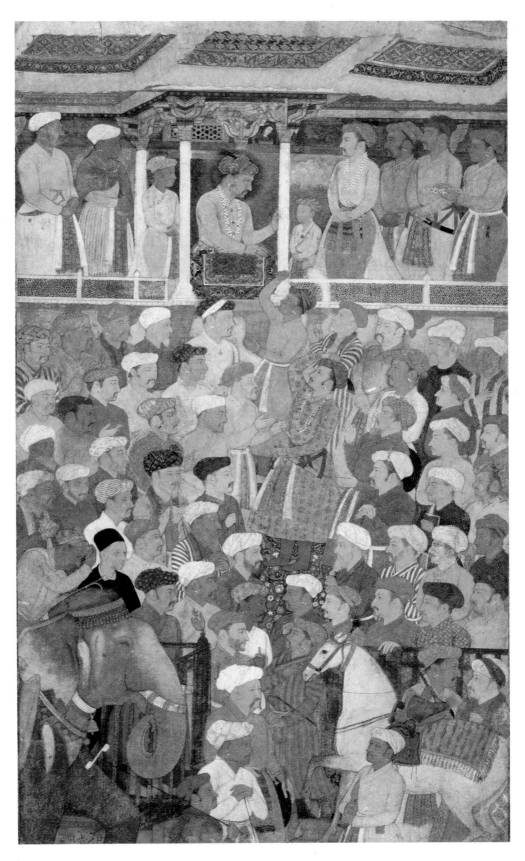

Colorplate 1 Darbar of Jahangir. Indian, Mogul. Opaque watercolor on paper. H. 15″. Francis Bartlett Donation of 1912 and Picture Fund.

Courtesy of Museum of Fine Arts, Boston.

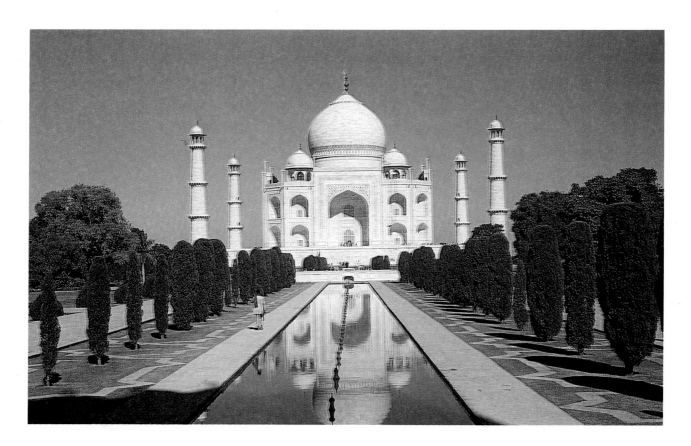

Colorplate 2 Taj Mahal, Agra. Photo: author.

॥ःपयसुनिकुरकोसिलबुारेपतिहीविःसुनीःचित्रसालाबालाःॐ
जःरुपकीसीमालाराधाउपकसुहोदैरीःपुरेखरनिकेःरुपप
रुपतांनिलोःतिपगतलवालदेतिःःपतिसनसाथेरी॥श्रोःसेमैदिषा
ई दीन्हीःःपोच्चकांब्रुसारकानूःवैसंचदेगातथैसेंजःतनःवताःरेरी॥

केःसौदासकोःहेपरैःःपलनैसलजसेःबैतलवसेःलोःवनेजलर
सेंकीःःपतेरी॥१६॥

Colorplate 3 Radha inviting Krishna to her pavilion. Miniature, color on paper. H. 7¼″. Rajput, Malwa School. Central India. Malwa (ca. 1634). Eugene Fuller Memorial Collection, Seattle Art Museum.

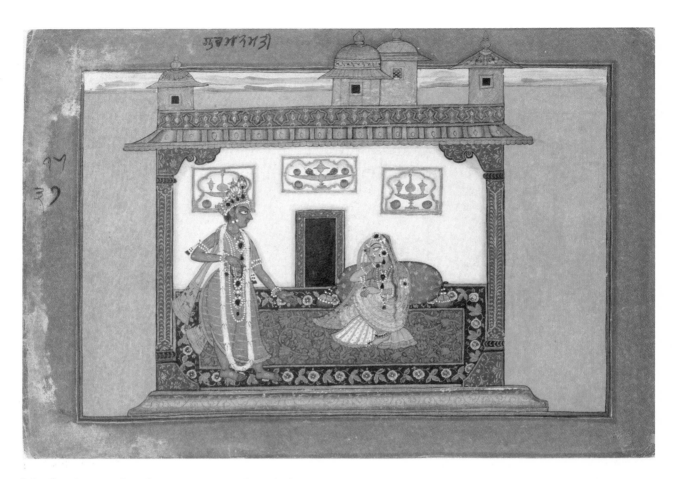

Colorplate 4 *A Nayika and Her Lover.* Opaque colors and gold on
paper. Punjab Hills, Basholi (ca. 1670–80). H. 9¼″ opaque 23.5 × 33.1
cm. Courtesy of the Arthur M. Sackler Museum, Gift of John Kenneth
Galbraith, Harvard University, Cambridge, Massachusetts. 1972.74.

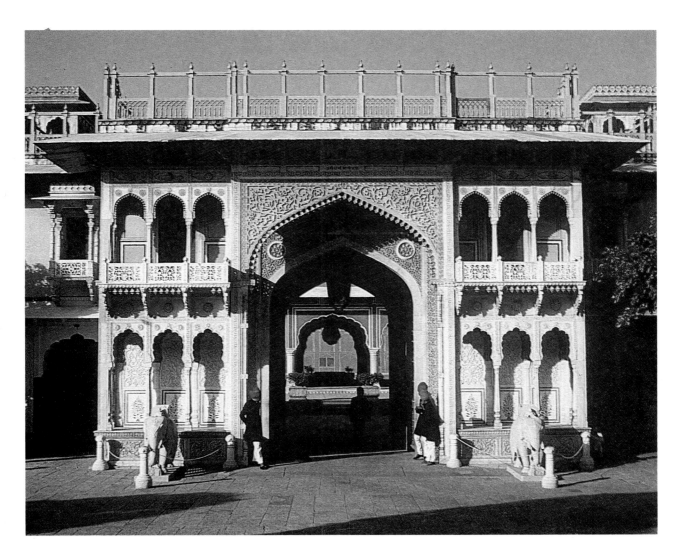

Colorplate 5 Rajendra Pol, City Palace, Jaipur. Sandstone and
marble (ca. 1900). © G. H. R. Tillotson.

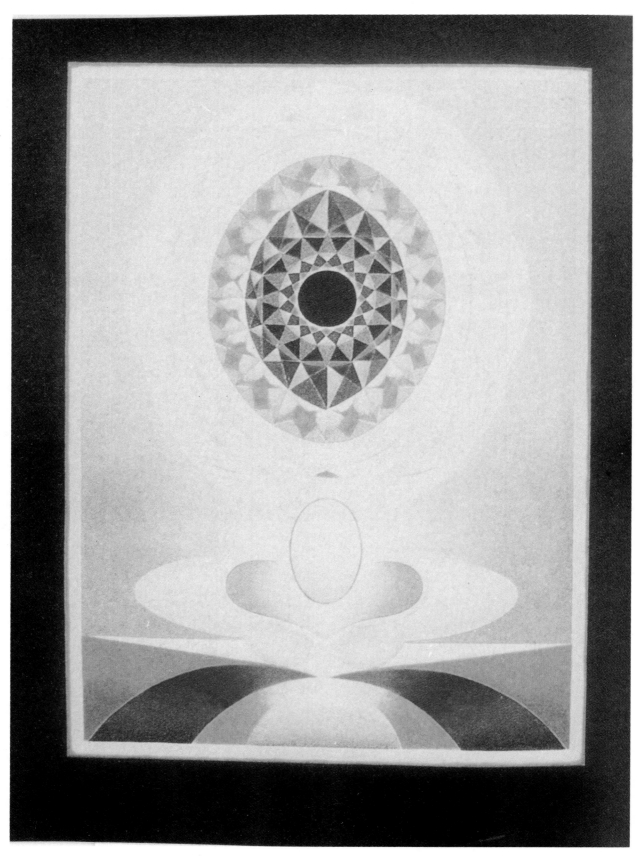

Colorplate 6 Painting. Oil on canvas (1982). H. 6'7". By G. R.
Santosh (b. 1929). National Gallery of Modern Art, New Delhi.

CHINA
PART TWO

CHRONOLOGY

B.C.

5000 NEOLITHIC PERIOD
4000
2000 XIA DYNASTY
SHANG DYNASTY (ca. 1600–1045) Last capital at Yin (Anyang)
1000 ZHOU DYNASTY (1045–221)
Capital at Pang near Changan (Xi-an)
771 Capital moved east to Luoyang
770–476 Period of the "Spring and Autumn Annals"
Lao Zi (ca. 604 B.C.)
Confucius (ca. 550–478 B.C.)
500 475–221 Period of the "Warring States"
400
300
200 QIN DYNASTY (221–207)
Capital at Xienyang near Xi-an
100 HAN DYNASTY (206 B.C.–A.D. 220) Capital at Changan (Xi-an) moved to Luoyang A.D. 25

A.D.

100 Syrian merchants in Luoyang
200 SIX DYNASTIES (220–589) in south
300 399–413 Fa Xian's pilgrimage to India
400 NORTHERN WEI (386–534) in north
Capital at Datong; moved to Luoyang in 494
446–452 Persecution of Buddhism by northern Wei
460–494 Cave temples at Yungang
494 Longmen Cave temples begun near Luoyang
500 520–530 Brick pagoda at Songyuesi
SUI DYNASTY (581–618)
Capital at Luoyang; moved to Changan in 605

600 TANG DYNASTY (618–906)
Capital at Changan (Xi-an) Emperor Tai Zong (r. 627–49)
630–45 Xuan Zang's pilgrimage to India
Emperor Gao Zong (r. 650–83)
672–75 Colossal Buddha at Longmen
Yan Liben (d. 673)
Wang Wei (699–759)
700 Wu Daozi (ca. 690–760)
Han Gan (ca. 750)
751 Battle of Samarkand
800 Zhou Fang (ca. 780–810)
879 massacre of foreigners at Gwangzhou
900 FIVE DYNASTIES (907–60) in North China
Li Cheng (ca. 916–67)
SONG DYNASTY (960–1279)
Capital at Kaifeng until 1127
1000 Fan Kuan (950–1026)
Mi Fu (Fei) (1052–1107)
1100 1127 Emperor Hui Zong kidnapped; court flees south to Hangzhou
Liang Kai (ca. 1140–1210)
Ma Yuan (ca. 1150–1230)
1200 Genghis Khan (1167–1227)
Xia Gui (ca. 1200–1233)
Mu-Qi (active late thirteenth century)
Kublai Khan (1215–94) (r. 1259–94)
1275 Marco Polo arrives in China with his father and uncle
1276 Kublai conquers Hangzhou and moves Mongol capital from Karakorum to Beijing
1300 YUAN DYNASTY (1260/80–1368)
Qian Xuan (ca. 1235–ca. 1300)
Zhao Mengfu (1254–1322)
Huang Gongwang (1269–1354)
Wu Zhen (1280–1354)
Ni Zan (1301–74)

MING DYNASTY (1368–1644)
Capital at Nanjing until the third Ming emperor, Yong Le, moved it back to Beijing in 1421; from 1407–21 Beijing was renovated and reconstructed for use as the Ming capital
1369 Jingdezhen established as the site of the kilns for the production of ceramic wares for the Imperial court

1400 Dai Chin (active ca. 1430–50) Founder of Zhe School
Shen Zhou (1427–1509) Founder of Wu School

1500 Tang Yin (1470–1523)
Wen Zhengming (1470–1559)

1600 Dong Qichang (1555–1636)
QING DYNASTY (1644–1911)
Capital at Beijing
Wang Hui (1632–1720)

1700 Gong Xian (1620–89)
Zhu Da (1625–ca. 1705)
1793 Carl George Macartney arrives at Summer Palace, Jehol, seeking trade concessions for Britain. Requests denied

1800 1839–42 The Opium War results in the opening of five treaty ports to foreign trade
1884–85 Sino-French War; France wins Annam (Vietnam)

1900 1900 Boxer Rebellion
1912 Chinese Republic established bringing end to dynastic system
1949 Chinese People's Republic established

Pronunciation of Chinese Words

The Pinyin system of transliteration is used in this book, not because it is deemed to be superior to the older Wade-Giles system, but because it is the one most used today. The values of each letter of the alphabet and some examples of combinations are as follows:

a	h*a*ll	j	*j*eep	s	*s*ome
b	*b*y	k	*c*at	t	*t*o
c	ha*ts*	l	*l*ed	u	s*ou*p
d	*d*o	m	*m*a	v	(see following)
e	*u*p	n	*n*o	w	*w*on
f	*f*at	o	l*o*t	x	*s*he
g	*g*o	p	*p*ot	y	*y*es
h	*h*ot	q	*ch*urch	z	(see following)
i	r*ea*p	r	(see following)		

The two most surprising values given to individual letters in this system are those for *q*, which equals the sounds of the *ch* in church, and the *x*, which is pronounced like *sh*. Perhaps the most difficult sound for Westerners is the *r* equivalent, which is pronounced rather like a combination of the English *r* and the French *je* (curling the tongue up helps). There is no *v* sound in Chinese.

In combination, some of the most used sounds are *ih*, which is pronounced somewhat like *erh*, so that *shih* sounds like the English word *sure* without the full depth of the *u* sound. Perhaps the sound we use in the word *shir*red is closer to the Chinese sound. The combination *zh* is like a *j* so that *zhou* is pronounced exactly like the name Joe. Here are some others:

ia	*ya*cht	uai	*wir*e
ian	Ind*ian*	uan	*wan*t
iang	Lee + *ang*	ui	*wei*gh
iao	m*iaow*	ue	*you* *e*ver
ie	*ye*s	uo	to*war*d
iu	*you*		
ong	German j*ung*		
ou	h*oe*		
ua	*wan*d		

Here are some Chinese words from the next few pages to try: Shang, Zhou, Zhou Koudian, Lan Tian, Xia, Erlitou, Banpo, Xi-an, Dahecun. Remember, it is not so important that you pronounce the Asian words with great accuracy, but it is *very* important that you *do pronounce* them. Otherwise they will become a stumbling block to learning.

10
· · · · · ·

THE YELLOW RIVER VALLEY
The Neolithic Age; the Shang and Zhou Dynasties

OLD STONE AGE
(PALEOLITHIC, ca. 500,000–ca. 5000 B.C.)

Ancient humans appeared in China in the **Paleolithic Age.** Like Old Stone Age people elsewhere, they used roughly broken stones as tools and weapons; they probably wore animal skins and sought shelter in caves; they hunted and fished but did not farm or make pottery, weave cloth, or build houses.

Since the discovery of the Peking man (the name given to the first ancient human remains to be discovered in China, found in the Zhou Koudian Cave, near Peking, now Beijing) in 1929, several other sites in various parts of China have yielded bone fragments and other evidence of Old Stone Age peoples. Lan Tien man was an earlier relative discovered in 1963, and a somewhat later and more highly evolved form of human was discovered in Anhui Province in 1982.

The old Stone Age was a period in which mere survival probably consumed all of the time and efforts of these ancient peoples. There was no time for embellishment; there was scarcely time to maintain adequate protection from enemies and to hunt food. Modern humans (*Homo sapiens*) appeared around twenty-five thousand years ago. Some twenty thousand years later, fundamental changes in life-style occurred.

NEW STONE AGE
(NEOLITHIC, ca. 5000–1600 B.C.)

China's ancient tradition reports that the first dynasty was that of Xia. Chinese archaeologists place the time of the Xia dynasty between 2100 and 1600 B.C., but, so far, no remains have been discovered that can be assigned with certainty to the dynasty.

Some Chinese archaeologists tend to believe that the site of Erlitou (which will be further discussed under the Shang dynasty, successor to the Xia), was probably the capital of the Xia dynasty as well. In any event, it seems likely that one or another of the Neolithic cultures will eventually be identified as that of the Xia people.

Particularly in the West, the very existence of the Xia dynasty is questioned by some scholars. But it should be remembered that this same skepticism was characteristic of Westerners' views of the Shang dynasty until the excavations of Anyang corroborated the tradition with credible archaeological evidence. In the third decade of the twentieth century Western scholars finally accepted the Shang dynasty as a fact.

At first it appeared that the Xia referred to a time period only, but years of scholarly study have revealed a much more complex picture. Just as the Shang were shown to have been but one of several coexistent cultural groups, so the Xia are now considered to refer to one of a number of groups that flourished at the same time in China.

The Chinese have traditionally called their country the **Middle Kingdom.** This concept may have arisen during the **Neolithic Age,** perhaps at the time of the Xia dynasty. Perhaps it was the first stirrings of separateness or a sense of distinctness, an in-group/out-group awareness, that initially inspired the Xia to dissociate themselves from their neighbors. One of the most distinguishing and enduring characteristics of the Chinese people as a cultural entity has been the sense of a need to protect themselves from outsiders.

Xia was the epoch of the great emperors of legend. Later Chinese looked back with admiration and gratitude, for this was the time when these legendary rulers taught the people agriculture, irrigation, pottery making, weaving, and all the useful arts.

The primitive subsistence of the Paleolithic people was replaced by settled communities, which practiced both the division of labor and specialization. More leisure time was available after the people learned to make pottery in which seasonal crops such as grain could be stored and protected from moisture and rodents.

The inhabitants of Xia communities lived in small huts with a central hearth and a smoke-hole in the roof. As time went on, the buildings became more substantial. The oldest Neolithic settlement discovered in China is that of Banpo, near Xi-an in Shenxi Province (fig. 11.1).

Neolithic architecture was simple but sufficient. The houses were small and the floors were usually sunk into the earth from three to six feet; this served to keep them warmer in winter and cooler in summer.

House plans varied from round to rectangular (fig. 10.1). The circular dwellings had walls that tapered in a cone like the American Indian *tipi*. Rectangular houses developed late and had vertical walls; they were in common use by the end of the Neolithic Age.

At Dahe village near Zhengzhou, remains of rectangular houses have suggested to Chinese archaeologists a curious, though logical, system of construction. The method apparently consisted of setting slender poles into the ground vertically and close to one another, forming the perimeter of the structure. These poles were then covered inside and out with mud stucco and smoothed over, concealing them inside the walls. After drying, the building was filled with brushwood which was also stacked against the exterior of the walls. The whole thing was set on fire, and this resulted in weatherproof walls that would not dissolve in the annual rains. It also produced fire-hardened floors, which were

a

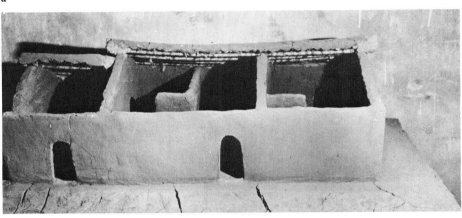

b

Figure 10.1 *a.* Neolithic house types (modern reconstructions) Banpocun, Shenxi Province, the People's Republic of China. Photo: Peter Rushton. *b.* Late Neolithic house type (modern model) based upon evidence found at Dahecun, Henan Province, the People's Republic of China. Photo: author.

less subject to **ground-damp.** The combined wood and mud walls provided better insulation from the winter cold of North China. After the walls were fired and walls and floors cooled again, roofs of small branches and thatch were fastened to rafters with cords.

The people were settled farmers who supplemented their food supply by hunting with bows and arrows and by fishing. They raised millet and pigs and knew how to weave cloth. They made their tools and weapons from stone and polished them to a remarkably smooth surface. They preferred the harder stones such as jade because of their superiority in holding an edge. The elegance of the shapes and the finely worked surfaces make Neolithic implements strikingly attractive to the modern eye (fig. 10.2). Considering the great expenditure of time and effort in their production, it seems evident that the embellishment of these pieces must have been important to the people who made them; it also indicates a great deal of leisure time in which to produce them, or a high degree of division of labor.

Agricultural surpluses that could be stored from harvest to harvest must be credited with making more leisure time available. But, the reason people took the time to create such objects must lie deep in the human condition. Before the dawn of history, people produced objects of utility embellished beyond simple necessity, in response to an inherent desire to create objects of beauty.

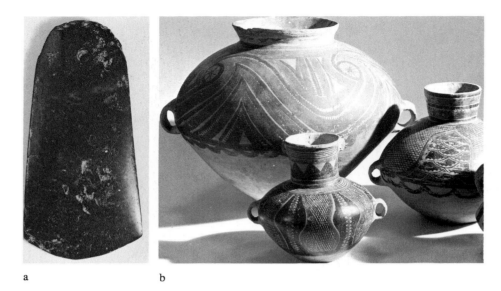

a b

Figure 10.2 *a.* Hatchet. Dark green jade. Neolithic (third century
B.C.). Asian Art Museum of San Francisco, the Avery Brundage
Collection. *b.* Yang Shao pottery. Banshan types; H. (largest) 13″.

Stanford University Museum, Mr. and Mrs. Stewart M. Marshall; Mr.
Mortimer C. Leventritt.

NEOLITHIC POTTERY

In addition to the polished stone weapons and tools, the
Neolithic Age produced well-made and handsomely
designed pottery vessels. They are of three basic types:
(1) painted, with designs in red, black, and sometimes
white, on a rust or buff-colored ware; (2) black, bur-
nished, but unpainted; and (3) gray corded, neither
painted nor burnished but showing impressions from
cord-wrapped paddles used in their formation.

The painted pottery preceded the black burnished
ware, while the gray corded pottery followed it.

The Painted Pottery Culture

The people who made **painted pottery** lived in the valley
of the Yellow River and its tributaries, that is, in North
China from Gansu Province in the west to Shandong
Province in the east.

Common Characteristics

Since painted pottery was first discovered at Yangshao
village in Henan Province, Yangshao has remained as
a general term for all the painted pottery cultures. Al-
though it varies in appearance from site to site, speci-
mens of this pottery share a few basic characteristics:
it is handmade without a potter's wheel, and the de-
signs were painted in mineral colors, which were made
durable when the pots were fired in bonfires or simple
kilns.

The need for storage of surplus grain encouraged
pottery production, since fired clay vessels could ex-
clude animal intruders and help to keep the grain dry.
The porosity of the vessel walls automatically regu-
lated the temperature and humidity of the contents
through heat and humidity exchange with the outside
air.

Cemetery Vessels

Painted vessels found in the cemetery sites of the Ban-
shan hills of Gansu Province are considered the finest
examples of such pottery. Although they are similar in
shape, with a small base and wide, rounded shoulders,
there is a great variety of painted designs (fig. 10.2*b*).
These jars were placed in shallow graves, where they
held food for the dead, indicating belief in life after
death. The custom of bringing food to graves has con-
tinued through the centuries.

Pottery Shapes

Jars from the Banpo village site (fig. 10.3) show the
impression of woven reed or split bamboo mats on their
bases. It is likely that a small circular piece of woven
mat was used as a base upon which to begin the coiled
clay pot, otherwise the damp clay would tend to adhere
to the work surface. (Even today, native American pot-
ters of the Southwest use a shallow fired pottery base
for the same purpose.) This was a simple solution to
the problem of making round vessels without a potter's

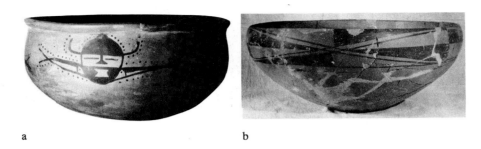

Figure 10.3 *a.* Yangshao painted pottery from Banpo village. Shenxi Provincial Museum. Photo: author. *b.* From Xiquan Xian, Henan Province. Photo: Henan Provincial Museum.

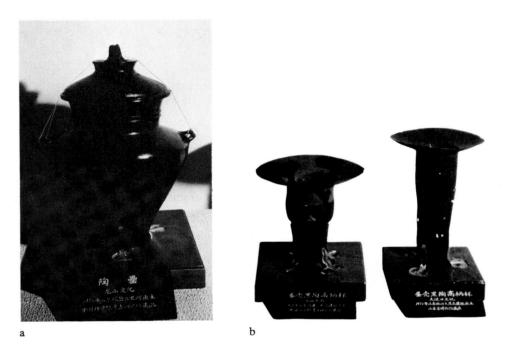

Figure 10.4 *a.* Longshan black pottery jar with cover. *b.* Longshan black pottery cup stand (?). Beijing Historical Museum. Photos: author.

wheel. The pots were simply rotated slowly on their own axes so that the hands of the potter could detect and correct irregularities in the shape. Thus the pot was "trued." The small piece of mat attached to the base would permit the pot to be turned quite efficiently, because the base mat would glide easily over a larger mat of the same material upon which the potter worked.

Black Burnished Pottery (ca. 2500 B.C.–into the Bronze Age; terminus uncertain)

Major sites of excavation of **black burnished pottery** are near Longshan in Shandong Province; the first site was discovered at Chengziyai in 1928. Longshan pottery is

as different from the earlier painted pottery as the cultures that produced them (fig. 10.4). It was first thought that Longshan centered in Shandong, with influences moving westward into Henan and Shenxi. However, the so-called Henan **Longshan culture** was a developmental phase that supplanted the painted pottery cultures just after 2000 B.C. in these provinces.

There were at least three distinct phases in the development of the Longshan tradition. The earlier pieces were very simple in shape and often of a gray or brown color. The walls were almost one-half inch thick. As time passed, the unpainted simple shapes of the Longshan Era became more complex, and by the time of the

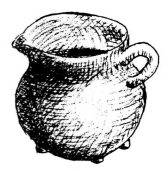

Figure 10.5 Pitcher with rudimentary feet. Dark gray clay. Erlitou, phase I (ca. 1900 B.C.). Erlitou Archaeological Station Museum.

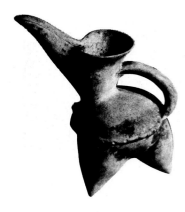

Figure 10.6 "White" Longshan tripod vessel. Late Neolithic. H. 8¼". Beijing Historical Museum. Photo: author.

Xia dynasty (ca. 2100–1600 B.C.) the forms and techniques began to change radically from the flat-bottomed, thick-walled simple jars and bowls. At least one small "pitcher" of globular form with spout and handle is supported on short rounded nubs or "feet" (figs. 10.5 and 10.6). The handle is on an axis with the spout. Spout, handle, and three feet are characteristic of the **jue** of the succeeding Bronze Age (fig. 11.3). It is possible that there is a *functional* continuity between such a clay vessel and later bronzes, but the specific shape, style, and thinness of wall in the bronzes suggest something more than a mere imitation of ceramics. None of the pottery of the Longshan phases before the probable beginnings of metal vessels appears to have either the angularity or the thin walls of those produced after the development of the metal technology (fig. 11.3).

The Longshan and Shang seem to have contributed elements to each other's cultures. Some of the most characteristically "Shang" traits appear earlier in the Shantong beginnings of Longshan, notably an unusual procedure used to foretell the future by asking questions of the spirits of the ancestors, then reading the answer in the pattern of cracks that appeared when heat was applied to dry bones (mainly shoulder blades of cattle or deer and later, at Anyang, of tortoise breastbones).

The Longshan may have used **rammed earth walls** before the technique was developed by the Shang. They employed **cowerie** shells as money, a logical usage for coastal peoples (even though the coweries probably had to be obtained by trade from the South China Sea) but surprising for the Shang inland culture with its nucleus in central China.

In Shandong, the Longshan sites have revealed no metal; but the highly developed black burnished ware, with its extreme thinness and sheen, seems to have been inspired by an emulation of metal vessels at a time when bronze was already being made at Erlitou.

The black burnished vessels were undoubtedly reserved for ritual use, since they are too thin and fragile (one to two millimeters thickness in some examples) for everyday use. But, except for divination, we know little of Longshan ritual or belief systems.

On the basis of present evidence, it seems possible that the Shang may have settled in eastern Henan as neighbors of the Longshan before they moved up the valley of the Yellow River westward to Erlitou, where they conquered the people who may eventually be identified as the Xia. The Shang history states that the capital was moved westward and northward several times before settling at Anyang. But before the ancient neighbors parted they may have exchanged some cultural traits.

Gray Corded Pottery (Before ca. 5000 B.C.–Shang Dynasty or Later)

Gray corded pottery has been recovered from many sites throughout North-Central China. This pattern results from beating the surface with cord-covered **wooden beaters** to consolidate the clay of the vessel. Two technical features distinguish this pottery from the earlier categories: its surface is rough because the clay is sandy, and the marks of cords are impressed into it (fig. 10.7). The cording prevented the damp clay from adhering to the wood beater.

Another basic characteristic of this pottery is that the body color is usually gray, rather than the red to buff of the painted pottery or the black of the fine Longshan pieces. Both painted and black ware were made in the same manner as the gray corded vessels, but in each case they were further refined in order to receive the finish desired.

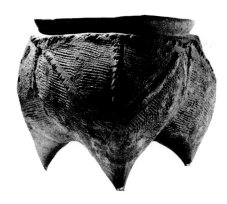

Figure 10.7 *Li*, corded ware. Shang (ca. 1300 B.C.). H. 5½″.
Stanford University Museum, Mr. and Mrs. Stewart M. Marshall.

Clay usually contains iron, which turns to rust when it is baked in a fire with adequate oxygen supply. The gray ware was baked in a fire with too little free oxygen to make it rust colored but not enough free carbon to be absorbed and turn the clay deep black.

Gray corded ware has been found at sites ranging from the earliest Neolithic through the Bronze Age. It is usually heavy-walled and sturdy in appearance. It is notable that some pieces may have small areas of gray, but the remainder of the surface may be brownish or reddish. That is attributable to uneven firing, which allowed some areas to be oxidized more than others. This variation is also found in the Longshan wares.

SUMMARY

In the New Stone Age, the ancient ancestors of the Chinese began to produce "art." At first this took the form of simple embellishments of utilitarian objects, perhaps to mark these particular objects as special and therefore suitable for ritual use. This may be true of some of the polished stone implements and pottery pieces that have been found.

The basic elements of the simple, settled, agricultural life-style that was to become the norm for the rest of China's long history were established in the Neolithic Age. Several village sites and some cemeteries have been discovered. These findings have revealed three fundamental pottery styles: a painted style, a black burnished style, and rough gray ware. There appear to be geographic concordances with these styles, but they all seem to have been practiced in the central area of North China, in Henan Province.

The chronological sequence indicates that the painted ware was the earliest, then the black, and finally the gray corded ware. Except for the technique of glazing, the basic technology of pottery making was well developed by the end of the Neolithic Age. In China, as in other cultures elsewhere, glazing was not used until the metal technology arrived in the Bronze Age.

GLOSSARY

Black burnished pottery One type of pottery produced in China during the Late Neolithic Age (ca. 2500 B.C. into the Bronze Age), characterized by a black, burnished, unpainted form in late Longshan culture. (p. 87)

Cowerie Small sea snail. Native to the South Pacific coastal waters of Asia. Used as currency during the Shang dynasty in China. (p. 88)

Cun Village.

Gray corded pottery A type of pottery made in Neolithic China, characterized by rough surface, marks of cord, and gray color. Succeeded black burnished ware in North-Central China. (p. 88)

Ground-damp The dampness arising from the earthen floors. (p. 84)

Jue Type of ritual vessel. Earliest known come from the Erlitou phase of Early Shang. Characterized by three legs supporting a small cup with a long spout to the left and a pointed tail to the right when the user holds the cup by its handle, which is always above the leg and at a ninety-degree angle to the spout/tail axis. (p. 88)

Longshan culture East Coast Chinese culture; later than painted pottery and earlier than gray corded ware. Black burnished ware is late Longshan. (p. 87)

Middle Kingdom Traditionally, a term the Chinese use to refer to their country. (p. 84)

Neolithic Age The New Stone Age characterized by use of polished stone implements, domestication of animals, weaving of cloth, and use of bows and arrows, ca. 5000–1600 B.C. (p. 84)

Painted pottery One type of handmade pottery produced in China during the Neolithic Age (ca. 5000–4000 B.C.), characterized by red, black, and white designs on rust or buff-colored ware. (p. 86)

Paleolithic Age The Old Stone Age characterized by use of roughly broken stones as tools and weapons; hunting and fishing for food, and shelter in caves, ca. 500,000–ca. 5000 B.C. (p. 84)

Rammed earth walls Walls for cities made by pounding damp earth into moveable wooden molds to form extremely durable protection from marauders. (p. 88)

Wooden beaters Cord-covered instruments used by Neolithic Chinese to form vessel shapes from clay. The cord prevented the damp clay from sticking to the beater. (p. 88)

Xia China's first dynasty (ca. 2100–1600 B.C.). (p. 84)

11

THE BRONZE AGE IN CHINA
The Shang and Zhou Dynasties

THE SHANG DYNASTY (ca. SEVENTEENTH–ELEVENTH CENTURY B.C.)

The Shang was but one of several coexisting groups in ancient China. Erlitou may have been the site of the first Shang capital, although no documentary evidence has been found to prove this (fig. 11.1). It had been occupied for at least two centuries before the time when Chinese traditional history records that King Tang, the first Shang ruler, overthrew the Xia kingdom and established the Shang. But the question of where the Xia capital was located and of where the decisive battle was fought are still vigorously discussed and have not been definitively settled.

Early Shang (ca. seventeenth–fifteenth century B.C.)

The earliest bronze vessels thus far discovered in China have come from the Erlitou culture, so that it is possible that bronze was an invention not of the Shang (which has been the prevalent view for over fifty years) but of the Xia people. Four phases of occupation have been identified at Erlitou. The first two may have been within the Neolithic Age. The third and fourth phases contained elements of culture that relate to the Shang cultural phase.

Erlitou was a walled city with a large central building on a raised base of **rammed earth** (fig. 11.2). This must have been a major structure and is referred to as the palace, although archaeologists point out there is no specific evidence, other than size, to support this designation.

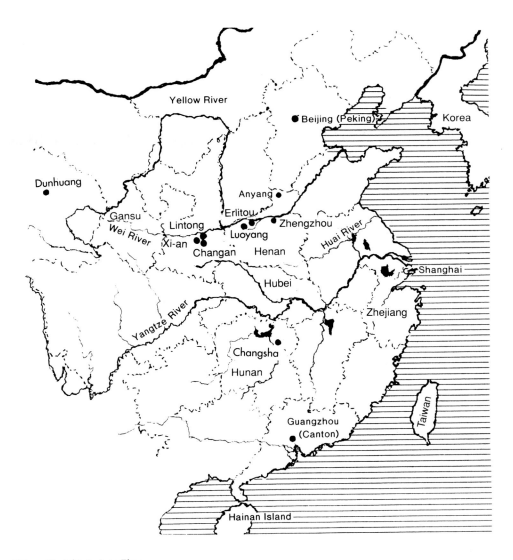

Figure 11.1 China—Neolithic to Late Zhou.

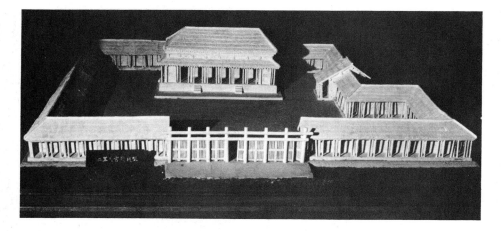

Figure 11.2 Erlitou. Model of palace. Luoyang Municipal Museum. Photo: author.

Construction differs from that of the Neolithic Age. Now, for the first time, a true system of **post** and **lintel** construction was used. (Posts are the vertical pillars and lintels are the horizontal beams.) That, in addition to overhanging eaves, orientation to the cardinal points, and the fact that the long side of the main building lay on an east-west axis, is characteristic of Chinese ceremonial architecture, and has remained the norm until modern times.

Centralized Power

Although Chinese archaeologists have not yet resolved the question of whether Erlitou was a Xia or a Shang capital, both factions agree that it was indeed a capital. Although cultural modes and artifacts from this era were to become more sophisticated in succeeding centuries, the capital's contribution to the Shang character is clearly visible in the life of Erlitou. The centralized power, walled cities, architectural types, and unbridgeable social and political abyss between the rulers and the ruled were all present. This life-style produced, and was in turn influenced by, the greatest industrial technology of any Bronze Age culture. Centralization of power made possible the conscription and maintenance of the large work force required in mining and smelting the ore, as well as workshops and foundries where bronze was finally cast into the striking forms created by master designers.

The ruling class held an absolute monopoly over the production of metal. The benefits of the new age were reserved exclusively for the rulers and their relatives. The land, the technology, and the workers all belonged to the rulers.

The mass of people continued living a Stone Age life-style, even while using the most advanced technology their world had ever seen to produce objects of precious bronze. The same abyss between the rulers and their subjects was expressed in many other ways. It was far from unusual in China for peasant farmers to live in a manner outgrown centuries earlier by the nobility. This relationship must have received a strong initial impetus when the people who were actually making the bronze objects were not permitted to own them, only to use them to work for their rulers. They lived in the Stone Age still, while working in the Bronze Age. The labor force was rotated from agricultural production to warfare to building construction to water projects and to other tasks as the season and need demanded. But the bronze weapons of the soldier and the bronze implements of the farmer were owned by the overlords, who likewise owned those who used them.

Use of Metal Objects

The discovery that metal could be worked into useful products was made in China, probably just preceding 2000 B.C. Future excavations will probably reveal earlier examples than those thus far known from Erlitou, which are the oldest yet discovered. About a dozen such objects have been found, including a few vessels thought to have been associated with ritual wine offerings. One type has three legs, a handle, and a spout. They are thought to have been used for heating wine over an open fire. Their small size would seem to indicate that if this was indeed their function, it was strictly ceremonial, because these small vessels could hold less than a cup

of wine. Perhaps in those early years wine had only recently been invented, and if so, it most certainly must have been reserved for ritual alone. Perhaps it was used to produce a trancelike state for the king or his **shaman** (religio-magical practitioner who fulfilled a role very similar to that of the medicine man in native American cultures), making it possible to contact the spirit world.

Bronze Technology

Shang bronze vessels were cast by the **piece-mold method.** Sectional or piece molds were made of the model, so that they could be taken apart and reassembled if desired. It was not necessary to destroy the mold in order to retrieve the finished bronze. These earliest bronze vessels are the most thinly cast; they are also the smallest. Their discovery has led to a reassessment of the evolution of bronze technology in China. Thus, while these earliest pieces may be neither dramatic nor especially attractive, they have caused a flurry of excitement among scholarly disciplines.

It is difficult for us today to understand clearly what the Bronze Age meant to China and how dramatic was the shift from the Stone Age. As time has revealed more and more bronze examples of earlier and earlier date, it has become clear that a gradual development from simple to complex shapes, techniques, and designs occurred.

The bronzes derived their *functions* from the earlier pottery cultures. That is to say, a water bowl for washing hands has a different function and therefore a different form from one for steaming vegetables over a fire or a vessel made for pouring liquid. But the earliest *models* used in the casting technique seem less and less likely to have been pottery. When the functions of the ceramics began to be expressed in metal, the heavier and more rounded shapes of pottery were left behind.

Burial Practices

The tradition of burying food with the dead continued in the Erlitou burials. The small graves are not very different from those of the Neolithic type, but they have revealed more objects of material culture. In 1975 three test pits were dug in the palace area. From them two bronze vessels, three weapons, and four circular metal discs were recovered. The vessels are three-legged and have handles set at ninety degrees to a narrow spout. At the opposite side the lip is a point (fig. 11.3). This vessel type continues throughout the Shang dynasty. Tiny prongs that extend upward from the rim, the size, and the proportions all vary as time goes by, but the

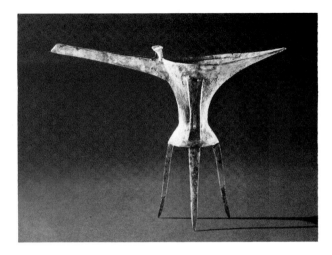

Figure 11.3 *Jue* ceremonial vessel. Bronze. Found at Erlitou (1975). Phase III Erlitou culture. Early Shang dynasty (ca. seventeenth century B.C.). H. 10⅛″. The Metropolitan Museum of Art, on loan from the People's Republic of China. Photograph by Seth Joel.

vessel type remains until the end of the Shang. These earliest vessels are more rectilinear than later ones, and their forms suggest that they may have been derived from a tradition of sheet metal working. The walls of these pieces are extremely thin (about two millimeters), but the legs are cast solid.

Middle Shang (ca. fifteenth–fourteenth century B.C.)

The pattern of life in the Early Shang Dynasty at Erlitou continued into Middle Shang Dynasty. Its capital was at the site of the modern city of **Zhengzhou** in Henan Province. It was surrounded by a rammed earth wall sixty feet thick and about thirty feet high, sections of which still remain. The evidence suggests that the compound near the center of the city and the large building it contained were very like those at Erlitou.

Outside the walls of the city lay the bronze foundries and other workshops, including those for processing jade, making pottery, and producing objects from various animal and human bones. In a small section of a refuse ditch inside the palace enclosure a recent excavation brought to light over one hundred human skulls. They were mixed in with animal bones and broken pottery fragments, but they are not in any sense a burial site, merely a dump site. The skulls had been very neatly sawed across on a straight line between the

eyebrows and the base of the skull. The sawed edges retain a very smooth and shiny ivorylike surface that seems to have been rather carefully attained by polishing. The function of these skulls is uncertain. It has been suggested that they were raw material from which bone implements were to have been made. But no evidence of this was found at the site, and a clearly recognizable bone workshop was found entirely outside the city wall to the north.

In this connection it is tempting to consider that the reason the Yuezhi left the borders of China (after which they moved eventually to India and set up the Kushan dynasty) was that their enemy, the Xiongnu (Huns), had captured their king, cut off his head, and made a drinking cup from his skull. But that was to be more than a thousand years after these skulls were dumped into a drainage ditch at Zhengzhou. On the other hand, the religion of Tibet retained crania of famous monks as ritual vessels into the twentieth century. Is it mere coincidence that the ancient Xiongnu lived on the northwest border of China, adjacent to the Tibetan highlands?

The first discovery of the Middle Shang culture at Zhengzhou was actually made at Erligang, a small hill about fifteen hundred feet beyond the southeast corner of the Old Shang city wall. The find site has given its name to the Middle Shang cultural phase, even though subsequent discoveries have made it apparent that the walled Shang city and the modern city of Zhengzhou occupy so much of the same land that it would be perhaps more proper to refer to the Middle Shang as the Zhengzhou phase. Actually, this is frequently done. Confusions may arise unless we understand that Erligang and Zhengzhou are two sites of the same culture, and that the former site is a small point compared to the large expanse of the Shang city that underlies the modern city of Zhengzhou.

Influence

Shang rule or influence spread farthest from its source in Henan during the Middle Shang years. Bronzes of the Middle Shang style have been found in Anhui, Hebei, Jiangxi, Shenxi, Shanxi, and Shandong. In Hubei there was a large and important city of the period that produced its own bronzes; remains of smelting, and of molds and other foundry equipment, have been found there. Whether these extensions of the style mean domination of or competition by the local regions is so far not clear. It is possible that the outlying peoples had by this time acquired the secrets of metallurgy for themselves.

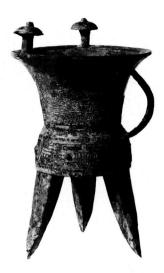

Figure 11.4 *Jia.* Bronze. Zhengzhou style, Middle Shang (fifteenth to fourteenth century B.C.). H. 13″. Asian Art Museum of San Francisco, the Avery Brundage Collection.

Bronzes

The bronze vessels of the Middle Shang are larger and sturdier than those of the Erlitou, but the major distinction is in the surface designs (fig. 11.4). A band or frieze of highly abstracted shapes divided into sections (often three) run around the circumference. The few square vessels have bilaterally arranged designs. These patterns are almost exclusively composed of a single-eyed animal resembling, it has been said, a bird seen from the side. Another version depicts two eyes as seen straight on and then looking like an animal face. The eyes are normally in relief above the surface.

Figure 11.5 shows a large vessel of type *ding.* These vessels were usually round with three legs, but this is a four-cornered version and is called a *fang* (square) *ding.* It is presumably for cooking; probably for stewing meat. The simple designs were cut and pressed into the interior of the clay mold so that they would come out in relief on the finished bronze vessel. Only two simple tools were used: a blunted round point to make the bosses and a needlelike point to make the line patterns. All of the patterns and the bosses were made directly in the mold, and no model was needed at all. This is the largest bronze of the Middle Shang period so far discovered. It was found in 1974 at Zhengzhou.

There is a style of bronze designs obviously related to, but differing from, that of the Erligang or Zhengzhou phase of the Middle Shang period. These vessels have mostly come from a few chance finds in the area

By the time Anyang became the capital, almost all casting problems had long since been solved, and the interplay between technical necessity and aesthetic preference, which so marks the evolution of style in the Early and Middle Shang, gives way to a greater desire for impressive ornateness. Each piece was still made individually. The piece-mold system dating from the Early Shang continued in use, but a much greater repertoire of animal motifs appears. Although the vessel types remain much the same, their appearances sometime change because of the surface designs. By the late Anyang period, these animal patterns often became raised three-dimensional forms as well as the older, intricate linear patterns sunken into the surfaces. A new motif, the square spiral, became prevalent as a background of compact rectilinear pattern against which the plainer animallike shapes can be seen. It is a characteristic of the Late Shang phase that the animal designs, which increased both in number and realism from the Early to the Late Shang, are composed of wider plain surfaces, while the backgrounds are extremely complex.

The **flanges,** vertical, flat projections standing at right angles to the surface, which are so prominent in Late Shang bronzes, are but one device by which the Chinese artisan overcame a technical obstacle, transforming it into advantage by making it into an aesthetic preference. They originated in the **flashing,** that is, the molten bronze running out between the sections of the piece-mold where they came together at the joints. At first these flashings were laboriously ground off the finished vessel, but gradually it became clear that since this oozing existed it might as well be incorporated into the design. Erlitou bronzes have no flanges, and they are minimal in Erligang/Zhengzhou, but by the time of Anyang, they become part of the overall design (fig. 11.6).

Tombs

The tombs of the Anyang period are far more elaborate than their predecessors. Some are considered to have been royal tombs, for example, those excavated from 1928 onward. Some were sixty feet below ground level and were approached by long ramps and stairs running down from ground level. The tomb chambers were rectangular and must have looked very much like flat-roofed, one-room log cabins in which inner and outer walls had been smoothed by use of the **adze.** They were embellished by designs from the same repertoire as those of the bronze vessels. Fragments of carved and painted designs originally decorating wooden objects have been found impressed and preserved in the fine soil, although the wood has long since disintegrated and disappeared.

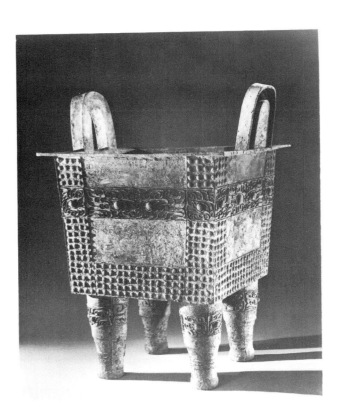

Figure 11.5 Rectangular cauldron (fang ding). Bronze. Middle Shang (fifteenth century B.C.). H. 39½″. Weight 181¼ lb. Excavated 1974 at Zhengzhou. Henan Provincial Museum. The Metropolitan Museum of Art, on loan from the People's Republic of China. Photograph by Seth Joel.

where the provinces of Hebei Hepe, Henan, and Shandong border each other, that is, down the Yellow River valley from Zhengzhou and northeast of that site. The new style is very like that of Zhengzhou but is more orderly and regular. The broad design areas are indicated by narrower linear depressions, which alter the ratio of sunken to raised pattern.

Late Shang (ca. fourteenth–eleventh century B.C.)

The capital was moved from Zhengzhou around 1400 B.C. The last (and only documented) capital, **Anyang,** was not established until about 1300 B.C. In the intervening century two other capitals are noted in the records, but no sign of them has as yet come to light, so our knowledge of the great cities of Shang is only three-fifths complete, even in terms of the major population centers. The historical gap between the last years of Zhengzhou and the establishment of the new capital at Anyang is reflected in a stylistic gap in the bronze designs of these two sites.

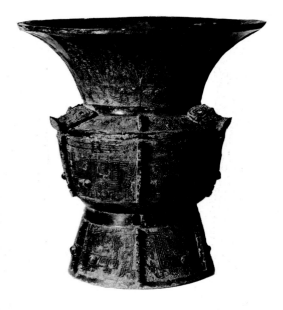

Figure 11.6 *Zun.* Bronze. Late Shang (thirteenth to eleventh century B.C.). H. 14″. Asian Art Museum of San Francisco, the Avery Brundage Collection.

These tomb chambers held the coffin, and around it were arranged the large quantities of grave goods the deceased would need in the next life. Not only various useful and ritual objects but also clothes and food as well as slaves, and sometimes even relatives, were buried with a high-ranking noble. In one or two cases slaves in large numbers have been found lined up in ditches several yards distant, with their feet pointing away from their master's tomb and their severed heads lined up in a row nearby. In one instance either slaves or prisoners of war were found in a large pit where they had been dumped, perhaps after their ritual sacrifice. Animals were often buried in pits, but horses and chariots were entombed separately from other animals, sometimes under the ramps leading into the tomb. The very last items added seem to have been the personnel who would accompany the dead. The great axes by which their heads were severed were often left with them on the floor and the tomb pit was then filled in level with the ground.

Although no exterior sign marked these tombs, local people devised a kind of treasure hunt by probing the soft rockless soil with long metal poles. This practice began around the twelfth century A.D. with a growing antiquarian interest. Good prices were paid for ancient bronzes, and it may be assumed that many a scholar's study contained one or more of these remarkable vessels. Because the silt that covers North China is rockless to a very deep level (since it was deposited

either by the wind or, in the river valleys, by the flooding of the river), whenever the seeker felt a probe strike any hard object, it was certain it was put there by humans. Digging down to the end of the probe very often brought to light more than one artifact since, once the level of the tomb had been reached, it was easy to extend the tunnel and find other artifacts. This grave-robbing tradition has deprived us of knowledge of how the missing items relate to those found at the time of excavation. We are missing not merely the piece but also important knowledge of how pieces were placed in the tomb. In the case of the so-called Royal Tombs of Anyang, grave robbing has deprived us of the very names of the rulers who were buried in those tombs.

Fewer than two hundred bronze vessels were recovered from the excavations carried out on the tombs at Anyang between 1928 and 1937. Hundreds more must have been stolen from these tombs during the preceding centuries. One estimate puts the number of Late Shang bronzes in various collections throughout the world at something like four to five thousand. This means that we know nothing about them except that their style is like those excavated at Anyang.

Until the 1970s the names of the occupants of the great tombs at Anyang were not known. Although many bronze vessels in museum collections are said to have come from there and have inscriptions bearing names, positive identification has not been possible because all of the excavated tombs had been previously plundered. In 1976, however, a small tomb was excavated and found to be completely untouched by grave robbers. It is the tomb of Fu Hao. This one tomb contained 440 bronzes in addition to 590 jade objects and 560 objects of bone. There were also many pieces of pottery, items made of stone other than jade, and ivory pieces as well. The tomb is identified by inscriptions on the bronze vessels as being that of the Lady Fu Hao, one of sixty-four wives of the fourth Shang king to rule at Anyang. **Oracle bone inscriptions** in the official archive found at Anyang seem to indicate that Fu Hao was one of the three major wives and was known as Queen Xin. This is the first Shang tomb whose occupant has been identified.

Advent of the Written Language

The bronze industry had already developed and was flourishing by the time Anyang was established as the Late Shang capital. At Anyang an equally important contribution to Chinese culture was made: writing and record keeping, which became literature and history and without which Chinese culture could never have developed as it did. So perhaps this was an even more important contribution than bronze technology.

One of the most powerful distinctions between the ruled and the rulers was literacy. It is significant that this function of language seems to have originated at the same time as the language itself. The written language was developed in the service of the Late Shang rulers. It undoubtedly grew out of the Late Neolithic method of prognostication by means of applying heat to the wider and flatter surfaces of animal bones, such as the shoulder blades (*scapulae*) of deer and cattle. The answers to questions, (or "oracles") asked by the king, or for him, through the intermediary of the *shaman* would be interpreted according to the patterns of cracks that appeared when the bones got hot. By the time of Anyang, tortoise breastbones were used as well, but even so, the system is still called **scapulimancy**, referring to the shoulderblades.

What Anyang seems to have contributed was not only the addition of tortoise bones as a medium but the innovation of keeping records of both the question and the answer. For example when the question, Will the king be successful in the hunt? was asked, this was recorded directly upon the bone, together with the answer, and these bones were stored. Hundreds of these records have been found in pits at Anyang and are the basis for the earliest history of China, for they constitute its earliest written records.

Writing was restricted and was probably an invention of the *shamans;* perhaps it was only one of several means by which they were able to communicate with the spirit world. Trances or cataleptic states and dreams were perhaps also used, but because of their ephemeral nature they have passed away. The attitude that literacy was the privilege of the ruling class is another characteristic of Chinese culture that has endured the centuries. It is also an indication of the Chinese pragmatic view of things. Writing has to do with ideas and their communication. The thoughts of peasants have rarely been of concern, whereas the thoughts of the rulers have always been valued. It has thus been regarded as a waste of effort to educate the peasants.

Surviving Objects

A great many objects of the Shang dynasty were too delicate to survive the rigors of time. Metal and stone objects are better preserved than fragile materials such as wood and cloth. However, we know that the Shang used silk and that at least the ceremonial buildings and the great tomb chambers were of wood construction. The roofs of major buildings are thought to have been of thatch and, like almost all the perishable materials used in those times, they have disappeared. It is the bronze vessels that preserve for us the high style of the Shang dynasty, but there were many other objects of bronze as well; implements and weapons as well as

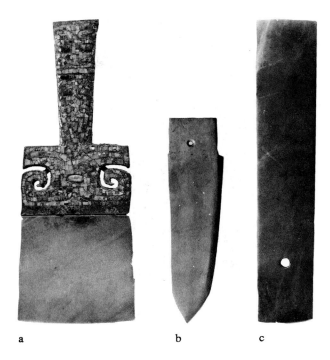

a b c

Figure 11.7 *a.* Ceremonial implement. Jade blade set in bronze; turquoise inlay. Late Shang (twelfth century B.C.). H. 8½″. Freer Gallery of Art. *b.* Dagger-axe. Ivory-color jade. Shang. H. 6¼″. *c.* Hoe blade. Jade. Shang. H. 9¾″. *b* and *c* Edward and Louise B. Sonnenschein Collection, 1950.232 and 1950.214. Photograph © 1991, the Art Institute of Chicago. All rights reserved.

chariot fittings and other paraphernalia of both ceremony and war. At the outset of the Early Shang dynasty, military and agricultural implements were made in very thin jade with a high polish. Their thinness seems to preclude a truly functional purpose, and archaeologists conclude they were symbols. Stone Age implements were excelled by products in bronze, but their former importance was not forgotten. They now became emblems of rank and of power; distinctive purposes they were to maintain for centuries after (fig. 11.7).

Bronze vessels were originally shiny silver or gold in color, depending upon the proportions of copper, tin, lead, or arsenic in combination with the copper that made up the bronze. They have become green, blue, brown, or red due to acids in the soil. The vessels are varied in both shape and in decor. The Early Shang vessels from Erlitou are small, thin, and minimally decorated (fig. 11.3). The Middle Shang bronzes from Zhengzhou are larger and thus exhibit larger areas of design, but most of the surfaces of these pieces are without surface designs (figs. 11.4 and 11.5). In the Late Shang style, designs tend to cover the whole vessel. At first these patterns were visible as plainer surfaces

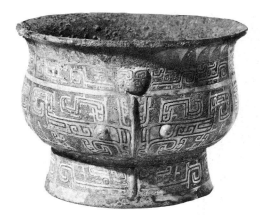

Figure 11.8 *Gui.* Bronze. Late Shang (thirteenth to eleventh century B.C.). H. 6″. Stanford University Museum, Mr. and Mrs. Stewart M. Marshall.

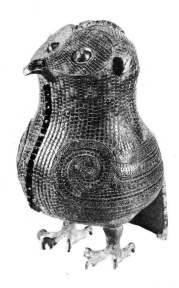

Figure 11.9 *Zun,* in form of owl. Bronze. Late Shang (thirteenth to eleventh century B.C.). H. 12½″. The Minneapolis Institute of Arts, Alfred Pillsbury bequest.

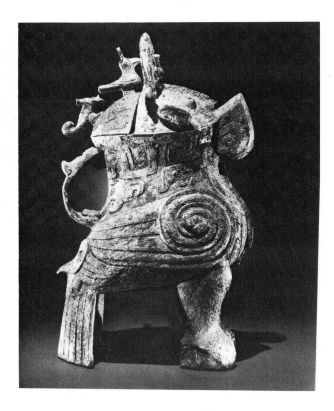

Figure 11.10 *Zun,* wine vessel in shape of bird. Bronze. Inscribed with the name Fu Hao. Excavated 1976 from the tomb of Fu Hao, Anyang. Late Shang dynasty, Anyang period. H. 18½″; Weight 36 lb. 12 oz. The Metropolitan Museum of Art, on loan from the People's Republic of China. Photograph by Seth Joel.

against a background of close-packed spirals sunken into the surface (figs. 11.6 and 11.8).

Vessels of the type seen in figure 11.6 have been identified as wine containers and those of the type seen in figure 11.8 as food containers. In the Early and Middle Shang, the vessel type had been restricted almost entirely to three-legged pouring vessels. By the Late Shang at Anyang there were more types and, presumably, more varied forms within the types. The owl-like vessel in figure 11.9 is considered to be the same *type* as figure 11.6, and they are both called by the same

name (*zun*), although the owl vessel is considered a subtype and it is called animal (*Xi*) *zun.* The important link between them is their *function,* not their appearance. But appearance, that is, *style,* is important in placing these vessels chronologically and/or geographically according to time and place of manufacture. The Fu Hao *zun* is also an animal *zun* of bird shape (fig. 11.10). But it is clear that figures 11.9 and 11.10 do not belong to the same style and are therefore of neither the same time or place. The patterns in figure 11.9 are simple feather designs. Nothing rises from the flat surface except the eyes, ears, and front and back flanges. These designs are incised into the flat surface. The Fu Hao *zun's* more complex animals are in higher relief. Compare the coiled serpents on the wings and note the full-round bird handle on the lid of the Fu Hao piece.

The sequence of Shang bronze style evolves from simple and flat to complex and relief patterns. We can conclude that the animal *zun* in figure 11.9 is earlier than that from Fu Hao's tomb (fig. 11.10). It may also

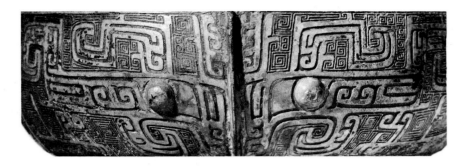

Figure 11.11 Detail of figure 11.8.

have been made at a Shang center other than Anyang. Excavations have revealed tombs in the south and east that have styles at variance with that of the capital. But these sequences of styles have not yet been worked out completely.

Shang bronze vessels were made in about thirty distinct forms derived from their specific functions (they were all containers for food or drink). Their technological excellence, the finest casting produced by any Bronze Age craftsmen anywhere, as well as the relatively small number that were produced, imply functions reserved for a small segment of society at special times. All of this points to a special ritual use, such as sacrifices made to the powers that were thought to govern life on earth.

The further fact that the largest and most impressive tombs excavated at Anyang, the last Shang capital, contained examples of these bronze vessels make it likely that these were vessels intimately connected with the rulers and with sacrifices. Their presence in tombs, where they contained food and drink, was meant for the welfare of the dead in an afterlife.

The most striking designs on bronze vessels are the animal masks (fig. 11.11). The eyes usually protrude above the surface of the vessel and frequently each half, right and left of center, can be read separately as an animal seen from the side; while taken together, the two make up the full face. The effect is rather like the skin of an animal that has been slit up the belly and down the back, leaving the head intact.

These **split animals** are everywhere in Late Shang art. They may have had a totemic protective significance, but their representations are more geometrical than natural. The combination of curving and straight linear patterns is very skillfully composed in relation to the forms of the vessels. These designs have meaning beyond mere decoration, and their significance can be better understood if we know something of the people who made them.

The Spirit World

Life in ancient China, based on agriculture and so much at the mercy of the whims of nature, was controlled by the changing of the seasons, the rising of the moon, the setting of the sun, floods, and droughts. Life was dependent upon these unpredictable, natural forces. In the hope of appeasing these powers, various sacrifices and ceremonies were practiced. Vessels of bronze, the "precious metal," were used to offer food and drink at set times as determined by the geomancer, or *shaman*, who had contact with the spirt world.

The great spirit was Shang Di, the First Ancestor. The ruler sacrified to him as well as to the natural powers, asking help and protection for his people.

The death of a Shang ruler was a catastrophe, upsetting the balance between humans and universe. In the hope that he would continue to exercise his influence in the realm of the ancestors, the ruler was provided with everything he had known in life: useful and ceremonial objects, chariots and horses, servants, and possibly even members of his immediate family.

There is a certain compelling, even bewitching power in the Shang bronzes that evokes, even today, a profound sense of awe. They reach out across thirty centuries to intrigue, baffle, and haunt, for they evoke from deep within us sympathetic responses to a time when people lived differently, thought differently, and prayed differently than we do today.

THE ZHOU DYNASTY (ca. 1045–221 B.C.)

The Chinese consider the Zhou dynasty their classical age. It was the longest dynasty in their history. During this era elements of the preceding Neolithic and Shang cultures were refined, while some new concepts were added that, taken together, formed the fundamentals of Chinese civilization.

The Zhou lived to the west of the Shang and their capital remained in Shenxi province, even after they had conquered the Shang, until 771 B.C., when they

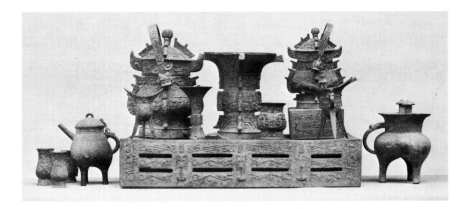

Figure 11.12 Set of ceremonial vessels. Bronze. Found in Shenxi Province. Late Shang to Early Zhou (eleventh to ninth century B.C.). H. (largest) 21″. The Metropolitan Museum of Art, Munsey bequest, 1924.

moved east and established a new capital near Luoyang in Henan Province. Thus the dynasty is conveniently divided into the Early Western Zhou and the Late Eastern Zhou.

The Zhou expanded the territory and instituted a system of feudal duchies whose autonomy continued to increase until finally the Zhou ruler had no real power to govern the dozen separate states within their kingdom. This decentralization of political power was reflected in art. The Eastern Zhou workmen in each of the capitals fashioned objects in distinctive regional styles. At the end of the dynasty constant wars took place between the larger states. This period (475–221 B.C.) is very aptly called the Warring States period.

Influence of the Shang Culture

Even before their conquest of the Shang, the Zhou had adopted much of that culture. Bronze vessels found in Shenxi include some in the Shang style, which are believed to have been produced under strong Shang cultural influence (fig. 11.12).

The Middle Shang influence had extended from the capital at Zhengzhou into the provinces of Shenxi and Hubei in the west and south and into Anhui in the east and Hebei in the north. Local variations arose, while more elaborate provincial versions of the Late Shang style were achieved by the Zhou prior to the conquest than had been produced by the Shang at Anyang.

The electrifying, savage tension in the Freer Gallery **gui**, a vessel for containing food (fig. 11.13*a*) is in sharp contrast to a vessel of the same function—but certainly of a later date—in the Asian Art Museum of San Francisco (fig. 11.13*b*). The latter style marks a departure away from the savage Shang tradition toward the docile domestic simplicity of shape preferred after the establishment of Changan (Xi-an) as the capital of the Western Zhou dynasty.

These two pieces express succinctly the difference between the style influenced by Shang and the inherent Zhou aesthetic preference. It may be assumed that since these are all ceremonial vessels, the sacrifices of Shang must have been practiced by the Zhou while they were under Shang influence. When they came into their own they probably modified or changed entirely some of the Shang rituals they had carried out. Some evidence for this is found in the vessels themselves and further corroborated by the written records of Zhou.

Mandate of Heaven

Some of the bronze vessel types that had been used in the ceremony of wine offerings were abandoned under the Zhou. Their records describe the Shang as having been dissolute drunkards, but this may be a rationalization for their own invasion of Shang. The Zhou felt that because the Shang had misused their power to govern, the "mandate of heaven" had fallen to the Zhou, so that it became not only their right but their duty to assume the righteous rule of the territory. This concept of rule by the righteous protected by heaven is established by the conquest of Shang by Zhou. It was to last throughout later Chinese history. When foreign invasion imposed rule by non-Chinese, it was viewed as retribution for the corruption and sacrilege of the Chinese dynasty. The conquerors were endured until heaven mandated a new Chinese rule.

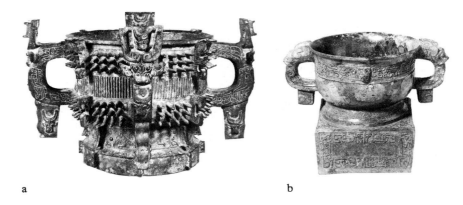

<center>a</center>

<center>b</center>

Figure 11.13 *a. Gui.* Bronze. Early Zhou (eleventh century B.C.).
H. 9⅛". Freer Gallery of Art. *b. Gui.* Bronze. Early Zhou (tenth century

B.C.). H. 8¾". Asian Art Museum of San Francisco, the Avery Brundage
Collection.

Late Zhou Designs

One of the Shang practices that the Zhou abandoned
was that of human sacrifice. At least by the end of the
period, images were substituted for people, as well as
animals, in noble tombs (fig. 11.14). The Zhou rulers
conceived of heaven (or sky) as being the supreme
power in the universe, although they continued the
Shang reverence for ancestors.

Numerous sites from the Eastern Zhou period have
been discovered. Eastern Zhou designs are complex,
indicating a marked preference for intertwined motifs
(fig. 11.15). Few animals remain in the repertory, but
these are repeated in endless variations. The two most
frequent are the serpent (or dragon) and the feline (or
tiger).

Inlaying bronze with turquoise and malachite, as
the Shang had, was revived with great flair (fig. 11.16).
The combination of inlaid turquoise, malachite, gold,
and silver on the glistening bronze must have produced
a dazzling effect. This seems to have been the aim: to
dazzle the eye rather than to awe or terrify (fig. 11.17).
The animal mask reappeared but was definitely do-
mesticated and charming in its decorative form.

Richly surfaced vessels are but one instance of a
whole range of splendidly ornamented objects with
which tombs were furnished. A few astonishingly well-
preserved wooden objects, painted with highly sophis-
ticated abstract designs in three or four colors of lac-
quer have survived from the tombs at Changsha (fig.
11.18). They indicate the remarkably high develop-
ment of this art in the south at the close of the period.
Such wealth was expended upon noble funerals that
they contributed to the decline of some of the smaller
states.

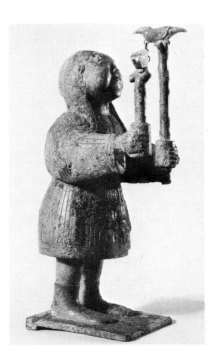

Figure 11.14 Figure holding birds. Bronze; birds, jade. Warring
States (fifth to third century B.C.). H. 10". Museum of Fine Arts, Boston.

Hunting scenes depicting humans and animals are
found on a group of bronze vessels dating from about
the fifth or fourth century B.C., that is, from the first
half of the Warring States period (fig. 11.19). These
figures are seen against sunken plain backgrounds
(perhaps originally inlaid). These hunting scenes ex-
press an important new concept: that figures could be
portrayed engaged with each other physically and psy-

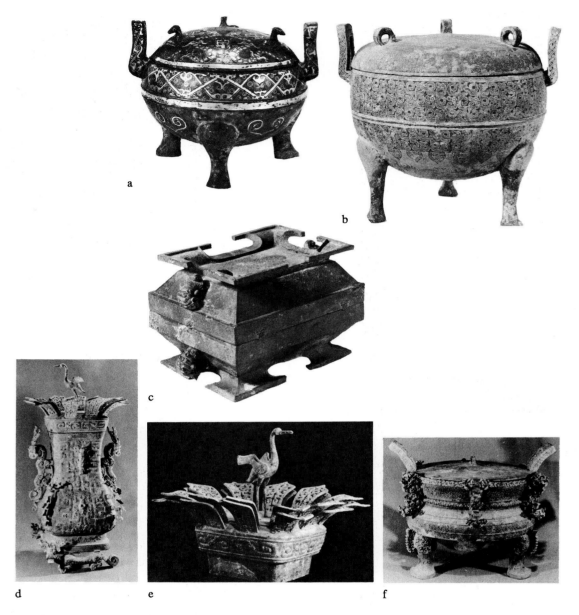

Figure 11.15 *a. Ding.* Bronze; silver inlay. Jin Cun style. Late Zhou (fifth to third century B.C.). H. 6". The Minneapolis Institute of Arts, Alfred Pillsbury bequest, 1950. *b. Ding.* Bronze. Liyou style. Late Zhou (fifth to third century B.C.). H. 8½". Stanford University Museum. Mr. and Mrs. Stewart M. Marshall. *c. Fu.* Bronze. Xinzheng style. Late Zhou (sixth to fourth century B.C.). H. 10". Asian Art Museum of San Francisco, the Avery Brundage Collection. *d. Hu.* Bronze. Excavated at Xinzheng (seventh to sixth century B.C.). H. 47". Henan Provincial Museum. *e.* Lid of *d. f. Ding.* Bronze. Excavated at Xiquan (eighth to fifth century B.C.). Henan Provincial Museum.

chologically. Shang animals had simply been placed next to each other on the vessel; they did not depict real animals in real space. These animals did not seem to be aware of each other; they did not react in any way to each other's presence.

The Eastern Zhou preference for intertwined animals was the first step in depicting actual relationships, which culminated in the hunting scenes: animal motifs were no longer isolated but became actively engaged, even to the point of fierce combat. From this early beginning the great pictorial tradition of Chinese painting gradually developed during the next fifteen hundred years to its zenith in the Sung dynasty.

During the Chou dynasty the art of China emerged from semibarbaric to civilized, from an exclusively graphic symbolism to a pictorial and narrative style;

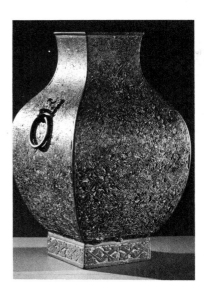

Figure 11.16 Square *Hu*. Bronze; malachite inlay. Late Zhou to Early Han (Zhou third century B.C.). H. 14½″. The University Museum, University of Pennsylvania.

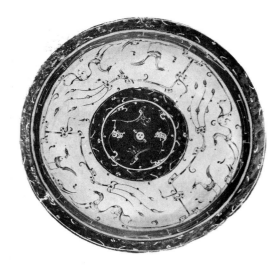

Figure 11.18 Bowl, Changsha. Wood painted with red and black lacquer. Late Zhou (fifth to third century B.C.). H. 10″. Seattle Art Museum, Eugene Fuller Memorial Collection.

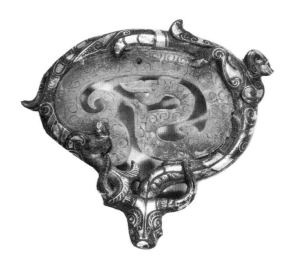

Figure 11.17 Buckle. Bronze; gold and silver inlay; jade center. Late Zhou (fifth to third century B.C.). H. 3¼″. Lucy Maud Buckingham Collection, 1930.703. Photograph © 1991, the Art Institute of Chicago. All rights reserved.

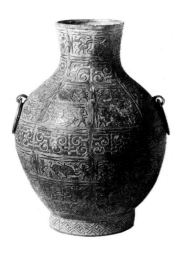

Figure 11.19 *Hu*. Bronze. Warring States (fifth to fourth century B.C.). H. 15½″. Asian Art Museum of San Francisco, the Avery Brundage Collection.

from an art motivated and prescribed by religious ritual to an art of playful inventiveness and rhythmic grace.

The political contentions of the Late Eastern Chou period were an expression of the general upheaval in moral and philosophical spheres. Old values were questioned and new systems were tried. Of the "Hundred Schools" of philosophy, two philosophers are of great importance for the later development of Chinese thought and art: Confucius (Kong Fuzi) and Lao Zi.

Confucius (ca. 550–478 B.C.) was concerned with human relations and the consequences of human acts. He was shocked by the irresponsibility characteristic of the philosophies of expediency, which made the end justify any means in political and moral matters. He defended a system of ethics in which moral responsibility of the strong for the weak, of the mature for the immature, was paramount. This became known as the

Five Relationships. These included the relationship between the ruler and the minister; between father and son; between husband and wife; between elder and younger brother; and between friend and friend. This philosophy of mutual responsibility and his ideal of the gentleman-scholar were written down by his students and passed on. **Confucianism** was an expression of such a profoundly Chinese attitude that it has remained the foundation of Chinese intellectual life and ethics to the present century. The Confucian system presented the Five Relationships as the basis for a moral society, upon which rested the stability and continuing welfare of life on earth.

Lao Zi (ca. 604 B.C.) was more concerned with the relationship of humans to the universe and formulated a philosophy called **Daoism.** The "Dao" (the Way) was the underlying principle that moved through all of nature and of which humans were but one manifestation. In Daoism the goal was to put oneself into harmony with this elemental force.

Daoism was a manifestation of the speculative, magical, and mystical aspects of Chinese life. Eventually it gave rise to such achievements as Chinese medicine, magic, and sorcery. In centuries to come it would be largely responsible for transforming Indian Buddhism into a Chinese religion (see chapter 13) and for the intense reverence for nature that inspired the rise of Chinese lanscape painting (see chapter 16).

Daoism and Confucianism have not only helped to determine Chinese culture, they are themselves expressions of it: on the one hand, the practical Confucian admiration of learning and social order and, on the other, the romantic Daoist desire to escape the milling life of the cities and return to the simple intuitive existence of the recluse in tune with nature and, through nature, with the Dao, that ultimate, ineffable mystery that is too vast to be encompassed and yet of which nothing is too small to partake.

SUMMARY

The Bronze Age in China encompassed the Shang and Zhou dynasties. The social and communal traits that had been evident in the Late Stone Age continued. People lived in small villages, hunted, and developed agriculture. But in the Early Shang dynasty large cities were built on a regular plan, surrounded by tamped earth walls. Within the outer wall was a central enclosure surrounded by a wooden stockade. Inside was a large building and several smaller ones. This was probably the palace. The earliest Chinese city we know is that at Erlitou. The common people probably did not live inside the city but only took refuge there during times of war.

The religion centered on the First Ancestor and the powers of nature. Sacrifices, both human and animal, were thought necessary to propitiate these invisible spirits. Such sacrifices required ritual objects of various kinds for acceptance by the deity. Many of these objects were various kinds of containers for food and wine; these were made of bronze, which was the precious metal of the day. At first these vessels were few in type and small in size, but by the time of the Late Shang, they had become numerous and larger. The vessels bear designs that are exclusively animal and may have had totemic and sympathic-magic associations. The Shang dynasty produced the finest bronzes of any Bronze Age in any region of the world.

When a Shang ruler died everything he had known in life was buried with him, including his wives and servants. A royal funeral, therefore, was a state occasion of great magnitude. Such tombs included animals, especially horses in full harness and hitched to chariots. Even the charioteer and his archer were buried to protect the dead leader.

Shang bronze technology was elaborate and required a large workforce. The transition from the Stone Age to the Bronze Age replaced stone weapons with armament of bronze. Subsequently, this was also true of farming implements. But the debt the Chinese people owed to their stone weapons and tools was not forgotten in the Bronze Age. These older types were transformed into symbols: extremely fine knife and spear-head shapes, hoes, and axe shapes were cut from very thin jade, then highly polished and often embellished with designs; these jade weapons were then presented to the various ranks of palace nobles as symbols of their rank.

After the Shang were conquered by the Zhou they apparently were allowed to go on living their own way of life. In fact, it seems probable that the Zhou had already become familiar with Shang ways before the conquest and had even produced bronze vessels resembling those of Shang. Within two or three generations after the conquest, the Late Shang style was replaced by a preference for simpler forms and designs.

In the eighth century B.C. the Zhou moved eastward to Luoyang because of barbarians on their western borders. The central authority of the Zhou monarch continued to decline until the Eastern Zhou states disintegrated into a period known aptly as the Warring States. Each of a dozen rulers established separate states and cities, where each carried out some of the sacrifices and therefore needed ritual bronzes of his own. This resulted in the great variety of styles found in this period. The theme that seems to run through them all in terms of design is that of animal combat, where serpent or feline forms writhe and attack in what appears to be a fight to the death. Rarely has art been such a

direct reflection of the political and military condition of the times.

Late Zhou bronzes share with other artifacts of the time a strongly rhythmical linearity of richly patterned surfaces, whether these are inlaid gold and silver and semiprecious stones on bronze, differing colored lacquer patterns painted on wooden objects, or elaborate patterns carried out in weaving or embroidery in textiles.

GLOSSARY

Adze A cutting tool that has a thin, arched blade set at right angles to the handle and is used chiefly for smoothing wood. (p. 95)

Anyang The last capital of the Shang dynasty in China established about 1300 B.C. (p. 95)

Confucianism Chinese philosophy formulated by Confucius based upon a system of ethics and moral responsibility. (p. 104)

Confucius (Kong Fuzi) Chinese philosopher who influenced the development of Chinese thought and culture, ca. 550–478 B.C. (p. 103)

Daoism Chinese philosophy formulated by Lao Zi holding that Dao is the underlying principle that moves through all of nature, with which humans must come into harmony. (p. 104)

Flange A vertical flat projection standing at a right angle to the surface of a bronze vessel. Derived from the flashing. (p. 95)

Flashing Molten bronze running out between sections of piece-mold where they come together in joints. (p. 95)

Gui A ceremonial vessel for holding food. (p. 100)

Lao Zi Chinese philosopher (perhaps legendary) who formulated the body of thought called Daoism, ca. 604 B.C. (p. 104)

Luoyang New capital established when Zhou moved from Changan eastward. (p. 104)

Oracle bone inscriptions Questions written on animal bones which were answered by applying heat and interpreting the resultant cracks. (p. 96)

Piece-mold method Casting method used by Chinese to make bronze vessels, with sectional molds assembled from many pieces. (p. 93)

Post and Lintel An architectural system in which timbers are set vertically (posts) to support horizontal timbers (lintels) which support the weight of the roof. (p. 92)

Rammed earth A construction technique by which the earth is packed into a wooden form and tamped with wooden tampers to make a very compact, hard, and enduring foundation for a building or a city wall. (p. 91)

Scapulimancy A Neolithic method of prognostication employed by the Late Shang Chinese shaman; applying heat to the shoulder blades (scapulae) of deer, tortoise, and cattle and receiving answers to questions according to the cracks that appeared. ca. thirteenth to eleventh century B.C. (p. 97)

Shaman A religious-magical practitioner who fulfilled a role very similar to that of the medicine man in native American cultures. (p. 93)

Split animal Shang Chinese animal mask design with the eyes protruding above the surface of the vessel and frequently having each half, right and left of center, visible separately as an animal seen from the side; taken together the two make up the full face, ca. seventeenth to eleventh century B.C. (p. 99)

Zhengzhou A major site of the Middle Shang culture; ancient China, seventeenth–ca. fourteenth century B.C. (p. 93)

12
· · · · ·

THE QIN AND HAN DYNASTIES
(221 B.C.–A.D. 220)

THE QIN DYNASTY (221–207 B.C.)

China's First Emperor

In 221 B.C. the state of Qin overthrew the last major contender of the Eastern Zhou conflict and brought the Warring States period to a close. The old state of Zhou had already been conquered by the Qin in 256 B.C. and Zhou and Qi had annexed, between them, all that remained, until finally Qin conquered Qi establishing the Qin dynasty. This enabled **King Cheng** of Qin to initiate a new era. For this he needed a new title, and he called himself the "First Emperor." From 221 B.C. King Cheng is known as Qin Shi Huang Di, the "August First Emperor of Qin." He was an egomaniac who tried to stamp out China's past so that its history might begin with his own reign. He burned the classical texts, which contained the bases of Chinese culture and history. He had scholars buried alive in the vain hope that no one would remain who could transmit pre-Qin history to posterity and thus expose his own actions. For two millenia he has been seen as a vicious, destructive tyrant, but China now sees him as its great unifier, the man who saved it from the internal conflicts of the Warring States, which his conquests brought to an end.

The dynasty that he foretold would last to ten thousand generations (that is, "Forever") in fact lasted fourteen years! But in his brief rule King Cheng seems to have overhauled almost every institution, to have questioned every belief, and in the end to have abandoned or destroyed most of them. He was efficient because he was ruthless; but he changed the history and culture of China.

Qin Art

In spite of Shi Huang Di's great destruction of tradition, it is ironic that the art of his dynasty, insofar as we know it, seems in large part to have emerged from the various styles of the Late Eastern Zhou centers in unbroken continuity. He interrupted China's history, but he apparently did not interrupt its art. One reason was perhaps that he needed the facilities of the workshops and the skills of the artisans in order to execute one great plan after another, which his erratic mind conceived.

Qin Shi Huang Di's Tomb

Seven hundred thousand workers, it is said, were occupied on Shi Huang Di's tomb alone. Our best information comes from China's first great historian, Sima Chien. His description of the tomb is mythic in conception and grandeur. Chien describes the tomb as a vast series of underground palaces and pavilions, a whole country complete with mountains and streams. The rivers, he said, were made of flowing mercury, which ran down to a mercury sea and returned by a complex series of water wheels and clockwork mechanisms to the hills to flow down again in a never-ending cycle. He described the oil lamps that lighted the palaces as supplied with enough oil to permit them to burn "forever." Everything the First Emperor would need or could desire in the next life (even his state officials) were buried with him. It is not clear whether these officials were in fact buried or whether they were represented only by votive images. But it is stated that Shi Huang Di's childless wives, along with other members of his household, were slain so that they might have the honor of accompanying him. When all was finished, even those who had made the final arrangements were themselves sealed within the tomb to become members of the entourage of the First Emperor "forever."

The tomb mound was enclosed by two walls laid out in a rectangular plan with the long axis running north and south (fig. 12.1). The outer wall is almost a mile and a half long and more than 3,000 feet from east to west. The inner wall is 1,900 feet from north to south and just over 2,000 feet long from east to west. The great mound of tamped earth rises over 140 feet above the ground and is almost 1,500 feet long on each side. It is pyramidal in form and invites comparison to the Great Pyramids in Egypt. It is about half the height but covers more than three times the area.

The entire plan resembles that of a walled palace precinct as first known from the Early Shang period at Erlitou. Historian Sima Chien's account, written about a century later, states that the tomb was robbed shortly after it was closed. The Chinese do not plan to excavate it in the foreseeable future.

The area around the tomb has yielded some surprises of its own. Outside the outer wall, about a mile to the east, a chance discovery in 1974 led to a glimpse of the reliability of Sima Chien's account, at least in terms of scale. In three ranks, standing as if ready to defend the tomb, an army of life-size pottery soldiers was found (fig. 12.2). It is estimated that there are perhaps over seven thousand figures in this pottery army. The personnel includes varying ranks and specialities. There are spearmen, archers, and cross-bowmen, as well as charioteers with four-horse chariots (figs. 12.3 and 12.4). The chariots, as well as the weapons, were real, but the wooden components had disintegrated, leaving only the metal fittings, together with the points and blades of weapons.

Each figure is individually modeled and appears to have individual features, as well as hairstyles, all showing a great deal of variety. The excavators say that

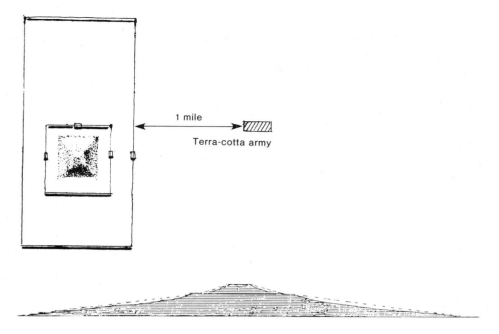

1 mile

Terra-cotta army

Figure 12.1 Tomb of Qin Shi Huang Di. Plan and elevation.
Lintong, Shenxi Province.

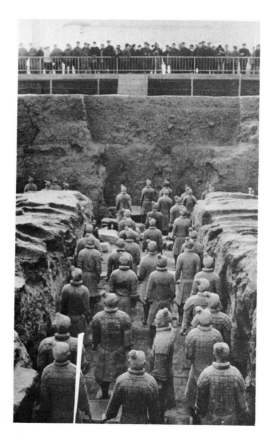

Figure 12.2 View of the terra-cotta warriors and horses unearthed in
the pit east of the tomb of Qin Shi Huang Di. Qin dynasty. Photo:
Shenxi Provincial Studio, courtesy of Museum of Qin Dynasty Terra-
cotta Warriors and Horses.

each face is different. These soldiers are not simple ge-
neric types. They are as individual as if each were pro-
duced from a different model posing for his portrait (fig.
12.5). One can hardly resist the conclusion that these
are indeed portraits of the members of the Imperial
Palace guard. It seems the models of the funeral sub-
stitutes of the Late Eastern Zhou states have been di-
vested of their stylization and have taken on a more
specific aspect. The funeral substitution practiced in
Zhou seems to have reached a fuller development in
Qin. It was to continue as a vital aspect of Han rep-
resentational styles also. Perhaps the impetus came
from the need to incorporate the spirit of the subject
in the substitute object so as to insure its proper func-
tion when it came to life in the hereafter. A general
representation could only be expected to be generally
functional; a specific representation would obviously
serve better because it would function specifically.

In 1981 two four-horse chariot groups of cast
bronze were found to the west of the tomb mound. These
figures are about half lifesize; it is very possible that
others may be discovered later.

Technical questions regarding the production of Shi
Huang Di's "army" remain open. Where and even how
they were made cannot be stated with certainty. The
legs of the figures are solid, but the bodies are hollow,
about one and one-half inches thick. This means that
they required long, gradual heating before reaching
maximum kiln temperature, and that this temperature

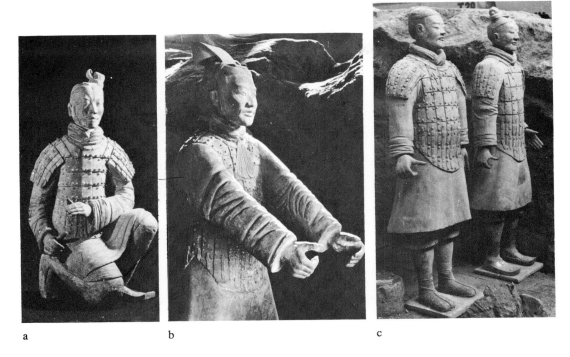

a b c

Figure 12.3 *a.* Kneeling crossbowman. *b.* Standing charioteer. *c.* Pair of standing spearmen. Qin dynasty. Photos: Shenxi Provincial Studio, courtesy of Museum of Qin Dynasty Terra-cotta Warriors and Horses.

must have been fairly low. Otherwise the great variation in clay thicknesses would have caused them to crack. The figures were probably produced locally in workshops and kilns set up on the spot for this great task. It is very unlikely that they would have been transported any great distances, since this would have been obviously impractical. The Chinese are characterized throughout their history by an instinct for technical logic and practicality.

The Great Wall

Shi Huang Di's tomb was but one of the fantastic schemes conceived on a colossal scale by the First Emperor. Perhaps his best known was the idea of building a wall to protect his country from the barbarians to the north. It is known to us as the **Great Wall.** The Great Wall was begun in 214 B.C. and probably extended about fifteen hundred miles. It has been renovated since, but probably it consisted at the time of a series of walls, less imposing than the structure we know today, built to link and protect the numerous outposts on China's northern border. It has the dual quality of controlling rebels within as well as barbarians outside the country. More hundreds of thousands were said to have been pressed into service on this vast project. Service on the

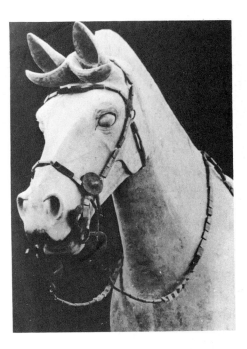

Figure 12.4 Horse. Pottery. Life size, with original bronze fittings re-assembled on leather bridle. Photo: Shenxi Provincial Studio, courtesy of Museum of Qin Dynasty Terra-cotta Warriors and Horses.

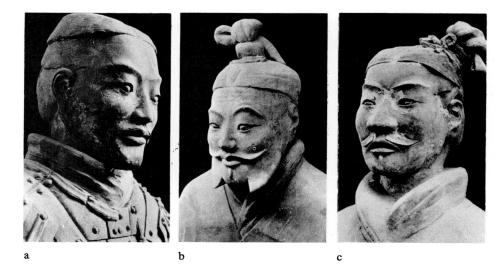

a b c

Figure 12.5 Heads of warriors showing individual features. Pottery with traces of pigment. Life size. Photo: Shenxi Provincial Studio, courtesy of Museum of Qin Dynasty Terra-cotta Warriors and Horses.

Great Wall was tantamount to a death sentence. It has been said that every foot of its length represents the death of a worker. Others have said that every brick in it is a gravestone. It was customary to bury the workers, as they died, in the rubble that formed the interior mass of the wall.

The Qin Capital

The remains of the Qin capital have been discovered and partially excavated just west of modern Xi-an, the present capital of Shenxi Province. One of Shi Huang Di's idiosyncracies included establishing a kind of outdoor "trophy room," again on an immense scale. The residences and palaces of the rulers of the states he had conquered were duplicated in the hills north of his capital overlooking the Wei River valley. A recent survey indicated that the ruins of these palaces cover an area seven miles in length from east to west! To these new dwellings he had the surviving members of noble families forcibly removed from their Eastern Zhou capitals in East China. Over one hundred thousand families were resettled here, where they would be a lesser threat and he could keep an eye on them. The First Emperor did indeed think big!

Qin Dynasty Falls

The emperor decided that an even larger complex should be erected to the south of the Wei River. This project was initiated two years before he died in 210 B.C. His death did not end this scheme, and his heir's stubborn refusal to discontinue the project was interpreted as a sure sign that heaven must have abandoned

the house of Qin. Terrible portents, which arose in the form of flood and famine, sealed the fate of the Qin dynasty. The Chinese believed that the mandate of heaven had been removed from the house of Qin following a general revolution and that it had come to rest upon a commoner, Liu Bang, a general who had been so valorous and effective in the civil war that upon the battlefield his fellow generals elected him their emperor.

The Han Dynasty (206 B.C.–A.D. 220)

The national unity gained at such terrible cost under the Qin was retained by the Han dynasty. Liu Bang used a different strategy to keep the various lords from rebelling. Instead of housing them nearby, he separated them far from each other, making communication between them difficult. Banishment, particularly to the hot and humid south, and other forms of punishment as well as frequent visits of inspection kept the country fairly peaceful within. The classics were rewritten, largely from memory, and, ironically, the break with tradition had permitted both Confucianism and Daoism to flourish. The former gained political support at court and the latter developed into an amalgamation of philosophy, science, and mythology.

Trade and Expansion

Territorial expansion brought the Han Empire into contact with more of Asia than China had previously known. Through the **Silk Route,** connecting China with

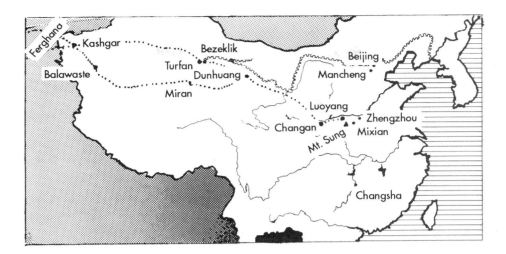

Figure 12.6 Central Asian oases of the Silk Route. Han and later.

the Middle East, and eventually with Rome, contact was made with cultures the Shang and Early Zhou had never even heard of (fig. 12.6). Territorial expansion also brought commodities from subject border regions, changing the standard of living of the noble classes to include more exotic products than had previously been available. Trade also began to encourage and to enrich a significantly large merchant class.

Much of the stability that made this possible was due to the First Emperor of Qin, who had bequeathed many of his patterns of standardization to the Han. For centuries to come his standards of weights and measures, of coinage, and even the standardization of the written language undertaken during his rule remained the basis for administrative and operational systems required for efficiently ruling a great empire.

The martial emperor, Han Wu Di (141–87 B.C.) followed the lead of the Qin in expanding and consolidating Chinese domination of North Vietnam, and in 108 B.C., at the other end of his empire, he established a Chinese outpost and trading colony at Lolang, in Korea.

The Xiongnu remained a threat in the northwest. Zhang Chien, whom WuDi had sent to make an alliance against them with their old enemy, the Yuezhi, finally returned after having been detained in Yuezhi territory for fourteen years. He had made no treaty with them, because they had moved far from the borders of China across central Asia and had settled in the region of Ferghana in South Russia, north of Afghanistan, out of danger from the Xiongnu. But Zhang Chien had found the source of the wonderful horses responsible for the superiority of Xiongnu cavalry. These fleet, strong, and agile steeds, far superior to the primitive small ponies of China, were found wild in Ferghana. In

52 B.C. the Chinese finally vanquished the Xiongnu and moved on westward to acquire Ferghana ten years later. This provided an assured supply of horses, which joined silk as a primary commodity of Silk Route trade. The Han Empire had stretched a long arm westward to come into contact with the Persian and Indian realms of influence (fig. 12.6).

Tombs

Shaft Tombs

The tombs of the Han dynasty were of two kinds. The earlier tombs and those farther from the capital, followed the late Zhou form and are known as **shaft tombs,** because they were essentially a vertical pit at the bottom of which the wooden coffin chamber was constructed, often one inside another in the manner of nested boxes. The innermost of these contained wider spaces in which the artifacts were placed. Another series of nested, boxlike coffins were then lowered into place at the center of this arrangement, and the outer lids were put in place. The inner coffins were sometimes elaborately painted in colored lacquers. **Lacquer** is tree sap colored by adding finely ground minerals. The trees were native to South China.

At Mawangdui, near Changsha in Hunan Province, a Western Han tomb of about 180 B.C. was discovered in 1971. It is the burial place of the wife of the Marquis of Dai; nearby her husband's and son's tombs were also excavated. The materials from these tombs show a remarkable state of preservation. Even the body of the Lady Dai was in such an extraordinary state that it was reported that the condition of one of her femoral

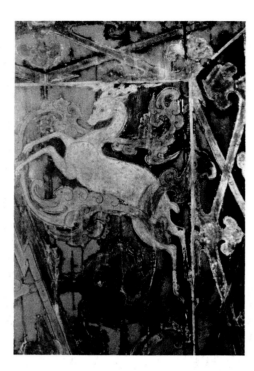

Figure 12.7 Design from the second of three nested coffins. Tomb of Lady Dai. End view, upper right corner detail. Wood painted in colored lacquers on red lacquer background. Mawangdui Museum, Changsha. Hunan Province. Photo: author.

arteries was that of a person dead no longer than forty-eight hours. The silks and lacquered wooden dishes and objects look brand new, while even remains of food may still be identified. Plums, pears, and other foods were set out in bowls and on plates of red and black lacquer. Her three coffins were painted with designs reminiscent of Late Zhou styles, in various hues with red, black, green, white, and yellow predominating and some blue in smaller areas (fig. 12.7). During the Western Han period factories were set up to produce lacquered ware for export as well as for home use. At the Lolang colony in Korea several pieces have been found with inscriptions indicating who was responsible for each phase of the production. In some cases as many as thirteen people were involved in making a small wine cup.

The silks of the Dai tomb are exquisitely made. Some were embroidered with bright colors while others had designs of cloud patterns or lozenge shapes woven into them. They are as perfectly and beautifully made as any modern textiles. Some of the weaving is so fine that the material is transparent. For her burial the lady Dai was dressed in more than a dozen layers of silk robes of different colors and patterns.

Chambered Tombs (Palaces and Villas)

The second type of Western Han tomb seems to have been influenced by that of Qin Shi Huang Di. The largest is that of Han Wu Di (140–87 B.C.), which took fifty-three years to complete. It stands today about ten feet higher than that of Shi Huang Di but covers only one-fourth the area. Like that of the First Emperor, the tomb mound is tamped earth in pyramidal shape. Tamped earth was a method of compacting the soil by tamping it down with wooden tampers. This method was used in Shang for building foundations and walls. One can only speculate, of course, but where did they obtain so much dirt? If it represents the volume displaced in making the tombs they must be on a vast scale indeed. Like Qin's, Han Wu Di's is said to be an underground palace. This idea of providing both a home and burial objects for the deceased became the standard and continued into succeeding centuries. It is said that Han Wu Di's tomb was so packed with luxurious and extravagantly expensive objects that on the day his coffin was carried in, there was no room for more grave goods to be added.

Funerary Objects

At Mancheng, about ninety miles southwest of Beijing, two more undisturbed Western Han tombs were discovered in 1968. They are those of the Prince Liu Sheng and of his wife Dou Wan. The prince died in 113 B.C. and his wife some years later. The tombs are near but do not connect with each other. Although carved into the face of a small stone mountain, the interiors were chambered, and the roofs were either carved in stone or supported by actual wood pillars and beams.

These tombs were provided with almost three thousand objects. Some of the bronze vessels follow the style of Eastern Zhou, with designs inlaid in gold and silver, but many are in the plainer manner that became standard for the later part of Western Han and for Eastern Han.

A few bronze objects were made in the form of animals and human figures. They exhibit the same interest in specific representation we have already seen in the pottery soldiers of Qin Shi Huang Di, but they are slightly more formal and reserved in their realism, perhaps due to the difference in materials.

The most surprising objects found here were the two burial suits of the prince and princess. Each was made of more than two thousand small, rectangular green jade plaques fastened together with gold cord passed through holes drilled through their corners. References to "jade clothing" had been known from

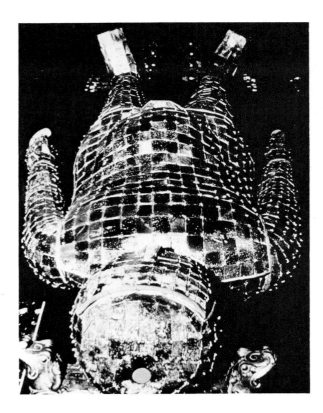

Figure 12.8 Burial suit of Liu Sheng. Green jade with gold cord fastenings. Excavated at Tomb of Liu Sheng, Mancheng, Hebei Province. Photo: MacQuitty International Collection.

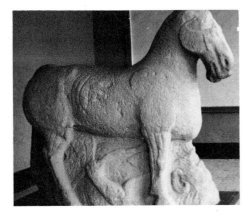

a

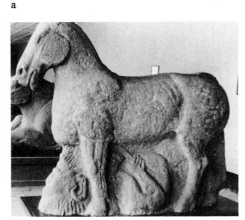

b

Figure 12.9 *a* and *b*. Two views of horse from the tomb mound of He Qubing, near Xi-an, Shenxi Province. Western Han. (The animals from the tomb mound had been removed and housed in two temporary shelters when these photographs were taken.) Photo: author.

literary sources, but these were the first actual examples to be excavated. These suits were meant to preserve the bodies of their wearers. Both jade and gold were thought to have this power (fig. 12.8).

Animal Sculptures Adorn He's Tomb

The Zhou had moved from Changan eastward to Loyang in 771 B.C. because of the pressures from the Xiongnu to the west. The Han deliberately chose Changan as their capital in the hope of keeping their enemies at bay. Han Wu Di sent a brilliant eighteen-year-old general, He Qubing (140–117 B.C.), against them less than five years after the failure of Zhang Chien to conclude an alliance against them with the Yuezhi. After six expeditions He died at age twenty-four and was brought back to Changan for burial. Because he was a personal favorite, the emperor had a unique tomb made for him near his own. Instead of the usual pyramidal shape, the tomb mound was made into a mountain form in memory of He's victories at Mt. Qilian in Gansu Province. Large granite boulders were brought back from there and were placed upon the

mound in a natural way. Fourteen of them were carved into animal forms. One is a horse standing over a non-Chinese figure; this may represent a Xiongnu warrior (fig. 12.9). It was said that He learned that the barbarians trained their horses to stand over their fallen riders to protect them; this sculpture may memorialize such loyalty. The horse is not trampling but standing perfectly still, all feet on the ground. The horse appears to be the central Asian type, while two other sculptures appear to be of the same kind (fig. 12.10). He must certainly have been impressed with these animals and probably had told the emperor more than once that the combat proficiency of the Xiongnu lay in the superiority of their stock.

The other sculptures, a tiger, wild boar, frog, and two fish, may represent fauna of Mt. Qilian or they may be symbolic (fig. 12.11). A baby elephant may refer to

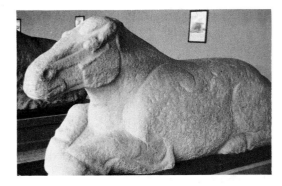

a

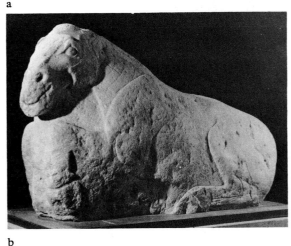

b

Figure 12.10 *a* and *b*. Rising horses. Stone. Life size. From the tomb mound of He Qubing. Photo: author.

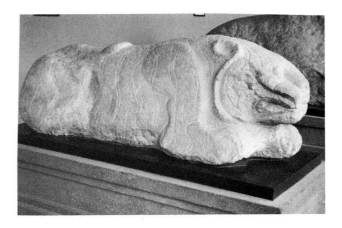

Figure 12.11 Tiger. Stone. Life size. From the tomb mound of He Qubing. Photo: author.

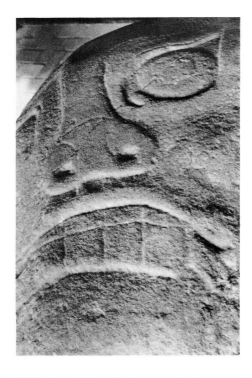

Figure 12.12 Detail of face of anthropomorphic figure from the tomb mound of He Qubing. Photo: author.

one in the royal menagerie. A reclining water buffalo can hardly have been associated with the mountains of dusty Gansu and is more difficult to explain. There are two other massive stones that are even more puzzling; one may be a human or anthropomorphic spirit (fig. 12.12) and another may be a man or ogre wrestling with a bear. The two latter could well have been stones that were already of special significance to the Xiongnu, perhaps marking sacred sites captured by He, and brought back as trophies.

The whole effect of the tomb must have been very close to that of the incense burners of the **boshan lu** type, with rising peaks and animal sculptures placed among them, a new idea in Western Han. The animals of the tomb are simple and some appear to be unfinished; the carving of the stone is minimal. They are impressive, either because stones chosen already resembled the subjects, or because the sculptor studied the stones until he began to "see" the form within. In their primal relationship to the matrix these sculptures appear less sophisticated than the few smaller sculptures in stone that we have from that period.

When compared to the pottery horses of the tomb of Qin Shi Huang Di, it is clear that these stem from a different impulse. He's seem awkward and not fully realized, but in their suggestion of massive power and innate spirit they rank among the most impressive animal sculptures China has produced. There is a haunting quality about them that arises from the union of natural stone and a human's simple but sensitive modification of that material. These sculptures reveal

an almost forgotten tradition—one that reaches back beyond the Neolithic to a time when humans first began to develop the faculty of imaginative vision, the ability to "see" what is not entirely there, to fill in the gaps of a partial pattern to complete it in the mind. This is the activity (which we sometimes call "daydreaming") that permits us to see sheep in clouds and landscapes on water-stained walls. The delicate balance among idea, material, and form is nowhere better exemplified in Chinese art than here.

The difference in style among the pieces might result from the fact that some may have been moved as already existing, while others may have been made specifically for the tomb mound. One cannot overlook the striking similarity of the eyes of the human figure (fig. 12.12) and those of Late Shang such as found in bronze designs from Anyang (fig. 11.11).

The Later Han

The continuity of the Han dynasty was briefly interrupted in A.D. 8, when Wang Mang usurped the power, but unity was again restored in A.D. 25. As a result the capital was moved from Changan in the west to Luoyang eastward down the Yellow River valley, following the pattern of the move of the Western and Eastern Zhou capitals. The period from A.D. 25–220 is called the Later Han or Eastern Han. As the Chou change of capitals presaged the disintegration of unified control by the throne, so in the Eastern Han there was an increasing difficulty in maintaining centralized control. One reason was that the territorial expansion of Han required more or less constant border police action, and the maintenance of the large military machine became an increasing drain on resources.

Eastern Han tombs continued the chambered style that had been established in the Western Han and that probably was inspired by that of Qin Shi Huang Di. The mounds are generally modest in size, and certainly none can compete with that of Han Wu Di, but the interiors tended to be more elaborate than those of Western Han. The number of chambers increased so that the tombs closely resembled the Eastern Han houses of the living, with rooms set aside for the various activities of a well-regulated household.

Zhang's Tomb

The tombs of Zhang Boya and his wife at Mi Xian, in Henan Province, excavated in 1960–61, are elaborated into six separate rooms, besides an entry hall and vestibule (fig. 12.13). Both tombs lie about twenty-five feet underground and are covered with small mounds rising above ground to about the same height. The tombs were

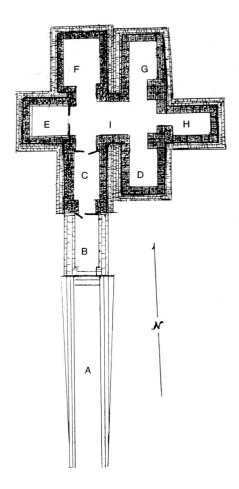

Figure 12.13 Tomb of Zhang Boya. Plan. Eastern Han. Mi Xien, Henan Province. *a.* ramp; *b.* entrance; *c.* vestibule; *d.* carriage hall; *e.* hall of sacrifice; *f.* burial chamber; *g.* food preparation hall; *h.* banquet hall; *i.* central hall.

robbed in the Song dynasty, so that interest lies not in their furnishings but rather in their structure and adornments in the form of murals. Zhang was a territorial governor of western Honan, and thus these tombs are indicative of the quality of upper-level bureaucracy rather than of the nobility. Excluding the entry stairs, each tomb is about thirty by forty feet, with ceilings from about ten to twenty feet high. The entrances are on the south, as they would be in a residence. Zhang's tomb is constructed of stones some three feet thick, while that of his wife's is of brick. The lower half of most rooms in Zhang's tomb are faced with black limestone slabs that have been very lightly engraved with plain, smooth figures against a slightly sunken background.

After descending the stairs and entering the first stone doorway (fig. 12.14) into the first room (fig. 12.13a,c), with its murals depicting guests being greeted (fig. 12.15), one continues through the second doorway

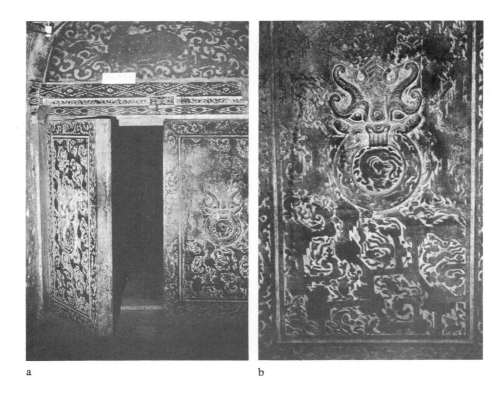

a b

Figure 12.14 *a.* Tomb of Zhang Boya, entry. *b.* Detail of door.
Black limestone. Photos: author.

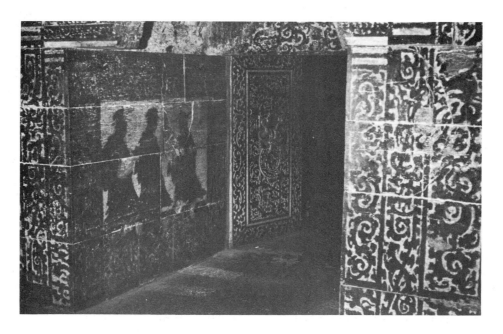

Figure 12.15 Tomb of Zhang Boya. Vestibule. Murals depicting
greeting of guests. Photo: author.

and enters the central hall, which extends westward into a long alcove, where there was a sacrificial altar. At the other end of the hall an alcove extended eastward, with murals showing scenes of food preparation (figs. 12.13*g* and 12.16). This represented the kitchen. Between the kitchen and the entry room, in an alcove extending to

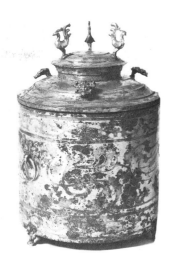

Figure 12.17 *Lien.* Gilt bronze. Late Zhou to Early Han (third to first century B.C.). H. 11″. Asian Art Museum of San Francisco, the Avery Brundage Collection.

Figure 12.16 Tomb of Zhang Boya. Chamber with mural depicting the preparation and cooking of food. Photo: author.

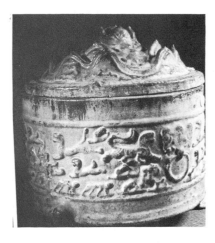

Figure 12.18 *Lien.* Green-glazed pottery. Cover in form of sacred Daoist Mountain, Penglai. Han (206 B.C.–A.D. 220). H. 10″. Asian Art Museum of San Francisco, the Avery Brundage Collection.

the south and parallel to it, chariots and resting horses are depicted (fig. 12.13*b*); this represents the courtyard, which would be located in front of a Han villa. Opposite this room (fig. 12.13*h*), on the north side of the central hall, is the dining room, where murals show a feast in progress, accompanied by various musical entertainments. Parallel to this room and extending off the central hall to the north, opposite the entry doors, is the chamber where the coffin was placed (fig. 12.13*f*).

The ceiling of the central hall is arched, while those of the other rooms are flat. The central hall and ceilings were originally covered with wood, which has disappeared, leaving the rough stone exposed. Neither the sacrificial room nor the coffin room have stone murals. They were presumably covered entirely in wood. The entire interior was undoubtedly painted. Though the remaining murals of Zhang's tomb are cut into stone, they are too shallow to be called reliefs and are in fact the base for painting rather than sculpture.

Stone doors probably separated the four side rooms from the central hall, just as the stone doors separate the entry way and first room. One might expect religious subject matter in the murals, so the scenes from daily life may seem strangely out of place until we recall that from earliest times the Chinese had envisioned life after death as a continuation of what the deceased had known in this life. Entertaining guests at lavish feasts has continued through the centuries to be the epitome of Chinese social life.

Bronze and Pottery Objects

During the Han the simpler shapes of the bronze vessels of the last years of Zhou continued to be preferred, particularly the large jars and the cylindrical covered containers (fig. 12.17), which became standard forms for both metal and pottery vessels. Confucian subjects of ethical virtue and Daoist folklore replaced the complex abstractions of Late Zhou designs (fig. 12.18). Some bronzes were gilded but most were plain, depending upon the simple horizontal bands and the small animal mask ring-handles to relieve the surface monotony.

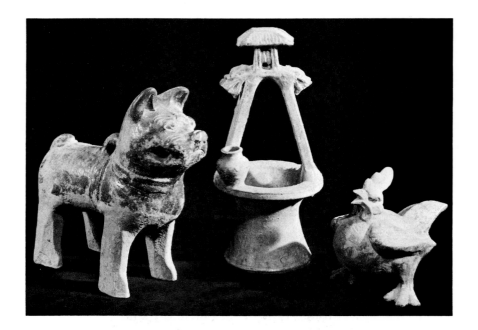

Figure 12.19 Dog, well, and rooster. Glazed pottery. Han (206 B.C.–A.D. 220). H. (of well) 15″. Stanford University Museum, Mortimer C. Leventritt.

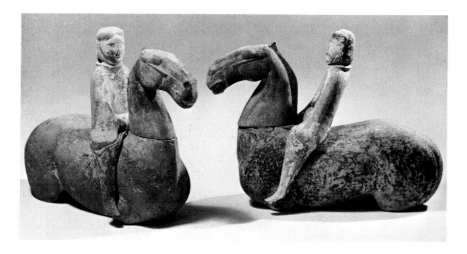

Figure 12.20 Horses and riders. Unglazed pottery; traces of pigment. Late Han (third century A.D.). H. 12½″. Stanford University Museum, Mortimer C. Leventritt.

Many pottery vessels were glazed. The colors ranged only from a dark green to an olive-brown. Some have become iridescent and their surfaces now have a mother-of-pearl luster, caused by age and burial.

Funerary objects from Han tombs indicate the same preference for simple shape that we have seen in the vessels. Thousands of pottery figures of animals and people, as well as houses, stoves, and barnyards complete with geese and pigs, have come from Han tombs (fig. 12.19). They vary greatly in quality; most were mass-produced in moulds. They were glazed or left unglazed and then painted (fig. 12.20).

The ideal of domestic familial contentment, supported by Confucian ethics and interwoven with the

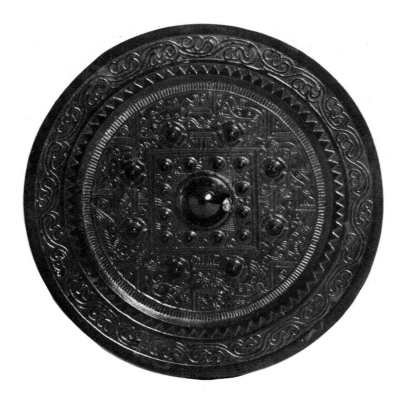

Figure 12.21 "TLV" Mirror. Bronze. Han (206 B.C.–A.D. 220). D. 6⅞". Asian Art Museum of San Francisco, the Avery Brundage Collection.

fabulous spirits and fantastic animals of Daoism, which we sense in the funerary arts of Han, remained the ideal. Life here and now was the concern, and life after death could be imagined in no better terms than those that the contented member of a good family had enjoyed among the living.

Cosmic Mirrors

The circular bronze mirrors, which had come into use in the Eastern Chou, during Han acquired a cosmological symbolism that sums up the Chinese world view. These **cosmic mirrors** have smoothly polished fronts; their reverses carry low-relief designs of various kinds (fig. 12.21). The type that seems most complete in its symbolism is called "TLV" after the small parts of the design that resemble these letters.

In the center of the back is a round knob representing the center of China, the "Middle Kingdom" of earth. From this center an invisible axis was thought to extend upward to the pole star, the "center" of heaven. The concepts symbolized in such mirrors were to remain as major aspects of Chinese cosmology until the twentieth century. The Imperial City in Beijing, established in the early fifteenth century, is sometimes

referred to as the "Purple City" because of a corruption of the reference to it as the "Polar City" (the sound for purple and polar sound very much alike in Chinese). The city was called this because it was the earthly center tied to the heavenly center by the axis mentioned. China is represented on the mirror back by the large square and heaven by the larger circle outside it. Between circle and square are the four gateways (the "T"s), one for each cardinal direction. Beyond are the animals of the Four Directions: south, red bird; west, white tiger; north, black warrior (tortoise entwined by snake); east, azure dragon.

These animals were also associated with the times of the year and with natural elements so that the full correlation runs as follows:

South	West	North	East
red bird	white tiger	black warrior	azure dragon
summer	fall	winter	spring
fire	metal	ice	wood

The idea of winter is equated with hibernation, darkness, and inactivity; summer is equated with light and action; spring and fall come between, with spring partaking more of light and growth and fall associated with darkness and decline. It can be seen that the

Chinese thought in terms of duality, which they had observed in action in the cyclical repetition of the seasons.

This duality they termed **yin and yang.** Yin is the principle of darkness, dampness, softness, passiveness; yang is the principle of brightness, dryness, hardness, action. The interplay of these principles determined the character of all things; and they were in a continuous state of waxing and waning throughout the hours of the day as well as the seasons of the year. These unseen forces never ceased their activity. As the yin principle waxed stronger, the yang waned; but when either was in total power the other began to ascend. Impermanence, or at least a continuous state of change, was the character of the universe as the Chinese saw it. The mirrors were miniature replicas of the ideal world (not the geographic) and were probably used by Daoist practitioners in rituals that attempted to control, or at least foretell, future events. Such mirrors were placed in the coffin, usually on the chest, in the hope of bringing the deceased into ultimate harmony with the celestial world, with heaven, and with the ancestors into whose world he or she had departed.

SUMMARY

The Qin dynasty destroyed much of China's culture and tradition under the Emperor Qin Shi Huang Di, who wished to start Chinese history with his own reign by destroying everything that had gone before. His vast schemes were often constructive as well as destructive, however. For example, he has left us the Great Wall and his own immense tomb. One of the most exciting archaeological events of the twentieth century was the discovery of the buried army to the east of his tomb, where it is estimated that more than seventy-five hundred life-size figures of soldiers and horses made of baked clay were placed in underground vaults, evidently to protect the emperor in his next life. The realism of these figures is amazing and marks a departure from the more abstract treatment of human figures in the preceding Zhou dynasty.

During the Han dynasty, which overcame the Qin, this sense of realism continued to be favored, and therefore Han tombs have revealed a great variety of human figures as well as animals and whole village and farmyard scenes apparently associated with the well-being of the deceased.

Recent discoveries of tombs of the Western Han dynasty have expanded our knowledge of the arts of this era. The Changsha tombs have furnished perfectly preserved examples of lacquer and silk, while the tombs of Liu Sheng and Dou Wan have given us the remarkable jade burial suits, as well as hundreds of elaborate and beautiful vessels and decorative artifacts.

The forms of the tombs changed during the Han dynasty. Those of the Changsha area were pit or shaft tombs, but the tombs of Mi Xien imitate domestic architecture. One of the most unusual Han tomb mounds is the tomb of He Qubing, which was formed with large boulders and great stone sculptures of various animals, both wild and domestic.

The arts of the Han favored smooth surfaces, but this preference seems to have had difficulty in asserting itself because of the strength of the heritage of the Late Zhou heritage.

GLOSSARY

Boshan lu Incense burners in the form of the cosmic mountain; Early Han, China ca. 206 B.C.–A.D. 8. (p. 114)

Chamber tombs Tombs imitating terrestrial architecture in diminished size. Several chambers with painted walls, often alluding to the various functions of domestic architecture of the imperial or wealthy classes. (p. 112)

Cosmic mirrors Circular bronze mirrors that came into use in China during the Eastern Chou period and acquired a cosmological symbolism during the Han period; miniature replicas of the ideal world; 206 B.C.–A.D. 220. (p. 119)

The Great Wall The wall begun in 214 B.C. by Qin Shi Huang Di, to protect China from invasions by barbarians to the north. (p. 109)

King Cheng The king of Qin, who took the title Qin, Shi Huang Di in 221 B.C. (p. 107)

Lacquer The sap of a tree native to South China colored by adding finely ground minerals. (p. 111)

Shaft tombs Essentially a vertical pit at the bottom of which a wooden coffin chamber was constructed, often one inside another in the manner of nested boxes, Late Zhou and Western Han, China ca. 200 B.C. (p. 111)

Silk Route Major trade route connecting China, the Mid-East, and Rome. (p. 110)

Yin and Yang Representation of Chinese duality; yin was the principle of darkness, dampness, softness, and passiveness; yang symbolized brightness, dryness, hardness, and action. (p. 120)

13

THE BUDDHIST IMPACT ON CHINA
The Six Dynasties and Northern Wei
(Third to Sixth Century A.D.*)*

More than two dozen minor dynasties ruled parts of China for short periods during the three and one-half centuries between the fall of the Han and reunification under the Sui dynasty (A.D. 581–618); for the sake of simplicity the period is usually referred to as the **Six Dynasties** (A.D. 220–589) in the south and the **Northern Wei** (A.D. 386–535). The Northern Wei was founded by non-Chinese, the Toba Tartars, who had fled into North China to escape the Xiongnu (Huns). The Wei established their capital at Pingcheng (present day Datung) in Shanxi and rapidly adopted Chinese customs and systems.

The collapse of the Han had seriously damaged Confucian prestige, since the government that it supported had failed to avert the chaos of the times. The people began to look more favorably upon Daoism, which offered emotional and metaphysical escape from, if not answers to, the problems of life in a disrupted world. Concern with daily life was overshadowed by the relation of humans to the universe. Without this shift in orientation the stage would not have been so well set for the advances of Buddhism.

BUDDHIST BEGINNINGS IN CHINA

According to tradition, Buddhism was introduced into China in the tenth year of the reign of Han Ming Di (A.D. 58–75) after a dream he had had two years earlier, in which he saw a golden man flying into the palace. On being told by his advisors that there was a wonderful Golden Man in the west who taught a new doctrine, he sent two emissaries from Luoyang westward in search. They followed the Silk Route into Central Asia, where they encountered two Indian monks, Dharmaraksha and Kashyapa Matanga, who offered to come to Luoyang to explain the Buddha's Law to the emperor. They brought with them **sutras,** the Buddhist scripture, and images carried on a white horse.

The emperor had a monastery temple built for them outside of Luoyang to the east. In honor of the white horse that had borne the sacred books on his back, the temple was called the White Horse Temple. Tradition holds that the emperor gave over a guest house (probably a caravanserai) for the temple and modifications were made to suit. The surrounding wall is probably derived both from palatial and guest house styles. In a caravanserai this was essential for the protection and corralling of the animals.

Although the original edifices are gone (the present buildings date from A.D. 1556), some remembrance of their plan is undoubtedly retained in the arrangement we know. The buildings are placed along a north-south axis that is longer than the width of the precinct from east to west, while the main buildings follow one another in line on the axis, and the minor structures are distributed symmetrically on either side along its length (fig. 13.1). The main buildings are enclosed in courtyards. These characteristics are to be found in succeeding Buddhist temples erected in China, Korea, and Japan. Presumably they are traceable back to the White Horse Temple and to Han palace architecture.

Of even greater interest are the burial mounds built for the Indian monks, located in the entrance courtyard, one on either side to the east and west. They are hemispherical mounds partly faced with stone, closely resembling the Indian Buddhist stupa of the period (fig. 13.2). These stupa-like tombs, as well as the fact that the "Sutra in Forty-seven Parts," which the monks brought with them, is known to have been translated into Chinese by at least as early as the second century A.D., seem to confer upon the White Horse Temple the honor of being the first Buddhist temple built in China. It is also significant that no other temple claims the honor.

Indian emissaries probably arrived at the Qin court in 217 B.C., during the Maurya dynasty (322–185 B.C.). Buddhist monks may have been among them, particularly in view of the strongly evangelical impetus given by Ashoka, and his expressed desire that Buddhism be preached in all parts of the world. The likelihood of such a mission is perhaps confirmed by the Indian reference to the people of Qin—the Indian pronunciation producing the word, *China,* the name by which the Middle Kingdom is known to us today. The Chinese, however, despising the Qin tyranny, preferred to call themselves the men of Han.

In any case it is clear that Buddhism was present in small monastic communities during the Han dynasty but did not become a significant force until the establishment of the Northern Wei dynasty. The Wei, like the Kushans, promulgated Buddhism, and the people found it to be full of promise.

BUDDHIST ART

Buddhist Images

Buddhist art before the Wei dynasty is all but unknown. The little that did exist was destroyed in later persecutions instigated against this foreign religion. Kushan influence is evident in the few remaining bronze sculptures of the fourth century. The earliest dated Chinese Buddhist image is a gilt bronze seated Buddha, dated by inscription to the year A.D. 338 (fig. 13.3). It is a somewhat simplified version of the Gandhara style as practiced at Bamiyan, Afghanistan, a flourishing oasis junction of the Silk Route, from China across Central Asia, with the caravan route from India.

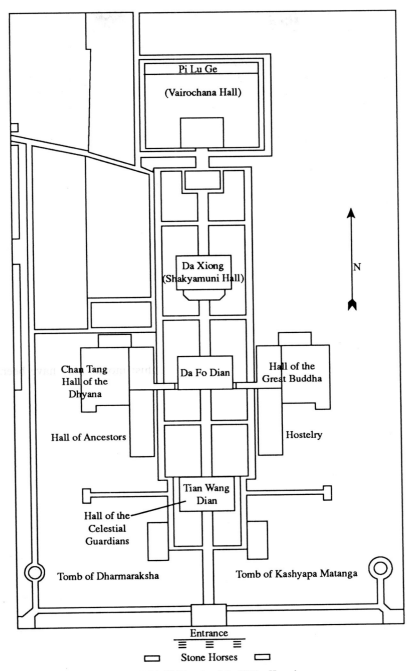

BAI MA SI (Temple of the White Horse)

Figure 13.1 White Horse Temple, Luoyang. Traditionally founded
A.D. 68, reconstructed A.D. 1556, in 1935, and after the Cultural
Revolution, in 1980. Schematic drawing (halls enlarged and walls
diminished; not to scale).

Figure 13.2 Tomb of Dharmaraksha (Zu Falan) at the White Horse Temple, Old Luoyang, Henan Province. Broken line shows height of mound today. Photo: author.

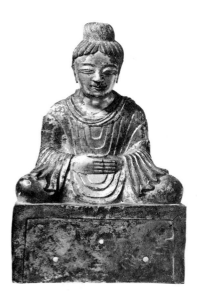

Figure 13.3 Seated Buddha. Gilt bronze. Inscribed and dated A.D. 338. H. 15½″. Asian Art Museum of San Francisco, the Avery Brundage Collection.

It has been estimated that by A.D. 400 nine-tenths of the North Chinese had accepted Buddhism. Monasteries and temples were established in increasing numbers, many under imperial patronage.

One of the most disastrous persecutions of Buddhism was undertaken by a Wei ruler in A.D. 444. When his grandson came to the throne (A.D. 452), he began to make amends for his grandfather's acts. Just ten miles west of the capital, at the site called Yungang, a series of cave temples were begun. They were carved into the face of a long cliff after the Indian manner of monastic rock-cut establishments. Begun in A.D. 460, twenty large and about the same number of smaller caves were carved out, decorated with relief sculptures and painted, before the capital was transferred to Luoyang in A.D. 494. The most remarkable of the many sculptures is the colossal seated Buddha inspired by the colossal imagery at Bamiyan (fig. 13.4). The Chinese version is more geometrically simplified than the Kushan Bamiyan figures. This is apparent in the bodily forms and proportions and in the treatment of the drapery folds.

The largest Wei dynasty gilt bronze remaining shares the style of the Yungang colossus but it is more refined in treatment (fig. 13.5). The body, quite discernible beneath the robes, is very Indian, reminding us of the Kushan Mathura style. The folds of the garment are related to the Kushan but are much more

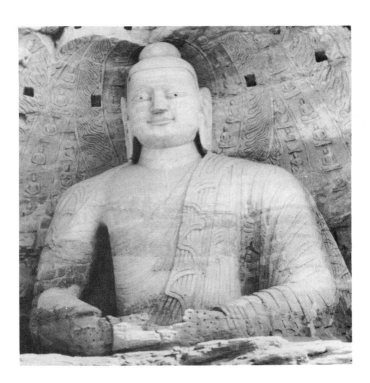

Figure 13.4 Yungang, cave XX, colossal Buddha. Rock cut. Northern Wei (second half fifth century A.D.). H. 45′. Photo: David Fridley.

stylized. The hair is treated like the Gandhara waves but more abstractly, forming a whorled pattern both on the forehead and on the **ushnisha,** the cranial protuberance on the skull of the buddha denoting intelligence. The widespread feet are a Mathura feature; the short lower legs, long arms, and big hands are Gandhara features. The figure is a fascinating composite of the two Kushan styles and the simplified geometrical treatment of drapery folds that we have seen at Yungang. In spite of this there is a compelling sense of spiritual vitality about this figure that expresses the Buddha's message in unmistakable terms.

Relief Carvings

When the Wei moved their capital to Luoyang (capital of the Eastern Zhou and the Eastern Han dynasties) in A.D. 494, another series of cave temples was begun at Longmen south of the city. These caves were carved into a dark gray-black limestone cliff. Only a half dozen were completed before the fall of Northern Wei.

The finest is that called Binyang, completed about A.D. 520. It had bas-reliefs depicting the emperor and empress as donors (fig. 13.6). These reliefs give an idea of the court life and of secular art of the period. The carving is linear and rhythmic as though the figures

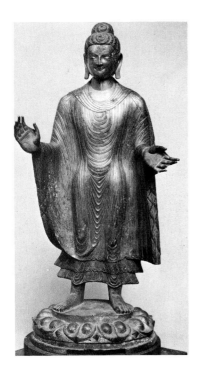

Figure 13.5 Standing Buddha. Gilt bronze. Northern Wei (dated A.D. 477). H. 55¼″. The Metropolitan Museum of Art, Kennedy Fund, 1926.

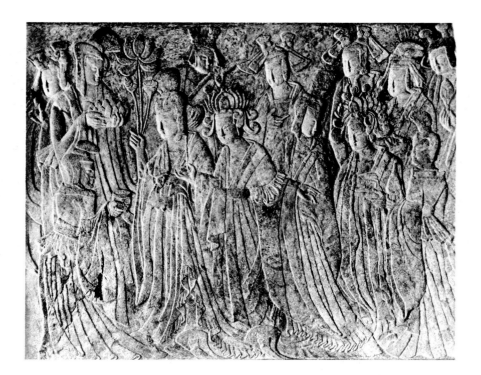

Figure 13.6 The empress as donor, with attendants, Longmen,
Binyang Cave. Limestone. Northern Wei (ca. A.D. 522). H. 6'4";
W. 9'1". Nelson-Atkins Gallery (Nelson Fund), Kansas City, Missouri.

were moving in a slow dance. The exceptionally long
sleeves, elaborate headdresses, and small heads with
delicate smiling features express an elegance removed
from the cares of the world.

These figures were originally part of a low-relief,
carved on either side of the walls of the cave, repre-
senting a stately royal procession from the doorway
toward the three huge Buddha figures (fig. 13.7a–c).
Both the spiritual and the terrestrial rulers are accom-
panied by their attendants, as was befitting beings of
supreme rank in their respective realms.

Gilt Bronzes

Small Buddhist figures in gilt bronze became objects
of dedication in temples or in shrines for private de-
votions in the home. Many have dedicatory inscriptions
telling us that the person named had this image made
for the benefit of parents or grandparents who had
passed away. The religion and the objects bearing the
inscriptions have changed, but the impulse to dedicate
ritual bronzes to the ancestors or on behalf of the wel-
fare of the deceased, seen as early as the Shang dy-
nasty, continued.

One of the finest Wei gilt bronze images shows how
far the style had evolved from the stocky proportions
and massive heavy forms of Yungang (fig. 13.8). The
bronze figure is vertically elongated. The sculptor is still
less concerned with anatomy than with the abstract
formalization of the drapery, which cascades from neck
to feet obscuring the body. The body halo with its flame
border emphasizes the linear rhythms of the drapery
and the hieratic symmetry of the whole image.

Painting in the Wei Dynasty

Painting in the Wei dynasty is best preserved at the site
of Dunhuang (fig. 13.9). At this great oasis, the caves
were made in a cliff of rather soft conglomerate stone.
The walls were covered with plaster upon which the
paintings were done. Because of the unusually dry cli-
mate these caves have retained most of their original
paintings in excellent preservation. Subjects include the
previous lives of the Buddha, larger scenes of the Bud-
dhas of the Past, Maitreya, the Buddha yet to come,
and numerous small seated Buddhas in rows, repre-
senting the Thousand Buddhas. The style is a mixture
of Indian, Central Asian, and Chinese. The color

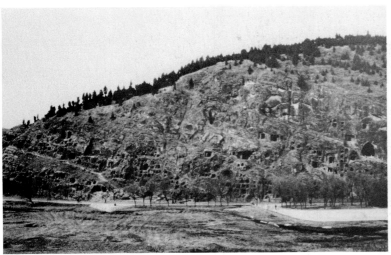
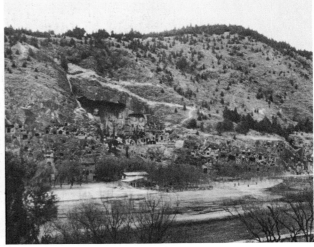

a

b

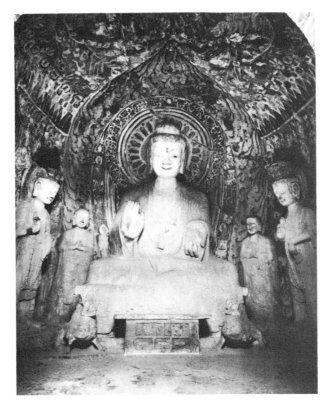

c

Figure 13.7 *a.* Longmen. General view from east bank of the Yi River. *b.* Longmen, Binyang Cave. Colossal seated Buddha. Black limestone. Photos: author. *c.* Seated Buddha with two monks and two bodhisattvas, Binyang Cave, Longmen. Limestone (first half of fifth century). © Kodansha Images/The Image Bank.

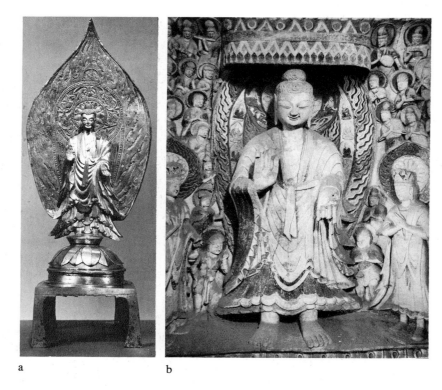

a b

Figure 13.8 *a.* Maitreya. Gilt bronze. Northern Wei (dated A.D. 536). H. 23⅞″. The University Museum, University of Pennsylvania.

b. Standing Buddha. Yungang, cave VI. Rock cut, painted. Northern Wei (second half fifth century A.D.). Photo: Asuka-en.

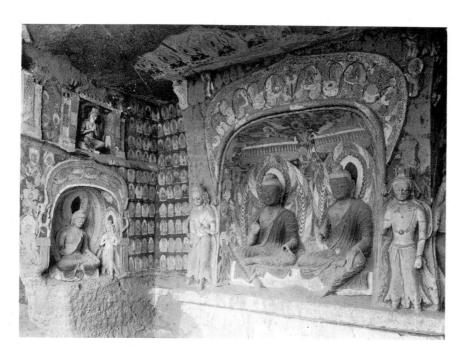

Figure 13.9 Dunhuang, cave 259, P. 111. Northern Wei (late fifth to early sixth century A.D.). Photo: Cliché Pelliot, Archives Musée Guimet, Paris.

scheme consists of blue, green, orange, rust-red, black, and white in flat patterns. Ceilings are frequently painted with textile patterns imitating baldachins or canopies stretched above the sacred images.

Travelers and merchants paused at Dunhuang to pray for safe passage or to give thanks for the successful conclusion of the perilous journey across Central Asia. Their supplication and gratitude embellished the cave temples. Through this bustling oasis poured the hybridized styles of central Asia, Gandhara, and Persia, along with pilgrims, monks, and Indian missionaries bringing new developments of Indian Buddhist thought.

Some of the caves at Dunhuang are rectangular in plan and have a shrine with a Buddhist group sculpted in clay over a wooden armature. These groups are composed of the Buddha and two bodhisattvas. Some of the other caves have an entry vestibule and a square chamber with a square column. On each of the four sides of this solid square column are carved and modeled a representation of one of the four Buddha paradises, which were thought to exist just out of our range of vision, one in each of the four directions.

In colorplate 7, two of the four Buddhas, with their two major bodhisattvas, may be seen. The Buddhas sit cross-legged on lotus thrones in niches representing body halos, and flames also top the niche. Above the flames, additional bodhisattvas descend in worshipful attitudes and flying scarfs. Rafters and lotus flowers are painted on the ceiling and a few of the thousand Buddhas may be seen painted on the walls of the walk space provided around the central shaft. It is clear that such caves must have provided the functional equivalent of Indian cave temples with stupas such as that at Karli (fig. 3.7), which had space between the columns and the walls for worshipful walking around (*pradakshina*) the stupa in meditation. At Dunhuang the presence of the Buddha, indicated by the stupa, is no longer a purely spiritual experience—a matter of faith alone, such as it must have been at Sanchi, where no image of the Buddha appears—but has become visualized, by the sculptural representation of the earthly Body of Magic Transformation, as at Ajanta (fig. 4.6). Compare the head in figure 3.15 and the robes in figure 4.2*a*. The column on either side of the niche seems to be covered with cloth and bound around with a rope. These elements seem to be badly misunderstood Ashoka capitals (fig. 3.1) where the falling lotus petals have here been interpreted as cloth; probably misunderstood from pilgrims' drawings made in India.

Caves such as those at Dunhuang are small, about ten feet high and with one small doorway. They were lighted only by oil lamps in ancient times. Many seem to have seen little actual use, as there is a minimal carbon deposit from the oil lamps. It appears that at least some of the more than four hundred caves at Dunhuang were made more as merit-gaining acts of supplication to the Buddhas for safe crossings of the Silk Road than as places for active worship.

The walls and ceilings of the Dunhuang caves were covered with brightly painted subjects; usually groups centered on the Buddha or row after row of the thousand Buddhas. The ceilings were usually tent-shaped, and subjects proper to the upper realm, such as heavenly musicians and allegorical figures, sometimes of mixed Indian and Chinese ancestry, may be seen. A square canopy decorated with Iranian, Indian, and Chinese motifs is to be found at the apex of many of the caves. It symbolizes the realm of the gods, and the whole schema is of Indian conception, as one might suppose since it represents an eastward extension of Indianized Central Asia.

One of the painted walls in cave 285 is a fine example of the early sixth century (fig. 13.10). A comparison of this figure with figure 4.2*b* indicates the changes that took place in the sixth century in the styles of representation of the Buddha. A comparison of these figures to figures 3.17 and 3.18 shows how much the sixth-century Dunhuang style depends upon the Kushan style of Gandhara. The fact is that the central Asian and Chinese styles were lagging behind Indian developments so that an Indian Buddhist in China would have thought the Dunhuang painters to be two or three hundred years behind the times.

The group in figure 13.10 consists of the Buddha, two bodhisattvas, and two lay figures. In the background four monk/disciples bring offerings. The bodhisattvas, *far left* and *far right,* are wearing the Indian dhoti and upper garment and jewelry (see especially the wide, flat, pectoral necklace) of the second century. A comparison with figure 4.8*c* shows the painted version of the Wei dynasty to be more linear and of course lacks the volumes of the sculpture. The upper body in both examples is bare except for the scarf, which, in the Indian version, is draped in a complex pattern over left shoulder and right forearm and back again over left forearm to end in a tasseled fringe near the lower edge of the dhoti.

Compare this painting style with the sculptural style of the bodhisattva in the Museum of Fine Arts, Boston (fig. 3.18), to see similarities and differences between them. In the painting, the volumes that are so prominent in the sculpture have almost disappeared; body and garments have become two-dimensional spaces on the flat surface of the painting. The garments in the painting represent the same pieces of clothing worn by the sculpted figure (although the *manner* of wearing the upper garment is different in each case—

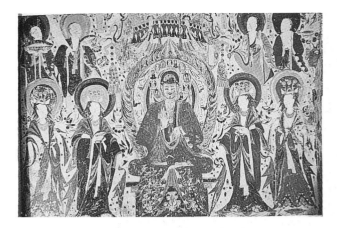

Figure 13.10 The Buddha preaching. Wall painting, cave 285, east wall. Dunhuang (ca. 520–30).

the painted bodhisattvas *far right* and *far left,* wearing their upper garment scarf over both shoulders and crossed in front at the waist). The style of sculpting is quite realistic when compared to the treatment of these pieces in the painting. The abstract, gravity-defying, and spikey silhouettes of these garments are, of course, derived ultimately from the Gandhara style but have been increasingly linearized in the Central Asian oases as the Kushan Gandhara style moved farther from the Roman Empire perceptuality into the realm of Indo/Persian conceptuality.

BUDDHIST ARCHITECTURE

The hemispherical solid stupa of India was replaced in China by the storied tower, or **pagoda,** perhaps inspired by the great stupa at Peshawar, which had been built by Kanishka. According to a sixth-century Chinese pilgrim's account, it was constructed of wood; it rose in thirteen stories to more than five hundred feet, and its spire was formed by thirteen golden discs. At least one Chinese example seems to have rivaled or perhaps surpassed the great stupa of Kanishka. In the center of the Northern Wei capital at Luoyang rose a pagoda over six hundred feet high. It was begun during the Northern Wei Era but was not finished until A.D. 615. It is said to have been visible more than ten miles across the flat Luo River valley. It was built of wood on a stone base, and it burned to the ground twenty years after it was completed. The mass of the structure was so great that the fire burned three months.

Mt. Song

The establishment of the White Horse Monastery at Luoyang during the Han dynasty had attracted so many courtly visitors that within three years of its founding it was deemed wise to find a quieter location for the monk-translators to pursue their tasks. In A.D. 71, in the foothills of the central sacred mountain of China, Mount Song, about twenty miles southeast of Luoyang, the Fa Wang Si was established. The region of Mt. Song had been traditionally a favorite retreat of emperors from as early as the Xia dynasty. One of the sons of the Zhou emperor is said to have located the center of the Middle Kingdom, and thus the center of the world, on the plains to the south. There a Daoist temple was built in A.D. 118, dedicated to the god of the mountain, but the place had been undoubtedly held in high reverence for centuries before that time.

Earliest Brick Pagoda

It is said that each of the seventy-two peaks of Mt. Song had its own temple or temples, and that the area was marked by a highly concentrated center of religious edifices. The Songyuesi, on the next ridge west from the Fa Wang temple, is the site of the earliest brick pagoda in China (fig. 13.11). Begun about A.D. 520, it was finished about A.D. 530. It is a fifteen-storied, twelve-sided tower rising over 130 feet high and is 110 feet in circumference. The ground story has twelve plain sides, as though forming a base for the building proper that it supports (fig. 13.12). Tall doorways originally opened to the four cardinal points, but those of east and west were bricked up at some later time. The next (or main story) is marked by octagonal **pilasters** at the corners of the twelve sides. They are surmounted by modified versions of the ancient Indian bell-capital, dimly recalling those of the Ashoka columns of the Maurya dynasty (fig. 3.1). These pilasters are modeled in brick relief, as are the representations that cover the walls between them. These are perhaps as interesting as any aspect of this engrossing monument, for they depict stupas with very high bases, at the tops of which may be seen the corner **acroteria,** the corner finials used on Greek temples. Their presence in China indicates the strong influence that came via the Silk Route to the Gandhara region of India and from there through Central Asia to China. Between these devices the stupa dome may be seen (figs. 13.13 and 13.15), complete with **harmika** (the cubic altar form at the top of a stupa, derived from the ancient Fire Altar of Vedic times in India) and topped by the inverted pyramid familiar to us from the Indian style of the early centuries A.D. (fig. 3.7).

Above the four doorways, arched windows are capped by the chaitya-window motif of India (fig. 13.14), and these are repeated in smaller scale on the stupa bases of the other eight faces of this story (fig. 13.15). These small stupas are represented as resting

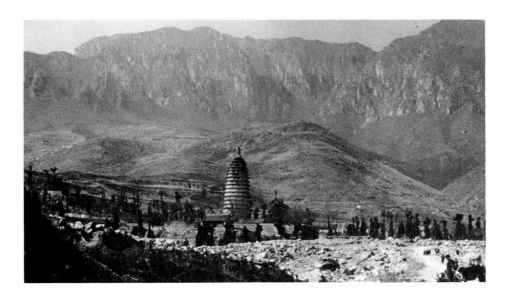

Figure 13.11 Songyuesi pagoda. Mt. Song in background. Henan Province. View east. Brick, stuccoed (A.D. 520–30). H. 130′. Photo: author.

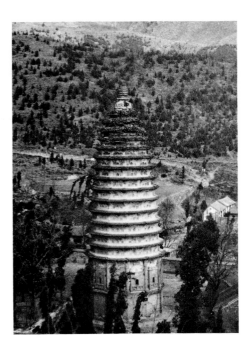

Figure 13.12 Songyuesi pagoda, ground story. Looking east. Brick stuccoed (A.D. 520–30). Photo: author.

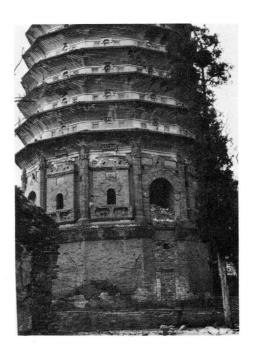

Figure 13.13 Detail of figure 13.12, east doorway.

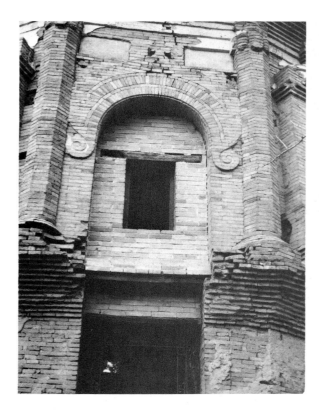

Figure 13.14 Detail of arch above west doorway.

upon Wei-style tables with their characteristic supports: straight outer and curved inner silhouettes. These are familiar from the many Buddhist bronze sculptures of the Northern Wei dynasty, as though the sculptor had copied a model carving that stood upon a table and included the table as a base (fig. 13.8a). This may indeed have occurred, since there are a number of very early Wei figures that follow very closely their Indian precursors but combine the figures with characteristically Chinese-style bases. Seated lions are seen under the table bases here, recalling the Lion Throne of Kushan India (fig. 3.15).

Fourteen stories rise above the main story. Each is marked by an eave extending beyond the sides of the structure in an upward and outward flare, imparting a sense of lightness and exquisite proportion. These eaves are produced by **corbelling** (succeeding courses of brick outward beyond the edge of the preceding course, in the typical Indian manner—a system not native to China).

The arched doorway in the face of each of the eight stupa bases may be compared to such motifs in Gandhara stupas. The stupa at Guldara in Afghanistan, for example, also includes the chaitya arch motif over similar false doorways in the center of each side of the

square base. In addition, the Guldara example has pilasters of similar proportion but of modified Corinthian type. The Songyuesi pilasters rest upon circular bases known from Hadda and other sites in Afghanistan. But there is no such combination of all these motifs in India proper or in Gandhara. This is an eclectic synthesis showing an extensive familiarity with various Indian styles.

The rectangular bases of the stupas in these brick reliefs suggest, by their greater height than width, that they are meant to represent actual architectural stupas rather than image containers. That is, they were meant to suggest the small shrines that could be set up in a home or a temple; this is confirmed by the treatment of their supporting tables. Two sources of inspiration may have been at work here. First, there were the Indian cave temples in which a major image of the Buddha and his accompanying bodhisattvas are housed in a square cella, with a doorway through which they were visible. Devotional practices in Buddhism, as in Hinduism, usually precluded entering the cella. The devotee payed respects to the divine presence by making obeisance at the doorway. This is the plan we have seen at Ajanta (fig. 4.4).

The other source may have been the growing interest in the idea of the Buddhas of the Four Directions. Devotion to Buddha of the West, Amitayus (Amitabha), had begun in Luoyang among a very small group as early as the second half of the third century A.D. The Buddhas of the directions were thought to reign over **Pure Lands,** where the faithful might be reborn after death. The basis for this devotion was the Pure Land Sutra, which described in glowing terms the glories of the Buddhist paradise. By the early fifth century a Pure Land Society, or sect, was founded. But already in the Eastern Jin dynasty (A.D. 317–420) a well-known monk had had an image of Amitabha made, revered it, and made a vow before it to be reborn in the Pure Land of the Western Paradise.

Spatial Symbolism

The same two- and three-dimensional symbolism seen in the Sanchi stupa I (fig. 3.2) is seen here but in more complex form. Both planar two-dimensional and vertical three-dimensional aspects are multiplied. The four door ways correspond to the four gateways at Sanchi, and the simple cylinder of the drum has become twelve-sided, symbolizing the desire to infuse every possible region with the Buddha spirit.

The division of the tower, which is really a series of fifteen bases one upon the other, symbolizes the **Lokas** (Realms of Existence). These realms existed in vertical layered stratification in Indian cosmology and were reflected in the divisions of the World Mountain. Sitting

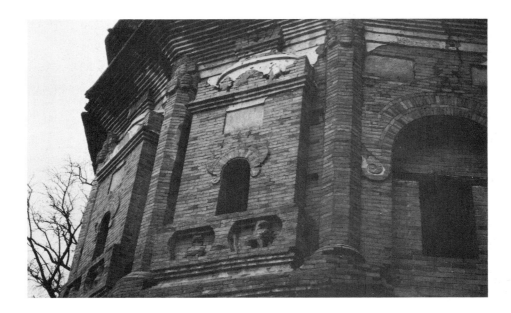

Figure 13.15 Detail of stupa motif between columns north of west doorway.

atop the fifteenth level, the tiny hemisphere of the stupa mound with its finiallike umbrellas may be seen.

This pagoda may have contained in the center of the main floor four sculptured groups representing the Buddhas of the Four Directions. One would have faced each of the doorways, but if so, no trace of them remains.

Understanding of the Songyuesi pagoda is essential to an appreciation of the China-India Buddhist milieu. It indicates close dependence upon Indian motifs, architectural style, and even the technique of corbelling, which inspired not only the eaves but the entire pagoda. Forms and concepts originating in one culture sometimes blossom better in foreign soils than at home. This phenomenon is clearly demonstrated in the fusion of the Kushan stupa with the Gupta temple spire in the Chinese masonry pagoda. Comparison of the Songyuesi pagoda with the towers of Angkor Wat in Cambodia indicates the complex cross currents and reciprocal influences involving Indian sources that occurred in cultures influenced by Indian concepts and techniques.

SUMMARY

There are very few examples of Buddhist art before the fourth century A.D. This is the century of the earliest dated Buddhist image in China. With the end of the Han dynasty, China entered a three-hundred-year era of national disunity. In the north the Wei dynasty and its ancillary kingdoms ruled, while south of the Yangci River a series of some twenty short-lived dynasties struggled successively to establish control. Throughout this politically unstable period faith in the Buddha seemed to promise a great number of people either the establishment of a new and stable cycle with the advent of the Future Buddha, Maitreya, or at least the attainment of personal salvation, Nirvana. The rapid spread of Buddhism involved the establishment of temples and monasteries. In some instances great cliff sites were transformed into cave temples. At Yungang, near the Northern Wei capital, the emperor established five large caves in memory of his predecessors and to obliterate memory of the terrible persecution that his grandfather had instigated against the Buddhists during that reign. When the capital was moved south to Luoyang, new caves were carved into the cliffs at Longmen and Buddhism continued to thrive throughout this epoch. The style of the Northern Wei was characterized by elongated bodies with long scarves, a vogue derived from the bodisattvas of India but now expressed in a strongly linear manner, with little or no sense of the bodily volumes so characteristic of Indian art. This style was transported to Longmen from the north, and it is also found in many small bronze freestanding sculptures; these were probably made for dedication to temples since they frequently carry inscriptions stating that they were dedicated for the welfare of parents of relatives and for the family. They vary greatly in quality but the style is consistent.

Wei dynasty painting is best preserved at Dunhuang in northwestern China. The style is a mixture of Indian, central Asian, and Chinese models. This is to be expected at a site that was regularly visited by caravans moving back and forth from east to west.

Indian types of Buddhist architecture were altered in China. Following the tradition of the White Horse Temple, Chinese Buddhist temples fused the style of the guest house or caravanserai with that of the palace to produce a series of buildings leading from south to north and bilaterally disposed in pairs across a central axis. Three or more buildings were arranged across the central axis. One of these may have been the pagoda, which was the Chinese version of the Indian stupa. Another may have been the image hall, and a third may have been either a lecture hall or a refectory. Since no temples of the period retain their original buildings in China, the evidence of the few Japanese temples and of remains of Korean temples of the period provides clues to early Buddhist architecture in China.

The earliest brick pagoda in China is in fairly good condition, revealing in its combination of strongly Indian building technique and use of Indian motifs, such as window and pilaster types, with Central Asian or Chinese influences, the ancient classical Western motifs that had come across the Silk Route to the Songyue Temple southeast of Luoyang.

GLOSSARY

Acroteria The corner finials used on Greek temples, continued in the Songyuesi Chinese pagodas at Mount Song, ca. A.D. 520. (p. 130)

Corbelling In architecture; an overlapping arrangement of bricks or stone in which each course projects beyond the course below it; used by the Chinese in the Songyuesi brick pagoda at Mount Song in typical Indian style, ca. A.D. 520. (p. 132)

Harmika The cubic altar form at the top of a stupa, derived from the ancient Fire Altar of Vedic times in India, incorporated into the Indian stupa and transferred to North Asia, where it appears as a part of the Songyuesi brick pagoda at Mount Song, ca. A.D. 520. (p. 130)

Loka Realm of existence. Related to Latin *locus,* place. The Lokas are: *Kama* (sensual); *Rupa* (ideational); *A-rupa* (beyond idea); Shvarga. (p. 132)

Northern Wei The term used for the rule of North China from A.D. 386–535; rule by non-Chinese who had fled into northern China to escape the Huns. (p. 122)

Pagoda Chinese storied tower, perhaps fashioned after the great stupa at Peshawar. (p. 130)

Pilaster An engaged pillar; structurally a pier, but architecturally treated as a column usually projecting a third of its width or less from the wall. (p. 130)

Pure Lands In Buddhist teaching the four paradises of the Buddhas of the Four Directions, where the faithful might be reborn after death; described in the Pure Land sutra. (p. 132)

Six Dynasties The term used to describe the rule of South China from the end of the Han dynasty to the beginning of the Sui dynasty, A.D. 220–589. (p. 122)

Sutra A collection of Buddhist teachings; scripture. (p. 122)

Ushnisha In Buddha images, the cranial protuberance of wisdom. (p. 125)

14
.

INDIA-CHINA CONTACTS RENEWED AND INTENSIFIED

THE TANG DYNASTY (A.D. 618–906)

In its time Tang China was the largest and most powerful country in the world. Territorial expansion brought Central Asia into the empire and protected the caravan routes to the west. Tribute was exacted from Southeast Asian kingdoms in the form of ivory, tin, pearls, coral, and spices.

All the arts flourished. The capital, Changan (Xian) (fig. 14.1), with a population of more than a million, was the most cosmopolitan city in the world. People of almost every race, color, and belief found their way here, attracted by the Tang expanding economy, which provided markets for their goods.

For the first two centuries Buddhism flourished in monasteries and at the cave-temple sites. Several new sects of Buddhism were introduced by Indian missionaries and at the same time both Christian and Jewish communities developed.

Chinese palace architecture continued to influence Buddhist architecture, although some examples seen in the Dunhuang wall paintings of the Tang may have been elaborated by artists as befitting the paradise scenes (fig. 14.2 and colorplate 8).

Between the Wei and Tang dynasties the incorporeal visionary style in both painting and sculpture began to change into a stiffly columnar form. After about A.D. 560 this stiff style became more fluid, the figures began to shift the weight to one foot, and a graceful rhythmic pose for bodhisattva figures evolved (fig. 14.3).

Perhaps sculpture best expressed the new vigor of the Buddhist faith. Although much was destroyed in the great persecution of the ninth century, enough survives to give some idea of the grandeur of this art (fig. 14.4*a* and *b*). Painted stone reliefs decorated the cave temples at Longmen, Tianlong Shan, and other sites. At Dunhuang clay or stucco over the soft stone core continued, as well as sculptures made entirely of clay upon a wooden **armature** (fig. 14.4*c*). Owing to a shortage of metals for coinage, with which the court hoped to pacify fierce border tribes, most of the larger bronze images were melted down by order of the court in the ninth century. Reaction to this order may have been the cause of the resulting persecution of Buddhism as well as other foreign religions at that time.

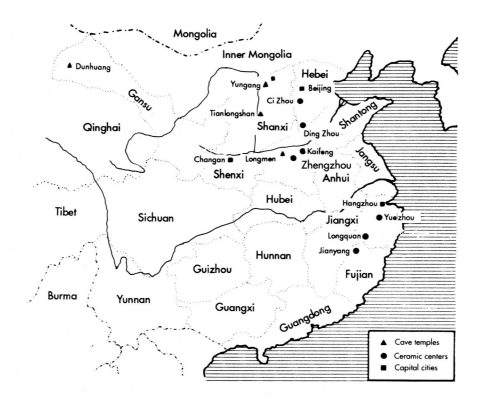

Figure 14.1 China—cave temple and ceramic centers (fifth to fourteenth century).

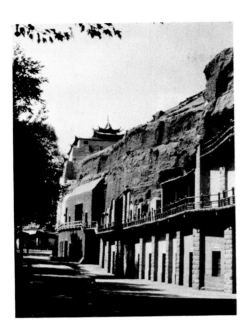

Figure 14.2 Dunhuang. View along cliff face. Photo: Per Olow Leijon.

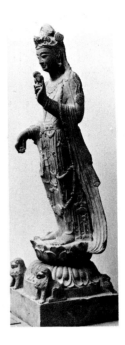

Figure 14.3 Bodhisattva Kuan Yin. Limestone (ca. 570). Northern Zhou (succeeded Northern Wei; 557–81). H. 8′2″. Museum of Fine Arts, Boston, Francis Bartlett donation.

THE BODHISATTVA

The new bodhisattva style is indicative of renewed Indian contacts, which increased in the last years of the Sui and early Tang dynasties. The complex doctrines and mystical intricacies of other sects were soon abandoned in favor of a popular, almost universal acceptance of the Amitabha sect, which saw the bodhisattvas as saving helpers. This sect promised not Nirvana or escape from rebirths but immortality in the paradise of Amitabha, the Dhyani Buddha of the West.

The Amitabha sect was more properly known as the Pure Land, where Amitabha, the Buddha of Boundless Light, reigned above a lotus pond in which the souls of the dead were constantly being reborn out of lotus buds that floated on the waters before the Buddha.

Buddhism had changed greatly from the Four Noble Truths and the Noble Eightfold Path preached by Gautama; it had been elaborated and universalized. The **cult of the bodhisattva** served a very real human need: since Gautama had passed into Nirvana, since Maitreya had not yet appeared, and while Vairochana (the Body of Essence) was unapproachable, humans felt the desire for some object of their spiritual aspirations, for someone to whom they could confide their difficulties and who could intercede with the Body of Essence on their behalf. It is no wonder, then, that the bodhisattvas became so popular that they almost obscured the Buddhas as objects of devotion. The quality of

mercy is expressed in both the sculptures and the paintings of the period, as preserved at Dunhuang. The figures stand in graceful poses, dressed in Indian garments and jewelry. The ecstasy of the Wei style has been replaced by a tender compassion, which certainly must have been more meaningful for the common individual, the merchant, the banker, and all the people who had neither time nor inclination to study the complexities of other Buddhist sects which, in their view, were better left to the monks.

MATURE TANG ART

By the eighth century, swelling, plump bodies and clinging draperies indicate strong Indian influence, and the Buddhas as well as the bodhisattvas were affected (fig. 14.5*a*). The gilt bronze Buddha preaching the First Sermon is a very obvious imitation of the Gupta stone version of Sarnath, which was justly famous throughout Asia, but it is "fatter" (fig. 14.5*b;* see also fig. 4.2*b*). This plumpness is also seen in secular art of the eighth century. In figure sculpture the forms are pneumatic, and in painting the lines swell to the contours of the body, in the Indian manner (fig. 14.6).

One of the glories of Tang art was undoubtedly its figure painting, although practically none remains except for the Buddhist paintings of Dunhuang. Zhou

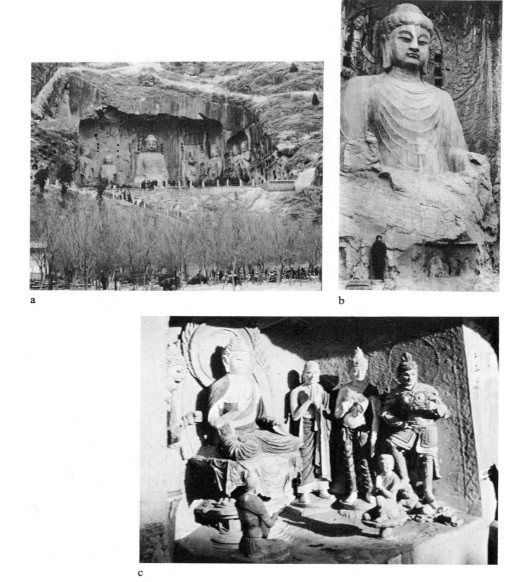

a

b

c

Figure 14.4 *a.* Longmen, Colossal Buddha with disciples and bodhisattvas. Black limestone. Tang (A.D. 672–75). H. of Buddha 35′. Photo: author. *b.* Detail of Buddha. *c.* Dunhuang, cave 458: P. 118 R. west wall. Clay sculptures. Life size. Tang (eighth century). Photo: John B. Vincent.

Fang, who painted from about 780–810, was responsible for establishing the category of ladies of the palace as a preeminent subject and also for setting the style for feminine beauty for generations to come. Only two or three of his paintings remain, although there are hundreds of imitations, copies, and just plain forgeries of his work. The scroll shown in colorplate 9 is typical of his best paintings. The theme is typical—ladies of the court left to their own amusement while waiting the time for their more official duties. This short scroll was painted in fine line and colors. The six standing women are spaced rather evenly against the blank silk. This lack of background is a characteristic of Tang figure painting. The silk has darkened with time, and the lines of the painting are so fine that they are hardly visible in the printed plate. But even so, one has the distinct impression that they are precise and impeccably drawn. Depth is shown only by position; two of the women are seen as being more distant because they have

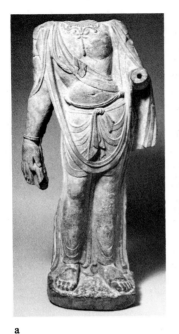
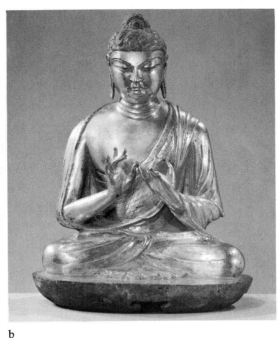

a b

Figure 14.5 *a*. Bodhisattva, Tienlong Shan, cave XXI. Sandstone. Tang (early eighth century). H. 51″. Asian Art Museum of San Francisco, the Avery Brundage Collection. *b*. Figure of the Buddha. Position of hands indicate the preaching of the First Sermon. Lotus base missing. Gilt bronze. Tang (early eighth century). H. 8″. The Metropolitan Museum of Art, Rogers Fund, 1943.

been placed higher in the space than the other four. The treatment is that of miniature painting. Minute details of face and dress are lovingly rendered.

Paintings such as this are richly rewarding, for not only do they present the painting style of the court but also, because of their subject matter, they reveal the fads and fashions of the day. The diaphanous scarves and patterned silks are very like those we have seen at Dunhuang. The garments of the ladies are forerunners of the Japanese kimono, while the lacquered hair was also later adopted in Japan. This is also true for the white makeup. Eyebrows and beauty marks came in many modes in Tang dynasty painting, indicating a wide range of cosmetics. The patterned dress shows Persian (now Iran) influence. Fresh flowers were worn by both young men and women in the Tang court. The little dog is a hybrid, bred especially by the Chinese to resemble the Buddhist lion. We know a descendant of the type as the Shih Tzu, or lion-dog. The red tassle on the black-lacquered wand with which the young lady amuses the tiny dog was probably made of yak tail, the material of ancient Indian royal flywhisks.

Although the figures express great delicacy and grace of movement, it is clear they are rather plump of feature. It is probable that this is an influence from the Buddhist sculptural style such as seen at Tianlongshan,

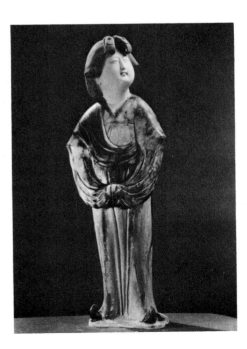

Figure 14.6 *a*. Court lady. Pottery, glazed except for facial features, which are painted. Tang (eighth century). Shenxi Provincial Museum. Photo: Chang Ping-yuan. (Note the sense of pneumatic expansion of the facial forms expressed as plumpness in the ceramic and by contour line in the painting (*b*).)

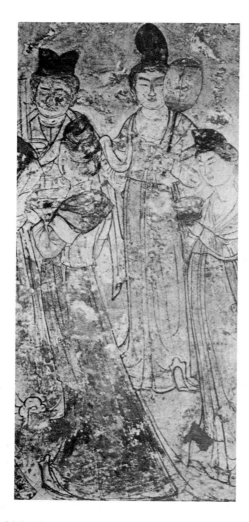

Figure 14.6 *b.* Wall painting. Female attendants. Tomb of Princess Yongtai, east wall of the front chamber. Xi-an, Shenxi (A.D. 706). H. 6½'.

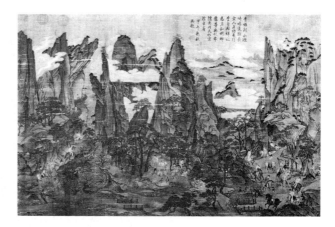

Figure 14.7 The Ming Huang Emperor's journey into Shu (Sichuan). Probably tenth century. After Li Zhaodao. Ink and color on silk. Tang (ca. 670–730). H. 21¾''. Collection of National Palace Museum, Taipei, Taiwan, Republic of China.

Secular Painting

Landscape as a subject became more important in the Tang. It was used as a setting for narrative or historical paintings, and it began to be treated in a more accurate scale relationship to figures within it. In figure 14.7 the narrative subject is the flight of the Ming Huang emperor (Xuan Zong) after the capital fell (A.D. 756) to rebels. It is said that his own concubine, Yang Guifei, had had a liaison with the rebel captain, An Lushan, and had aided him in attaining high station and power. For this reason she was killed by the emperor's guards, when they rebelled and refused to go farther, so long as she lived.

The composition is divided into three space cells. This division is emphasized by the great towering rock masses closing them off from the distant landscape, which appears to be a lowland bordering a large lake far below. The painting is telling a story, which says, in part, that the trail into Sichuan to the city of Chengdu, where the emperor took refuge, leads through rugged mountains and past lakes. And, on the journey it is necessary to make camps and to break the trip into several days.

Those viewing this painting would have probably known such things already, but for us, it is important to try to see the painting as they did. What *we* see first, which is entirely wrong, is a single point in the journey being portrayed at a single moment in time. We see it like we see a photograph. And by doing so we miss the narrative—the continuity in time—that the painting contains. There are three space cells because there are

just at the beginning of the eighth century (fig. 14.5*a*). This influence came just in time to affect the style of feminine beauty in the paintings in the Princess Yongtai's tomb, which, while they have plump faces, have long and slender bodies. By the time of Zhou Fang, the style in ladies had become amplified and was more like that of the tomb figurine (fig. 14.6*a*) of the late eighth century. Gradually this misunderstanding of the Indian concept of *prana* in sculpture would produce really fat figures such as we see in figure 14.5*b*. A studied comparison of these examples with the preaching Buddha from Sarnath (fig. 4.2*b*) will reveal more than words can.

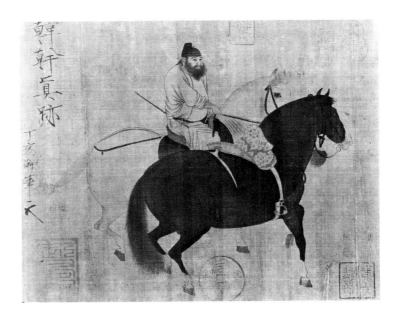

Figure 14.8 Two horses and groom. Ink and pigment on silk. Attributed to Han Gan (active ca. 750) by the Emperor Hui Zong (r. 1101–27) in his inscription written on the left of the painting in 1107. H. 10⅞″. National Palace Museum, Taipei, Taiwan, Republic of China.

three sections to the story: the beginning, middle, and end. None of the figures or animals are shown three times, but the viewer would have seen here, at the right-hand side, the column entering into the first open space and would perhaps have recognized the figure of the emperor on the chestnut horse approaching the first bridge. The horse is one of the famous Ferghana breed, (see fig. 14.9). The emperor is dressed in red and behind him there is a group of his other concubines wearing broad-brimmed and high-crowned hats with red scarves to protect from the hot sun. In the middle segment the pack mules have been unloaded and are resting after a hard day. At the far left the pack train is on its way again heading up the steep trail over the pass. The lead figure is already making a steep descent on the other side.

If we read this painting as we would a photo, we might wonder why the group on the left is well on their way while that in the center is resting. Our conclusion might be that another rebellion is taking place and the palace guard is making off before the emperor has even arrived. What we are really seeing is a series of episodes repeating no section of the entourage so that three totally separate episodes are displayed. The Tang observer would have found this very comfortable. What would have been uncomfortable would be a single setting with all participants in one place and in scale to the surroundings, as in a photo.

By this time there was a very long tradition of segmented pictorial presentation. When the stories of the previous lives of the Buddha were shown in sculpted relief or in painting during the sixth century they were always shown in segments so that the Buddha, for example, would appear many times in the same story, for he would appear in many scenes. In the present painting a move toward consistency has been made. None of the figures is repeated but they are still shown separated as though on three different stages. Consistent spatial presentation was yet to be developed. Although this painting was once attributed to Li Zhaodao, the Qian Long emperor identified it as being from the tenth century. Though Li is listed as having painted the subject in those large compendia of Chinese painting histories, it is somewhat doubtful if he was even still alive at the time the event took place. This illustrates only a couple of the many problems encountered in the study of Chinese painting history. In any case the painting is generally accepted as being representative of the Li style, whether by him or a follower.

One of the reasons for extending the Tang empire into Central Asia was to insure again a source of supply of the powerful and fleet horses from Ferghana. A pair of these, with their Central Asian groom, is the subject of a painting by Han Gan (fig. 14.8). The white horse is almost hidden by the black, contributing a sense of depth, since neither foreground nor background is otherwise indicated. The tense, even-width fine line and silhouette define the volumes and space.

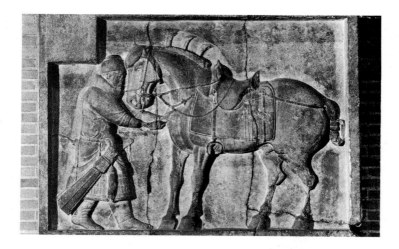

Figure 14.9 Horse of Tang Tai Zong (r. 626–49). Stone. Said to have been carved after a design by the painter Yen Liben (d. 673). H. 5'8". The University Museum, University of Pennsylvania.

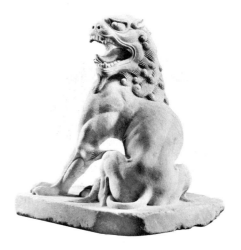

Figure 14.10 Guardian lion. White marble, traces of pigment. Tang (618–906). H. 11¾". Nelson-Atkins Gallery (Nelson Fund), Kansas City, Missouri.

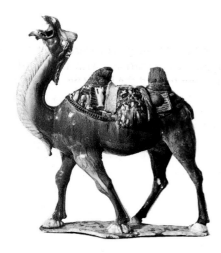

Figure 14.11 Bellowing camel. Glazed pottery. Tang (618–906). H. 35". Asian Art Museum of San Francisco, the Avery Brundage Collection. M. H. de Young Memorial Museum.

The horses of Ferghana were so prized by the Emperor Tai Zong that he had six of his favorite chargers carved in relief and set up at his tomb (fig. 14.9), recalling the practice of burying horses with Shang nobles. The idea still persisted that in the life after death the representations of men and animals in the tomb would take on a new life and become in reality what they had been in this life.

One of the most powerful of Tang animal sculptures is the small white marble lion (fig. 14.10). The intensity of anatomical interest in Tang could hardly be better illustrated, since the powerful musculature and dynamic vigor are admirable expressions of the Tang vitality.

Literally thousands of objects have been recovered from Tang tombs. They range from everyday household articles to human figures of all types; to such animals as camels, so important in the caravan routes, dogs, and other domestic animals, as well as the beautifully rendered Ferghana horses (figs. 14.11 and 14.12). Most of these were made of fired clay, either glazed or painted. The ceramic arts had made great strides since the plain green or brown glazed wares of Han. Tang glazes range from transparent to deep blue, including

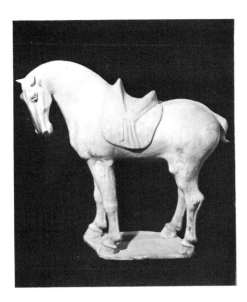

Figure 14.12 Horse. Glazed pottery. Tang (618–906). H. 21″. Stanford University Museum, Mortimer C. Leventritt.

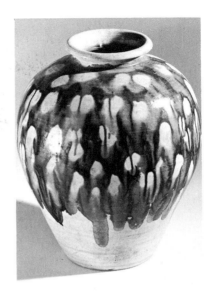

Figure 14.13 Jar. Glazed pottery. Tang (618–906). H. 10½″. Stanford University Museum, Mortimer C. Leventritt.

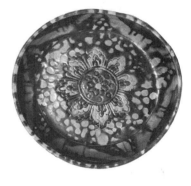

Figure 14.14 Deep plate. Glazed pottery. Tang (618–906). D. 10″. Stanford University Museum, Mr. and Mrs. Stewart M. Marshall.

green and amber. These glazes were most frequently used in dappled combinations, with the mottles dripping and running toward the base (fig. 14.13). In some instances designs were stamped into the clay, leaving a narrow groove or channel around the main elements of the design (fig. 14.14). When the glaze melted during firing it ran into these channels, which provided a control for them. The clay varies from almost white to pink, visible in the lower sections, which were left unglazed to prevent the dripping glaze from causing them to adhere to the bottom of the kiln.

Foreign Influence

The international character of the Tang dynasty led to the importation not only of foreign raw materials and products but also of foreign workers. The conquest of Sassanid Persia by Islamic Arabs in the eighth century caused the Iranian crown prince to take refuge in China; this flight of Yezdegerhd II and his entourage brought Persian styles as well as workers to the Tang capital. What the Chinese had long admired as exotic imports could now be made at home. Many elements of Tang secular art were derived from the Persian West. For example, the sudden strong emphasis on floral and foliate designs probably owes much to these foreign craftspersons. Persian techniques are especially perceptible in silver and goldsmithing (fig. 14.15).

Many pottery and metal shapes can be attributed to Persian influence. At least one of these, the **amphora**

(a long-necked, two-handled storage vessel for oil or wine), is a Roman form that had become standard in the Middle East and eventually found its way through Persia into China (fig. 14.16).

The great persecution against all foreigners and foreign religions carried out between 841 and 845 destroyed most of the temples with their sculpture and paintings. Only small images that could be kept in the home shrines, some of the cave temples, and more remote monasteries seem to have escaped the wrath of the court. Fortunately Japan never experienced such persecutions, so that much of the best-preserved material in the Tang style is to be found there today.

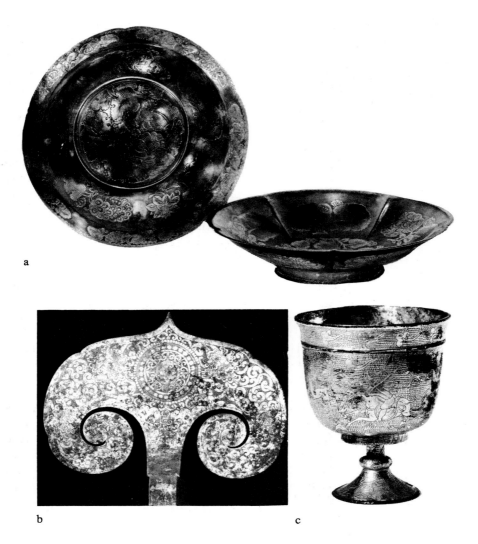

a

b c

Figure 14.15 *a.* Bowl with cover. Silver, gilt floral designs. Tang (618–906). D. 9½″. Seattle Art Museum, Eugene Fuller Memorial Collection. *b.* Base for feathered fan. Gilt bronze. Tang (eighth to ninth century). H. 9″. Stanford University Museum, Mortimer C. Leventritt. *c.* Stem cup. Gilt bronze. Tang (618–906). H. 2⁹⁄₁₆″. Ontario Museum, University of Toronto, Canada.

SUMMARY

China flourished under the Tang dynasty, and so did the arts. Noble patronage encouraged Buddhism and the court accepted exotic tribute. The capital, Changan, saw people from almost every land bringing goods and ideas to make it the most cosmopolitan city in the world.

The rebellion by An Lushan in the mid-eighth century destroyed first Luoyang and then Changan, but the dynasty survived this uprising. In the mid-ninth century an extensive persecution of foreigners occurred. In an effort to pay off the barbarians through whose territories the Silk Route ran, the court requisitioned metal sculptures from temples to be melted down for coinage. Many monks refused to give up their sacred images, and their temples were destroyed by government soldiers, the monks and nuns either killed or returned to lay life, and the metal objects confiscated. For these reasons no large-scale metal sculptures remain in China. This is also true of Tang temple architecture. Some of the temples were rebuilt after the persecution but never flourished as they had in the earlier years of the Tang dynasty.

By the beginning of Tang, Buddhist sculpture had evolved from the stiff postlike style of the late sixth century into a more natural stance, with the weight borne upon one foot and the body disposed in a more relaxed posture. This tendency toward realism increased through the seventh century, and by the early

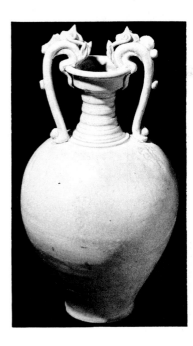

Figure 14.16 Amphora-shaped jar. Glazed pottery. Tang (618–906). H. 15″. Stanford University Museum, Mortimer C. Leventritt.

eighth, fresh contacts with India were reflected in the more fleshy look of the figures.

These new contacts also fostered the development of the Pure Land sect, which had arisen from the concept of the universal Buddha. The sect promised immortality in the paradise of Amitabha.

At Dunhuang, caves were increasingly dedicated to the Buddhas of the Four Directions. Buddhas and bodhisattvas were modeled in stucco and painted. Increased activity in establishing new chapels attests the increased trade across the Silk Route during the Tang dynasty, since it was the profits from trade that made the religious establishments possible.

Tang expansion across central Asia brought the Chinese to the homeland of their beloved Ferghana horses, which they memorialized in painting and in ceramic tomb figures. At least one emperor had six of his favorite horses carved in stone for his tomb. Expansion also brought the Tang into contact with the Middle East and into conflict with the Muslims at the Battle of Samarkand in 751. The crown prince of Persia had already fled his homeland for refuge in China, where he entered the Chinese army and died at Samarkand. Along with him came many craftspersons as well as others of his household staff. Of special importance for the arts of China were the gold and silversmiths. Their influence may be seen not only in Tang metal arts but in ceramics and other arts as well. Vessel types that had originated in ancient Greece had been transmitted through the eastern Roman Empire found their way into the Chinese repertory of forms and motifs.

Although the period was marked by internal strife and persecutions, the Tang produced the highest standard of living thus far for its people and achieved the most luxurious opulence for its rulers. The great achievements in architecture, sculpture, and painting are gone. We can perceive the shadows of their grandeur in some of the sculptures of the Longmen cave temples, in a few of the paintings at Dunhuang, as well as in certain examples of the architecture and sculptures of the Nara period in Japan. We acquire a hint at the quality of court painting from the very few scrolls that remain. Ironically, however, it is not in those arts where we approach most closely to the original condition and appeal of the arts of the Tang dynasty, but rather through the so-called minor arts, the ceramic, gold, and silver vessels and the splendid tomb furnishings of noble tombs.

GLOSSARY

Amphora A long-necked, two-handled storage vessel for oil or wine; Roman type. (p. 143)

Armature The framework used by a sculptor to support the structure of the work. (p. 136)

Cult of the bodhisattva Buddhists saw the bodhisattvas as saving helpers. (p. 137)

15
.

THE CHAN REFORMATION
OF BUDDHISM

The destruction of Buddhist institutions at the end of the Tang dynasty in China marked a critical shift in Chinese attitudes. Suddenly the full acceptance with which Tang China had welcomed foreign ideas ceased. When the challenge came, the Chinese court was more concerned with maintaining a viable economy than with abstract metaphysical speculation.

CHAN—MEDITATION

The pragmatic goal superseded the speculative in China during this period. But, concealed among the ruins of the more orthodox Buddhist system, was **Chan** (Sanskrit: Dhyana; Japanese: Zen), relatively untouched by the great persecution of the ninth century. Chan was a form of Buddhism in which meditation, coupled with self-reliant work, was seen as the primary means to the end desired. Meditation had been a major component of Buddhism as well as of Hinduism in India. But in China it became the primary means of preparation for becoming awake, of seeing behind the ordinary aspects of everyday life the Buddha mind, which is to be found in all things and which repudiates the illusion of separateness between the specifics of life and the universal.

The Shaolin Temple

In the fourth century certain monks had already emphasized meditation. A sixth century monk, Bodhidharma, is credited with establishing the Shaolin Temple on Mt. Song. This became the fountainhead of Chan Buddhism in China and its later descendant, Zen, in Japan. According to tradition, Bodhidharma founded his small temple in A.D. 527, that is, at the same time in which the brick pagoda of the Songyue Temple was being constructed in the next valley to the east on the southern slopes of Mt. Song.

At the Shaolin Temple are a group of 220 brick funerary monuments built over the centuries to hold the ashes of the most prominent monks (fig. 15.1). Three date from the Tang dynasty, that is, about a century after the temple was established. A comparison between these stupas and the pagoda of the Songyue Temple (fig. 13.11) is enlightening because it indicates how closely the stupas built to house the relics of Shaolin teachers follow the traditional stupa in its developed Indian and central Asian form, while the pagoda is more related to Indian temple types. The silhouette of the tower is similar to the spires of later northern Indian temple architecture, particularly those of the northern type in the manner in which the horizontal divisions decrease in both height and width from bottom to top (figs. 6.11 and 6.12).

Goal of Chan

Chan is both a reformation of Mahayana Buddhism and a return to pre-Buddhist Chinese concepts and attitudes. It gave up the redemptive aspects of Mahayana Buddhism in favor of direct, intuitive discovery of reality. In this it followed Gautama's own method, but it also introduced some typically Chinese aspects. It is said of Chan that those who know it do not speak and

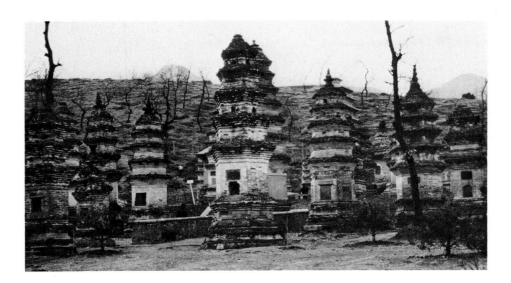

Figure 15.1 Cemetery, Shaolin Monastery. The ashes of 220 revered monks and teachers are enshrined within the brick and stone reliquaries, which date from the Tang dynasty onward. Photo: author.

those who speak about it do not know. In the Dao de jing it is said of the Dao that what can be called the Dao is not the Dao. The goal of Daoism was union with the Dao, the return to the natural state. This was considered to be possible through the understanding and observance of natural law.

The goal of Chan Buddhism was the same awakening that the historical Buddha had experienced by the understanding and practice of the Law as it exists underlying and beyond the natural law, which we perceive. By meditation the practitioner of Chan was enabled to see through the apparent world to the real world. Nothing in the external world appeared differently; it was the Chan practitioner who changed, not the surrounding world. But in that change, which was the sudden awakening, all aspects of existence were seen to fall into their proper relationships, both physical and spiritual. In other words, the change that occurred was a heightened and deepened perception of the significance of all things.

A NEW "CHINESE" BUDDHISM

In reforming Buddhism, Chan reduced the importance of both written texts and iconography. The Buddha and the bodhisattvas were no longer presented as paintings or sculptures worthy of veneration because, in the Chan system, identification with such tangible representations of these beings was nothing but illusion. Instead of traditional iconography Chan devotees revered depictions of the founder and of the great teachers who succeeded Bodhidharma as patriarchs of Chan. By doing so, Chan removed the last visible foreign aspect from Buddhism; thus, without images of the Buddha and bodhisattvas this new sect eliminated its foreign appearance. It is primarily for this reason that Chan was able to survive the persecution which destroyed iconographic Buddhism in China. It looked Chinese; it sounded Chinese; and it functioned in a Chinese manner.

The **sinicization** of Chan is what is significant to us here. It represents the absorption and renovation of Indian Buddhism by the Chinese mind; it became acceptable because it became Chinese.

This religio-philosophic system was no longer an imitation or a mere aesthetic expression. It meant actually doing what the Buddha taught and was no longer an emotional identification with the Buddha or a devotional recollection of his deeds: Instead, it was a patient expectation—while carrying out one's daily tasks and responsibilities—of the same personal awakening that he had experienced and that he himself had awaited through terrible days and nights, torments, terrors, and temptations as he meditated under the Bo tree at Bodhgaya.

In one profoundly significant leap Chan left the Indian trappings of Buddhism behind. While Chan may seem to have been a negative factor in the evolution of Chinese art since it ignored or rejected the complex pantheon of Buddhist deities; in fact it effected a radical change in the conception of religious art in China and, subsequently, in Japan.

SUMMARY

The Tang persecution of Buddhism had less effect on Chan than on the other sects because Chan seemed less foreign. Its temples were in the hills and the architecture was usually of the simple Chinese style. Instead of stressing complex rituals and displaying the foreign-looking Buddhas and bodhisattvas of other sects, it emphasized self-discipline and hard work.

The founder of Chan, Bodhidharma, had aimed at the same awakening that the Buddha himself had experienced. In this, Chan was really a reformation, an attempt to return to what the Buddha had taught, as distinct from the religions that depended upon faith or magic. Chan had been imbued with Chinese characteristics from the time its founder retreated to Mount Song, China's central sacred mountain, where he meditated for nine years.

Both Chan and Daoism considered direct intuition the primary means for achieving the highest human potential. Both regarded nature as the proper setting for such achievement, away from the dust and distractions of the city streets. If Buddhism is the language of the spirit, Chan is the translation of that language into Chinese.

Meditation, which had been a part of all Indian religions, became the primary training by which the awakening might be induced. The immediate goal of meditation was the discovery of the true self, and this, in turn, would lead to elimination of the false self so that the true condition of being might flow in. At that moment awakening might take place.

Complex argumentation and the multiplicity of Buddhas and bodhisattvas and the externals of religion were left behind by Chan. In Bodhidharma's new system Indian Buddhism was at last made Chinese; at the same time a profound shift in the idea of the holy and of religious art took place.

GLOSSARY

Chan Literally: meditation. A form of Sinicized Buddhism in which meditation combined with self-reliant work was perceived as the primary means to discovering reality; sixth-century China; increasingly influential from the tenth to thirteenth century. (p. 147)

Sinicization Modification through Chinese influence. (p. 148)

16
.
THE SONG DYNASTY (A.D. 960–1279)

CHARACTERISTICS OF THE SONG DYNASTY

After the fall of the Tang dynasty it took more than fifty years (the period of the Five Dynasties) to establish a stable rule. Finally, in A.D. 960, the Song dynasty was established, with its capital at Kaifeng. The Northern border tribes continued to press into China, and in 1127 the court was forced to flee south, where a new capital was founded at Hangzhou. The Song dynasty is thus divided into the Northern Song (960–1127) and the Southern Song (1127–1279). The emperors of Song were not militarily inclined, and rather than fight, they usually preferred to bribe the barbarians into peaceful coexistence. The rulers were more concerned with internal than external affairs, and the period was one of brilliant intellectual and artistic activity. At the court, painters and craftspersons were employed, and an academy was established in which different military ranks were conferred upon artists of special genius.

One of these special geniuses was Li Anzhong. He served in the Painting Academy of Song Hui Zong (r. 1101–27), where his work was much admired by that emperor. Li Anzhong went along with the court when they fled south to Hangzhou and the Painting Academy was reestablished. Li, like other members of the academy, specialized in both subject matter and in technique. Li's specialty was in the "fur and feathers" category; that is, the highly realistic treatment of birds and small furry animals, mainly kittens. Li was awarded the Golden Belt. It was actually a military award, but the Hui Zong emperor had diverted it and other awards from the field of military achievement to that of art. This act was certainly indicative of Hui Zong's intense love of painting (he was a very fine painter himself), but it also indicates his total disregard of military preparedness, making the country a pushover for the invaders from the north.

Li's *Shrike* is painted in a realistic manner but, like most Asian painting, it lacks a light source (colorplate 10). Instead of modeling in the Western sense, where the light falls on one side of the subject and gradually diminishes toward the other side, which is in shadow, Asian painting typically indicates no light source so that the three-dimensional aspect of objects must be suggested by other means. In the case of the *Shrike* it is suggested by the fluffy masses of feathers, which are seen to overlap one another in a realistic manner, giving structure to the bird. Li continues the Tang manner of representing form. A comparison to the Han Gan horses indicates the thin outline (best seen in the rump of the white horse) and subtle shading in both (fig. 14.8). In the *Shrike* there is no line enclosing

the body—but the feather groups are softly shaded against each volume to convey a very real sense of the tactile distinction between the down of the breast and the firmer planes of wing feathers and tail. The beak and eye are marvels of tactile variations—all done entirely without any light source or cast shadows.

The fluffed appearance of the soft gray feathers of the bird suggest it is wintertime, and this is corroborated by the leafless branch upon which it perches. The composition is effective in subtly presenting two qualities of the bird by entirely visual means: its harsh shrill staccato voice is suggested by the harshness and thornlike staccato accents of the leafless branches, and the beautiful swooping flight of the bird is echoed in the roller-coaster glide down the back, along the curve of the tail and looping upward through the upright bamboo leaf. These two visual contrasts are reminiscent, perhaps, of contrasting aspects of the shrike. It must be stressed, however, that this is an interpretation only. We cannot know for sure the intent of the painter. And certainly it was not a conscious intellectual effort that equated the elements of these aspects of bird and painting of bird. It had to be subconscious or, at least, unconscious, because there are only subtle hints in the composition (overstressed in these words for demonstration). Great art may be appreciated by analysis, but it is never made that way. It is made by synthesis, by focusing all the artist's knowledge and feelings in a unified totality. Thinking, as such, is not a part of creativity, because it is disintegrating. Thinking breaks out of the unified personality, of everything that the artist is, as a whole being. Thinking is an operation of a single faculty, but creativity requires the operation of all the faculties at the same time without any division or separation out of the total unity. Joan Miro, the famous Spanish modern painter once said that painting is like making love—once the painter/lover comes to, that is, *thinks,* it is all over. The spell is broken. Li certainly has maintained the spell; so effectively that his painting casts an engrossing spell upon us. When we focus upon what Li experienced, his feelings and vision become for a while our own. This intimate transmission works a wonder in us. We ourselves become focused and "lose ourselves" in the painting. For a blessed moment our self-consciousness is left behind and we exist only in the joy of the work.

Song Aesthetics

The Song refined Tang techniques and aesthetics. At this time technical efficiency and aesthetic judgment seem to have reached a very high level, particularly in

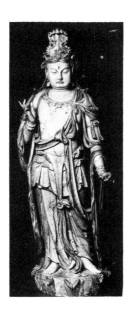

Figure 16.1 Kuan Yin. Wood, painted. From Shanxi Province. Song (second half twelfth century). Repainted in 1349. H. 6′3″. Nelson-Atkins Gallery (Nelson Fund), Kansas City, Missouri.

painting and the ceramic arts. Sculpture, which continued to serve the various sects of Buddhism that required imagery, seems weak, but what it lacked in Tang vitality it made up for in an amplitude of form (fig. 16.1).

Painted and gilded wood was the primary medium, and some of the figures seem to have reached the zenith of realism. Flesh-painted bodies, brilliantly decorated robes, fluttering scarves, and jewelry in gold and in various hues express a sensuous enjoyment of materials, indicating one manner in which Buddhism was finally adapted to the Chinese mode. The Western Paradise sect had already envisioned a heaven in very earthly terms. It remained for the Song to embellish that paradise with even more voluptuous and richly adorned bodhisattvas, who by now had eclipsed the Buddhas as focal points of worship.

The good life was eulogized in poetry and drama and was enjoyed in the sumptuous palaces of the court and the magnificent estates of the wealthy. But paths other than these were open to the serious seeker of spiritual reality, few though they may have been.

Mountain Retreats

The meditative aspect of Chan echoing, as it did, the Daoist "return to the source" inspired some to vigorous spiritual practices. It seemed the most Chinese form of Buddhism, but meditation could not take place readily in the midst of crowded cities. Hence Chan monks sought out mountain retreats, as had their Daoist predecessors, and the ideal of the rustic country life became a popular aspiration of the busy merchants and administrators. Those who were not able to retreat physically to the hills and streams were able to do so, at least in spirit, by means of landscape paintings, which found a ready market among the bureaucracy. A landscape scroll could, in a moment of leisure, be taken out, unrolled, and admired as an aid to nostalgic relaxation, if not actually to meditation.

THE DEVELOPMENT OF LANDSCAPE PAINTING

While Chan needed no art because it had no iconography, it was an important factor in the encouragement of landscape painting. With the decline of the more ritualized forms of Buddhism a significant synthesis of thought began to take place. This emerged as **Neo-Confucianism;** as Chan was an attempt to return to what the Buddha taught, so Neo-Confucianism was a reformation of Confucian thought. Several factors contributed to the success of this movement. By the time of the Late Tang dynasty Buddhism had already died out throughout most of India. Then there were the periodic Chinese denouncements of foreigners and foreign ideas, culminating in the great persecution and expulsion of foreigners in the middle of the ninth century.

Even in the early Tang the court had decreed that every province should build a temple to Confucius and that ceremonies honoring him should be reinstated. The Song revived the civil service system, and its examinations were based on knowledge of the Confucian texts. In addition, the entire intellectual flavor of the Song was conducive to introspective looking back to their native heritage. In this they were antithetical to the spirit of the Tang, which had been aggressively, and, in the earlier years, cosmopolitan in taste.

Now China was tired. Like an old man who had experienced a vigorous youth and fought his share of battles, China now sat and dreamt of the past. In China's dream Confucius became the central figure. Thus, the Zhou and Han periods became for the Chinese a kind of Golden Age. It was quite natural that the Neo-Confucianists should try to re-establish the harmonious political and social patterns that they ascribed to the ancient past. But both Daoism and Buddhism had had their effect. It was impossible to think in strictly Confucian terms; Buddhist concepts, phrased in Daoist terminology, were by now the standard equipment of Chinese thought. What emerged now was not a simple revival of Confucianism but a

synthesis of Confucianism, Daoism, and Buddhism. Thus the practical (Confucian), romantic (Daoist), and metaphysical (Buddhist) aspects were subtly and unconsciously fused into a Chinese philosophy that was so satisfactory that it remained until the twentieth century the pattern of Chinese thought. There continued to be adherents of Buddhism in one or another of its older forms, but these were minorities and even they tended to look upon their own religious practices as means of insuring good fortune here more than achieving Nirvana later.

A Sublime Art

Landscape as primary subject matter for painting was a happy development. It could express the Confucian sense of ordered relationships, the Daoist renunciation of urban society, with its sense of identity with nature, and the transcendent emotional impact of Buddhism. Thus, it appealed to all and satisfied all. Landscape painting had been long developing from the earliest beginnings of representational art such as we have seen on the Hunting Vases of the Eastern Zhou, through Han, the Six Dynasties, and into Tang. But this had been only a kind of simplified stage setting for the action of figures, who were most important, since they were acting out the narrative. It was not until the end of Tang and the succeeding Five Dynasties (907–960) that landscape was thought of as appropriate in itself as subject matter. During the Late Five Dynasties and Northern Song (tenth and eleventh centuries) artists of great genius developed landscape painting to such heights of excellence that it has been considered ever since to be the most sublime of all subjects for the painters' art in China.

Fan Kuan

Perhaps the greatest landscape painter of all was Fan Kuan (ca. 990–1030). Great painters preceded him, but he is the creator of what may well be the finest single landscape painting ever produced in China (fig. 16.2). It is a monumental composition of towering cliffs rising behind a Buddhist temple, hidden among the trees of a rocky promontory, in the middle distance. From the cliffs a thread-thin waterfall plunges into the valley and is lost in the mist, which envelops the base of the rocky mass, providing a soft light background against which the dark irregular silhouettes of trees and roofs stand out clearly. When one has at last discovered the donkey train (*lower right*), the immense scale of the painting becomes apparent, and the grandeur of the artist's concept of the sublimity of nature, by which humans are dwarfed to almost microscopic insignificance, echoes

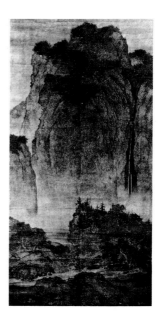

Figure 16.2 *Travelers Among Mountains and Streams,* by Fan Kuan. Ink and slight color on silk. Northern Song (early eleventh century). H. 6′9¼″. National Palace Museum, Taipei, Taiwan, Republic of China.

across the consciousness. Each detail of the painting is meticulously treated, and each of the minute brush strokes is visible in the original. The cliffs are built up of vertical "raindrop" strokes accented by heavier jagged lines at the edges of each mass. The small strokes become lighter and more widely separated toward the base of the cliff until they finally disappear altogether, creating the haze. Different kinds of strokes convey the individual character of the various trees. But it is not the likeness, so much as the "seemingness," of nature that Fan Kuan has captured. Each small stroke seems inextricably united to the next in what we might call a molecular way. The form of each stroke is determined by the nature of the object it represents, while at the same time the reverse is also true: the nature of the object is determined by each small stroke, which makes up its total form. This produces a painting that is not an instantaneous image of a given section of a landscape at any particular moment but a totality produced not so much by the *appearance* of nature as by its *method.*

Absolute manual control combined with complete understanding of the technical aspects of ink, water, and silk are the prerequisites of such painting. To these must be added a profound insight into the truth behind the appearance; here the merely facile technicians are separated from the geniuses. We are told that Fan Kuan gave up studying with the master painters of his day, since he came to realize that the only adequate teacher

was nature itself. He is said to have lived the remainder of his life in seclusion among the mountains. Only such intimate, firsthand knowledge, acquired after years of study and observation of nature in all its moods, could have produced such a painting. Each stroke and groups of strokes, forms and groups of forms must be seen and seen again, and studied and restudied, for one even to begin to become aware of the high quality of the relationships of the parts to the whole. Although Fan Kuan was a Daoist, the sense of order in nature conveyed by this painting is fundamentally Confucian in concept. Each part is logically related to the other, the smallest stroke to the whole, if one is able to trace the relationships. In just such a way was the country of China conceived of in Confucian ethics. The smallest child, in the smallest village of the farthest corner of the empire, was a part of the whole through the system of relationships of younger to elder through the provincial governor right up to the emperor. The system held them in firm and clear relationships one to another. As in the painting, an over-riding sense of the rightness of relationships culminated in a harmonious unity made up of thousands of separate elements.

Guo Xi

Another master of the Northern Song was Guo Xi (1020–ca. 1090). His greatest painting, when compared to the Fan Kuan, seems mannered and less true to the reality of nature (fig. 16.3). The forms of rocks and trees are contorted into a grand, swirling symphony of writhing linear rhythms. There is more ambiguity in depicting relationships of one part to another; the closely spaced small strokes of Fan Kuan have become wider, larger, and softer, creating a tortuous, unreal, visionary landscape—exciting, restless, charged with romantic vitality but conveying less of the truth of nature than the Fan Kuan. By comparison, the work of Guo Xi seems more the invention of an extremely clever conjuror who has raised before our eyes an enchanted landscape, magnificent but unreal. The gnarled and twisted old pines, the writhing rocks, and the distant vistas lack geologic rationale; romantic, intuitive excitement about the landscape seems to be Guo's intent. The virtuosity of the painter seems greater than his own identity with his subject.

Expression of Spiritual Discoveries

Both Fan Kuan's and Guo Xi's paintings are great, but they are poles apart in their conception and execution. Where Fan Kuan's painting displays the careful structures of nature as it exists, Guo Xi's is the poetic suggestion of nature as he thinks it ought to exist or as it might exist. Guo Xi is concerned with suggesting a

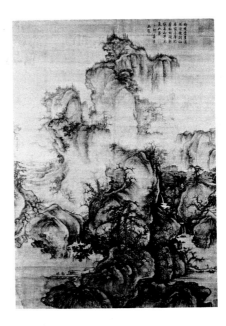

Figure 16.3 *Early Spring,* by Guo Xi. Ink and slight color on silk. Northern Song (eleventh century). H. 5'2¼". National Palace Museum, Taipei, Taiwan, Republic of China.

mood by means of the manipulation of nature, while Fan Kuan rests secure in his penetrating insight into nature and lets it speak for itself.

Like the ancient Han "TLV" mirrors (chapter 12), these paintings may be seen as microcosmic representations, but they differ from them in being not simply *mandala*-like but full-fleshed expressions of the spirit through imagery, with vitality of their own. It was not sufficient to present an illusion of the surface of an object; its very structure and pattern of growth, its "history" of how it came to be what it is, must be conveyed as well. Finally, coherence must be achieved, so that each brushstroke was perceived in an expanding awareness, until the entire painting was taken in as a unity, and from the whole, reflected back into the smallest element. This last principle endowed Chinese painting with the quality of organic unity. The effect on the viewer is rather as though the painting were breathing, inhaling and exhaling, as the observer's awareness of the whole expands and contracts.

From all this it is apparent that painting was looked upon as an exercise in moral virtue; only the most highly disciplined coordination between mind and hand could produce great paintings. But the masterpiece could be achieved only if the mind was guided by spiritual insight.

Among those painters influenced by Chan, this was the reason for painting. They found painting to be the most direct expression of the impact of their spiritual discoveries.

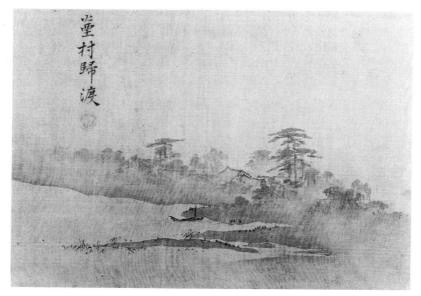

a

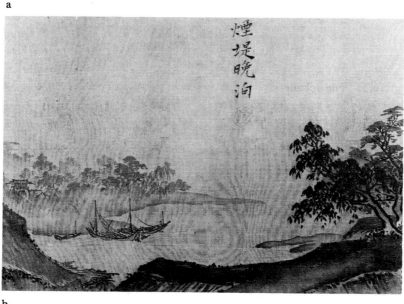

b

Figure 16.4 *a. Twelve Views from a Thatched Cottage*, by Xia Gui. Ink on silk. Second section of handscroll. Southern Song (late twelfth to thirteenth century). H. 11″. Full length: 7′6¾″. *b.* Sixth section. Nelson-Atkins Gallery (Nelson Fund), Kansas City, Missouri.

Xia Gui

After the flight of the Song court south to Hangzhou, the subjects of Song landscape painting became the rivers, lakes, and mists of south China. Xia Gui (1180–1230) was one of the famous painters of these subjects. Xia's style is spontaneous in comparison to Fan Kuan or even Guo Xi (fig. 16.4a). He developed a shorthand manner in which forms are suggested more than depicted. There is more mist than ink; against the void, fragments of nature are silhouetted; the strokes are broad and bold or delicately shaded (fig. 16.4). It is a subjective style that purposely omits large sections of landscape in order to concentrate upon the closer components. It is strongly infused with both Daoist and Chan concepts about nature and reality: that we cannot know reality (the Dao; the Buddha nature) in its totality; we can only glimpse it in its smaller fragments. This is the purpose behind the questions and surprising

answers used by the Chan sect to release the consciousness so that free flights, beyond reason, might be possible; whereby direct, intuitive identification with reality might occur, focusing the attention so suddenly and shatteringly on the material world that it might be penetrated and, in a sudden blazing awakening, perceive the reality behind it.

Xia Gui's direct, forceful brush strokes seem to be translations of natural forms into living ink, and the voids seem to be filled with potential. This recalls the Indian concept about the living rock; the potential to form existing in the unformed. For the Southern Song, empty space, the void, held much the same vitality.

Chan Painters

Liang Kai

Xia Gui's paintings are not as austere as those of the Chan painters. Liang Kai (ca. 1170–ca. 1245) carried the suggestive character of the brush stroke to an almost explosive development. His painting of the celebrated Tang poet Li Bo seems a condensation out of nothingness into the physical form and spiritual concentration of Li's personality (fig. 16.5). The formless void has been made to coagulate into form; *The Buddha-nature Assuming the Form of Li Bo* would be an equally apt title entirely in agreement with the artist's intent. Every touch of the brush to the paper has been more than a translation of form; it has been its distillation. Concentrated, distilled vital power—that is the greatness of this painting. Later artists will employ some of the same visual techniques, but they will indicate only virtuosity. Liang Kai was not interested in "visual effects," nor was he interested in the painting, except as a means of expressing the ecstatic moment. With him it is still virtue, not virtuosity.

The purity of black ink on white paper or silk had a definite metaphysical attraction for painters inspired by Chan. Not only was it the simplest and most direct means, it also partook of the ancient Daoist duality. But for these painters it was not necessary to show the interaction of dark and light in the full range of constantly shifting relationships, as it was for Fan Kuan, for example. It was necessary only to express the absolute relationships as simply and directly as the discipline of their hand, heart, and mind would allow. The spontaneity of these paintings, producing a breathtaking surprise in the viewer, shattered for a moment the attachment to the world of illusion and provided the opportunity for an equally spontaneous reaction in the form of a sudden profound realization that reality is the simple unity behind the multitude of appearances.

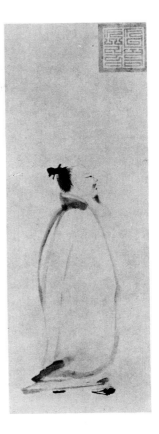

Figure 16.5 *Li Bo Chanting a Poem,* by Liang Kai. Ink on paper. Southern Song (late twelfth to thirteenth century). H. 30⅞". National Commission for the Protection of Cultural Properties, Tokyo. Photo: M. Sakamoto.

Mu Qi

One of the greatest Chan paintings ever produced has as its subject six persimmons (fig. 16.6). It was painted by Mu Qi (active in the first half of the thirteenth century), who was a Chan priest. It is a small painting charged with evocative spontaneity; on compositional grounds alone it is a remarkable work. It could be analyzed bit by bit in terms of spacing, repeat of varied motifs, and so on, but this analysis would result only in a series of broken segments. Analysis is not the key to its meaning; meditation is (that is, long, long looking until what is looked at is *seen*). When the painting has been thoroughly examined, in parts and as a whole, at close range and at a distance, with concentrated focus of the mind, setting the mind at rest and calming the spirit, then the real subject of the painting will make itself apparent.

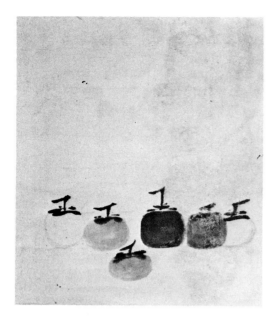

Figure 16.6 *Six Persimmons,* by Mu Qi. Ink on paper. Southern Song (first half thirteenth century). H. 17¾". Daitoku-ji, Kyoto. Photo: M. Sakamoto.

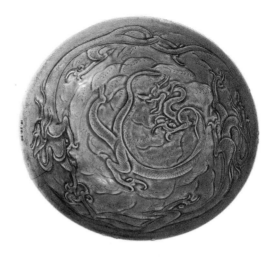

Figure 16.7 Bowl, Yue ware. Carved design of dragons and clouds. Northern Song (960–1127). D. 10½". The Metropolitan Museum of Art, Rogers Fund, 1917.

Six persimmons; can this really be the subject? What makes it such a great painting? But is it six persimmons? Is it the Buddha and five disciples? And here, when the sudden realization rushes in upon the viewer that the subject is the First Sermon, the lightning flash of Chan has occurred. But is it not sacrilegious to interpret six persimmons as Gautama and disciples? Not in Chan terms. That is the whole point: to see the Buddha, Turning the Wheel of the Law, in a group of everyday objects as familiar as persimmons; to behold the apocalypse of St. John in the petal of a flower, so to speak.

Painting in the Song dynasty was as varied as the artists. Subjects included traditional themes from literature and the classics, and there were specialists in flowers and birds, in figures and in landscape. We have spoken of only five paintings, but these are among the grandest products of the painter's art. They are different in appearance and intent from Western painting, but they are no less sublime.

SONG CERAMICS

Of the many crafts practiced during Song, the greatest of all was pottery. After the development of high fired ware in the late Tang dynasty improvements continued to be made in refinement and control of glazes. Even-

tually several types evolved that became standard. They are named after the village or district where they were made; however, a single kiln sometimes produced more than one kind of ware. The major types of Song ceramics are described below.

Yue Ware

Yue Ware is gray stoneware. It has a transparent or semitranslucent gray-green glaze; low-relief carving and incising of designs into clay was done before the glaze was applied. Yue ware has a very long history. It is mentioned in literary records as early as the third century A.D. The bowl illustrated in figure 16.7 is probably the finest example of the Yue kilns in existence. It was made during the Northern Song dynasty (before 1127) at one of the kilns south of the Yangtze River in northern Zhejiang Province, and was superseded by Longquan in the Southern Song.

Cizhou Ware

A northern ware made in Hebei Province is **Cizhou ware.** It may have been in production by Late Tang times. It is cream to buff stoneware with a thin **slip** (liquid clay) of white, covering all but the base. Designs were painted in black slip; or sometimes the piece was dipped first in white, then in black, and the design scraped through the black, producing bold patterns. This is the method used for the vase illustrated in figure 16.8, considered to be the masterpiece of Northern Song Cizhou ware.

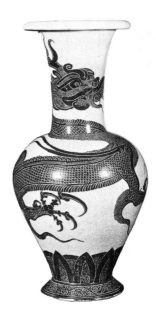

Figure 16.9 Bowl, Ding ware. Pair of swimming ducks and reeds incised. Northern Song (960–1127). D. 8″. Museum of Fine Arts, Boston, Helen and Alice Colburn Fund.

Figure 16.8 Vase, Cizhou ware. Dragon design incised through black slip to expose white slip beneath. Northern Song (960–1127). H. 22⅜″. Nelson-Atkins Gallery (Nelson Fund), Kansas City, Missouri.

Ding Ware

Ding ware is made at Dingzhou, Hebei Province and was the most highly prized type during Northern Song. It is a white thin porcelain with designs incised freely or impressed by means of a mold and covered with a thin transparent or slightly creamy glaze, which collects in lower depressions of designs; the rims are left unglazed and covered with fitted metal bands (fig. 16.9).

Qingbai Ware

Qingbai ware is sometimes called Jingdezhen ware, after the place in Jiangxi Province where it was made. It has a transparent, delicate, aquamarine glaze; the rim is not glazed and except for the color of the glaze it is very similar to Ding ware (fig. 16.10).

Jun Ware

Jun ware is thick buff stoneware made in Henan Province. Its thick translucent glaze is in a range of hue from blue-green through violet (fig. 16.11a). This ware is primarily used for flowerpots and bulb bowls.

Jian Ware

Jian ware is thick purple-brown stoneware made in Fujian Province. The glaze is thick black with brown

Figure 16.10 Bowl Qingbai (Jingdezhen) ware. Song (960–1279). D. 7″. Collection of the Santa Barbara Museum of Art, gift of Wright S. Ludington in memory of Charles Henry Ludington.

or metallic streakings running toward the base, where the glaze stops in a thick welt above the foot of the bowl, which is left unglazed (fig. 16.11b). The teabowl was the only product of the Zhianyang kiln. These bowls became very popular in Japan, introduced there by the Chan masters.

Henan Black Ware

Henan black ware is a northern black ware made in several centers in North China but mostly in Henan Province (fig. 16.12). Black wares of the Tang dynasty may be predecessors. Related black ware is made in nearby Hebei Province at Cizhou and other districts. The use of supersaturated iron in painted designs seems

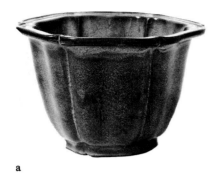

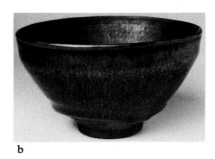

a

b

Figure 16.11 *a.* Flower pot. Jun ware. Song (960–1279). H. 9″. Asian Art Museum of San Francisco, the Avery Brundage Collection.

b. Teabowl, Jian ware. Song (960–1279). H. 2¾″. Asian Art Museum of San Francisco, the Avery Brundage Collection.

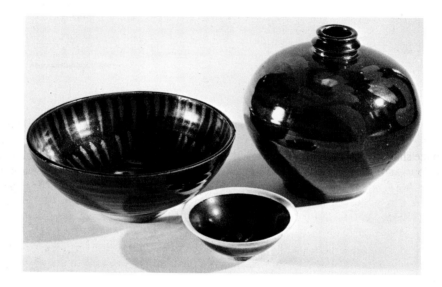

Figure 16.12 Henan black wares. Song (960–1279). H. (globular vase) 7½″. Stanford University Museum, Mr. and Mrs. Stewart M. Marshall; Wm. S. Picher.

to reflect an admiration for the Jian ware when the strokes are vertical and painted on bowls (fig. 16.12). The floral designs painted on globular jars and vases are more directly reminiscent of the Cizhou designs. They share the powerful and free brushwork. The combination of rust and black in the Henan products produces a richer, but not so striking, effect as that seen in Cizhou painted examples.

Longquan Ware

Made in Chekiang Province, **Longquan ware** is the descendant of the long and distinguished line of Yue wares

(fig. 16.13). In Southern Song it developed rather quickly into a position of greatest prominence. It is gray-white high-fired stoneware with a thick translucent glaze ranging from blue-green to dove-gray. The glaze is filled with minute bubbles formed from gases during firing. These bubbles refract light to produce what to the Chinese was the greatest triumph of the potters art: porcelain, which rivaled jade in its unctuous translucent lustrous quality. Another group, probably only a further development of Longquan, is called **Guan** (official) **ware** (fig. 16.14). It is usually less brilliant in hue, tending toward the green-grays and blue-grays, and it has definite crackle in the glaze, imitating the

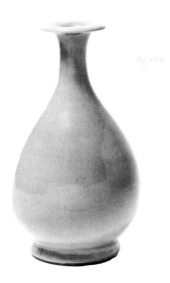

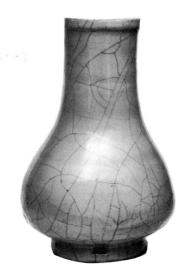

Figure 16.13 Bottle-shaped vase, Longquan ware. Southern Song (1127–1279). H. 10½″. Asian Art Museum of San Francisco, the Avery Brundage Collection.

Figure 16.14 Vase, of archaic shape, Guan ware. Blue-gray glaze; brown crackle. Southern Song (1127–1279). H. 10″. The Metropolitan Museum of Art, Mrs. Samuel T. Peters, 1926.

veins and cracks in old jade. It is interesting that this ware is most frequently made in imitation of ancient Shang and Zhou bronze shapes, indicating both the antiquarian interest of Song and the desire to reserve this ware for the most time-honored shapes.

As early as the Tang dynasty the green-glazed Yue wares were exported as far as Fostat (Cairo) in Egypt. The twelfth-century sultan of Damascus, Saladin, was passionately fond of Chinese export green wares. It is in fact possible that the French term for them (*celadon*) is derived from his name.

It is one of the great ironies of history that the same generation that saw the benevolent gift of Longquan to the outer world also saw China receive in return the most malevolent invasion of conquerors in the history of the world, the Mongols.

SUMMARY

The Song dynasty was divided into the Early, or Northern, and the Late, or Southern eras, when the court fled south in A.D. 1127 to escape the barbarian invaders who had captured North China.

The Song emperors had been pacifist and conciliatory, tending to concentrate more on the aesthetic life of the court than on the military strength of the country. The displacement from the north to the south affected the character of the art produced during the Song dynasty. The Buddhist sculptures produced for northern temples that had been reestablished after the great Tang persecution exhibit a degree of realism unknown even in Tang.

Northern Song painting was dominated by a new interest in landscape, although older subjects also continued to hold the attention of artists specializing in birds and flowers or figures and genre scenes. Fan Kuan, the master of the Northern Song, painted landscapes from firsthand and intimately observed experience. With a meticulous technique, his paintings present nature in her awesome grandeur. Guo Xi employs a less literal rendering, with a generalization of forms in a more broadly treated manner, substituting washes where Fan Kuan would have insisted upon minute individual brushstrokes to convey the sense of rocks and trees.

The move to the south involved re-establishing the court in a new setting and climate at the head of Hangzhou Bay on the east coast. The lakes, rivers, and mists of the region fulfilled the artists' desire to present in painting the good life of the classical past. The outgoing spirit of Tang had become introspective, and China now looked to its own past for its inspiration. Confucius was regarded as the perfect model of the scholar-gentleman. Re-examination of his thought produced the Neo-Confucianism of Song. But this was actually a blend of Daoism and Buddhism with Confucian ideas and attitudes. The new synthesis was admirably expressed in landscape painting and thus the southern landscape seemed particularly well suited to the new blend.

In this novel style the landscape is not so much described as it is suggested. A tree, a rock, the edge of a stream, a distant peak emerging from and enveloped in

the humid southern mists appealed to the nature-loving sensibilities of the court and the city dwellers alike. These paintings seem to have a metaphysical aspect suggested by the way the painters handled the broad washes that represented soft mists. This contrast between what was seen and what was merely implied, or the void, probably symbolized the Buddhist concept of *sunyata,* the void from which all form originated and into which it will eventually be reabsorbed. Southern Song landscape paintings are suffused with a deep sense of calm and peaceful repose, a perfect mood for meditating on nature and our relation to it.

Chan painting demonstrates the potential of painting to stir the deeper consciousness to the point where we suddenly "see" what we have previously only been looking at. This seeing in the physical sense is but a symbol of the seeing or perceiving in a spiritual sense. The translation of forms into brushstrokes, characteristic of Southern Song painting in general, is even further condensed in paintings by Chan masters.

The heights of subtlety attained in painting were paralleled in other arts, particularly that of ceramics. The wares were known by the names of the villages that produced them; they ranged from stonewares to near-porcelain and in hue from a combination of black-and-white designs to the subtlest shades of gray-blue or violet-blue to frosty green.

There were probably many secrets and techniques known to families and villages of potters. But the one overriding "secret" of the unique gift of China's potters to the world lies in the bubbles in the glaze. For it is these bubbles that contribute to the translucent quality of the glaze. These minute globules are the result of gases that formed from the various chemicals present in the glaze and are associated with certain conditions of firing. No other country developed translucent glazes to the same degree as China; certainly no other potters ever produced such noble products as the potters of Song.

Although there is some loss of vigor when one compares the arts of the Tang with those of Song, there is a gain in elegance and quality in the arts of the Song dynasty which makes this the high water mark of Chinese achievement.

GLOSSARY

Cizhou ware Northern Song period; buff to gray stoneware with white covering all but the base, designs painted in black slip (also carved, many variations). (p. 156)

Ding ware Northern Song period; white thin porcelain with designs incised freely, or impressed by means of a mold, then covered with a thin transparent glaze. (p. 157)

Guan ware Southern Song period; gray-white high-fired stoneware with a thick translucent glaze of green-gray to blue-gray; a definite crackle in the glaze imitates old jade. (p. 158)

Jian ware Song period; thick purple-brown stoneware with a thick black glaze and brown or metallic streakings. (p. 157)

Jun ware Song period; thick buff stoneware, with a thick translucent glaze, blue-green to violet in color. (p. 157)

Longquan ware Southern Song period; gray-white high-fired stoneware with a thick translucent glaze from blue-green to dove gray. (p. 158)

Mandala circle Microcosmic diagram of cosmos. Basis of Indian temple plans and of Chinese cosmic mirrors (see Glossary, chapter 12). (p. 153)

Neo-Confucianism A reformation of Confucianist thought in China, involving a synthesis of Confucianism, Daoism, and Buddhism; Song dynasty. (p. 151)

Qingbai ware Song period; thin porcelain with a delicate, transparent aquamarine glaze. (p. 157)

Slip Liquid clay applied to an unfired body of the vessel. (p. 156)

Yue ware Song period; ceramics of gray porcelain with a gray-green glaze; the clay was sometimes carved before the glaze was applied. (p. 156)

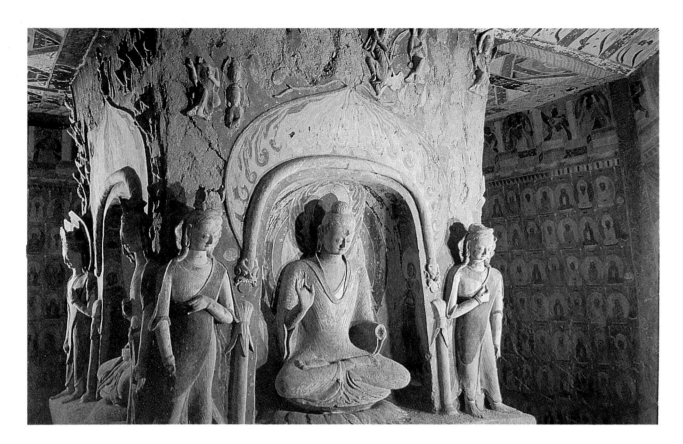

Colorplate 7 Buddhas of the Four Directions on the central shaft,
cave 248, Dunhuang. Painted clay. About life size. Northern Wei
dynasty (sixth century).

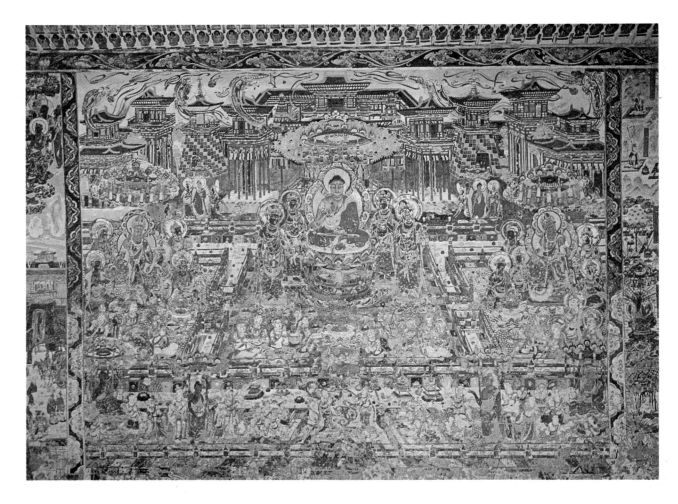

Colorplate 8 Dunhuang, cave 217. Wall painting of paradise. One of the Four Paradise Buddhas and entourages. Note Tang style architecture in background. Tang dynasty (first half eighth century). © Kodansha Images/The Image Bank.

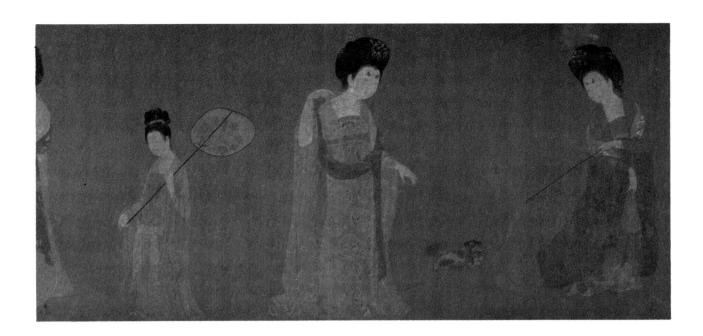

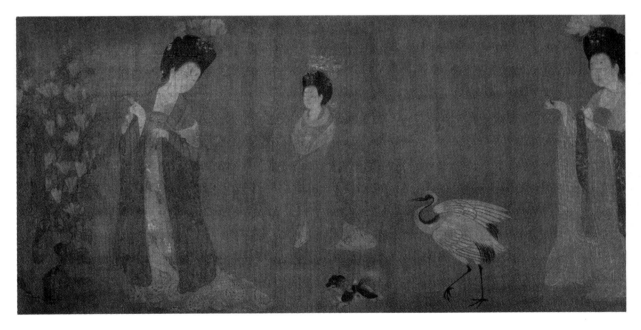

Colorplate 9 *"Ladies-in-waiting."* Handscroll. Ink and color on silk
by Zhou Fang (active ca. 780–810). H. 7¾″ (total length 18″).
© Kodansha Images/The Image Bank.

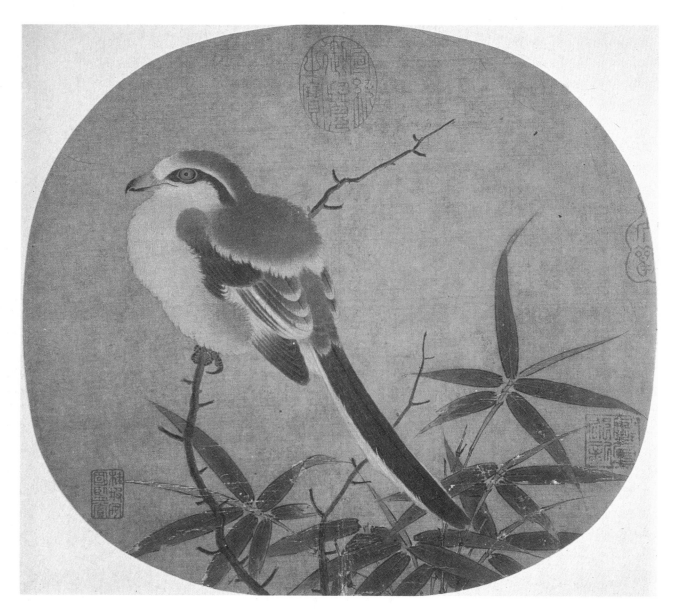

Colorplate 10 *Shrike,* by Li Anzhong (ca. 1110). Ink and color on
silk. H. 10″. National Palace Museum, Taipei, Taiwan, Republic of
China.

17
.

THE MONGOL CONQUEST
The Yuan Dynasty (1260/80–1368)

Genghis Khan united the nomadic tribes in Mongolia and from 1211 to 1215 pushed into north China, destroying the land behind him by sowing salt in the fields. By 1221 he had turned westward and conquered central Asia and Samarkand. Genghis divided the vanquished lands between four of his sons before his death, in 1227. By 1279 his grandson, Kublai, had swept through China and ruled Korea, Tibet, and Manchuria as well. By the end of the thirteenth century four great Khanates held in subjugation all the land from Poland to Korea and from Siberia to Vietnam, including Persia and part of Arabia. Two attempts by Kublai to invade Japan were thwarted. This Yuan dynasty ruled from 1260/80–1368.

EFFECTS OF THE MONGOL CONQUEST

The effects of the Mongol conquest of China can hardly be overstated. It is estimated that 50,000,000 Chinese were killed; almost half the total population. China never fully recovered from this destruction at the hands of the Mongol hordes, who were not so numerous as they were efficient and ruthless.

Few Chinese were willing to work for the barbarous intruders; therefore other foreigners, Persians, Turks, and Central Asians, were placed in administrative offices.

In spite of the terrible agony by which they had brought China to its knees, the Mongols seemed to wish to forget this phase as soon as possible and to accept Chinese customs and manners. The Venetian Marco Polo (ca. 1254–ca. 1324), who stayed seventeen years in the service of Kublai Khan, spoke glowingly of the advanced Chinese civilization and of Hangzhou, the Southern Song capital, as the noblest and grandest city on earth. Polo's arrival in China in 1275 coincided with the last efforts of the Song to hold back the invaders, and the Mongols' consolidation of the empire, that is until 1292, when Polo left China to return home. It is doubtful if he had any clear idea of the magnitude of the Mongol destruction. Failing in his attempt to have Rome send Christian missionaries to convert his subjects, Kublai resorted to Buddhism (the Tibetan form known as Lamaism) as a means of civilizing his Mongols and of assimilating them into Chinese society.

ART REFLECTS POLITICAL STYLES

The painters of the Yuan dynasty held the Song government responsible for allowing their country to be overrun by the Mongols. Yuan artists saw the military weakness of Song reflected in the Southern Song landscape paintings, which seemed to them to express a soft sentimentality both in the choice of subjects and in their use of broad, graded washes of ink. These paintings seemed to have exchanged the structure and strength of the Northern Song styles for effect and evocation of mood.

Some Yuan painters rebelled by discarding washes from their painting methods, while others substituted dry brush. The break with the Southern Song tradition made it necessary for painters to rely more upon their own resources rather than upon ready-made technical formulas of tradition. This led to more individual styles and eventually to greater eclecticism than had previously existed in Chinese painting. Both these qualities, innovation and eclecticism, became hallmarks of succeeding styles in the Ming and Qing dynasties.

YUAN PAINTERS

Even during the Northern Song period Zhejiang Province (see map, p. 91) had been of major importance for the development of painting; with the move from the north to Hangzhou, the Southern Song court had attracted many of the best. Zhejiang continued to produce the finest painters in the Yuan dynasty. Two only can be dealt with here; both Qian Xuan (ca. 1235–90) and Huang Gongwang (1269–1354) were scholar-officials who retired from public life; Qian Xuan when the Mongols came to power and Huang Gongwang after serving them a short time.

Qian Xuan

Qian Xuan based his style on the birds and flowers paintings of the tenth century, while Huang Gongwang found inspiration in the tenth-century landscapes of the Zhejiang area. Both painters are of interest and significance, since they are typical of the new developments of Yuan.

Qian Xuan, in his *Early Autumn,* has transformed both the technique and the style of his predecessors into a characteristically Yuan painting (fig. 17.1). The intricate detail of earlier painters is retained, but their fine ink lines are gone. Washes of color alone indicate the forms. The atmospheric depth, fading into mist, is a Southern Song characteristic, as is the preference for the small segment rather than the panoramic view of nature. Here, however, the artist has brought us right down to the grass roots, showing us only four running feet, of nature (fig. 17.2). Dragonflies devour mosquitoes; the frog hungrily eyes the dragonfly; beetles and grasshoppers munch on the green foliage. What appears at first to be a lyric delight in the depiction of natural elements takes on a melancholy aspect. A strong sense of allegory pervades the painting; perhaps the devastation of China's fertile lands by the Mongols may

Figure 17.1 *Early Autumn,* by Qian Xuan. Handscroll, colors on paper. Yuan (second half of thirteenth century). H. 10½″; L. 47¼″. The Detroit Institute of Arts.

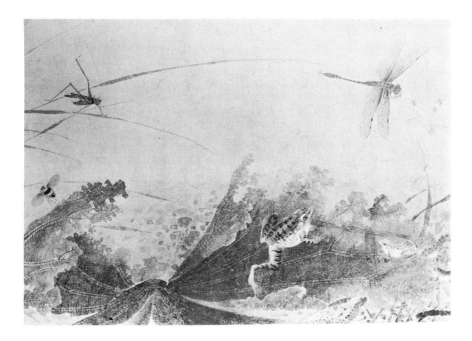

Figure 17.2 Detail of figure 17.1.

be the symbolic intent. The Southern Song landscape painters had used the fragment of nature to suggest the unencompassable whole. Perhaps Qian Xuan wishes also to suggest, by this tiny disaster in the natural realm, the vastness of the human tragedy.

Huang Gongwang

In the next generation, Huang Gongwang expresses less of the tragic than of the escapist—the old Daoist retreat from society into the hills (fig. 17.3). He did in fact become a Daoist priest and spent the remainder of his life in the Fuchun Mountains west of Hangzhou. His style is more spontaneous than his predecessors, Dong Yuan and Juran, who had painted in the Zhejiang area three centuries earlier. Huang Gongwang's style is also drier, less dependent on washes than on strokes, more freely and loosely applied. There is less

interest in nature than in scenery and less emphasis on specifics than on the generalities of natural form. Horizontal blobs of dark ink stand for tree foliage; long-arched dry lines represent rock masses; undulating dry lines denote waves. But the vigorous freshness unencumbered by detail more than compensates for the loss of the Song formula, which was being carried on by lesser painters during Yuan. It is his boldness and audacity that attracts us to Huang Gongwang and that gained him the admiration of later Chinese painters.

In comparison to Song, Yuan landscape painting seems to be more sketchy and drier. The soft washes and fluid lines of Song were abandoned in favor of less romantic austerity of unpainted areas and dry-brushed lines. It is a reaction against the Southern Song style, which the Yuan painters associated with the sentimental weakness that had allowed their country to be overrun by the Mongols. Yuan painting is a reassertion

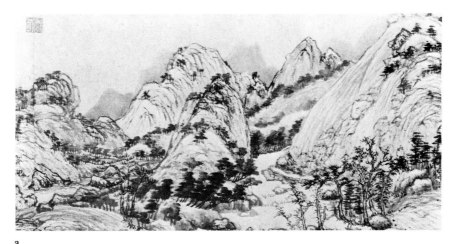

a

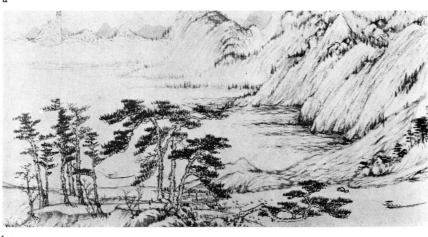

b

Figure 17.3 *a. Dwelling in the Fuchun Mountains,* by Huang Gongwang. Handscroll, ink on paper. Yuan (dated 1347–50), section 4. H. 12⅞″; full L. 20′11″. National Palace Museum, Taipei, Taiwan, Republic of China. *b*. Section 6.

of the native strength that had overcome previous invaders and that would eventually overpower even the Mongols.

YUAN POTTERY

Most of the Southern Song pottery kilns continued into the Yuan dynasty. In general their products became heavier-bodied, while the shapes tended to be sturdier and more robust (fig. 17.4).

A finer quality of white porcelain was produced, but the glaze had a strongly aquamarine hue reminiscent of the Qingbai wares of Southern Song. The Yuan learned to apply this transparent glaze very thinly and this makes the color less evident.

Another major achievement was based upon an earlier accomplishment and refined during the Yuan. It is the technique of underglaze blue painting on white porcelain (fig. 17.5). The Tang potters of Changsha in Hunan Province had invented a system of painting with a brush directly onto the clay body and then covering the vessel with a transparent glaze. But while the Tang had used copper and iron as colorants, cobalt became the dominant pigment during the Yuan era. There was some experimentation with reducing copper, but it was difficult to control due to the fact that the subsequent transparent glaze often tended to prevent complete reduction. The resulting hue might be blackish or greenish or a nondescript combination rather than the desired red. The Yuan potters were able to obtain fine, rare cobalt from Persia. It must have been a delight for them to discover that cobalt is "true blue" and foolproof; whether oxidized or reduced, it produces the brilliant deep sapphire blue designs painted in cobalt on the white porcelain, covered with a transparent glaze. These have become well known to the West as "blue-and-white."

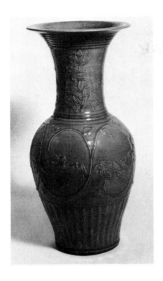

Figure 17.4 Celadon vase. Yuan dynasty (first half of fourteenth century A.D.). H. *29″*; D. *12″*. Asian Art Museum of San Francisco, the Avery Brundage Collection.

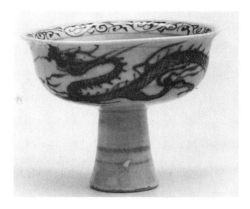

Figure 17.5 Stem cup. Blue and white porcelain. Yuan dynasty (first half of fourteenth century). H. *3⅜″*; D. *4⅜″*. Asian Art Museum of San Francisco, the Avery Brundage Collection.

Yuan crafts such as porcelain did not experience as negative effects of Mongol rule as painting did. This can be attributed to the fact that the craftspersons did not enjoy the same freedom as artists possessed. Porcelain production by the end of Song was a complex and highly technical operation requiring the joint efforts of hundreds of workers at the larger centers. Under Yuan the city of Jingdezhen in Zhiangxi Province was established as the official center for the production of porcelains for the court. There, both copper-red and cobalt were used for underglaze painting. Cobalt designs produced the blue and white ware that became so popular with the later rulers and was eventually exported in great quantity to other Asian countries and to Europe.

SUMMARY

The Chinese reaction to the Mongol conquest profoundly affected all the arts. Many officials, among them several well-known painters, refused to work for the new government, so Kublai Khan turned to foreigners to fill the gap. The arrival of Marco Polo just at this time made it easier for him to be accepted by the Khan than it might have been in other periods and for him to be given a position of trust.

Many of the finest painters of the Yuan period came from Zhejiang Province, once again indicating this area's rich contributions to the cultural history of China.

Recall that this region had been the center not only of much of the finest Song painting but also for the exquisite green ceramics of both Tang and Song.

Because the pacifist qualities of Song were now perceived as military weakness, the Southern Song style of painting was despised by many early Yuan painters who associated it with the military unpreparedness that had permitted the Mongol conquest. The soft misty washes of Southern Song landscapes were abandoned in favor of techniques of a less romantic nature. Instead of the facile transformation of forms into brushstrokes, Yuan painters adopted a dry-brush technique that by comparison seems awkward and brusk. Description replaced suggestion, and instead of the euphoric effects of graded tones, Yuan landscapes confront us with a stark prospect defined by blunt and ragged strokes and filled out by scrubbed-on grays in ungraduated tone. Whereas Southern Song landscape paintings were almost entirely covered with ink washes over the entire surface of the silk, Yuan paintings leave a good deal of the paper showing, thus altering the mood drastically from one of cohesive tonality to one of contrasting lines and clumps strewn across the white paper.

Many of the ceramic centers continued to produce through the Yuan dynasty. Two great innovations occurred: at Cizhou the use of overglaze enamels was introduced and at Jingdezhen underglaze designs were painted directly upon the ware in underglaze cobalt, which produced a blue, and in underglaze copper, which produced a red design when covered with a transparent glaze and fired at a high temperature. The blue and white, especially, was exported widely.

18
.

THE MING (A.D. 1368–1644) AND QING (A.D. 1644–1911) DYNASTIES

MING DYNASTY

In 1333 great famines began in China and lasted for fifteen years, followed by floods in the Yellow River valley. Local uprisings became frequent, and finally in 1368 the first Ming emperor seized Beijing, the Yuan capital, destroyed the Mongol power, and established the Ming dynasty (see map, p. 111). In 1421 the third emperor moved the Ming capital from Nanjing to Beijing, as protection against the Mongols, who had fled north beyond the Great Wall.

The traumatic shock of Mongol rule caused the succeeding Ming dynasty to look back to the Song, Tang, and Han as their models in government and culture. The alien Yuan dynasty had caused a bitter resentment of foreigners, foreign religions, and customs. The reaction was a return to the native traditions in which Confucianism was given the place of honor. The Ming was a period of strong nationalism in which the Chinese way in all things was promoted as best.

Painters: Professional and Amateur

Painting during the Ming dynasty continued in two streams, the conservative professional painters and the individualist scholar-gentlemen "amateurs." The outstanding representative of the former was Qiu Ying (active first half sixteenth century), who was of humble origin and who began his career as a professional painter but, by his great talent alone, rose to become one of The Four Great Masters of Ming.

Qiu Ying was skilled in a variety of styles and copied old masters with accuracy and spirit. He revived the "blue and green" style established by the Li family in the Tang dynasty (fig. 14.7). It became the favored style for depicting such legendary subjects as Daoist paradises and dream landscapes. He used it to embellish a popular folk tale about a young man who, when out in his boat in the winter, sees peach blossoms drifting downstream. The young man follows the stream to its source, a cave in a cliff. He enters and discovers that it goes right through into a beautiful valley, where people live in harmony and where it is always springtime. This utopian tale is amplified by the sumptuousness of Qiu Ying's treatment (colorplate 11). In exquisite detail the figures are seen in their everyday activities, strolling along paths, having tea, and enjoying conversation and other diversions against the backdrop of brilliant green and blue mountains hugged by elegant white clouds. The sections shown here represent about two-thirds of the composition. The most prominent element is the mountain range, made up of the central peak and foothills on either side.

The relationship between this painting and the Qing Shan (Green Mountain) erected by Kublai Khan in Beijing is fascinating to consider. The Qing Shan is made up of a major central peak with two minor ones on either side, very similar to but more regular than the painting. Why did Kublai decide to build such a mountain? Blues and greens, especially turquoise and malachite, both ores of copper, were the primary colors of precious stones in the earliest periods of Chinese history. They were used as inlays on precious ceremonial objects as early as the Shang and Zhou dynasties (figs. 11.7*a* and 11.16); Lonquan (celadon) green and blue and white were the two most produced wares of the Yuan dynasty, as well as the most exported. The green wares had been exported as early as Tang and the bulk had gone to Islamic rulers in the great centers of Islam in the Middle East. The Mongols were nomadic; it was the green fields of China that invited them, so hungrily, to the country—to provide food and forage for their ever-increasing numbers of people and animals. Green has a special aura in desert nomads' symbolic colors. It is simply the color of life.

Added to these considerations must be the possibility that Kublai had seen old paintings of the blue and green school, perhaps from the Tang period, among some of the looted collections in the palaces or in private hands. In any case the admiration of blues and greens in all their variations was common to the Chinese and their conquerors. The simple fact that the tradition of blue and green painting had already existed before Kublai might, in itself, be enough inspiration for his Green Mountain, as it might be for the revival of the style by Qiu Ying, but, given the historical and political aspects of the question, it seems that both the mountain and the painting style have multiple inspirations. And it seems more than probable that Kublai's mountain served as a special kind of inspiration to the painting style for Qiu Ying, which he would have known from actual paintings as well. We may, therefore, have in the *Peach Blossom Valley* the best idea of what Kublai's mountain looked like when new.

It is especially interesting to consider that the style became associated with subjects of utopian or paradisal character, that is, unreal subject matter. For, at least in the Li Zhaodao painting the subject is certainly not of such a nature (fig. 14.7). It has to do with an emperor fleeing his own capital. It is not a lovely story, and it is a tragedy both personal and national. It may have been Kublai who transferred the character of paradise to the blue and green style. If so, it was certainly the nomadic sense of paradise as a green oasis that inspired his remarkable garden.

Kublai laid out his city around the Qing Shan as a focal center but also as a symbol of the Mongols' quest and as a monument to their success. In the latter sense, and in good Mongol tradition, it was a kind of open air

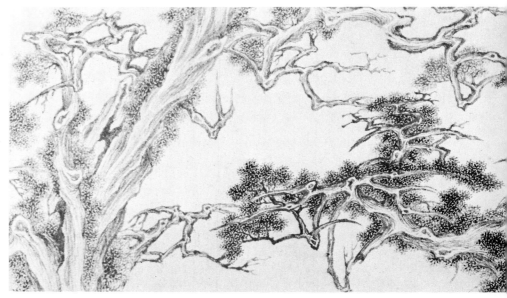

section 6

Figure 18.1 *Seven Junipers,* by Wen Zhengming, sections 5 and 6 of handscroll. Ink on paper. Ming (dated 1532). H. 11¼″. Full L. 11′10½″. Gift of Mrs. Carter Galt, 1952. Honolulu Academy of Arts.

trophy room. In their conquest of China the Mongols piled up skulls into large pyramids at crossroads to warn and terrorize the living. Kublai's trophies were the most beautiful blue and green rocks and the most splendid shrubs and trees taken from all corners of the conquered nation and arranged in five peaks east to west across the north-south axis of the city.

Perhaps the most representative example of the individualist scholar-gentleman "amateur" stream of painting during the Ming dynasty is Wen Zhengming (1470–1559), a descendant of a famous Song hero. Wen's father and grandfather had been officials and scholars, and he himself served for a time as a compiler of the official record of the Yuan dynasty in the Hanlin Academy, the citadel of Confucian literacy, at the Ming court. He returned to his native Jiangsu to devote his life to scholarly and artistic pursuits. He was a friend of most of the great painters of the day, both conservatives and individualists, and painted in several styles. Many of his descendants are numbered among the later prominent painters and calligraphers. Wen Zhengming established the position of the amateur individualist painter as superior to that of the conservative professionals.

The rugged individualism of Wen's personality is expressed in the peculiarly complex rhythms of his *Seven Junipers* (fig. 18.1). This was created in his mature style, when symbolic expressionism seems to

have been his goal. The seven trees were a famous landmark in his home province, but they acquire a uniquely human quality under the dry-brush-and-dot technique of Wen, as if he were painting seven very old and wise gentlemen who had weathered the storms of life. The Confucian ideal permeates the painting; the indomitable spirit of the grotesquely gnarled trees becomes that of Confucianism itself: in spite of external vicissitudes, the Right prevails.

Buddhism fell to low esteem during the Ming dynasty, in reaction to its espousal by the Mongols. Buddhist sculpture was produced, but the best seems to have been made for Confucian temples (fig. 18.2). The best of these exhibit a subtle fusion of line and mass, which creates an awesome dignity.

Ceramics

The most important ceramic center during the Ming dynasty was at Jingdezhen. The technique of underglaze blue was popular (fig. 18.3), along with the overglaze three-color wares using red, green, and yellow enamels, either alone or in conjunction with underglaze blue designs. Monochrome porcelains were also produced, with white and red most favored. Hundreds of thousands of pieces of porcelain were ordered in some years for the use of the emperor and the court. Tens of thousands of families were employed at Jingdezhen in the mass production of these wares.

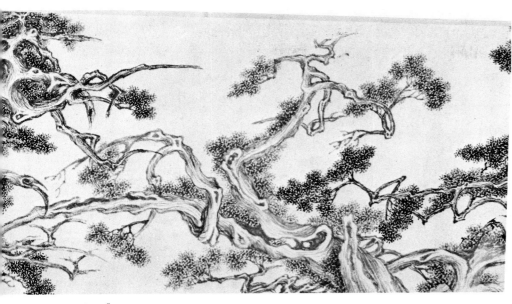

section **5**

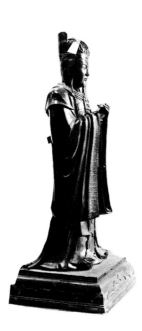

Figure 18.2 Confucius (?). Bronze. Ming (sixteenth century). H. 5'10''. Stanford University Museum, Daniel C. Jackling.

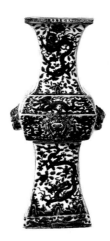

Figure 18.3 Square vase. Blue and white porcelain. Ming, reign of Wan Li (1573–1619). H. 18¼''. Stanford University Museum, Mortimer C. Leventritt.

QING DYNASTY

Although the Ming dynasty came to an end in 1644, when the Manchus invaded China from Manchuria, the new rulers maintained the Ming systems of government and cultural continuity was unbroken. The Man-

chus recognized the superiority of Chinese civilization, even though as a class they kept strictly to themselves.

They established the Qing dynasty and retained Beijing, close to their own origins, as their capital. Qing dynasty arts are a continuation of the developments of the Ming but with greater emphasis upon intricate patterns, brilliant colors, and technical perfection.

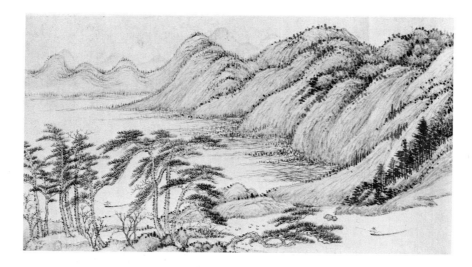

Figure 18.4 Landscape scroll by Wang Hui. Ink on paper. Copy of Huang Gongwang's *Dwelling in the Fuchun Mountains* (see fig. 17.3*b*). Qing (late seventeenth century). H. 15⅛"; full length 24'4¾". Freer Gallery of Art.

Painting

Traditionalists

The traditionalists tended to be eclectic and painted with great virtuosity in one or another of the many earlier styles. Perhaps the most famous traditionalist was Wang Hui (1632–1717), one of the four Wangs who were among The Six Great Masters of Qing. Wang Hui is known to have copied many old paintings; figure 18.4 shows a section of the handscroll that he copied after Huang Gongwang's *Fuchun Mountains* (fig. 17.3).

Comparison of the Yuan painting with Wang Hui's copy reveals expected differences between a copy and an original, but it also shows how Qing painting differed from its predecessors. One might say that the Wang is just like the original except in everything. All the elements are there; they are spaced and composed in very much the same way. But the difference lies in the degree of condensation of strength into the individual brushstrokes. There are fewer strokes in the Yuan painting and they seem brisker, creating a staccato visual percussion. In the copy Wang has covered more of the paper with strokes that are spottier; the entire rendition is softer and sweeter than its prototype; it is more carefully rendered. This technique produces a painting that emphasizes the decorative over the expressive character. The spontaneous quick brush of Huang Gongwang has become with Wang Hui an almost tediously timid but reverential imitation of appearance; it lacks the spirit that inspired Huang's technique. This is a characteristic of Qing traditional painting; and it should be remembered that Wang Hui was considered among the very best of his time. This indicates that those values so admired in the Song and continuing in the Yuan—spirit, structure, life force— were interpreted in Qing in more decorative terms. Among traditional painters careful rendering replaced the power of spiritual insight.

Individualists

The individualist painters of Qing are among the most spirited and exciting artists in China's long history. They departed so far from traditions that they were little appreciated outside their own circles and only now are becoming generally recognized. One of these was a Nanjing painter, Gong Xian (ca. 1617–89). His paintings are monumentally organized compositions made up of strong vertical and horizontal forms built up from soft, broad strokes (fig. 18.5). Line is almost nonexistent, and the paintings depend upon light against dark edges for their clarity. The ink tones range from almost pure white paper to deep rich blacks. There is a stark somberness about these paintings that indicates, for Gong Xian, that landscape was a source of awe and mystery, not a subject for making mere pictures of scenery.

Another individualist, perhaps the most powerfully dramatic of all, Zhu Da (1626–1705), seems to have had an unerring sense of composition. Zhu Da's small paintings of flowers, humorous fish, or sulking birds recall the spontaneity and strength of Mu Qi or Liang Kai. Appearing inept at first, these paintings exert an increasingly magnetic attraction as one studies them (fig. 18.6). In a great explosion of quick expression, Zhu Da seems able to concentrate in a few strokes all that can be said of his subject.

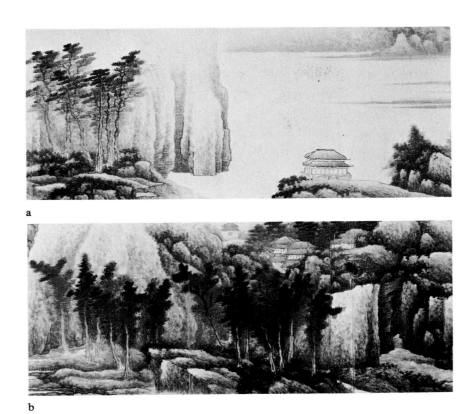

a

b

Figure 18.5 *Landscapes,* by Gong Xian. Handscroll, ink on paper. Qing (late seventeenth century). *a.* Section 2. H. 10½''; full L. 31'10''.

b. Section 6. Nelson-Atkins Gallery (Nelson Fund), Kansas City, Missouri.

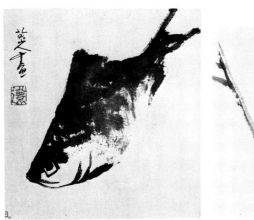

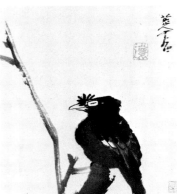

Figure 18.6 Two sheets from an album of ten paintings by Zhu Da. Ink on paper. Qing (seventeenth century). H. 10¹/₁₆''. Freer Gallery of Art.

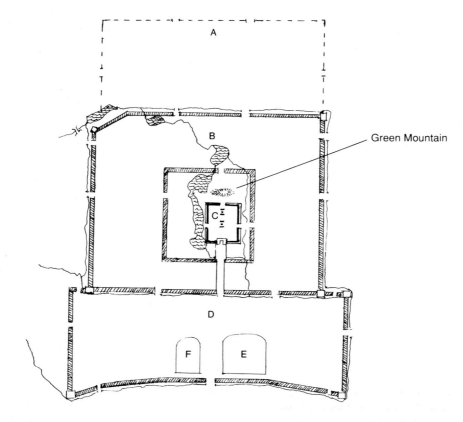

Green Mountain

Figure 18.7　Plan of Beijing. *a.* Yuan dynasty north wall (removed in Ming dynasty); *b.* inner city; *c.* Imperial Palace within the Imperial (Forbidden) City; *d.* outer city; *e.* Temple of Heaven; *f.* Temple of Agriculture.

Architecture: A Town Plan

Architecture of the Ming and Qing dynasties may be studied in the best remaining example of a capital city. Better than other extant cities, Beijing preserves the concepts of traditional Chinese town planning. The site that it occupies has a long history. It was the location of the capital of the state of Yen (sixth to third century B.C.) during the Eastern Zhou dynasty, then it was destroyed in the third century B.C. by Qin Shi Huang Di. Centuries later the site was the capital of the Jin dynasty (A.D. 1122–1234). In 1215 the Jin city was burned by the Mongols, who overthrew the Jin regime in their drive to subdue all of China. In 1264, Kublai Khan decided to establish his new capital there and called it Khanbalic (City of the Khan).

The Grand Canal, which had been started during the Sui dynasty, was extended north to the region of Beijing by the Mongols in order to supply the capital from the rich agricultural regions of the south.

Marco Polo, who arrived a decade after the establishment of the new Mongol capital, was entranced by the newly designed metropolis and reported that it was so beautiful it was beyond description. He admired the regularity of its plan with spacious, straight streets intersecting at right angles and separating the blocks of houses. The city was a walled rectangle oriented to the points of the compass and was somewhat longer north–south than east–west.

The plan of the Yuan city was retained when the Yong Le emperor moved the capital from Nanjing back to Beijing in the early Ming dynasty, but some modifications were made. The north wall was abandoned and a new brick wall was built almost a mile to the south. The east and west walls were faced with brick, covering the earlier tamped earth wall, while the wall on the south was moved farther south so that the effect seems very much as though the entire city wall had been lifted up and moved (fig. 18.7). A small loss in size resulted: the Yuan capital was sixteen miles in circumference, but the Ming capital was only fourteen. In the sixteenth century a broad rectangle was enclosed adjoining the southern wall, increasing the overall perimeter to about twenty-four miles and, in effect, making two cities. The first came to be known as the Inner City and this new one as the Outer City.

The Imperial Palace

Within the Inner City lay the **Imperial Palace** (the so-called Forbidden City of the Qing dynasty), surrounded by a wall and a moat two miles around. Although the old walls of Beijing were removed in the latter half of the twentieth century, the palace walls have been retained. The Imperial Palace as a whole has been maintained as a museum under the People's Republic. The buildings were established in the Ming dynasty, though many were remodeled at later times and have been restored and repainted more recently.

Layout

The palace is laid out symmetrically on either side of the long avenue that runs from the south wall of the Outer City through the Inner City into the imperial city, and thence straight through the Imperial Palace precinct. The palace, begun in 1406 and renovated and restored as it is, still retains the features of the original plan. An embassy, approaching from the south, would have passed through eight increasingly massive gates and impressive courts before attaining the outer court of the Imperial Palace, with the great rectangle of the Tai-he Dian (Hall of Supreme Harmony). This was the first ceremonial hall encountered on the long walk northward and is the first of only six buildings located astride the central axis of the city; all other buildings were placed well back to the east and west from the line of approach.

The Tai-he Dian is a massive rectangular building rising from a three-tiered terrace of white marble and provided with **balustrades** of the same material (colorplate 12). This was the audience hall, where the emperor celebrated important events and occasions with his people, represented symbolically by his ministers and officials.

The next building to the north was the Zhong-he Dian (Hall of Middle Harmony), a small square building that served as a private chamber for the emperor to rest between audiences and where he might write prayers and memorials to the ancestors on behalf of his people. This structure is in the center of the terrace, between the Tai-he Dian and the Bao-he Dian (Hall of Protecting Harmony), which served as an audience hall for receiving scholars and the major officials of the huge bureaucratic system that enabled the empire to function. It was also the place where chiefs of border tribes who had accepted Chinese rule were received and their petitions accepted (fig. 18.8).

The second group of three buildings in the inner court was likewise positioned on a marble terrace; the structures were of the same style as those of the first group. These were the more private buildings for the

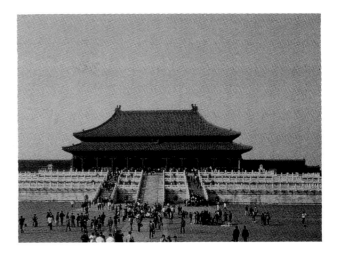

Figure 18.8 The Imperial Palace. Second courtyard looking north toward the Bao-he Dian. Beijing. Wood pillar and beam with tile roofs and marble balustrades. Ming dynasty. © Globe Photos, Inc.

imperial family. The first was the residence of the emperor; his wives and concubines resided in the more secluded sections of the palace to the north, and the second, smaller building was the private throne room for the empress. Her own personal residence was the last of these buildings to the north on the great terrace. In the Ming dynasty the small central building was also on occasion used as a bridal suite. But this seems to have been changed during the Qing dynasty. Other functions varied from time to time; thus, some of the Manchu rulers of the Qing preferred living for at least a part of each year outside of Beijing in the hills of the northwest, where they established summer palaces to escape the heat and dust of Beijing.

Pleasure Gardens

The inspiration to establish pleasure gardens may have been close at hand. When Kublai Khan established Khanbalic he had a great shallow lake made by dredging the earth from a swampy region to the west of the city. He had the excavated soil piled up into a huge hill six hundred feet high and a half mile long. It still stands, just north of the north gate of the Forbidden City. Today this hill is called Jing Shan (Coal Hill), a corruption of Qing Shan (Green Hill), named after the green and blue rocks and splendid trees and shrubs with which Kublai had had it adorned.

It is said that Kublai had the most remarkable and most beautiful trees from various parts of his empire carefully transplanted on this mountain. Unusual rocks were also transported here from all regions. He preferred green- or blue-colored rocks so that great outcroppings of malachite and azurite might be seen in

this blue-green wonderland. Even the paths were covered with turquoise and other stones. This entire project may have been inspired by the "blue and green" tradition of landscape painting, which probably existed at least as early as the Tang dynasty (fig. 14.7).

Significance of Plan

One of the intriguing questions about Beijing is: Why did the Ming emperor move the northern wall to the south? It appears that the Green Mountain was located in the central section of Khanbalic. But Chinese custom, so different from the Mongol, preferred a location for a city that provided a mountain to its north. By moving the city southward, the Yong-le emperor was able to turn the Green Mountain from a mere garden into a functional screen for the protection of the city from the evil influences from the north. Placing the Imperial Palace to the south of the mount not only afforded protection; it also provided easy access for the family and friends of the emperor, who could readily be carried up the steep slopes to escape the heat and dust of summer or simply to admire and enjoy the view. This latter function has given the Green Mountain its other name, "Prospect Hill," because the entire prospect of Beijing, from the Forbidden City to the Temple of Heaven at its southern extremity, was spread out before the enchanted viewer. Unfortunately, modern buildings and smog now prevent our enjoyment of such prospects from "Prospect Hill."

It is enlightening to consider the oldest known Chinese palace precinct, that of Erlitou, in relation to Beijing. We cannot compare the details, but many aspects of concept and plan are strikingly similar: the orientation is to the south; the buildings are placed on raised platforms; they are positioned transversely across the south–north axis. In both instances the palace is surrounded by another walled enclosure; in the space between these walls were the mass of the people, who lived in the urban areas of the city beyond the walls of the palace.

It is helpful here to compare the plan of Beijing with the plan of the Great Mosque at Xi-an. The present buildings date from the Ming dynasty and, like the first Buddhist temple in China, the Mosque is based upon Chinese domestic architecture rather than upon the religious architectural style of the country of origin. Thus the Great Mosque provides good evidence of what the large villas of Ming must have been like.

The plans of the mosque and of the city are surprisingly similar; several courtyards are arranged, one after the other, along the long axis of the mosque compound. They are separated by transverse walls penetrated by gates along the axis. The subsidiary buildings are located at the far sides of the courtyards, set back

from the central axial approach in the manner of the Imperial (Forbidden) City. But two buildings interrupt the axis of the mosque. In the third courtyard an octagonal, three-storied pagodalike pavilion stands in the center of the court and in the fourth a short stairway rises to a terrace, where an open hexagonal pavilion contains covered galleries extending right and left, which terminate in smaller versions of the tiled roof of the pavilion.

Beyond this point a higher terrace supports the mosque assembly hall, which stands across the long axis of the whole plan in the same way that the audience halls in Beijing do. While the Imperial City is notable for its lack of garden setting, the Great Mosque is more typical of the Ming love of vegetation as a natural setting for their great homes. Of course the long axis of the Great Mosque runs east to west so that the approach along the axis is toward Mecca, the sacred city of Islam, while the city of Beijing was oriented to the four directions with the axis running from the south to the north. But it is interesting to realize that the Imperial City was conceived of as a villa of the time enlarged to an enormous size as befitting the residence of the emperor. An example of the great Ming villas is that of the Yu family built in Shanghai by a city official. The garden that remains is the kind that became familiar to Europe through the so-called "willow ware" export porcelain. It contains pavilions and teahouses set among small hills and ponds. There are elegant bridges, and the courtyards are joined by decorative gateways. There is a fine point and counterpoint between architecture and planting (fig. 18.9).

Temple of Heaven

The so-called Temple of Heaven was built by the Yong-le emperor before the capital was moved back to Beijing in 1421. It is composed of three components located along a north–south axis, reflecting the orientation of the Imperial Palace, but it is positioned off the major axis of the city to the east and was outside the city to the south. The tall, or most northern building, is round with a blue-tiled, triple roof, where the emperor reported to the ancestors annually (fig. 18.10). It is now known as the Hall of Annual Prayers for Good Harvests. It is a masterpiece of Ming design, standing in the center of a three-tiered circular terrace edged by white marble balustrades. It is balanced at the southern end of the compound by an almost identical three-tiered circular platform but without any building on the upper terrace. This is the Altar of Heaven. Between the Hall of Prayers and the Altar of Heaven runs a broad, raised walkway, which is interrupted at midpoint by the small, single-roofed building called the Imperial Vault of

were imported in large quantities during the seventeenth and eighteenth centuries. The *Familles* are "families" of overglaze enameled porcelains related by the predominance of a single hue. The monochromes include the brilliant deep red of the Oxblood, the brown flecked with greenish tan of Tea-dust, apple-green, deep blue, and pure white known in Europe as Blanc-de-chine.

SUMMARY

The Ming dynasty brought China once more under native rule. The Mongols were driven out, and the third emperor moved the capital from Nanjing back to Beijing after extensive remodeling of the Yuan city.

Ming painting continued the two modes: traditionalists and gentlemen-scholar painters. The former lived in the Zhejiang area, while the latter resided in the region of the city of Suzhou. The traditionalists revived the style of the Southern Song, whereas the individualists based their styles upon a wide variety of sources.

The ceramic centers flourished from the time of the third emperor. Jingdezhen products were designated the imperial or official ware. Both the blue and white and the overglazed enameled ware were admired by the court, and some very fine monochrome wares were also developed. Although the techniques of underglaze blue painting and overglaze enameling were developed by the Yuan potters, they were further refined during Ming.

There are scattered examples of Ming architecture in China, but the most representative Ming city is Beijing, where the Inner City and its Imperial Palace remain relatively unimpaired in both plan and detail. The layout symbolized the relationships between heaven and earth, between the ancestors and the emperor. The emperor reported periodically to the ancestors regarding the conditions of his people and prayed for their welfare. South of the city the complex of the Temple of Heaven was built by the Yong Le emperor for these functions.

GLOSSARY

Balustrades Railings for stairs or balconies; made of vase-shaped supports lined in a row, surmounted by a rail. (p. 173)

Imperial Palace Beijing, China, established as Yuan capital and restored during the Ming and early Qing dynasties. (p. 173)

Figure 18.9 Moon Gate. Yu Yuan, private Villa. Detail of Garden. Ming (1559–77), Shanghai. Photo: Peter Rushton.

Heaven. The entire arrangement vividly recalls the arrangement of the three major buildings within the first great courtyard in the Imperial City, the central building in each group forming the apex, where the emperor could retire from ceremony. The Hall of Annual Prayers for Good Harvests was burned in 1889, but the reconstruction is said to have carefully copied the original fifteenth-century building.

Ceramics

Ceramics and the minor arts attained unprecedented heights of technical excellence during the Qing dynasty. Many new types of glazes were developed, so that an entire rainbow range of hue was available (fig. 18.11). Many of these bear French or English names (Famille Rose, Jaune, Noire, Claire de Lune; Peach-bloom, Oxblood, Tea-dust), indicating the great admiration that these wares aroused in Europe, where they

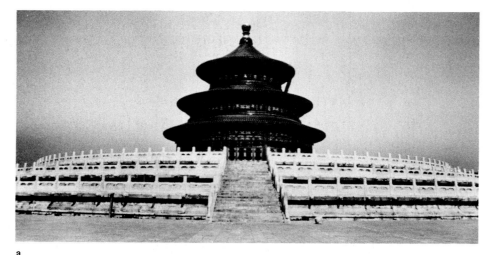

a

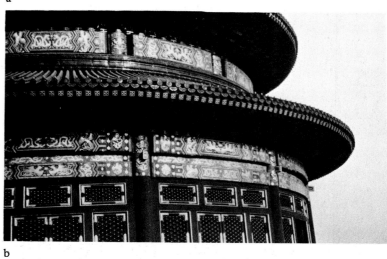

b

Figure 18.10 *a*. Temple of Heaven, Beijing. Wood, painted and gilt.
Recently repainted. Ming. Restored after fire in nineteenth century.
Photo: Peter Rushton. *b*. Temple of Heaven, detail. Photo: author.

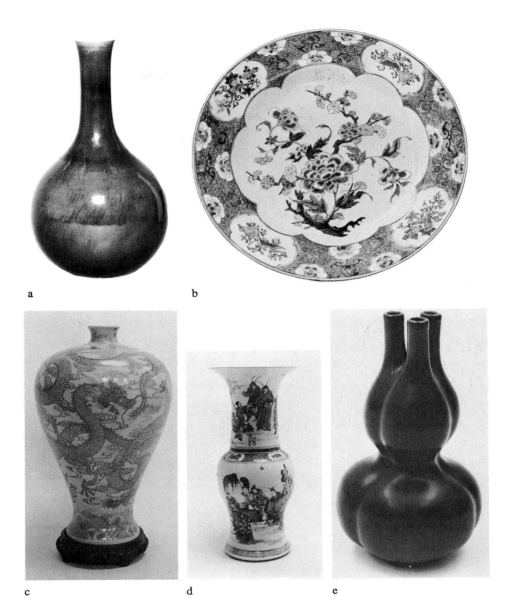

Figure 18.11 *a.* Oxblood vase. H. 14½". *b.* Famille rose plate. D. 12". *c.* Famille jaune vase. H. 15¼". *d.* Famille verte vase. H. 17½". *e.* Tea-dust triple-spouted vase. H. 9½". Qing: reign of Kang Xi (1662–1722); reign of Yong Zheng (1723–35); *c.*, *d.*, and *e.* reign of Qian Long (1736–95). *a.* Asian Art Museum of San Francisco, the Avery Brundage Collection; *b.* to *e.* Stanford University Museum, (*b.* and *d.* Mortimer C. Leventritt; *c.* Ikeda Collection; *e.* Mr. and Mrs. Francis V. Keesling).

19
.
MODERN PAINTING IN CHINA

The nineteenth century witnessed a dwindling of the spirit in China. In art, the styles of the Qing continued to repeat the past, but for the most part the vitality was gone.

With the overthrow of the Qing dynasty, a new system of government was introduced into China. The establishment of the Chinese Republic (1912) under President Sun Yat Sen was based upon the general lines of the United States democratic government.

CHINA/EUROPE INTERCHANGE

Eighteenth century Europe had been afloat in **Chino-iserie,** which were minor arts made in China and imported or imitations of Chinese styles and techniques made in Europe. Furniture, ceramics, architecture, wallpaper, and items of bric-a-brac in "Chinese" style were the rage. But by the early twentieth century this interest had waned.

The nineteenth-century Open Door policy, imposed upon China after the Opium War of 1839–42, had forced the opening of five treaty ports to foreign trade, with the result that the Chinese began to take an interest in things foreign.

From the beginning of the Chinese Republic, cultural contacts were made with Japan and young painters studied Western painting methods there, where its study had been undertaken, like everything else Western, by proclamation of the Emperor Meiji, made in 1868. But the May Fourth Movement of 1919 caused a boycott of Japan, and so young Chinese painters looked to Europe, which was now directly accessible because World War I had ended in 1918. For the next thirty years many went to study in Europe, especially in Paris, and a few stayed abroad. Those who returned did not find a ready audience for their Europeanized styles except among a small, sophisticated elite, mainly in Shanghai and Tianjin. Some of them reverted to the Chinese tradition, and a few painted in both styles.

Two of these young men were able to make real contributions to the evolution of the modern style in China. Liu Haisu (b. 1896) was the major proponent of the modern movement in Shanghai. He ran into severe opposition when he introduced working from nude models. He moved to Taiwan in 1948 but left behind a heritage of students well acquainted with Western painting subjects and techniques. Xu Beihong (1895–1953) played the counterpart to Liu Haisu in Beijing. Both these painters were ultimately more important for breaking the hold of the tradition than for their works in Western style, but Liu made several trips to Europe in the 1920s and 1930s and was influenced by both impressionism and expressionism. He was the leading teacher of painting in the area of Shanghai for

many years, but his art was unacceptable to the Communist Party because of his Western tendencies. He was, however, reinstated in the post-Mao period and admired once again.

As a result of the European influences, Liu's color became an integral part of the paintings rather than merely a tint added after the structure had been established in ink, as in the traditional method of painting. But even in his monochrome paintings, Liu's powerful structural sense is apparent (fig. 19.1). Liu's painting of the Huangshan is not made up of tiny strokes as in Fan Kuan's painting, for example (fig. 16.2), nor is it a translation of forms into a few abstract strokes as in Xia Gui (fig. 16.4). Liu applied the ink in great pouncings of the loaded brush onto wet paper and let water and ink mix at will, with no interference from the artist. All of these runny edges and hard edges, which had been so carefully avoided for centuries by earlier painters, seem to have been found and gathered together and dashed against the paper by Liu.

Xu Beihong was encouraged by his parents to take up art at a very early age. His father, a self-trained painter, imparted to him a great manual dexterity by having him copy paintings by other artists. Xu studied natural objects and had a good eye for portraiture. He was able to spend six months in Japan in 1917, where he admired the new forms of Japanese painting based upon the French Barbizon and Impressionist styles. In 1919 he received a government scholarship to study at the Ecole des Beaux Arts in Paris, and for the next eight years he spent most of his time in France, Germany, and Italy and became well informed on European painting styles.

When Xu returned to China in 1927, he began to put his European training to work as head of an art academy in Shanghai and as a professor of painting and drawing. Like many to come after him, Xu felt the old fire had gone out of Chinese painting, and he was a pioneer in attempting to revive it. His method was to inject the Chinese tradition with European attitudes and techniques. In 1946 he became the president of the Art College in Beijing, where he stayed on through the Chinese Communist occupation until his death in 1953.

Xu's European realist style suited the Chinese Communist party. They adopted the Russian socialist realism form of propaganda painting as the official one and reinforced and defended the choice by tracing socialist realism in China to Xu Beihong. Although he had painted a few mural-size paintings in an idealized manner, they were based on traditional Chinese tales and had nothing to do with the Communist revolution, and they were painted well before the establishment of the Communist People's Republic of China in 1949. Under the Communists, Xu did a few bland paintings

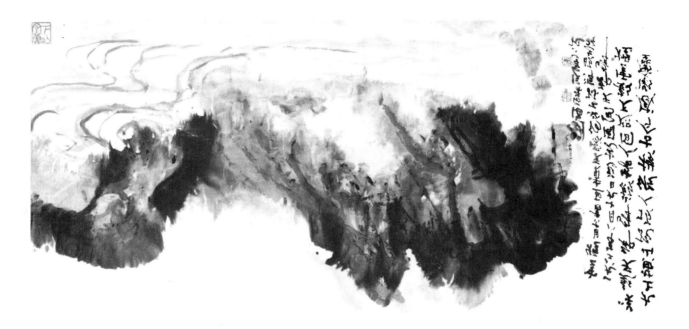

Figure 19.1 *Peaks and clouds of Huangshan,* by Liu Haisu (1896–). Ink on paper (dated 1982). H. 26⅜″. Courtesy of the Chinese Culture Center of San Francisco.

of groups of figures engaged in mildly "social" activities (often group meetings).

Xu's charcoal self-portrait is typical of his departure from Chinese styles and his adoption of the Western tradition (fig. 19.2). The pose of the subject, facing left but looking to his right, presents an offhand candid effect—a small moment—characteristic of the modern European movements of Xu's day, of the Impressionists and Post-Impressionists. The medium and the treatment of the shading, light source, and shadows are all European. What is left of the Chinese is the subject.

Xu was best known in the West for his running horses in Chinese ink and brush on paper (fig. 19.3). These paintings are not quite traditional Chinese, nor are they Western. Xu's works in the adopted Western style seem to be more fully realized than those in his native Chinese tradition, but whatever history may conclude about his work, his role as instigator of the reappraisal of the Qing painting tradition is firmly fixed, as is his pioneering position in introducing Western painting to Chinese artists. Many of his students became famous and influential and extended his influence into the next generations.

Figure 19.2 *Self-portrait,* by Xu Beihong (1895–1953). Charcoal on paper (1942). Courtesy of Fangfang Xu/Xu Beihong Memorial Museum.

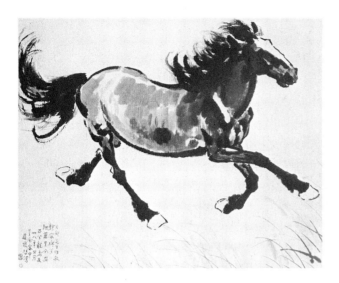

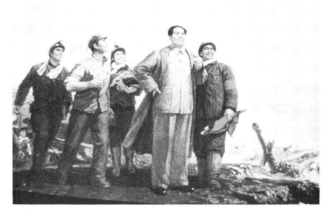

Figure 19.4 Chairman Mao views Fushan coal mine. Oil on canvas (1972). Photo: Joan Lebold Cohen.

Figure 19.3 *Galloping horse,* by Xu Beihong (Hsü Pei-hung; in France, Jupéon). Hanging scroll, ink, and color on paper. 92 × 109 cm. Courtesy of Fangfang Xu/Xu Beihong Memorial Museum.

THE JAPANESE INVASION AND THE COMMUNIST TAKEOVER, 1937–49

As in Shanghai and Beijing, in Hangzhou and Suzhou Western-style painting was being taught in the 1920s and 1930s. But China was invaded by the Japanese Army in 1937, and in the next few years the institutions in the eastern part of the country were relocated to the western part of China, in Chongqing, Kunming, and Chengdu. Many painters turned to the sufferings of the people as their subject matter, and the Western style was better suited to this reportage of timely events than the traditional style, which had aimed at a timeless abstraction from immediate reality as one of its goals.

Between the establishment of the Chinese Republic in 1912 and the Communist People's Republic of China in 1949, China was in political, economic, and military turmoil. The invasion by Japan in 1937 continued into World War II, and upon its conclusion the Civil War between the Communist and the Chinese Republic, or nationalists, continued until the nationalists fled to Taiwan, leaving China to the Communist regime under Mao Zedong (1893–1976). Between 1912 and 1945, many artists left China for foreign countries. A few went to Taiwan and some to Hong Kong, but most of the best went to other countries. For example, Zhao Wuji went to Paris and Tseng Yu-ho to Honolulu.

Qi Baishi stayed in China and developed a new style. He became China's leading painter. But Zhang Daqian and Wang Jiqian settled in America as painters with international reputations. Zhao Wuji achieved international fame as a painter in oils. Qi Baishi (who died in his nineties in 1957) was one of the three or four most admired traditional painters at the time the Communists came to power. He was already in his eighties by then and had had a long and successful career as a painter of birds and flowers. Both he and his students were chastised because the government thought their art was decadent, and they were not reinstated until after the Cultural Revolution, after Qi's death.

Many painters tried to follow government directives, and the traditional-style landscape with a tiny red tractor working away became a cliché for "modern" Chinese painting of the 1950s. There was also a new emphasis on figure painting, particularly figures engaged in working on engineering projects throughout the country (fig. 19.4). The painters even collectivized themselves into groups, where their individuality was completely submerged, as on the farms.

Suddenly, in 1956, as a result of another shift in the party line initiated by Mao's famous statement, "Let the Hundred Flowers bloom," all over the country a new air of liberality encouraged variety in the arts as well as in thinking. During this short-lived freedom, painters like Fu Baoshi (1904–65) were free to return to the past for inspiration.

Fu, considered by many to be the most important Chinese painter of the twentieth century, realized from his knowledge of China's painting tradition a need to amalgamate the old and new and the Chinese and Western traditions. He spent two years studying in Japan (1933–35) but returned to China sensing that the solution lay within his own tradition, not in Japanese or Western styles. He felt that art was an expression of intensely felt depths of a peoples' soul, not simply

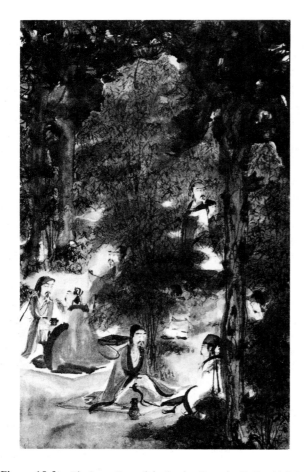

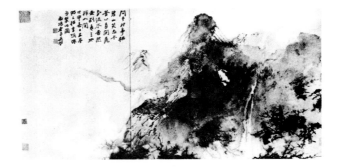

Figure 19.6 Landscape illustrating Li Bo's poetry, by Zhang Daqian (1899–1983). Ink and colors on paper (1968). H. 37¾″. Collection of Chang Pao-lo, Carmel, California.

scholarly literati class that later, in the Song to Qing dynasties, produced the literati painters, as distinguished from the professionals who painted for a living. These are the elegant elite of China's past, recalled so convincingly that it seems an impertinence to ask how Fu has bridged seventeen centuries to take us there to have a quiet peek at these august persons.

THE REFUGEE PAINTERS ABROAD

Zhang Daqian

Zhang Daqian (1899–1983) was born in Sichuan Province in Southwest China. He learned drawing and painting from his mother and elder brother and sister. From age seventeen to twenty he studied weaving and dying of cloth in Kyoto and returned to Shanghai to study calligraphy and the various styles of ancient Chinese scripts. He also studied painting and became so adept at imitating the styles of two of the Qing painters that his teachers claimed his works to be almost indistinguishable from the originals.

The inscription on the painting in figure 19.6 says that people ask him why he settled in the green hills, but he just smiles and does not say. His mind is at peace. The peach blossoms drift down the stream and disappear with the stream into another world. The peach blossoms are a literary reference to an ancient Chinese utopia, which Zhang seems to imply here that he had found in Brazil. The artist states that he was inspired by the verses of the Tang dynasty poet Li Bo (fig. 16.5) and painted this on the shore of a lake in a Chinese garden in Mogi, Brazil, where the artist had gone to live in 1954 after leaving China in 1948. He has written the inscription as though he were the poet Li Bo. It is revealing of both the poet's and his own situation. It is a clear, though indirect, reference to his own exile from his homeland. In the inscription, Zhang refers to Li Bo

Figure 19.5 *The Seven Sages of the Bamboo Grove,* by Fu Baoshi. Ink and color on paper (1946). H. 45½″.

new techniques and styles. In Japan he had studied Chinese art history in the fine collections of both Chinese and Japanese texts.

Fu developed a light, spidery line against broadly massed, freely washed background areas, which give his style a spontaneity of the moment while his subject matter recalls themes from the past. This somewhat occult combination seems to give the viewer a sense of the wisdom of applying old values to present crises. It results in a feeling of continuity and stability. His painting *The Seven Sages of the Bamboo Grove* was painted just three years before the fall of the Chinese Republic (fig. 19.5). Its subject is a group of high political officials, as well as poets, musicians, and scholars, of the third century A.D. who used to meet in a bamboo grove to enjoy the aesthetic delights of poetry and music to the accompaniment of conversation, meditation, and good wine. These were the true enjoyments of friendship among educated Chinese gentlemen. This concept, of retreat from the petty into the lofty domains of scholarly and aesthetic pursuits, was the ideal of the

as "the Banished Immortal"—certainly a self-description and a very ancient literate tradition.

Zhang said that his eyesight began to fail in the 1960s and that, to make a virtue of his weakness, he developed a broader style simply because he could not see any more precisely. It is axiomatic in almost all cultures that young painters tend toward descriptive precision and visual clarity, but as they age they tend more toward suggestive expression and visual truth. This distinction seems to be the conflict in China. The party wanted idealized realism and believed they could legislate artists to produce it, but many of the best painters were more interested in truth of a higher order than the literal fact. So, although Zhang modestly acknowledges his failing eyesight, it is probable that aesthetic preference was as much a cause of this shift in style. After all, he could have bought glasses!

In any case, the looseness and freedom of his brush produces a striking spontaneity here. It is as though the painting is in the process of becoming the landscape right before our eyes. There is a good deal of Daoism and of Chan in this—as in Zhang, himself.

Wang Jiqian

Wang Jiqian, better known in America as C. C. Wang, was born in 1907 in Suzhou, Jiangsu Province, near Shanghai—the region famous for many of China's greatest painters since the fourth century. His family was an old and wealthy one dedicated to public service. His grandfather was an official in the Qing dynasty, and one of his ancestors, Wang Ao, was the prime minister during the Ming dynasty. Wang Ao was also a scholar-gentleman painter and a well-known calligrapher. Wang Ao was also a friend of Wen Zhenging (see fig. 18.1) and Qiu Ying (colorplate 11).

Wang Jiqian is a literatus (scholar-painter) of the old school—one of the last. His education as a son of a wealthy family was strictly traditional, with concentration upon the classics and training in calligraphy. In his early teens he began to study painting seriously. He took as his models the outstanding painters of the Northern Song, Ming, and Qing dynasties. He learned to paint in the customary manner, by copying the old masters.

Wang Jiqian, like his artistic forebearers in the literati tradition, gathered together one of the greatest collections of Chinese paintings of the modern period. Many now enrich the public museums of America. He has been said to have seen a greater percentage of the great paintings in the major collections in China before the change in government than any other living painter. Like his ancestor, Wang Ao, he was friends with the major painters and collectors of his time and thus was

freely invited to study their paintings at leisure. In 1936 he had a remarkable opportunity to examine and study the thousands of paintings now in the National Palace Museum Collection in Taiwan when they were temporarily in Shanghai, where they had been shipped for safety in the face of the imminent invasion of China by Japan. As advisor to the selection committee of the great London exhibition, he had several months in which to study the works from all periods. As a scholar these were invaluable experiences and they have also helped him to become one of the most dependable authorities in the difficult field of authentication.

C. C. Wang left China before the Communist takeover and settled in New York City, where he soon became interested in Western painting, including the contemporary works of the Abstract Expressionists. His new environment provided an opportunity for him to study the European styles that his peers had studied earlier in Europe and in Japan. This new exposure inspired him to study briefly at the Art Students' League of New York and to reconsider his own techniques as well. Gradually he reevaluated all aspects of his art, including brushes, ink, stroke, and paper. He experimented with applying ink in a number of unconventional ways, including pouncing it on with an inked sponge or ink-soaked crumpled paper, which left wrinkle patterns resembling geological formations (fig. 19.7).

Both geology and paper have definite limits, that is, ways in which they cannot react (in circular patterns, for example), and in both stone and paper, there are very precise physical laws that produce a likeness, a visual integrity, throughout all parts of the material. A mountain of granite and a small fragment of granite are, of course, structurally identical; they obey the same tectonic law. And paper wrinkles, whether large or small, look alike. In figure 19.7 patterns of darks, some large and some very small dots, were applied by painting broad strokes of the ink-loaded brush across hard-surfaced paper or plastic. The ink coagulated into irregular patches and dots, which were absorbed by the surface of the painting when pressed against it. After studying it, the artist began to "see" the subject in these very general amorphous darks and lights and, as he worked, the image became clearer to him and he made it clearer to us by adding broad-brushed washes and linear brushstrokes. At the very last, he "discovered" the meadow at the left edge and sketched in a group of houses there to establish the human factor and to give scale to the mountains, which are thus seen to be rather reminiscent of the scale of the Fan Kuan Northern Song painting (fig. 16.2). Note also the waterfall in the upper right in both paintings. A connoisseur of Chinese paintings would recognize the source of it to be that of

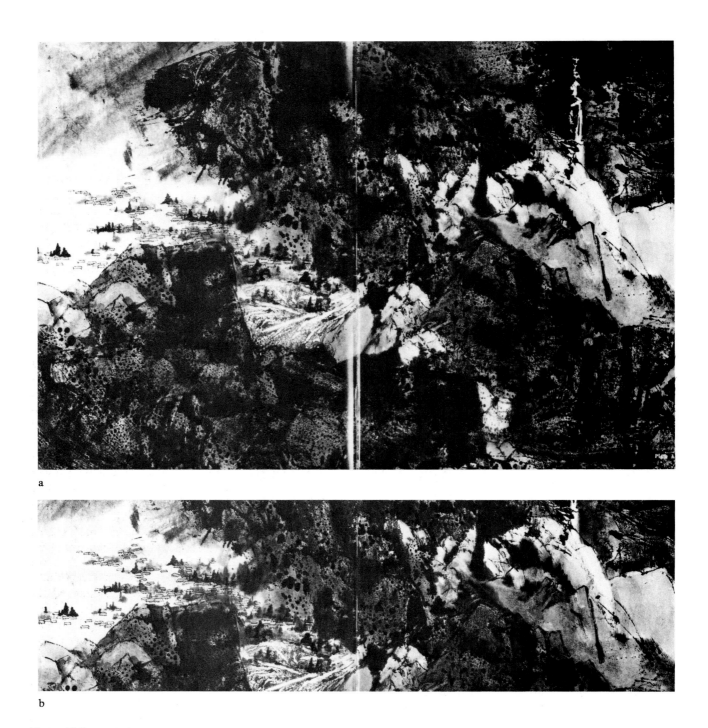

a

b

Figure 19.7 *a. Shadows of Summer Woods,* by Wang Jiqian (Wang Chi-ch'ien, Wang Chi-ch'uan, b. 1907). Ink and color on paper (1969). H. 24''. Detail.

Fan. By such slight and subtle means Chinese painters of the traditional styles have paid homage to their revered predecessors.

In recent years, Wang has almost abandoned the brush, the ancient instrument of the Chinese calligrapher and painter, and has developed entirely new means for ink application. Against very great odds he has transformed the traditional styles and techniques of the literati painters into breathtakingly modern terms and has, thereby, retained their spirit. But he has also become more spontaneous in his art and has developed a new technique to suit. He involves the viewer more directly by presenting a kind of artistic Rorschach test in which the viewer is in the midst of a deep aesthetic struggle—the tension between abstraction and verisimilitude—between chaos and meaning, which stretches the powers of the aesthetic perception to overcome the chaos by finding the meaning.

It is remarkable to find, in our own time, a painter who is so totally exemplary of the life-style and interests of a painter of an earlier time. He gives us the deepest insight possible in our time of the refinement of the scholar-gentleman painter.

C. C. Wang discovered that the patterns of paper wrinkles share a relationship between large and small geological forms: the smallest part reflecting the largest. This principle is of course ancient in Asia; it was seen in the microcosmic reflection of the macrocosm as exemplified in the stupas and temples of India.

Chen Qikuan

Chen Qikuan (b. 1921) is a native of Beijing. He practiced architecture in Nanjing before leaving for the United States in 1948. He has taught architecture at the Massachusettes Institute of Technology and collaborated with the world-renowned architect and countryman, I. M. Pei, in drawing up the plans for the Tonghai University in Taiwan.

Chen is also a well-known painter who has made great departures from the tradition. In figure 19.8, the subject is a series of infinitesimally small boats with people on a river seen through a narrow defile. The vertical sections of the cliff were achieved by painting on the back of the paper with various shades of green, bluegray, brown, pink, and black. But it is the pattern rather than the color that engages our attention. The relationship of the dark and light spotted vertical sections is played off against the pure paper of the stream, and then we see the mosquito-like people and boats. We then realize the dark vertical strips are cliffs and that we are

looking straight at their vertical walls, a view confirmed by the perspective of the boats. Finally, it becomes clear that the irregular pink blots bordering the cliff walls are peach blossoms. Then we recall the story of the peach blossom spring, the story of the simple fisherman who follows peach blossoms out of season floating down a stream to their source and goes through a narrow hole in a cliff and discovers a utopian society. When he leaves the valley he finds that several generations of time have passed in his own real world. He longs to return to the valley but is unable to find the entrance to it again. A comparison between the painting by Qiu Ying (colorplate 11) will show how far Chen has departed from the traditional presentation of this subject. Instead of the beautiful valley, which had so captivated the artists of the past, he has concentrated on the vastness of the natural environment, leaving the rest of the story entirely to the viewer's imagination.

Liu Guosong

Liu Guosong was born in Shandong Province in 1923 and moved to Taiwan in his late teens. In Taibei he organized some of his fellow painters into the Fifth Moon Group, the most widely known of the Taiwan modernists, in 1956. The name derives from the group's annual meeting, held in May, the fifth month.

Liu's early works exhibit an almost dazzling control of the brush coupled with an equally striking looseness of application, which combine to evoke the unity of form and content. These brushstrokes, which so powerfully suggest landscapes, remain brushstrokes. This is visual abstraction on one of its most thrilling levels. Liu's method changed from the direct use of the brush to cut and torn paper shapes applied to the painting to suggest landscapes of quite another kind.

In a more recent painting, a long handscroll in the collection of Hugh Moss, Liu's full range of techniques and style is visible (fig. 19.9*a*). The painting begins with spring and proceeds through summer, fall, and winter in one continuous handscroll. The owner had the unusual opportunity to be present at times as the painting progressed over a two-month period. He tells us that what he observed was a continuous dialogue between the artist and the materials. In other words, Liu had not conceived the entire work in his head and made a painting to match, but rather he had the inspiration of subject and probably general compositional arrangement; as he put down his shapes and patterns and colors, they formed an ever-changing partner in the creative process. Far from being an exercise in "copying" from

a b

Figure 19.8 *a. Where is Arcadia?* by Chen Qikuan (b. 1921).
b. Detail. Ink and colors on paper (ca. 1960–64). H. 40″. Suisongshi
Shanfang Collection, Hong Kong.

"copying" from nature or from his imagination, the development of the painting resembled much more a musical duet: what was painted called forth painterly responses.

Liu, Moss tells us, laid out the composition in very general "abstract" terms, without specific details of any kind, using a large brush and working very quickly. Then he would sit and stare at the parts as well as the whole until the almost meaningless shapes of ink on paper began to coalesce in his mind into meaningful relationships, until each section of the painting "came alive." Then it was merely a matter of revealing its life. Although this might be time-consuming and tedious, it was really the skilled aftermath of the creative encounter.

After much consideration of the inked shapes, Liu lifted off some fibers from the darkest areas so that the brilliant white paper was revealed in amazingly succinct patterns, suggesting such varied details as roots and branches of trees, creasings in rocks, waterfalls and streams, and even snow (fig. 19.9*b*). These suggestions are reinforced by broad washes or sharp brushed accents in other areas. Liu Guosong's finishing techniques are elaborate compared to the spontaneous painters of the Song dynasty, but they share some of the same spirit.

THOSE WHO STAYED BEHIND: THE CULTURAL REVOLUTION, 1965–79

The artists and intellectuals of all kinds who remained in China during the Cultural Revolution suffered greatly in many ways. All were deprived of a decade of schooling, seen by its promulgators as a means of destroying all political ties with the past. "Cultural," in this context, referred to political continuity rather than, in the Western sense, the refinement of aesthetic potential. The great irony was that it was precisely the

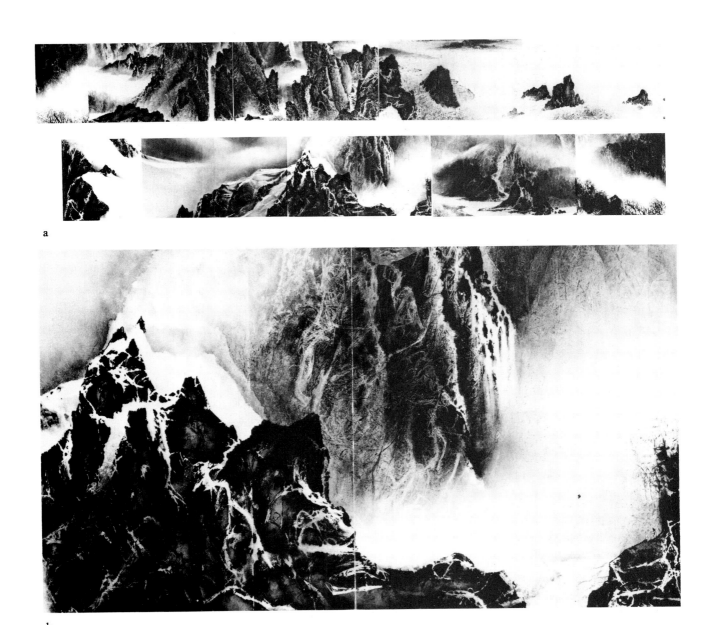

a

b

Figure 19.9 *a. The Four Seasons,* by Liu Guo-sung (Liu Guosung).
Ink and colors on paper. Handscroll (1983). H. 1′11½″. L. 29′2⅜″.
b. Detail.

real cultural aspects (and thus the aesthetic) that were destroyed in the hope this would weed out the politically negative attitudes among the people. Thousands of ancient buildings and art objects were destroyed by the Red Guard in an effort to destroy the past and have history begin with them. It reminds us too much of the great tyrant, Qin Shi Huang Di.

The government emphasis on collectivization, which had penetrated every aspect of work, was also felt among artists. In Mao Zedong's edict that artists must paint for the masses, abstract art had been ruled out on the grounds that the masses would never understand it. Nudes were prohibited because they would promote "wrong thoughts." In such a repressive atmosphere it was natural that artists, by nature individualistic, would have huddled together in their shared principles against the storm of government directives telling them what to paint and how to paint it. In the

larger cities where artists lived, those painters who felt there was more to artistic life than propaganda painting, formed small clubs.

In 1979 the April Society was formed by photographers intrigued with the reality they saw of life all around them—so different from the government decreed painting formula of happy young workers smiling at their work. The great posters that had sprung up all over China reproduced beyond truth the same vapid view of a life unknown to the people of China. The April Society presented a true view of life as it was being lived in the fringes of the Communist leaders' dream.

Such painting groups and societies dealt likewise with reality but with the internal subjective-reality of the life of the aesthetic spirit. They engendered a kind of mutual moral support and encouragement at a time when being a creative artist was encouraged neither by society nor by the government. The Cultural Revolution had turned China upside down. Values treasured for millennia were suddenly overturned; professors and scientists, musicians and poets were all turned out of their professions and "sent down to the countryside" to work on farms. While they were "re-educated," totally untrained peasants were installed in positions of leadership and authority.

THE NEW PAINTERS

In late 1979 a more liberal view was promulgated. The government view of painting, which had been based on Russian nineteenth-century realism modified by the French Impressionists and Song dynasty Chinese style, was junked and artists were told to be freer and more inventive. This break in the tradition permitted, one might say required, painters to look at their subjects more intently. For centuries painters learned from their predecessors' works—the codification of method became such a standard that painting manuals were published, reproducing (by means of woodblock prints) the manner in which the subjects of painting, landscape, birds, flowers, and rocks, etc., should be painted. Variations were given according to several artists, from which the aspiring painter might choose (or, better yet, become adept at several or all). This rigorous training, repeating the same stroke over and over in the severe training in the ballet of the brush, was abandoned during the Cultural Revolution and China's youth focused on "sensible" pursuits, that is, "political" and therefore destructive.

Yang Yanping

One of the first groups of the post-Mao era was the Oil Painting Research Association organized in Beijing in

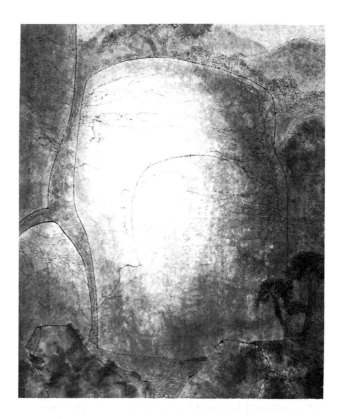

Figure 19.10 *Towering Mountain,* by Yang Yanping (1934–). Pen and ink and color on paper (undated). H. 26½″. Courtesy of the Chinese Culture Center of San Francisco.

early 1979. This prestigious group includes China's finest oil painters, including Yang Yanping (b. 1934), who often bases her abstract paintings upon ancient Chinese calligraphy and later ink-painting styles. Yang graduated from Qinghua University in 1958 and held various jobs related to the visual arts until she settled upon painting in 1980 and enrolled in the Beijing Painting Academy.

Her painting of *Towering Mountain* is ink on paper with colored washes (fig. 19.10). It shows an elegant refinement in the sense of proportion, spatial relationships, and linear patterns. It is not large but suggests great monumentality because of the compositional relationships. In its largest enclosed shape it recalls dimly the great cliff of Fan Kuan (fig. 16.2), but this is a completely streamlined version. But her painting is so abstract that it would be fairly difficult to pin down precise sources, even for the artist. It is just as likely that Yang had no immediate inspiration at all. The composition is so common a part of the visual language of China, particularly the Northern Song dynasty, that it has become a kind of ghost-image of the group subconscious, to put it in Jungian terms. Tall cliffs tend to fill

every viewer with awe, placid waters with calm, etc. And even when the specific details are almost or entirely lacking, the very geometry, abstracted to its simplest terms, still functions in triggering such emotions.

Huang Yongyu

Huang Yongyu (b. 1924) is one of the real successes in terms of absorbing modern Western influences and transforming the Chinese tradition in a fundamental way. It is revealing that his works command the highest prices of any living Chinese artist. Along with most other artists and intellectuals, he was forced to work on a farm and his paintings were destroyed. He was accused by Jiang Qing, the wife of Mao Zedong and instigator of the Cultural Revolution, of being a capitalist and a supporter of Zhou Enlai against Mao. But later he was awarded the highly prestigious commission to design the ninety-foot-long landscape tapestry that hangs behind the colossal sculpture of Mao in the entry hall of his mausoleum in Beijing.

In his strongly expressionistic *Red Lotus,* Huang may be referring to the state of modern China (colorplate 13). To any Asian the lotus is the symbol of Buddhahood, that is, of illumination, of awakening out of a strife-ridden world of attachment to the untrammeled state of nonattachment. It may be that the painting represents Huang's dream for his country. The color of life in China from the earliest times is red. Red is also the color of Communism. It is interesting that his symbol of the lotus, which grows out of the mud through the waters to bloom free in the clear light above, is painted red. Does the artist mean that Communism will bloom, once it gets out of the muck and mire, or that China will? Or both?

The form of the painting is striking in its initial impact—varied reds through rust-orange to the creamy pink of the abstracted, squared-off petals against the background of wide blue to deep-violet brushstrokes against the white paper. Crisscrossing are quick, free lines in gray-brown, dull yellow, and greens accented with staccato dots. Both the larger areas of dull hues and the smaller, brighter ones work in a visually interlocking, dynamic relationship. Rather than presenting the finished and static state of the flowers, as a photograph would, this painting involves us, first by the color contrast and then, almost immediately, by the shapes of the dark and light patterns and their relationships to each other—of petal to broad blue strokes. Both are rather narrow rectangular shapes, some straighter and some more curved. Then come the smallest but most active shapes of the narrow stems, accented by the bumpy dots. These stems repeat the smaller curved lines on the petals, which represent their

ribs. At the left and right sides of the composition are the most contrasting shapes to all the others because they are irregular and rather bloppy, almost like accidents. They are the least colorful (blue-black), but their role becomes satisfyingly active once the observer sees what relationship they might have to real lotus flowers and stems.

The interior dynamics of the formal organization of this painting make it very rewarding to contemplate—rather like hearing a good piece of music. The artist has transposed the real-life subject into a new life—an art-life, so to speak, in which the success of the work depends less on the painting's relationship to the original subject of inspiration than it does upon the formal reorganization of that subject within the work of art.

In contemplating the painting, we may find ourselves rising lotus-like from the mud of dark visual confusion, through the waters of clarification into the light of understanding and celebration of our concordance with the artist. The whole experience is like the ancient Indian concept of the realms, of moving from the sensory realm upward through the realm of the form or idea into the realm of transcendent unity. In terms specific to the *Red Lotus,* we are first attracted by the color and composition, the purely sensory aspects of the painting. Then we find the form, that is, the relationships of these parts to each other within the form of the painting (as differing from the form of poetry, for example). Then, building on these perceptions and experiences, we rise to the connotative apprehensions of meaning, and finally we arrive at a state of calm and blissful delight—a kind of gratitude and satisfaction that soothes and thrills the spirit.

Zhao Xiuhuan

Zhao Xiuhuan was born in 1946 in Beijing, where she was trained at the Beijing Painting Academy. She is a modern "bird and flower" painter who is reviving the Northern Song tradition of the tenth and eleventh centuries.

Such artists as Li Anzhong (colorplate 10) would feel at home with the spirit of Zhao's works. Both Li and Zhao share an intense observation of biological detail arranged in striking compositions. Although Zhao is broadly related to the new realism style, her paintings reach beyond the real world to a realm of idealization. In her painted world everything is clean and pure and perfect and far from photo realism or the political idealism of the social realism school of Chinese Communist propaganda (fig. 19.11).

Zhao's paintings seem to be a kind of underground one-woman movement to return to the Pure Lands,

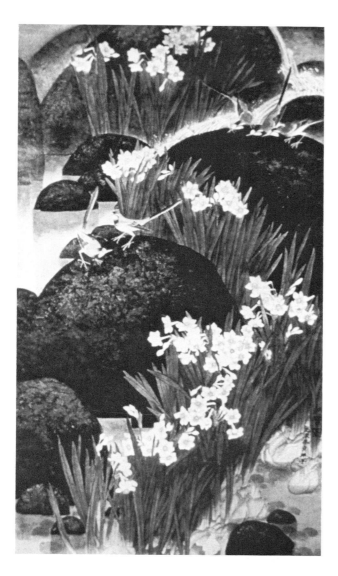

Figure 19.11 *Spring,* by Zhao Xiuhuan (b. 1946–). Ink and color on paper (1983). H. 5′4″. Photo: Joan Lebold Cohen.

those Buddhist paradises where the faithful of bygone ages could hope to be reborn (chapters 13 and 24). Although the artist probably did not consciously intend this, her paintings present nature in a "glorified," not in a "real," manner; there is no insect damage or withering and decaying foliage (compare fig. 17.2). All is eternal springtime, so to speak. A careful comparison between this painting and the horses and groom of figure 14.8 reveals the same use of a fine even line and delicate shading plus the combination of large simple forms (horses and rocks) and smaller complex patterns (saddle and narcissus). Although these visual relationships are similar, the basic spatial attitudes are different. Whereas the Han Gan has no background, the ground

plane being implied only by the positions of the horses, in Zhao's painting the ground plane is very clear. It is the surface of the small pond above which all other elements rise. Our eye enters the picture at the bottom and moves along the line of flowers in a graceful curve up and around the rocks, thus emphasizing by contrast the flowers' delicacy and the rocks' massiveness. It might be interesting to look again at figures 16.2, 16.4, 16.6, 17.1, 17.3, and 18.5 to discover similarities and differences as may be noted between the paintings of the past and the painting of the twentieth century.

As in all other forms of production in the People's Republic of China, the state became the only patron of artists because it forbade them to sell their works themselves or to anyone but the government, which in turn sold them for a much higher price than the pittance it paid the artist. But even worse in the Western view is the fact that the system destroyed the vital link between artist and client.

The difficulties with art under the Communist regime in China are the same as in other modern totalitarian states. The question for China remains: Can the highest quality be produced by denying the individual "fine tuning" of the aesthetic perceptions in subordination to a committee-originated set of aesthetic rules? The system usually causes painters to fill their quotas with mediocre, quickly done work often following a formula that has succeeded before. The state has tended to destroy quality and spirit. The saddest aspect of the whole situation is that of wasted or truncated human potential—the millions of people, not only artists, who have been blocked from individual fulfillment by the dictates of totalitarianism.

This system of excessive control has produced an atmosphere so alien to art that one is surprised that any work of quality is produced at all. And yet there seem to be several dozen excellent artists producing quite good work. One must admire their stamina and courage and fervently hope for better times.

SUMMARY

As the Chinese Republic replaced the overthrown Qing dynasty, it began to be clear to some of the major artists that the long and great tradition of Chinese painting was waning. Younger painters looked to Japan and then to Europe itself for training in the more exciting Western style of painting. When some of these young artists returned they inspired an ever-growing interest in the foreign styles. When Mao Zedong and his People's Army destroyed the Republic and turned their wrath upon the wealthy and politically entrenched, many of the artists and intellectuals fled to Europe or

America. Many of those who remained in China suffered greatly because of the government's view that individuality was out—only the group mattered. Thus, artists were diametrically and unalterably opposed to Mao's views. Painters were required to paint propaganda or they were not permitted to paint. Many of the expatriate artists enjoyed both fame and fortune abroad, while their brothers and sisters suffered extreme indignities at home. This situation was exacerbated during the infamous years of the Cultural Revolution, when many teachers as well as artists were stripped of their dignity, sent to work on farms, and prevented from practicing their vocations.

It appeared, in the wake of the Cultural Revolution, that a new and more gentle view of Chinese culture was growing among the politicians, and for ten years fewer repressive restrictions were enforced. It appeared to some Westerners that democratic views were on the rise, and one of the hallmarks was the very great variety of styles that artists employed. The spirit of modern art—intense individuality—seemed to be on the rise. During this period there have been a great many painters persevering, in spite of the odds, and turning out paintings based upon proud tradition or foreign styles but in many cases transformed into surprisingly individual expressions. Since the Tiananmen Square incident in Beijing in 1989, it has been difficult to get specific data regarding artists or intellectuals, but there seems to be a basic dichotomy between the rulers and the people. The people will prevail, as they always have, and it is hoped that they will somehow gain the space they need to lead intellectual and creative lives, which will benefit them and their country.

GLOSSARY

Chinoiserie French for "things Chinese." A style of imitation of Chinese-made minor arts made in European countries in the eighteenth century. The craze for the fad was so intense among the French nobility that the French word is used even in other countries. (p. 179)

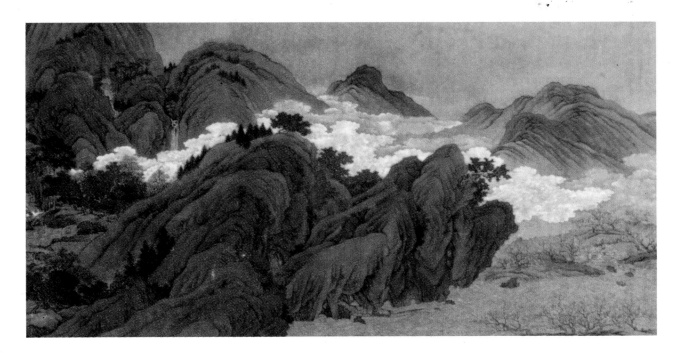

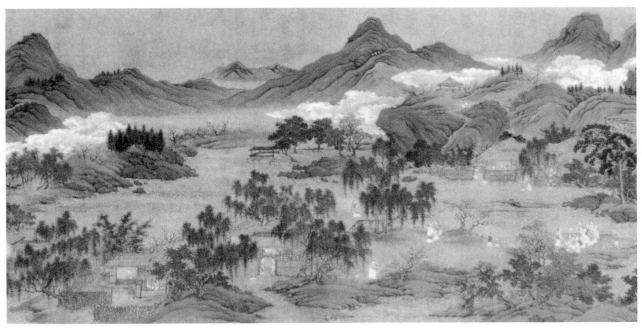

Colorplate 11 *Peach Blossom Valley,* by Qiu Ying (active ca.
1522–60). Handscroll. Colors and ink on silk. H. 11″. National Palace
Museum, Taibei, Taiwan, Republic of China.

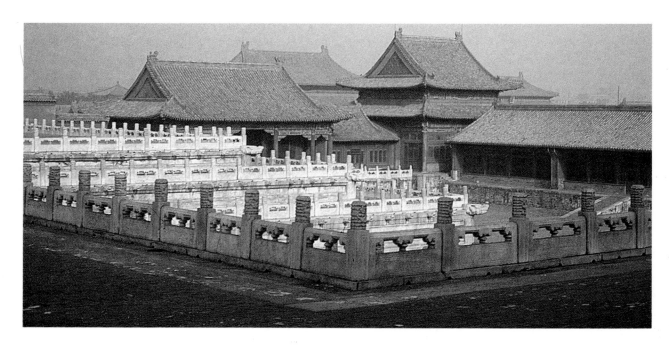

Colorplate 12 View inside the Tai-he Dian Compound, Imperial
Palace, Beijing. © Peter Rushton.

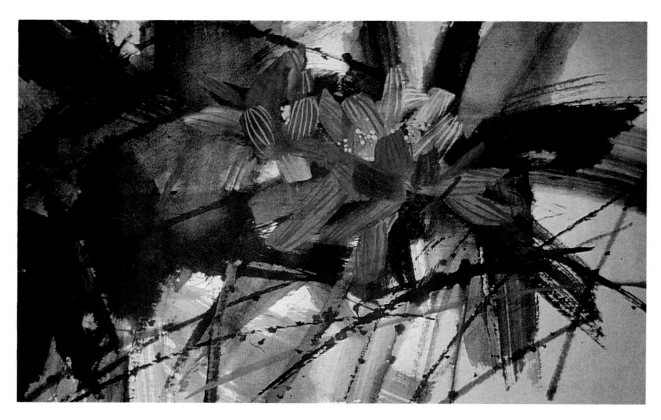

Colorplate 13 *Red Lotus,* by Huang Yongyu (b. 1924–). Ink and
color on paper (1978). Collection Chuang Ruxiang. Cambridge, Mass.
Photo: Joan Lebold Cohen.

JAPAN
PART THREE

CHRONOLOGY

B.C.
5000–200 B.C. JOMON CULTURE
200 B.C.–A.D. 300 YAYOI CULTURE

A.D.
A.D. 300–500 KOFUN PERIOD; rise of Yamato Clan
552 (or 538) Buddhism brought to
Japan from Korea
600 ASUKA PERIOD (552–710)
(From 645–710 known as the
Hakuho period)
607 Horyu-ji founded
700 NARA PERIOD (710–84)
Capital at Nara (from 784–94, at
Nagaoka)
Todai-ji founded 747
Toshodai-ji founded 759
800 HEIAN PERIOD (794–1185)
Capital at Heian (Kyoto)
805 Saicho returns from China with
Tendai; 806 Kukai introduces
Shingon
838 Diplomatic and trade relations with
China cease, due to civil unrest at
close of Tang dynasty
900
1000 ca. 1002–19 Lady Murasaki Shikibu
writes Genji Monogatari
1053 Byodo-in at Uji
1159 Taira family victorious in battle
with Minamoto family. Burning of
the Sanjo Palace
KAMAKURA PERIOD (1185–1333)
New military capital set up at
Kamakura
1192 Yoritomo is made shogun

1200 1279 and 1281 attempted invasions by
Kublai Khan repelled
1300 1333 Kamakura burned, Hojo defeated
NAMBOKUCHO PERIOD (1336–92)
ASHIKAGA PERIOD (1392–1573)
Capital relocated at Kyoto
1400 1398 Kinkakuji built by third Ashikaga
shogun, Yoshimitsu
1467 Onin Civil War breaks out in Kyoto
1468–69 Sesshu (1420–1506) in China
1500 1542 Portuguese bring guns to Japan
1549 St. Francis Xavier arrives
MOMOYAMA PERIOD (1573–1615)
1568 Oda Nobunaga occupies Kyoto, ending
Ashikaga rule
1582 Nobunaga assassinated by Akechi
Mitsuhide, one of his generals; Akechi
killed by Toyotomi Hideyoshi
1590 Hideyoshi unites all of Japan once more
1592 Hideyoshi makes unsuccessful attempt to
invade China via Korea. Kano Eitoku
(1543–90) Kano Sanraku (1559–1635)
1598 Tokugawa Ieyasu succeeds Hideyoshi;
1603 Ieyasu made shogun
1600 TOKUGAWA PERIOD (1615–1868)
Capital Edo (Tokyo)
1603 Nijo Castle
1609 Himeji Castle. Completed
1620 Katsura Villa
1634–36 Ieyasu's tomb at Nikko
1639 Japanese forbidden to travel abroad;
country closed to foreigners
Honami Koetsu (1558–1637) Tawaraya
Sotatsu (?–1643)
1700 Ogata Korin (1658–1716)
Ogata Kenzan (1663–1743)

1800 Katsushika Hokusai (1760–1849)
 1853 Commodore Matthew Perry arrives at
 Uraga Bay seeking trade concessions
 1854 Military treaty obtained
 1858 Commercial treaty obtained

1867 Military power returned to Emperor
 Meiji
MEIJI PERIOD (1868–1912)
TAISHO PERIOD (1912–26)
SHOWA PERIOD (1926–88)

Pronunciation of Japanese Words

Vowels are pronounced as in Italian. Consonants are pronounced as in English. *G* is always pronounced as in *go*, never as in *ginger*. Each vowel receives equal stress and is always pronounced separately, never as one sound: Maeda = *Ma-e-da* = *Ma* as in *ma*ma, *e* as in *E*ddie, *da* as in *Da*da (not as in Daddy).

20
.

MOST ANCIENT JAPAN
The Jomon and Yayoi Periods

Japan was settled from the Asian mainland during the Last Ice Age, when the sea level had dropped and land bridges connected the present Japanese islands to the continent. Subsequently, with the melting of the great ice caps, the sea level rose, isolating the Japanese islands from the mainland. The long isolation, which began about ten thousand years ago, may have contributed to the Japanese cultural character.

JOMON CULTURE (ca. 5000–200 B.C.)

By about 3000 B.C. the first period of Japanese culture was at its height. It is known as the Jomon ("cord pattern") period, because many of the pottery vessels made during this time bear patterns of cord impressions on their surfaces, reminiscent of the corded ware of Neolithic China. Archaeologists have divided the Jomon period into five phases, which lasted more than five thousand years.

The Jomon people lived along the coastal plains and in river valleys in simple lean-to huts. Judging by the widely scattered remains, the Jomon people were hunters and food gatherers who also engaged in fishing. Rice cultivation was not yet practiced, so that the Jomon seem to have been somewhat behind the mainland development, where by this time, settled farming communities had developed an agrarian life-style.

Pottery

Although agriculture may have been late in developing, the aesthetic life of the people appears to have reached a high level. Pottery vessels produced by the Jomon people are considered to be the most advanced ceramic art attributable to a pre-agricultural society anywhere in the world.

Typically the earliest Jomon pots have inverted cone shapes, with pointed bottoms. Some have surface patterns that appear to have been made by matting or basketry, but most examples have parallel lines scratched into the surface, perhaps in imitation of the mat or basket pattern. There are also vessels with designs on their surfaces made by pressing shells against the damp clay.

The second-phase vessels have flat bottoms and tend to be more cylindrical. The surface is often accented with whorled patterns made up of parallel lines that stand out among the more complex texture of the background cord impressions.

Elaborate Corded Patterns

In the third, or Middle, Jomon style, these corded patterns and plainer whorls became extremely elaborate.

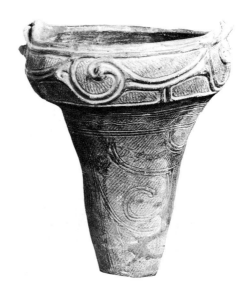

Figure 20.1 Jar. Pottery; cord impressions. Jomon (ca. 2000 B.C.). H. 20″. Tokyo National Museum. Photo: M. Sakamoto.

The whorls become rope-like, due to the parallel lines that delineate them and the tendency to raise the designs higher and higher from the surface (fig. 20.1). The effect is rather like that of heavy macramé. Toward the end of the middle period the mouths of vessels lose their simplicity and take on a highly sculptural character, indicating a playful interest in the qualities of the clay itself. These vessels seem to have surpassed mere functionalism in the pure rapture of aesthetic invention. There is an amazing variety to these works, and within the bounds of the type, it seems that every possibility of creative response to the material was explored. The potters obviously relished their material and enjoyed their work. If art is the overflow of joy in the making of an object, then these ancient potters certainly excelled as artists. It is very difficult to discern any functional motivation in these designs, so we are forced to accept their embellishment purely for its own sake, whether or not there was a symbolic inspiration.

After the end of the Middle Jomon, the vessels lost their flamboyance of decor, although a greater variety of shapes developed, and an increased sense of functional efficiency returned. An interesting new technique of decoration, the "erased cord pattern," developed. The entire surface was first covered with cord patterns, then, curvilinear designs were incised into the surface. Parts of the corded pattern were smoothed out to reveal two contrasting areas of design: one with and one without the characteristic cording.

It is clear that although the use of the cord-covered beater was similarly employed in ancient China, the

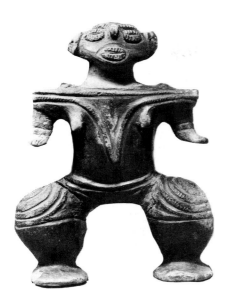

Figure 20.2 Female figure. Pottery. Jomon (ca. 2000 B.C.). H. 9″. Tokyo National Museum. Photo: M. Sakamoto.

corded ware of Japan presents effects that are quite different. In China the corded type of beater was seen only as a technically utilitarian device, increasing the efficiency of production. In Japan, the simple, practical necessity of using the cord-covered beater to prevent the clay's adhering as it was gently paddled into the desired shape was exploited for decorative invention.

Small Figurines

Throughout the Jomon period, small figurines were carved in stone or modeled in clay. They are believed to have had ritual symbolism, and they vary from quite simple ones with only minimal indication of form to very elaborate and highly decorated examples from the final phase (fig. 20.2). The designs may represent tattooing. Since almost all such figures are female, they have been considered to be fertility figures.

Isolation Produces Leisure

The Jomon people are of interest because, safe from invaders and blessed with a relatively benevolent environment, which provided a plentiful food supply, they had time to embellish utilitarian objects. Perhaps the high standards of their decorative elaborations stemmed from a greater abundance of leisure than was available to most of the hunting and gathering cultures in other lands. Their tendency to enhance objects, and indirectly, their own lives, and to make their time and place

as beautiful as they could indicates that life, even in these early times, meant more than the mere acquisition of basic necessities. It concerned itself with creating beauty, with ritual and symbol as well.

These attitudes and desires were expressed and materialized with the simple, basic components available. For example, it seems probable that the design of the larger rope patterns developed in the middle period owe their character to the fact that the tool used to make them may have been split bamboo. Why the emphasis upon parallel lines occurred early in Jomon pottery is not clear. It is possible that it imitated other material. The fact that it was treated as incised parallel lines may be attributable to the use of the bamboo implement; this may have led to further invention or creative experimentation in which the rope patterns appeared as a direct function of the implement. In this connection it is notable that the earliest so-called ropes were only incised, but that gradually, they appeared in ever-higher relief above the surface, until in the last years of the Middle Jomon they were so high that they probably were made by applying thin coils of clay directly to the surface.

The Significance of the Jomon Period

Jomon pottery bears similarities to continental types found in Mongolia, Siberia, and China. This suggests that the Jomon culture may have been an extension of a larger culture that stretched across the Eurasian continent from the Ural Mountains to the Pacific Ocean. It may also indicate that by the time of the isolation of Japan, because of rising sea levels at the end of the Ice Age, pottery was being made throughout this large area, and that it had developed the specific stylistic traits that link early Jomon with pottery produced at a wide range of continental sites. This may in turn point to a very early beginning for Jomon pottery in Japan, a fact that has been implied by the various methods of dating in the past few years, but thus far these conclusions are not universally accepted.

THE YAYOI PERIOD
(ca. 200 B.C.–ca. A.D. 300)

A major change in the cultural pattern in Japanese life took place in the Yayoi period, with the introduction of rice cultivation from the mainland. This new way of life probably came from South China into the western island of Kyushu, whence it spread to Korea and eastward to the inland sea region of Japan.

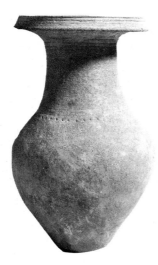

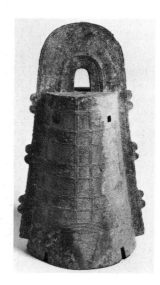

Figure 20.3 Jar. Pottery. Yayoi (ca. third century B.C. to fourth century A.D.). H. 16″. Asian Art Museum of San Francisco, the Avery Brundage Collection.

Figure 20.4 *Dotaku*. Bronze. Late Yayoi period. H. 24⅝″. Asian Art Museum of San Francisco, the Avery Brundage Collection.

New Pottery Style

A new style of pottery appeared during the Yayoi period. It presented a simple solution to the basic, everyday needs of a primitive agrarian people. These vessels have very limited surface designs, so that their attraction resides in their shape rather than in texture or pattern. Thin and well made, they range in hue from gray to red through shades of buff. Discreet incised patterns express highly refined restraint (fig. 20.3). Some pieces are made of burnished red ware. The burnishing technique, combined with the thin body and lack of other embellishment on these pieces, is reminiscent of the Longshan black pottery of China.

New Bronze Objects

Several new types of objects of material culture, inspired by mainland models, were produced during the latter part of the Yayoi period. These include bronze objects such as the bell-like **dotaku** (fig. 20.4), large blades, swords, and spearheads.

In addition to the bronze weapons, which were often made in a much larger size in Japan than they were on the continent, the Yayoi people produced a few bronze mirrors more or less resembling those of the Han. These, as well as Han Chinese mirrors, seem to have been objects of personal wealth or authority. They have been found buried with the more prestigious members of the society in the large pottery burial urns that were used for entombing prominent persons in the later years of Yayoi.

SUMMARY

The Jomon culture shares many characteristics of mainland civilizations. But perhaps due to its greater isolation, Japan developed some striking differences, of which the raised corded patterns of the Middle Jomon period were perhaps the most striking.

Jomon pottery may be summarily described as having surface embellishments by textural or sculptural means. The succeeding Yayoi pottery is thinner and more refined in shape and in surface design.

The differences in pottery types express differences in living modes. The Yayoi is not a style evolved from the long line of Jomon pottery but rather a new type introduced into Japan together with a new way of life. Food gathering, hunting, and fishing evolved as a new culture based upon rice farming. This agricultural life-style provided a more constant food supply because the surplus rice could be stored for later use.

GLOSSARY

Dotaku Bronze bell-shaped objects; perhaps ritual fertility implements. Japanese Yayoi period ca. A.D. 100–200. (p. 198)

21
· · · · ·

THE KOFUN (OLD MOUND) PERIOD AND CONTINENTAL CONTACTS
Shinto, the Way of the Gods

The Kofun (Old Mound) period followed the Yayoi and lasted from about A.D. 300–ca A.D. 650. This was another culture that arrived from the continent and came to dominate the Japanese way of life, developing certain concepts and attitudes that have lasted to the present day. New objects of material culture are found in this period.

KOFUN TOMBS

Many objects of a different type from those of the Yayoi period have all come to us from tombs (figs. 21.1 and 21.2). The Early Kofun tombs were made by digging a pit at the top of a small natural hill, and then the body, arranged inside a wooden coffin, was lowered into it. The coffins were formed by splitting tree trunks, then hollowing them out to make boat-like containers of the lower half while the upper half served as a cover.

Entombed Objects Reflect Migration

In the Late Kofun an entirely new type of tomb appeared and with it a much more elaborate collection of tomb equipment. Gilt bronze and iron trappings as well as bronze or iron weapons indicate that a new, horse-riding culture had become dominant. These people seem to have come from northeastern Asia, perhaps Manchuria, or more immediately, from Korea, and apparently they had connections with similar cultures to the west in Siberia and through these, with tribes even farther to the west. These wide-ranging migratory peoples contributed many elements to the new life-style that came to Japan in the Late Kofun period, so that motifs derived from the ancient Mediterranean world, such as the **palmette** and the **acanthus,** found their way across Asia and into Japan (fig. 21.2).

Sue Ware

One more indication of the influx of strong cultural aspects from Korea is the pottery known in Japan as **Sue ware.** It was made by potters brought from Korea by the horse-riding people as a part of the support personnel needed to maintain their initial dominance. At this time a new kiln type was introduced. It was made by digging short tunnels in a hillside at an angle of about ten degrees. This "climbing kiln" arrangement permitted a much stronger draft, thus increasing to one thousand degrees Centigrade the temperature attainable, producing what is technically stoneware.

Sue Ware Construction

Sue ware is dark gray, wheel thrown, and thinly potted. A strong updraft carried the wood ash through the kilns,

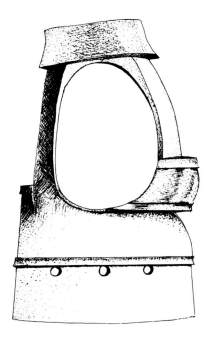

Figure 21.1 Hoe-shaped bracelet (?). Green stone. Early Kofun. H. 6¾".

where it was deposited on the vessels, producing a self-glaze where it came into contact with the silica of the clay body. This glaze usually appears only on the side that was toward the firebox of the kiln and produces an irregularly glassy area, sometimes with thick globules of glaze at the edge.

Kilns

The kilns of the earlier periods in Japan were of an open bonfire type or formed as a shallow covered pit. In either type the temperature was not variable except by the addition of fuel, and it could not be raised very much higher than the normal combustible temperature of that fuel. The climbing kiln was the first major improvement in firing of pottery in Japan, but its integration into the pottery-making methods seems to have been restricted, and it did not come into common use until several centuries later.

Mounds Entomb Clan Leaders

The intrusive culture of the Late Kofun period contrasted sharply with the simple agrarian life of the Early Kofun, but although these new people dominated, they did not destory the established mode of life they encountered in Japan. They set up the first court and probably instituted the concept of the divine origin of the ruler. The great tombs of the Kofun are those of clan leaders and emperors. The great tombs are found

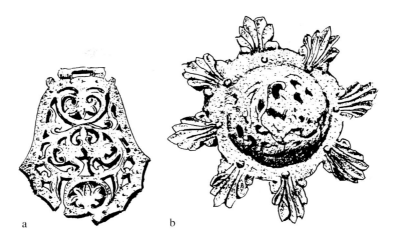

a b

Figure 21.2 *a.* Gilt bronze pendant from harness. Gumma Prefecture Kofun. *b.* Gilt bronze harness buckle. Wakayama Prefecture Late Kofun. (Note palmette motifs.)

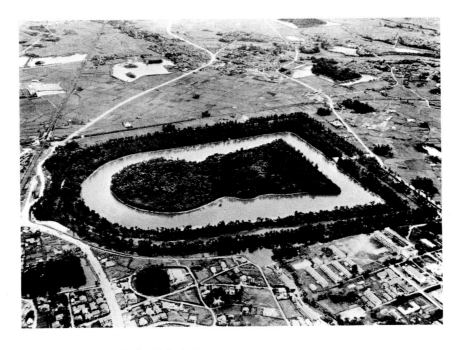

Figure 21.3 Tomb of Emperor Nintoku, near Osaka. Kofun (mid-fifth century A.D.). Length of tomb mound (excluding moats) 1700′. Photo: Heibonsha Henshukyoku.

on the Yamato Plain in the Osaka-Nara region. The largest of them is a huge, keyhole-shaped mound measuring almost seventeen hundred feet long and surrounded by three moats (fig. 21.3).

By this time the split tree-trunk coffins had been replaced by rectangular caskets made of stone. Toward the end of the period the tomb chambers began to resemble those of the Late Han or Early Six Dynasties in China. They were entered through a vestibule, and the entire interior space was created by piling up massive boulders or roughly dressed stone blocks (fig. 21.4). These tombs are more crude than those of China, but their plan as well as the component materials are similar. In addition they frequently were decorated with designs of men and horses or geometric patterns, perhaps symbolic, which were painted on their interior

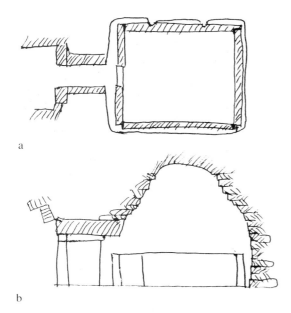

a

b

Figure 21.4 Tomb chamber, Idera Tomb, Kumamoto Prefecture: *a.* plan; *b.* cross section. Kofun. After Kidder, Jonathan, "Japan before Buddhism."

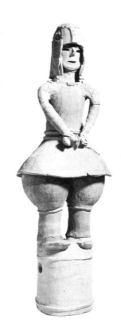

Figure 21.5 Haniwa warrior. Pottery. Kofun (fifth to sixth century A.D.). H. 47⅜". Asian Art Museum of San Francisco, the Avery Brundage Collection.

walls, although all were simpler than those found in China (figs. 12.13–12.16).

Funerary Objects

Another strikingly Chinese influence appears in the items buried with the dead. In addition to objects of a personal nature, there appear miniature replicas of people, animals, and even houses, all produced in fired clay miniatures. These artifacts seem to express the idea we have already noted in China: that life after death was but a continuation of the good life of the here and now.

Clay Retaining Walls

To prevent erosion of the grave mounds, retaining walls were built. Hollow cylinders of baked clay (**haniwa**) were set up in rows around the mound at successive levels to form a kind of pottery fence. The lower portions of the cylinders were placed in the ground and the upper sections protruded slightly. As time went on, the haniwa makers began to embellish the tops of the cylinders as they made them, modeling them into the shapes of animals and other figures. Freely and spontaneously created, their great variety and refreshing simplicity make them especially appealing. Their technique seems the very essence of artistic candor: slits for eyes and mouth; pinched clay for a nose; beads, ribbons, and belts made by placing pellets or flattened ropes of clay onto the surfaces. The figures are direct,

innocent, and refreshingly vivid. But, above all, they are clay (figs. 21.5 and 21.6).

RESPECT FOR "KAMI"

In these early works we can sense a basic characteristic of Japanese art: respect for the material. This peculiarly Japanese attitude gives us an insight into Japanese religion. All natural phenomena were perceived as though endowed with their own spirits, called **kami.** This attitude has continued through Japanese history, and it is inseparable from the sense of beauty that draws the people to the countryside to admire and reverence cherry blossoms in the spring and maple leaves in the fall.

From this concept a whole series of prescriptions developed, the purpose of which was to harmonize human actions with these spirits. Bascially these were what we would call rules of hygiene as well as techniques of production and of agriculture. One example will suffice to show both the logic and the wisdom of these ideas: when a tree was felled its kami had to be given a chance to escape and to take up abode in another tree, which the wise woodcutter had already planted. The tree was allowed to rest a certain length of time before it was sawed into timber. If it was too quickly used, the kami would become angry, and in its flight from the tree, the spirit might well rend it asunder. If the tree were used as a ridgepole in a house it could

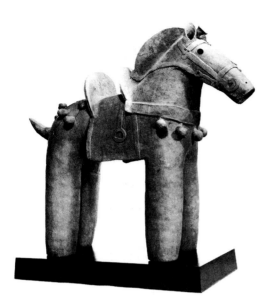

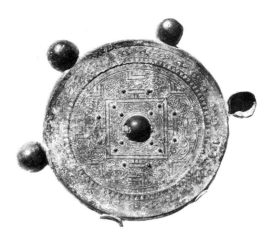

Figure 21.7 Belled-mirror. Bronze. Kofun (fifth to sixth century A.D.). D. 9¼″. Stanford University Museum, Mortimer C. Leventritt.

Figure 21.6 Haniwa horse. Pottery. Kofun (fifth to sixth century A.D.). H. 30⅞″. Gift of Robert Allerton. Photograph © 1991, The Art Institute of Chicago. All rights reserved.

result in collapse of the dwelling and even the death of the unwise builder who had not respected the spirit of the tree. In short: well-seasoned wood makes the best timber, but this implies stripping away the charm of myth and the quality of reverence. It is this reverence for nature that has been the foundation stone of what came to be called **Shinto**—the Way of the Gods. Shinto is an accumulation of insights and prescriptions from the experiences of the distant past, enabling one to live harmoniously with the kami, who were all around—in the wind, rain, rocks, trees, mountains, rivers, metal, and clay.

This spirit of reverence has led the Japanese to treasure the individuality of natural materials, teaching them to work in subtle cooperation with these materials. This spirit is admirably expressed in the haniwa.

The Sun Goddess

In the great creation myth of Japan, the sun goddess, **Amaterasu-no-Omikami,** once retreated into a cave because her brother had offended her. All the other gods were distraught because the sun had gone away, but she was finally enticed from her rocky refuge by hanging a mirror on a sacred tree, by displaying jewels, and by a dance.

Mirrors of the Late Kofun were sometimes provided with jingle bells, a feature unknown in China. The design of the mirror in figure 21.7 is obviously derived from the Han "TLV" type (fig. 12.21); but the animals of the four directions had no meaning for the Japanese, so they have been replaced by simple pairs of birds facing one another.

Jingle bells are not unusual accoutrements of horse-riding cultures like that of North Asia. They were also associated with **shamanism,** a religion of North Asia which professed that the spirits can be influenced or controlled by specially endowed and trained practitioners called *shaman* in the Tungusic tongue, a language spoken in central and eastern Siberia. The myth may well incorporate traditions of annual shamanistic rituals to insure the return of the sun after the long, dark, and cold Siberian winter.

The symbolism of the sun-mirror is simple and obvious. The Japanese believed Amaterasu-no-Omikami, the sun goddess, was the greatest of all the kami, and one of these mirrors is her home. It is housed in the main building of the Great Shrine at Ise. It is fascinating to learn that it is set up in a hollowed-out tree trunk that almost exactly duplicates the coffins of the Early Kofun period; this, in turn, recalls those of the burial mounds of Siberia. The ancient intent of the symbolic relationship between tree trunk and mirror at Ise must surely have been the same as that which caused tree trunks to be used as coffins ages earlier: to make it possible for the sun goddess to return to her other home in high heaven, as the dead person in such a coffin was believed to return to an original state of existence.

This may have explained how the sun goddess returned each morning to the sky after having sunk to earth each evening. Although the sun did not die each evening, the parallel between death and sleep was probably evident in ancient cultures. In Siberia, the sacred tree that separated heaven and earth was the

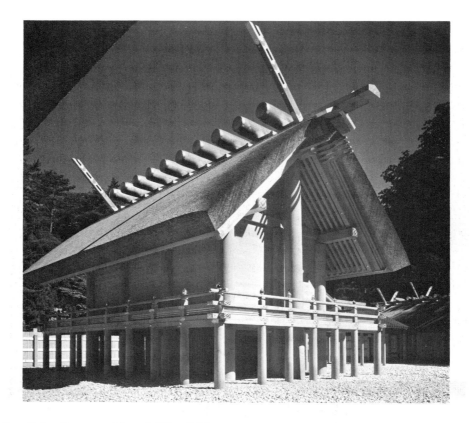

Figure 21.8 Ise, Great Shrine. Cypress wood (last rebuilding, 1973).
H. 45'. Photo: Y. Watanabe.

means by which the "sun-maiden" was able to descend to earth; likewise it was the way by which the shaman might ascend to the plane of heaven, or, in some versions, the position from which he was able to assume the form of a bird and fly into that realm.

It is significant that the tree and sun are also associated with a bird in China, where the myth of the ten suns was known at least as early as the Western Han dynasty. The myth states that there were originally ten suns, which their mother washed daily in the waters of the Indigo Sea and hung them up to dry on the fabulous Fu Sang tree, which grew on an island in that sea to the east of the country of China. As each sun dried it climbed higher and higher in the branches of the tree until, when it was finally dry, it took off from the top of the tree and flew across the heavens.

There is a fascinating parallel between this idea and that of the shaman. The raven, which is the bird depicted in the sun in the painted banner from the Western Han tomb of Lady Dai at Changsha, is the bird that either carries the shaman or into which the shaman is transformed to make the flight into the spirit world.

Thus, the association of sun, tree, and bird, especially the raven, links the Japanese sun goddess to both

North Asia and to China, suggesting that all share a common mythic root in very ancient times.

The Great Shrine at Ise

These very ancient and rich interrelationships with mainland Asia reached Japan at various times. In addition to the North Asian contributions, important influences from South Asia arrived in Japan as well. The main building of the inner shrine of the Great Shrine at Ise presents a remarkable paradox in its amalgamation of two architectural traditions (fig. 21.8). Much of the form of the building is thought to have been inspired by South Asian traditions introduced into Japan during the Kofun period. Parallels may be found in raised-floor dwellings of bamboo and thatch found in the Malay Archipelago. There is, however, a peculiarity in this structure: the South Asian buildings are made of a framework that supports the floor and the roof. The walls are hung between the posts and beams and do not bear the weight of the roof. At Ise, the walls no longer support the weight of the roof, but they did at one time.

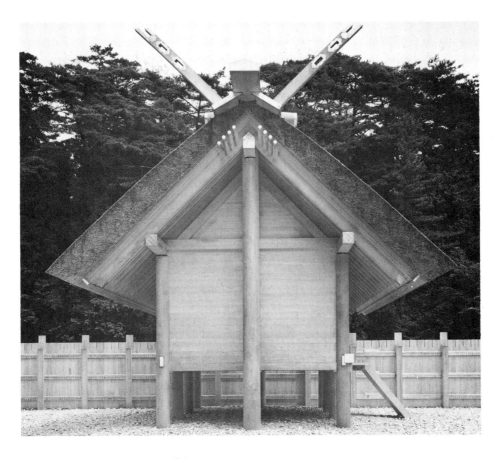

Figure 21.9 West end of East Treasure House, Inner Shrine compound, Ise. Photo: Y. Watanabe.

An "Architectural Museum"

These shrines have been rebuilt every twenty years, almost without exception, since about the fifth century. It would appear that in their earliest state the structure had roof-supporting walls constructed in the interlocked log arrangement or technique familiar to us in log cabins. With the passage of time the rustic aspect of these buildings was changed apparently in response to the more refined architecture of Buddhism. One of the changes was the planing of the logs, at first on the interior, and later on the exterior as well, until only relatively thin and smooth planks remained. Although they retained their interlocking relationship, it soon became evident that they would need further support in the form of vertical posts at the corners and at two points across the long sides of the buildings. There are a number of separate buildings at Ise that, in a remarkable manner, exhibit a series of stages of change, from their presumed original state. The entire complex is rather like an architectural museum.

The Mikeden, or Hall of Daily Offerings, of the Outer Shrine most clearly preserves the interlocking but planed-down planks but without the later addition of corner and wall supports. Both the Mikeden and the main building of the Main (Inner) Shrine have two extra end posts that do not touch the walls. They rise out of the ground, slanting inward on the longitudinal axis, but they are vertical on the lateral axis. Their purpose is to support the ridgepole, but at the time of construction, the ridgepole does not rest upon these supports. There is a space of several inches between the bottom of the square ridgepole and the slotted end posts (fig. 21.9). After a few years, the weight of the roof and the ridgepole come to rest upon these end posts, because the walls, unable to sustain the weight of the roof, settle down under the weight, thus bringing the ridgepole into contact with the end posts, which then share the weight with the walls.

Although this shrine was probably established about the third century A.D., the original buildings were not built until a century or two later, that is, this was a sacred place before wooden buildings were constructed. Since then the buildings have been renewed every twenty years by replicating them on alternate adjoining plots. The old buildings were completely dismantled after the new ones were completed.

Since it was established this practice has been interrupted only twice. At the ceremony of rededication, the sun goddess is ritually transported from the old to the new building by transferring the mirror, covered with silk so as not to be defiled by being seen.

Made of cypress wood and thatched with reeds, this shrine is noteworthy not only because it is the most sacred Shinto shrine in Japan but also because of its purity of form and precision of proportion, which have been compared to the Parthenon. The Kofun was a period of intense amalgamation of various cultural strains. Nothing illustrates this quite so strikingly as the Great Shrine at Ise, combining several of these traits and housing the sun goddess in a Chinese mirror.

SUMMARY

During the Kofun period strong continental cultural influences came to Japan. These affected the living, as well as the way in which the dead were buried. Perhaps the greatest changes were those of the tombs. At first small hills were chosen as the sites for burial, and coffins were made of tree trunks that were hollowed out to receive the body. Later, artificial mounds of great size were constructed, and the coffins were made of stone and placed inside the stone chambers constructed in the artificial mounds.

The objects of material culture that have been recovered from these tombs exhibit strong links to mainland styles, especially to the South Russian migratory cultures of the steppes region. Both iron and bronze armor as well as weapons testify to the warrior-like character of these new people. But the most significant objects are those of horse trappings, saddles, bridles, stirrups, and related artifacts of an equestrian character, often of gilded bronze, which clearly indicate that these warriors were mounted; they belonged to a horse-riding culture who introduced horses into Japan.

Many of the metal objects of the horse-riding culture bear designs based upon the ancient classical palmette and acanthus motifs popular in Greece and Rome. Accordingly, these represent the most eastward extension of influences from the Mediterranean world that found their way across Asia.

At this time a new ceramic type was also introduced from Korea: the so-called Sue ware, produced by Korean potters brought to Japan by the horse-riding peoples. The equestrian style dominated life in the Yamato Plain and probably developed the basis for the political as well as the religious traditions of Japan.

The exteriors of the great tomb mounds were fitted with retaining walls made of fired, hollow clay cylinders (Haniwa) set into the ground vertically. With the passage of time the tops of these Haniwa were modeled more and more fully into figures of animals and people. Such figures are characterized by a strong sense of the clay as a participating agent in the creative process. A comparison between the haniwa horses and those from the tomb of Qin Shi Huang Di indicates the difference between the two attitudes toward the component material as exemplified in Japan and China (figs. 12.2–12.5). Rather than dominate the material completely, as did the Chinese artist, the Japanese permitted the clay to speak for itself.

This sense of the appropriateness of the material to the forms to be produced may stem from the concept of the spirit, or kami, which was traditionally considered to be present in all matter, animate or inanimate. The consideration and reverent regard for such spirits form the basis of Shinto, the Way of the Gods, the native Japanese tradition since time immemorial.

The greatest kami is Amaterasu-no-Omikami, the sun goddess, who lives in the Great Shrine at Ise. This building complex combines at least two major architectural traditions, one from South Asia and one from North Asia, reflecting the complex genetic as well as cultural heritage of the Japanese people.

GLOSSARY

Acanthus An ornamentation representing the leaves of the acanthus—a family of prickly herbs found in the Mediterranean region. (p. 200)

Amaterasu-no-Omikami Japanese sun goddess, greatest of all kami. (p. 203)

Haniwa Cylinders of baked clay forming a pottery fence, Japanese Kofun period. (p. 202)

Kami Japanese spirits believed to endow all natural phenomena. (p. 202)

Palmette An ornamentation representing the leaves of fan-leafed palms. (p. 200)

Shamanism Religion of North Asia based upon the belief that spirits can be influenced or controlled by specially endowed, trained practitioners—shamans. (p. 203)

Shinto The collection of insights and prescriptions accumulated from the experiences of the distant past so as to live harmoniously with the kami. (p. 203)

Sue ware Dark gray, wheel-thrown, thinly potted stoneware with an irregular self-glaze, Japanese Kofun period. (p. 200)

22
.
BUDDHISM REACHES JAPAN

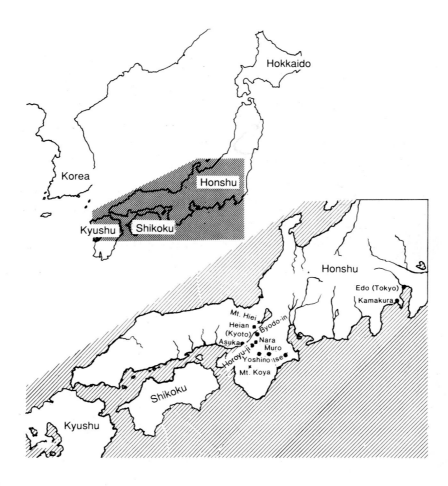

Figure 22.1 Japan.

THE ASUKA PERIOD (A.D. 552–645)

When Buddhism was introduced into Japan from Korea in the middle of the sixth century A.D., it met a simple people who, unlike the Chinese, had had little experience in the vagaries of metaphysical argumentation. It was not the doctrine so much as the accompanying ritual and splendor of the temples and images that first impressed the Japanese. To them Buddhism represented an advanced way of life that they were eager to adopt.

During the Asuka period under the reign of the empress Suiko (593–628), Buddhism received the support of the court; but the person most directly responsible for the rapid growth of Buddhism was her nephew, the crown prince Shotoku (572–622). He was quick to adopt the Chinese language and wrote explanations of the Buddhist *sutras,* which had come to Japan with the Buddhist monks. In 607 he and his aunt established the Horyu-ji west of Nara, at that time simply a pleasant country area, with the court located at Asuka, present-day Nara Prefecdure (fig. 22.1).

There are two parts to the temple at Horyu-ji, the west compound and the east compound. The first is on axis with the long south–north approach; the second is to the east. The west compound contains a five-storied pagoda and an image hall, while the east compound contains a single octagonal building. Each compound is surrounded by a covered gallery.

The Horyu-ji was built by Korean architects and other craftspersons and artists who were sent in the hundreds from Paekche (Kudara) and settled in the region. The temple is of the Kudara plan of which no example remains in Korea.

IMAGE HALL AND PAGODA

The Horyu-ji is the world's oldest extant wood construction (fig. 22.2). Records indicate that a fire in 670 destroyed some sections. Instead of the usual north–south axis, the image hall and pagoda are on an east–west axis (fig. 22.3). The architectural style reflects that of sixth-century China (fig. 22.4). As in the Chinese tradition the buildings are placed on raised platforms.

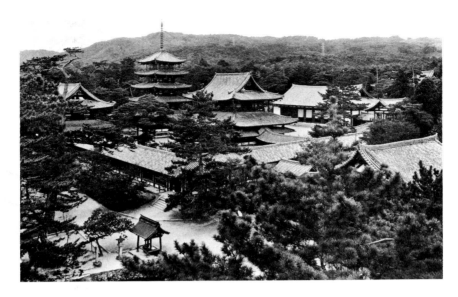

Figure 22.2 Horyu-ji compound, looking northwest. Asuka (founded A.D. 607). *Left to right,* roof of Chumon (Middle Gate); five-storied pagoda; Kondo; Refectory (not original). Photo: Heibonsha Henshukyoku.

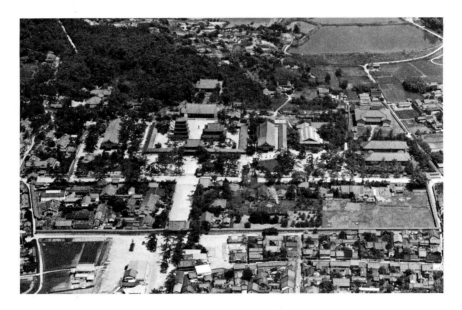

Figure 22.3 Horyu-ji compound from air showing, *left center,* long approach, South Gate, and *beyond,* the Middle Gate opening into compound. Asuka (seventh century A.D.). Photo: Heibonsha Henshukyoku.

There are steps on the four sides of both the pagoda and the image hall, recalling the four gateways of the Indian stupa.

The pagoda is the counterpart of the stupa, and though very different in style, it retains the same fundamental symbolism (chapters 3 and 13). The relics, which in India were placed inside the mound, are here guarded in a stone relic container under the shaft of the wood mast (a single huge tree), which is the support for the storied eaves and to which they are fastened by a system of **cantilevering.**

The Kondo ("Golden Hall," that is, hall for golden images) contains a group of Asuka period sculptures. They are placed upon a raised rectangular platform in the center of the room, allowing space on all sides

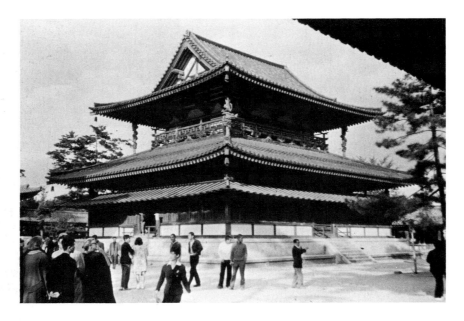

Figure 22.4 Horyu-ji Kondo. Looking northeast from Middle Gate. Asuka (seventh century A.D.). H. 55'. Photo: author.

for circumambulation. These sculptures are "old-fashioned" when compared to pieces of the same time made in China.

Bronze Sculpture

A bronze group including Shakyamuni (Sage of the Shakyas)—that is, Gautama (Japanese: Shaka)—and two attendant figures has an inscription on the back of its large body halo indicating that it had been dedicated in 623 to insure that the Crown Prince Shotoku, who had died the previous year, would be reborn in the Buddhist paradise (fig. 22.5). The image shares the basic characteristics of the Chinese Wei style of the sixth century, but its features are heavier and the drapery even more regimented into geometrical patterns.

Wood Sculpture

Two important large wood sculptures represent the bodhisattva Avalokiteshvara ("The Lord Who Looks Down from Above"), called Kuan-yin by the Chinese and **Kannon** by the Japanese. This bodhisattva of mercy became extremely popular in China, Korea, and Japan. These wood sculptures are believed to be made in the Korean style. The Yumedono Kannon (named after Hall of Dreams, the octagonal building in the east compound of the Horyu-ji, where the image is kept) is very thin from front to back (fig. 22.6). The style is clearly suited to wood carving, and the shallow relief

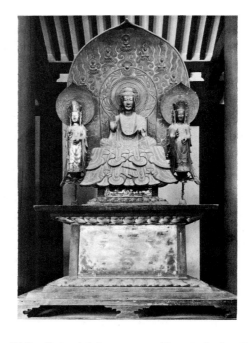

Figure 22.5 Shaka triad. Bronze on wood base. Asuka (inscribed and dated A.D. 623). H. (excluding base) 5'9¼". Horyu-ji Kondo. Photo: M. Sakamoto.

with sharp edges indicates the economy of effort attainable by a master artist. The body has been dematerialized, and the sculptor is still more intrigued by the drapery than by anatomy. The crown is cut from

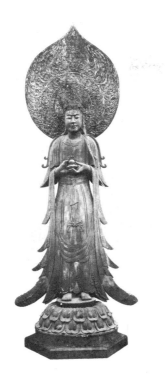

Figure 22.6 Yumedono Kannon. Wood, covered with gold leaf. Asuka (seventh century A.D.). H. 6′5½″. Horyu-ji, Yumedono. Photo: Asuka-en.

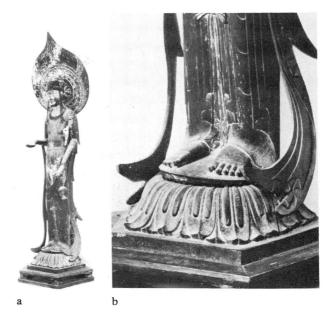

a b

Figure 22.7 *a.* Kudara Kannon. Wood, painted (mid-seventh century). H. 6′9½″. Horyu-ji Temple Museum. *b.* Detail, showing the technique of carving the lower section. Note the edges of the folds, which are made by cutting with the knife held at a ninety-degree angle to the wood surface in one stroke and the planes, which are cut by holding the flat of the knife parallel to the surface and cutting sideways to meet the incised lines. Horyu-ji Temple Museum.

sheet bronze, gilded, and set with blue glass. The flame-edged halo and outward-swinging scarves are like the Wei style, but the face, especially the nose and chin, are heavier.

The Kudara Kannon (named for the ancient Korean kingdom of Paeckche, called Kudara by the Japanese, from which the figure is said to have been brought) is more post-like, and its long scarves hang from the arms in a plane that runs from front to back rather than sideways as in the Yumedono Kannon (fig. 22.7*a*). Both bodhisattvas stand on lotus pods with double rows of petals falling downward and outward. The Kudara retains traces of pigment while the Yumedono Kannon is covered with gold leaf.

These two wood sculptures are exquisite examples of the applications of the knife's cutting perpendicularly into the wood surface to establish the line and then further enhancing it by cutting to it in a plane more or less parallel to the surface to "sharpen the line" (fig. 22.7*b*). These sculptures are carved from tree trunks with the arms and scarves made from thin planks and attached.

It is clear that the style of the Asuka period derives ultimately, but not directly, from that of the Chinese Northern Wei. Although no wood sculpture of the

Northern Wei period remains, its existence is implied by the sculptural forms found in stone and bronze images. A comparison of figures 13.8*a* and *b*, for example, indicates the similarities of the tendency to stress line more than volume and to emphasize that line by sharpening its edge, so to speak. This same tendency is seen in both stone and metal. It does not seem to be native to either medium.

When the wood sculptures of the Asuka period are compared to these Wei examples, it is clear that the forms produced by sharp, sure strokes of the knife's cutting the wood are the source for the Chinese forms preserved in Wei sculpture only in stone or metal. This strongly linear and sharp-edged drapery style continued through the next two or three generations. It may be seen in the Shaka group in bronze (fig. 22.5) and in the Four Heavenly Kings in wood in the Kondo of the Horyu-ji (fig. 22.8).

The figures of the Four Heavenly Kings stand, one at each corner of the dais, inside the Kondo. They are derived from the four Hindu deities—Brahma, Vishnu, Shiva, and Indra—who were taken into Indian Buddhism and gradually became Guardian Kings of Buddhism. Like the Kannons they stand stiffly frontal.

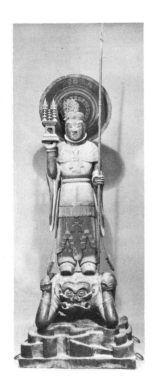

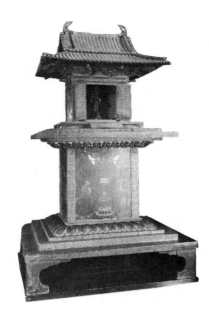

Figure 22.9 Tamamushi Shrine. Wood, painted; metal trim. Asuka (seventh century A.D.). H. 7'8''. Horyu-ji Museum. Photo: M. Sakamoto.

Figure 22.8 Tamon Ten, one of the Four Heavenly Kings. Wood, painted. Asuka (mid-seventh century A.D.). H. (figure only) 5'2''. Horyu-ji Kondo. Photo: M. Sakamoto.

One of them is inscribed with the name of a Japanese artist known to have worked around A.D. 650.

The debt of Asuka sculpture to Korea can be appreciated by comparing the Guardian King to the Kudara Kannon. Compare, for example, the scarves hanging from the arms, the sheet-metal crowns, and the general columnar character combined with the flat relief of the carved drapery. Each of the Guardian Kings has its own attributes. Tamon Ten, Guardian of the North, carries in his upraised right hand a small stupa or pagoda and in his left a trident.

TAMAMUSHI SHRINE

In painting the only important work remaining is the group of panels on the doors and sides of the base of the Tamamushi Shrine, a miniature wooden building reproducing in detail a tile-roofed temple building in the Chinese sixth-century style (fig. 22.9). On the four sides of the high base are two **Jataka** tales, left and right, and two symbolic scenes, front and back. The corners of the base and of the shrine itself are edged in openwork gilded sheet-bronze. Originally, iridescent green beetle (Tamamushi) wings were fastened in place

in back of these metal edges and glittered through the openings, giving the name to the shrine. The combination of gilt bronze and beetle wings has been found in objects excavated only in southern Korea, and this seems to point to a Korean source and Korean artists in Japan.

Ancient records tell us that during the late sixth and early seventh centuries, many painters were invited to come from Korea to Japan to fill the demand for Buddhist paintings. The Tamamushi Shrine, however, holds the only remaining evidence of what these paintings must have been like. Its figures are simple, and ample space is provided so that figures do not overlap; landscape elements are arbitrarily arranged for clarity rather than for realism. The colors, green, red, and yellow against the black background, must have greatly enhanced this clear depiction when they were fresh and bright. The Jataka tales deal with the 550 previous lives of Gautama before he became the Buddha. The painting on one side of the base depicts the Buddha in a former incarnation coming upon a tigress and her cubs that had fallen into a rocky gorge unable to get out (fig. 22.10). Realizing they would starve, the bodhisattva (for he had not yet been born as Gautama) carefully hangs his clothes on a tree at the top of the gorge and throws himself into the pit, where, in the last scene at the bottom, he is being devoured by the tigress and her cubs. This compassionate act was rewarded by his immediate rebirth in

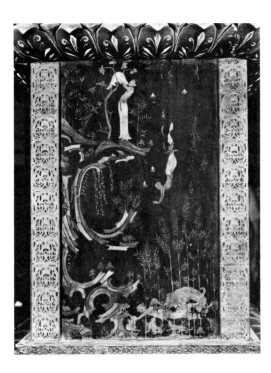

Figure 22.10 Tamamushi Shrine, side of base. Panel showing the bodhisattva hanging his robe on branch, leaping from cliff and, *bottom,* being devoured by tigress and her cubs. Horyu-ji Museum. Photo: M. Sakamoto.

a higher state. Whether in architecture, sculpture, or painting, the Asuka style is direct and clear, even though "old-fashioned" in terms of the patterns simultaneously developing in China. The encouragement and sound planning that the crown prince Shotoku Taishi so energetically manifested during his lifetime flowered after his death; the number of monasteries and temples increased from forty-six in A.D. 624 to 545 by A.D. 692.

SUMMARY

The arrival of Buddhism brought advanced cultural as well as ethical and religious standards to Japan. The Horyu-ji, founded by the crown prince and his aunt in the seventh century, reflects the architecture and sculpture of China a century earlier. Because direct contact was not with China but with Korea, this also indicates that the style in Korea at the time was already old-fashioned in relation to China. The Horyu-ji preserves for us these examples of the Buddhist culture of China and Japan during the sixth and seventh centuries, even though wooden examples of architecture and sculpture have long since disappeared in those countries.

This is also true of the few paintings for the period. The Horyu-ji also includes the Tamamushi Shrine, which has the only complete scheme of painted decor from the period. Its iconography and symbolism may be seen as a kind of recapitulation of Indian, Chinese, and Korean versions of Buddhist art, making it one of the most significant of all works of Buddhist art extant.

GLOSSARY

Cantilevering A system of projecting beams supported at only one end, such as a bracket-shaped member supporting a balcony. (p. 209)

Jataka Tales of previous incarnations of the Buddha. (p. 212)

Kannon Japan, the bodhisattva of mercy. (p. 210)

23
· · · · ·

CHINESE CULTURE TRANSPLANTED TO JAPAN
International Buddhism

In 646 the Japanese political system was re-cast in the Chinese mode, and increasing interest in China was to change the history of Japan.

NARA ADOPTS TANG CULTURE (NARA PERIOD, A.D. 710–94)

Some idea of the impact of China on Japan during the Nara period can be gained by considering the fact that when the new capital was established at Nara, it was laid out on the grid system, with streets running north–south and east–west in imitation of the Tang capital city of Changan. This profound desire to adopt Tang culture is the outstanding characteristic of the Nara period.

In support of Buddhism the emperor issued an edict in A.D. 685 urging that home shrines be established. In 741 the emperor Shomu ordered temples to be built in every one of the sixty-four provinces, in accord with his desire to make of Japan a "Buddha-land."

The centerpiece of this plan was the Todai-ji (Great Eastern Temple) in eastern Kyoto, where a large hill was leveled to make room for the enormous image hall, the Daibutsuden (Great Buddha Hall) and its two pagodas, one on the east and one on the west of the huge courtyard in front of the temple (fig. 23.1a). The Daibutsuden, even today after three re-buildings, resulting in a building only two-thirds the size of the original, is still the largest wooden building in the world (fig. 23.1b). The twin pagodas may recall the two stupa mounds in the south courtyard of the White Horse Temple at Luoyang—the burial mounds for the two Indian monks who brought Buddhism to the Han emperor (chapter 13). The Indian stupa had already become transformed into the pagoda in China, from there the pagoda form was brought to Japan through Korea, as seen at the Horyu-ji (fig. 22.2).

In 752 the largest bronze Buddha in Asia was completed at Nara at the Todai-ji. It was Vairochana (Japanese: Roshana) seated upon his lotus. The image was over fifty feet high and gilded. It was severely damaged in the twelfth and seventeenth centuries, and the present restored image gives little hint of the aesthetic quality of the original. Some of the lotus petals of the base were undamaged; these preserve engraved designs that show the style of the original sculpture (fig. 23.2). The drawing is sure and mature, the forms amply suggested, in the Tang manner.

The finest remaining Tang-style bronze sculptures of large size are the Yakushi (Buddha of Healing) and two bodhisattvas of the Yakushi-ji near Nara (fig. 23.3). The bodhisattvas stand in *contrapposto*, with the weight on one foot and the body gently balanced on the other. The swelling forms are fundamentally Indian, as are the draperies, crowns, and jewels. These sculptures were made either in 697 or in 718. The temple was moved from a former site in 718, but it is not certain whether the images were also moved or new ones made.

HOLLOW DRY LACQUER SCULPTURE

In the Golden Hall of another temple, the Toshodai-ji ("Temple Brought from Tang"), established in 759, the main image, also Roshana, is made in hollow dry lacquer, a technique much used during the Tang-Nara period (figs. 23.4 and 23.5). Cloth soaked in lacquer was modeled over a clay core. When the modeling was completed, the clay was washed out, leaving a hollow, lightweight sculpture. Dry lacquer had the great advantages of being easily modeled (especially draperies, since real cloth only needed to be draped into folds) and of being readily transportable. Painting and gilding with gold leaf could be applied after the clay core had been removed. This Chinese technique suited the desire for naturalism, which characterized the Tang-Nara period. The ten-foot-high seated Roshana of the Toshodai-ji is one of the finest expressions in this medium. The one thousand Buddhas of the one thousand worlds may be seen seated in the halo.

The "Temple Brought from Tang" is appropriately named. It was established by the Chinese priest, Jian Zhen, who brought with him architects, sculptors, and other craftspersons to construct this temple at the Nara capital.

UNFIRED CLAY SCULPTURE

The unfired clay sculpture technique that originated in India and flourished in central Asia, and that we have seen at Tunhuang, was also used in the Nara period. This medium is also eminently suited to the depiction of natural expression and anatomical accuracy; it was developed much further in China and Japan than it had been in India. The Four Heavenly Kings of the Kaidan-in (Ordination-Platform Hall), established at the Toshodai-ji by the Chinese priest Jian Zhen (Japanese: Ganjin) (688–763), who also founded the Toshodai-ji,

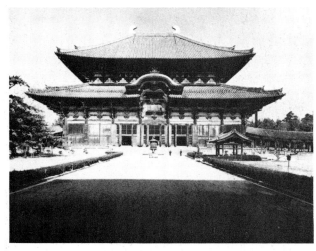

a

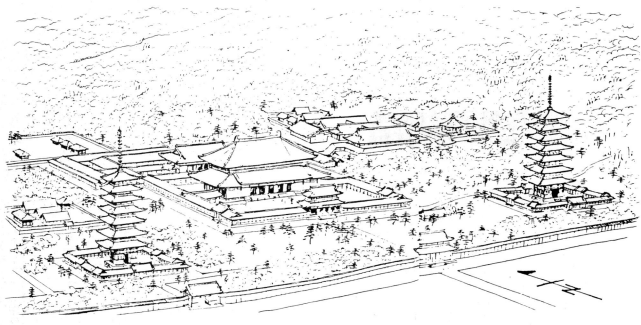

b

Figure 23.1 *a*. The Daibutsuden (Great Buddha Hall) of the Todai-ji, Nara, as rebuilt in 1708 (A.D. 751). H. 160′; L. 190′. Original size: H. 161′; L. 276′.

b. The Todai-ji, Nara. Conjectural reconstruction, showing the great eastern and western pagodas in the south courtyard. Daibutsuden in center. Source: From Kazuo Nishi and Kazuo Hozumi, *What Is Japanese Architecture?*, 2d edition. Copyright © 1986 Kodansha International, Tokyo, Japan.

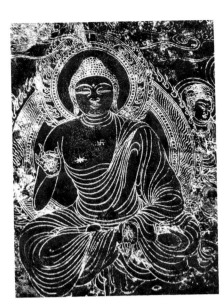

Figure 23.2 Rubbing from a bronze lotus petal of the base of the Great Buddha, Roshana, showing engraved seated Buddha. Daibutsuden, Todai-ji, Nara (749). H. 4'6''. Photo: author.

a

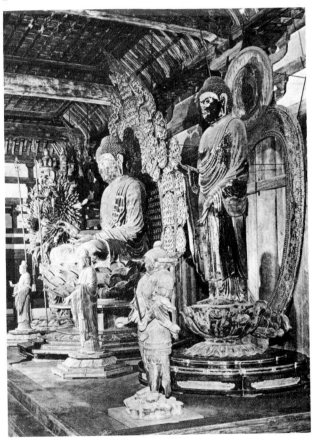

b

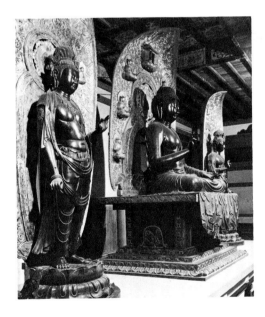

Figure 23.3 Yakushi triad. Bronze. Nara (seventh or eighth century). Halos modern. H. 10'10''. Yakushi-ji, Nara. Photo: M. Sakamoto.

Figure 23.4 *a.* Kondo (Golden Hall) of the Toshodai-ji, Nara, 759. Established by Jian Zhen (Ganjin). H. 51'; L. 102'. Sakamoto Photo Research Laboratories. *b.* Interior of the Golden Hall (Kondo) of the Toshodai-ji, Nara, 759. Large figures, *far left,* Kannon Bosatsu (Bodhisattva) of the Thousand Arms; *center,* Buddha Vairochana (Birushana Butsu); *right,* Bhaisajyaguru Buddha (Yakushi Butsu). All three, hollow dry lacquer, gilt, and partially painted. H. each, 16'. Small figures later.

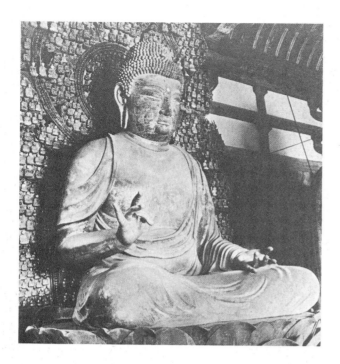

Figure 23.5 Buddha Vairochana (Birushana Butsu), Golden Hall, Toshodai-ji, Nara. Hollow dry lacquer with gold leaf. Nara period. H. (figure only) 9′.

most realistic of all the Buddhist figures remaining from this time (fig. 23.6). Painted with bright colors and gold, they must have been strikingly lifelike when new. In style and technique they recall the Chinese sculptures of Dunhuang (fig. 14.4c).

The Nara period ended when the emperor, hoping to escape domination by the Buddhist clergy at Nara, who had become wealthy and influential, moved the capital in 794 to Heian (Tranquil Peace), now known as Kyoto.

SUMMARY

During the Nara period Japan adopted Chinese culture. The Tang style predominated in Buddhist architecture, sculpture, and painting. Even the new capital emulated that of Tang China in its plan, and the largest bronze Buddha in Asia, cast for the Todai-ji at Nara, was inspired by the great Buddha carved in the cliff at Longmen, the Chinese cave-temple site near the Tang capital.

Since many internal persecutions and war have destroyed all the large bronze sculptures in China and damaged the cave temples, Japan has become a repository of the Tang style, so that the temples of Nara and their treasures provide us today with the best insight into what the artistic life of China in the eighth century must have been like.

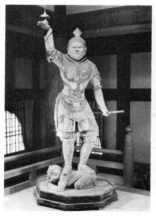

a

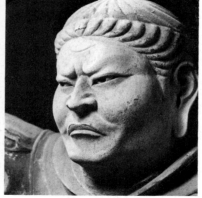

b

Figure 23.6 *a.* Tamon Ten (Heavenly King of the North). Unfired clay; eyes black glass. Nara (eighth century). H. 5′4″. Todai-ji, Kaidan-in (Ordination Platform Hall). Photo: M. Sakamoto. *b.* Detail of head. Photo: Asuka-en.

24
· · · · ·

RITUAL MAGIC AND AESTHETICS
Modification of Indian Buddhism

THE EARLY HEIAN (JOGAN) PERIOD
(A.D. 794–897)

During the Heian period two new sects were introduced from China that were to affect the history of Japanese art profoundly.

Tendai

The first sect, **Tendai** (so named after the monastery of Mount Tien-tai in Zhejiang Province, China, where this form of Buddhism had been established in the sixth century), was brought to Japan by the monk Saicho (posthumous name: Dengyo Daishi), who had been sent to China by the court to study. In 788 he founded a small monastery on Mount Hiei, northeast of a marshy lowland that six years later became the capital. The emperor recognized in Saicho's system a means of escaping Nara Buddhism, with its several conflicting sects, and established a new capital at Heian (now Kyoto). The center of this system was Shaka, the historical Buddha. Tendai is at once a reform, returning to what Gautama taught, and a universalization. Saicho saw all individuals as potential Buddhas. He stressed study and long years of monastic discipline.

Shingon

Tendai had just become firmly rooted as the court-supported official form of Buddhism in Heian when, in 816, another monk who had also gone to China for study established a monastery on Mount Koya, south of Nara. This was Kukai (posthumous name: Kobo Daishi), and his form of Buddhism was very different from Tendai. It was called **Shingon** (True Word) and had developed in China from the Indian Mantrayana (Magic Formula Vehicle) system during the Tang dynasty. Instead of the historical Buddha, the center of Shingon was Vairochana (Japanese: **Roshana**), the Buddha Essence who had been brought to earth in the great bronze Buddha at Nara (but in Shingon called Dainichi, "Great Sun," to distinguish him from the earlier exoteric form). Shingon did away with scriptures in favor of **mantras** (religious-magical spells), which were chanted. Its secret knowledge was passed on from teacher to pupil by word of mouth. Many of the mantras were sanskrit phrases and were quite unintelligible to the initiate. Nevertheless, it was the belief in the accuracy of repetition and the efficacy of these charms that represented the power of Buddhist doctrine. These words were said to have been those spoken by Vairochana himself. Ritual magic was the core of Shingon practice since ultimate reality was expressible only in terms of magic signs, diagrams, and symbols, not in ordinary words.

Tendai and Shingon were esoteric, not for the masses but for the elite, and both were monastic, seeking places of retreat and withdrawal from the world (they are referred to by the Japanese as "mountain-forest" sects).

Architecture of the Muro-ji

None of the architecture of the time remains at either Mount Hiei or Mount Koya. Only one monastery from the period has escaped the numerous fires that beset these outlying mountain sites. The Muro-ji, southeast of Nara, is a fascinating example of a pre-Buddhist site taken over by the foreign religion. In ancient times it seems to have been a place highly revered as the home of a powerful water spirit. In periods of drought ritual ceremonies were performed before the Dragon Hole Shrine. In the eighth century when the heir apparent became seriously ill, Buddhist priests were sent from Nara to chant the proper sutras for his recovery. The heir recovered and ascended the throne in A.D. 781 as the emperor Kammu, who moved the capital to Kyoto in 794.

As a result of the cure of the crown prince, a Buddhist monastery was founded at Mount Muro in the late decades of the eighth century. At first, monks from the Kofuku-ji in Nara were in charge of the new temple. The second abbot had studied at Mount Hiei with Saicho before the latter went to China, and it may have been he who introduced esoteric aspects of the mountain-forest sects that were to be found at Muro-ji. But because the more famous Kukai was also known as a prodigious rain maker, his name may have become associated with the temple for that reason.

Tradition says that Kukai renovated or restored the temple in the Tencho Era (824–33), but there is no documentation to support this. The pagoda and the kondo are considered to be the oldest buildings and may date from the last decade of the eighth or the first half of the ninth century (fig. 24.1).

These later buildings are placed among the huge evergreens along the steep hillside. The symmetry of the Asuka and Nara period temple plans is gone. These buildings are the earliest remaining expression of the native Japanese feeling for site planning. The Kondo at Muro-ji is a small, unpretentious building nestled against the hillside (fig. 24.2). There is no long, straight approach with gates, as at the Horyu-ji, nor is there any axial alignment. The same general scheme probably prevailed at Mount Hiei and Mount Koya, but it

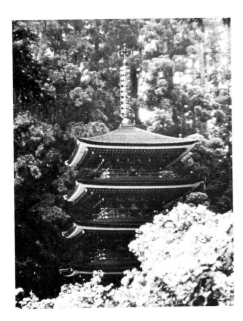

Figure 24.1 Muro-ji, five-storied pagoda (lower story hidden by shrubbery). Painted wood; thatched roofs; gilt bronze spire. Early Heian (ninth century). H. 53'. Photo: author.

is well to remember that this concept of building to suit the site, without disturbing its natural character, may have been imposed upon both sects in China by the rocky nature of their mountaintop home monasteries. Whatever its origin, the asymmetrical plan was retained for Tendai and Shingon esoteric Buddhist communities in forest settings. However, in cities, the monasteries tended to conform to the symmetrical plan as shown by the To-ji, the Shingon temple of Heian.

Sculpture

It is tempting to see in the sculpture of Early Heian a Japanese preference for natural materials, for most of the sculpture was carved from single solid blocks of wood and left unpainted. This may be Shinto impulse, or it may derive from a legendary sandalwood image said to have been made in Gandhara as a "portrait" of Gautama. There seems to be little doubt that there was an early image of great fame, probably made of wood and rather certainly in the Gandhara style. It was recorded in Chinese legends, and a Chinese copy in wood was brought to Japan in the Heian period. The standing Shaka in the Kondo at Muro-ji is a large-size version of this type. The parallel ridged folds of the robe relate this image to the Gandhara style.

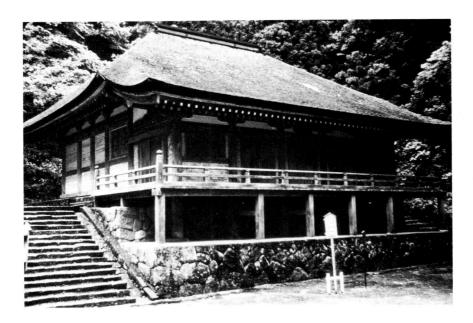

Figure 24.2 Muro-ji, Kondo. Wood; thatched roof. Early Heian (ninth century). H. (including stone base) 40'. Photo: author.

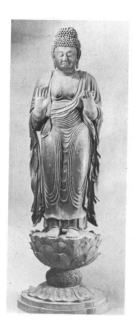

Figure 24.3 Yakushi Buddha. Sandalwood, unpainted except eyes and lips. Early Heian (ninth century). Lower arms and hands modern reconstructions. H. 5′6″. Jingo-ji, Kyoto. Photo: M. Sakamoto.

It appears that when fragrant wood, either sandalwood or camphor, was available the Japanese sculptures were left unpainted so as not to impair their fragrance. The Yakushi Buddha in the Jingo-ji, Kyoto (fig. 24.3), and the Eleven-headed Kannon of the Hokke-ji, Nara (fig. 24.4*a*), are unpainted sandalwood images. The Shaka of Muro-ji is cypress wood and was painted and gilded (fig. 24.4*b*). The Jingo-ji Buddha shows two further characteristics of Early Heian sculpture: heavy, almost gross proportions and the gathering of robe folds into unnatural concentric ridges between the thighs, which are fat and smooth like those of Kushan Mathura. It is clear that the Early Heian received a part of its inspiration from India through central Asia to China, and the sculptures embody a unique quality of form traceable some six hundred years earlier through China back to the Gandhara type (fig. 3.17).

It is significant that this was the last Indian inspiration to reach Japan because, as we have seen, it was the first style in which India portrayed the figure of the Buddha. That this archaic residue should have been associated with esoteric Buddhism is not surprising when we consider that both Tendai and Shingon were themselves summations of the whole history of Buddhist thought: Tendai through rationalization and Shingon through magic formulas, in which we might even perceive pre-Buddhist, Vedic period vestiges brought into Buddhism in India, then passed on to China and Japan.

Painting

Painting in the Early Heian was stimulated by the need for images of the multitude of deities associated with Shingon. Among the many figural subjects were the Five Guardians (four directions plus the center), the Five Benevolent Kings, and the Five Enlightened Kings, obviously derived from the Four Heavenly Kings of ancient India (colorplate 14). In the Hindu manner, these have multiple heads and arms, indicating multiple powers. But the Japanese went even further and multiplied not only the number of beings (there are, for example, the Twelve Guardians of Yakushi and the Twenty-Eight Guardians of Kannon) but also the number of legs with which some of them are equipped, in a quite obvious desire to match the number of arms with as many legs. These figures, often surrounded by flames and always shown in terrifying aspect, are meant to fill the believer with awe in the face of ultimate reality. Many of the paintings were made for use in Shingon initiation ceremonies, where the large image was hung in the initiation hall and the initiate knelt before a great bonfire. At the point in the long ceremony when the novice was supposed to have reached spiritual identification with one or another of these fearsome beings, he was instructed to look up and beheld the painted image seeming to emerge from pulsating flames. It must have been a moving experience indeed.

THE LATE HEIAN (FUJIWARA) PERIOD (A.D. 897–1185)

Chinese contacts, which had been so important in the Early Heian, were terminated in 894, when imperial missions from Japan were terminated. The Late Heian is known as Fujiwara, after the family that had, by marrying its daughters to successive emperors, gradually gained virtual control of the country. During almost three centuries the Fujiwara court at Heian set the taste and formed the culture of Japan.

Painting: Horizontal Scrolls

Secular literature began to develop, and illustrated novels appeared. The best known is *The Tale of Genji,* written about A.D. 1000 by a member of the court, the lady-in-waiting, Murasaki Shikibu. It is widely considered to be the world's first novel. It is a very long and complex tale containing over five hundred characters and covering the life of Prince Genji and his children and grandchildren through the reigns of four Heian emperors. The novel is very detailed and gives us a precise view of the life of the court at Kyoto. Much of the

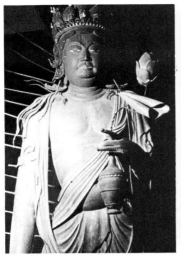 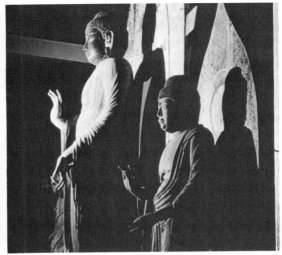

a b

Figure 24.4 *a.* Eleven-headed Kannon Sandalwood, unpainted except for eyes and lips. Early Heian (ninth century). H. 39″. Hokke-ji, Nara. *b.* Muro-ji, Kondo interior. *Left,* Shaka. Cypress wood, painted. *Right,*

Yakushi camphor wood, unpainted. Early Heian (ninth century). H. (Shaka) 7′8″. Photos: author.

work is devoted to the pastimes and pleasures of the nobility, and chief among these are the amorous adventures of Prince Genji, his friends, his enemies, and his children.

Colorplate 15 deals with the rivalry between Genji's grandson and Kaoru for the hand of the emperor's niece. Here, the lovestruck Kaoru, *right,* peers through a bamboo fence at his loved one and her sister as they play music in the moonlight. The moon, *top right,* above Kaoru's head breaks through and illumines the scene. The girls sit swathed in their everyday wear, multiple-layered and voluminous kimono, with only their heads visible, inside the house. A part of one sister's kimono billows out onto the verandah, where two attendants sit. The composition is elegantly and very subtly arranged. The reader would have just finished a short section of the text and moved on to the left, in the way such scrolls were unrolled. The painting is about eighteen inches long—just the right size to be unrolled while keeping the forearms parallel and resting upon the low table that would have supported the scroll.

The scroll format had come from China in the Nara period, but the style of these kinds of paintings is entirely Japanese. The drawings were done first in fine ink line. Opaque watercolor pigments were then applied and a few lines were redrawn, but it is not a style that depends upon brilliant brushwork, as does the Chinese style.

The text sections and the paintings in the Genji scrolls were interspersed so that the reader might be, in a sense, rewarded but also relieved to find respite in the visualizations, for the story is very densely packed. The paintings have a generally passive character. In the scene shown in colorplate 15, Kaoru (*lower right*) is discovered by the viewer by his "sudden" placement at the very right edge. The fence secludes and isolates him from the action, in which, we may assume, he yearns to partake. So much is narrative, but the visual enhancement is most interesting. The painter has closed off Kaoru by the angle of the fence, which imprisons him visually in the corner, where the clouds hang over him at head height. We follow his gaze across the painting to the colorful pile of clothing and ladies and music. This group is further contrasted to Kaoru by the bright colors and by the strong light and dark patterning, which emphasizes the positives of the girls against the negatives of the suitor's plight. The diagonal slash of the verandah edge is perhaps the subtlest, but most definite, separator between the girls and Kaoru; but there is a counterbalance to these elements in the movement of our eye through a large arc from Kaoru's head along the clouds, originally bright but now dull and silver, to the light pillar and to the white face next to it onward to the next face, located a little lower to the left. This movement is confirmed by the strong, downward-curving rolled bamboo curtain to the last

pillar at the left edge of the painting. At this point our eye is directed sharply back to the right by the curving mass of black hair of the left attendant figure and moves along the bottom edge, past the red mass of kimono until it meets the bottom of the bamboo fence in Kaoru's corner. There it glances up to the right through the curve of his sleeve to rest again upon his face, only to be drawn again through the compositional oval once more.

All of this makes for a very rich but emotionally relaxing experience, and these Genji scrolls set the tone for one branch of Japanese painting for the next eight hundred years. This kind of painting became known as **Yamato-e** (Japanese painting) to distinguish it from Chinese painting, which began to come to Japan in the succeeding Ashikaga period, and from Buddhist iconographic painting. Yamato-e has tended to remain secular. By the end of the twelfth century, Japanese painting, whether religious or secular, was characterized by the fine line, strong patterning, and bright colors. Very often gold and silver were used, as in the moon and clouds, but, as here, the silver tarnishes and becomes black with time. The original effect, however, must have been quite delightful.

The designs were first sketched in with a fine brush and ink and then the colors were added, perhaps by workshop craftspersons, for sometimes, where the paint has flaked off, there can be seen color notes written underneath. The same system, of the artist doing the design and others doing the execution, will appear again and again in the Yamato-e tradition in later times.

It was a period of luxurious pomp, of courtly intrigue, and elegant taste. The rise of the **Jodo** (Chinese: Jingtu; Pure Land) sect to a position of first importance is indicative of the bemused and, at the same time, slightly wistful character of the age. Jodo promised rebirth in the glorious Western paradise of Amida. More and more this sect became a matter of faith alone.

For artists it offered untold possibilities, since there were no canonical restrictions as to how elaborate the paradise scenes might be. Veritable visions of elegant graceful Amidas surrounded by the heavenly host of bodhisattvas, musicians, and "angels" were painted in colors and gold leaf on silk or actually created in three dimensions in temples and gardens.

An Elaborate Temple: Byodo-in

The Byodo-in at Uji, just south of Kyoto, is the most elaborate extant example of a temple from this period (fig. 24.5). Fujiwara Yorimichi built this temple on his family lands. The central hall is called the Ho-o-do, or Phoenix Hall, after the two gilt bronze images of these birds that crown the roof. They were the Chinese symbol of the empress and in this instance may have been references to the Fujiwara family's empress-daughters. This elegant and symmetrical building is Chinese in style.

The pond represented the pool in the Western paradise, above which Amida sat on his lotus throne and in which lotus buds, containing the souls of the faithful departed, were continuously opening as they were reborn in paradise. The large gilt wood Amida could be seen inside its pavilion across the pond, creating a sublimely peaceful effect. The host of heavenly beings is represented inside the hall in wood carvings attached to the wall; they, as well as each pillar, beam, and bracket, were originally painted in brilliant colors. The coffers of the ceiling, and the brackets, still retain traces of delicate floral patterns in red, yellow, blue, orange, and white.

The Amida sculpture was fashioned in Heian by a sculptor named Jocho (colorplate 16). Its beautifully proportioned style affected Japanese Buddhist sculpture so profoundly that practically every seated Buddha figure made since is a reflection, often a very dim one, of this great masterpiece. Jocho and his assistants used the **joined block technique,** which allowed them to make parts of the sculpture in sections and join them together. This enabled them to make hollow wood images that were lighter and that were not so likely to split as were those of the single-block technique of Early Heian.

SUMMARY

In the ninth century two new Buddhist sects were introduced into Japan from China by two Japanese monks. They were instrumental in modifying Buddhist art and architecture. The Tendai sect considered Shaka, the historical Buddha, to be the major focus of devotion, while the Shingon sect worshipped the Buddha of Essence, Vairochana. Both sects were monastic and established temples in the mountains. As a result, they tended to adapt their temple buildings to the site. The Muro-ji is the best example of the resulting asymmetrical arrangement of such temples.

The sculptures made for these isolated places of worship were provincial variations of urban styles. They were made by local workers, perhaps by the monks themselves, and were carved out of solid tree trunks. They appear stolid and heavy; images of austere expression and heavy proportion with stiff, unnatural-looking folds of drapery. The type seems traceable to Kushan India and to the Gandhara style, which had prevailed for so long a time in central Asia and China. It is interesting that this first of the anthropomorphic styles of Buddhist sculpture should have been one of

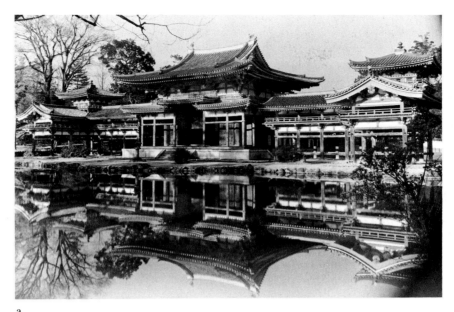

a

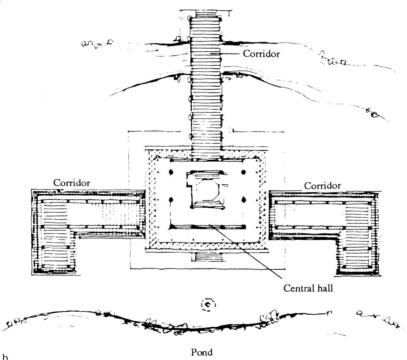

b Pond

Figure 24.5 *a.* Byodo-in, Ho-o-do (Phoenix Hall). Painted wood; tiled roof. Late Heian (mid-eleventh century). H. 48′. Photo: M. Sakamoto.

b. Byodo-in plan. Late Heian (A.D. 1053). From Kazuo Nishi and Kazuo Hozumi, *What Is Japanese Architecture?*, 2d edition. Copyright © 1986 Kodansha International, Tokyo, Japan.

the last of the continental Buddhist types to be introduced into Japan. This indicates the complexity of the evolution of styles in Buddhist art.

Shingon also brought with it many of the pantheon of Indian Hindu deities, which it had absorbed. Their fierce look, together with the multiple arms and heads, was intended to indicate their intensity of purpose and their spiritual powers, some portion of which were believed to be transferrable to the initiate when, after long study and practiced devotion, the novice was able to identify spiritually with one or another of these beings, who could be so disturbing to the non-believer.

The last part of the Heian period was dominated by the Fujiwara family and the cultural expression it supported. The elegance of the era is perhaps partly responsible for the increased popularity of the Pure Land sect, though at the same time this sect in some measure engendered such gracious elegance. The finest remaining example of Pure Land temple architecture is the Byodo-in at Uji. This light and graceful building houses a seated figure of the Buddha Amida, with the entire complex of temple, garden, and pond intended to represent the Western paradise brought down to everyday reality. This is a logical result of the whole tradition of the sect. The Indian concept of the Buddha Essence and his emanations, the Meditation Buddhas who represented him in the four cardinal directions, became less an abstraction in China, whereas the paradise of each Buddha, rather than being seen as a way-station on the road to final extinction, became ends in themselves. This is nowhere indicated more clearly than in the paintings and sculptures at Dunhuang in China in the eighth century Tang style. But it is at the Byodo-in that the idea became reality. It is not a mere similitude of a paradise, but rather, quite literally, that paradise itself, complete with pond out of which lotus buds should be rising, as they must originally have risen, and from which the souls of the dead should be awakening reborn.

Both China and Japan had attempted such depictions earlier. In Japan the walls of the Horyu-ji Kondo were painted inside with counterparts of the four paradises in the Nara period, but none of these compares to the Byodo-in in bringing paradise to earth.

The graceful elegance of the Byodo-in is the perfect expression of the qualities inspired by the Fujiwara family. It is no wonder that this period of the Later Heian is sometimes referred to as the Fujiwara period.

GLOSSARY

Jodo Japanese sect believing in the promise of rebirth in the glorious Western paradise of Amida, Late Heian 897–1185. (p. 224)

Joined block technique In sculpture, the image is made in sections and later joined together. (p. 224)

Kegon (Flower Garland) Major sect of the Nara Period. Todaiji major temple; dedicated to Roshana Buddha.

Mantras Religious-magical spells, Japanese Shingon religious sect, ninth century. (p. 220)

Roshana (Sanskrit: Vairochana) The Buddha Essence of the Kegon sect. (p. 220)

Shingon A monastic form of Buddhism focusing on Dainichi (Vairochana), the Buddha Essence, and based in ritual magic; brought to Japan in 816 by the monk Kukai. (p. 220)

Tendai A monastic form of Buddhism focusing on Shaka, the historical Buddha; brought to Japan in 788 by the monk Saicho. (p. 220)

Yamato-e "Japanese painting." The name used to distinguish the Japanese form of painting, with its Japanese subject matter, style, and techniques, from "Chinese painting," which followed the Tang style in Japan. (p. 224)

25

JAPAN UNDER MILITARY RULE
The Kamakura and Ashikaga Periods
(Twelfth to Sixteenth Century A.D.*)*

The Late Heian ended in a series of family feuds, which broke into open warfare, resulting in the removal of the governing power from the Heian court by a group of military leaders (**shoguns**) and the establishment of the new military government at Kamakura near Tokyo in the east.

POLITICAL REBELLIONS

The removal of the military government to Kamakura (beginning the Kamakura period, 1185–1333, (see map, fig. 22.1), leaving the emperor at Heian powerless, did not end contention between the major families. It took Minamoto Yoritomo five years to subdue all Japan under his rule. When he died ten years later he left two minor sons, and feuding broke out among his generals as to which would succeed as shogun. Yoritomo's wife's family, the Hojo, gained control and ruled as the Hojo regency from 1203 to 1333, accompanied by family feuds and intrigues, as well as a growing desire on the part of the large warrior class who served the shoguns to gain for themselves some of the comforts and privileges of the nobility. The court at Heian was meanwhile beset by its own feud as to which of two brothers should be the rightful emperor. Later the grandson of one of these brothers was forced to abdicate by the Kamakura shogunate. He openly rebelled and tried in vain to restore the Kamakura power to the Heian court. By now Japan was embroiled in a series of wholesale rebellions, some in favor and some against the ousted emperor. Even the great monasteries at Nara and on Mount Hiei were involved, and on the capital raids by warrior monks were frequent. The Todai-ji at Nara was burned to the ground in 1180, seriously damaging the huge bronze image of Roshana. Other temples suffered proportionately.

The dethroned emperor, Go-Daigo, was captured but escaped, and Ashikaga Takauji, sent to recapture him, defected and joined his cause in the hope of destroying the Hojo and regaining the power for his own family, which was related to Yoritomo. Another branch of the Minamoto wiped out the Hojo at Kamakura in 1333.

In 1335 Ashikaga Takauji again changed sides, this time against Go-Daigo, who had been restored as emperor, seized Heian in 1336, and set up an emperor from the rival line of descent. Go-Daigo and his followers fled to the mountains south of Nara and set up the southern capital. For fifty-six years Japan had two emperors and the period is called the Nambokucho (southern and northern courts, 1336–92).

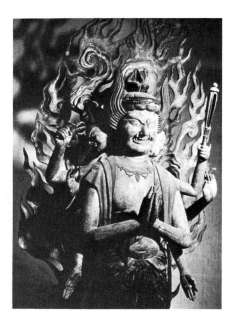

Figure 25.1 Bato Kannon (esoteric form). Wood, painted. Kamakura (dated 1241). H. (figure only) 4'. Joruri-dera, Kyoto. Photo: author.

In 1338 Ashikaga Takauji made himself shogun, but he was never able to rule the whole of Japan, although the period 1336–1573 is termed the Ashikaga period. Many of the **samurai** (warrior class) had shifted their allegiance from the shogun to the lesser local leaders. The old Kamakura unity had broken up into splinter groups, who fought continually among themselves, while the two rival emperors carried on their own battles for complete control.

Everyone suffered from the chaotic situation. The prestige and wealth of the court declined; the noble families were hard pressed to support their large following of warriors; these warriors were seldom well housed or fed and thus turned to marauding and plundering the common people.

ARTISTS CONTINUE TO FUNCTION

In spite of the furies raging around them, the artists were somehow able to function. The Buddhist sects still required sculptures and paintings. In sculpture a new virility replaced the elegant refinement of the Fujiwara style (fig. 25.1). After the destruction of the Nara temples new buildings and images were needed to replace those lost. The earlier Nara style quite naturally became the inspiration, since artists wished to replace as faithfully as possible the original images.

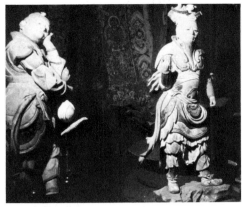
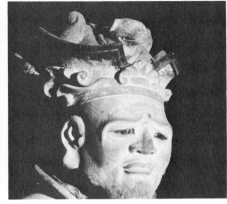

a b

Figure 25.2 *a.* Two of the Twelve Guardians of Yakushi, also known as the Twelve Guardians of the Hours of the Day (Horary Guardians). Wood, painted; crystal eyes. School of Unkei, Kamakura (thirteenth century). H. 3'. Muro-ji, Kondo. Photo: author. *b.* Detail of figure *a.* Head of Basera, who watches over the period from 7–9 P.M. and wears the animal symbol (dog) for that time in his headdress. Photos: author.

Emphasis on Realism

Thus in Kamakura sculpture a new realism developed. It was undoubtedly encouraged by the Song sculptural style known in Japan from renewal of direct contacts with China. This realism was carried so far that the eyes of images were made from rock crystal, painted on the back side and set into the heads. The joined block technique made this possible. The greatest sculptor of the period was Unkei, of Nara (active 1176–1223), who gave expression to the Kamakura desire for realism (fig. 25.2). His six sons, his students, and his grandsons continued his style throughout the Kamakura period.

The emphasis upon realism naturally led to portrait sculpture. Famous priests, warriors, and laypersons were depicted. The apparently abstract character of the warrior portraits is derived from the faithful depiction of their stiff ceremonial robes; it is an abstract form of dress, not of sculpture (fig. 25.3).

Rigorous Religion

Amidism, favored by the Fujiwara, had become a popular religion of the common people. It was promulgated by wandering monks, one of whom went so far as to declare that the mercy of Amida was so great that all that was necessary was to say his name once during a lifetime in order to be saved. But the real innovation during Kamakura was the introduction of Chan Buddhism from China into Japan, where it was known as **Zen.**

This sect, which emphasized meditation and rigorous self-discipline, had a strong appeal for the military classes. Concentration of all one's powers in a single action was useful in training swordsmen and archers, and the practical shoguns saw in Zen an excuse for the conditions their followers had to endure. From rigid self-discipline to hardship was but a single step, and under the blanket of Zen, the samurai might be induced to persevere. Those who did not were considered spiritually weak.

Scroll Painting

Painting, too, returned to a vigorous direct approach. Lives of various sainted monks and priests, histories of monasteries and temples, episodes from political and military history were all fine subjects for the **E-Makimono** (rolled pictures), which became the major form of painting. These narrative scrolls, unrolled a section at a time from right to left, were usually painted in bright colors on paper. The style stressed bold patterns and quick, strong technique. The most famous of these Kamakura scroll paintings is the Heiji Monogotari, which narrates the story of the Heiji War. The painting illustrates a short episode in the difficulties encountered by the court in Heian at the close of the Fujiwara period, involving intrigues between the Minamoto, Taira, and Fujiwara families in the winter of 1159–60. Three scrolls of the set remain, two in Japan and one in Boston. The latter deals with the burning of the Sanjo Palace by the Minamoto (fig. 25.4). The spirited drawing of animals and men in action and the sense of confused clamor that this scroll conveys carry all the noisy excitement of clashing armies; it is easy to see how these stories had great appeal for the rough, hero-worshipping militarists of Kamakura. One can

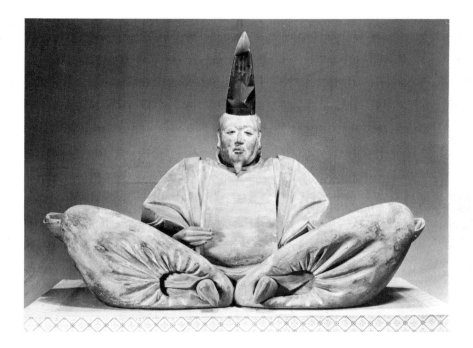

Figure 25.3 Portrait of Uesugi Shigefusa. Wood, painted; crystal eyes. Kamakura (thirteenth century). H. 26½″. Meigetsu-in, Kamakura. Photo: M. Sakamoto.

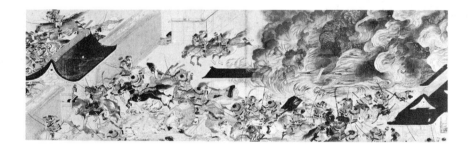

Figure 25.4 Heiji Monogatari, portion of long handscroll showing burning of the Sanjo Palace, Kyoto. Ink and colors on paper. Kamakura (mid-thirteenth century). H. 16¾″. Museum of Fine Arts, Boston, Fenellosa-Weld Collection.

almost hear the crackling of the fire as the great flames reduce the palace to ashes.

The *Nachi Waterfall* is a splendid example of a new branch of Japanese landscape painting (fig. 25.5). It is, in fact, one of the earliest examples of painting in which the landscape is the major interest. In the eleventh and twelfth centuries, there were Buddhist paintings in which landscape acted as a background setting but was not the principal subject itself (fig. 22.10). The *Nachi Waterfall* is a Shinto painting. It points up the difference between the Buddhist and Shinto world views. Whereas certain Buddhist subjects were seen

against a landscape, in this Shinto painting, the landscape *is* the subject, because the landscape was the residence of the great Kami Hiryu-Gongen. There were shrine buildings at the base of the waterfall, partially visible at the bottom of the painting.

A comparison between the Nachi painting and figure 16.2, Fan Kuan's *Travelers Among Mountains and Streams,* indicates the Chinese interest in atmospheric progression into depth— in contrast to the Japanese emphasis upon flatness and stylization of forms, seen especially in the formalized waterfall itself. And it is interesting to note that, although the title of the

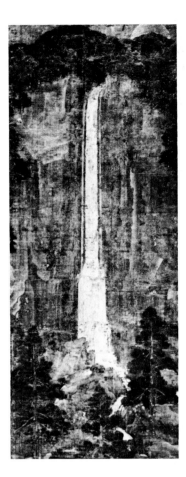

Figure 25.5 *Nachi Waterfall.* Hanging scroll. Colors on silk. H. 64″. Late thirteenth century. Nezu Art Museum, Tokyo.

Chinese painting includes "travelers," it too depicts temples, probably Buddhist, at the base of a great cliff and high waterfall. Intensive comparison of these two paintings reveals much about basic Chinese and Japanese painting attitudes.

THE ASHIKAGA/MUROMACHI PERIOD (1336–1573)

This period is called either Ashikaga, after the shogunal family, or Muromachi, after the part of Heian (Kyoto) where their headquarters were established when the first Ashikaga shogun, Ashikaga Takauji, moved the military capital from Kamakura in 1336. In 1392, the third shogun, Ashikaga Yoshimitsu, brought some sense of order to Japan, but in 1467 a great civil war broke out and bad times continued for the next hundred years.

From the difficult and impoverished times the Japanese developed three concepts that are fundamental to the understanding of Japanese art from Ashikaga

on. **Wabi** means honest integrity; poverty without impoverishment. **Sabi** means timeworn; mellowed by use; preference for the old rather than the new; the patina of metals and unpainted wood surfaces. **Shibui** means bitter but refreshing, like the taste of the powdered green tea; it is sometimes translated as astringent.

It is clear that these three ideas were products of the hard times. They are expressions of the Japanese efforts to "make do"; but the results went so far beyond the merely adequate that they became the aesthetic basis of Japanese visual arts from that time to the present century. They are at the root of domestic arts and architecture, the creation of a total harmony between human-made and natural objects, of homes, gardens, and ceramics. They are the re-emergence of the native and ancient attitudes that we have seen expressed in Shinto.

Popularity of Zen

The great popularity of Zen in Ashikaga was the result of its adaptability to the Japanese environment. It renounced foreign styles of imagery, stressing the Buddha nature in the humblest products of humans and nature, and provided an expanded philosophical framework within which aesthetic activity was given meaning far beyond sensuous perception. Chinese **monochrome ink paintings** by such Song masters as Mu Qi and Liang Kai were highly prized (figs. 16.5 and 16.6), and many of their finest works were brought to Japan by the Zen monasteries, which carried on a lively trade with China. Zen monks were active in government, often as advisors to the Ashikaga shoguns, and their encouragement of the China trade led to an improved Japanese economy.

Monochrome Ink Painting

The early fifteenth-century painter Shubun based his style on Song painting, but his brushwork is more angular (fig. 25.6). There is more blank paper and a preference for long vertical format in the Yuan manner; but the spidery delicacy of touch is his own contribution. He was the first painter in the Chinese style to be appointed official painter to the Ashikaga government, and as such he exerted a great influence upon painting of the period.

But the real founder of monochrome ink painting in Japan was Sesshu (1420–1506), who may have been a pupil of Shubun, since they were both priests at the Shokoku-ji Zen monastery in Kyoto before Sesshu went to China in 1468–69. While there, Sesshu was able to see much painting and the Chinese landscape that had inspired it. He was highly regarded both as a monk and

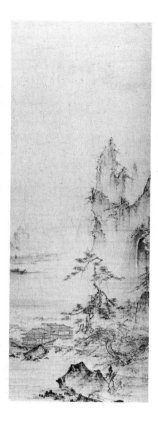

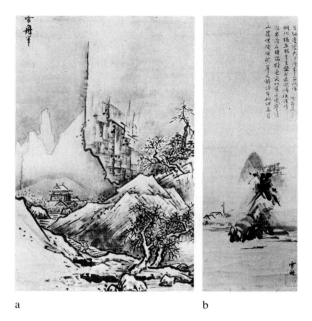

a b

Figure 25.7 *a. Winter Landscape,* by Sesshu. Ink on paper. Ashikaga (second half of fifteenth century). H. 18¼″. Tokyo National Museum. Photo: M. Sakamoto. *b. Landscape,* by Sesshu. Ink on paper. Ashikaga (second half fifteenth century). H. 30⅜″. Seattle Art Museum, Eugene Fuller Memorial Collection.

Figure 25.6 Landscape attributed to Shubun. Ink on paper. Ashikaga (mid-fifteenth century). H. 35″. Seattle Art Museum, Eugene Fuller Memorial Collection.

as a painter in Ming China. His style goes far beyond Shubun in the boldness and sureness of line and in his ability to condense into a minimum of strokes a maximum of structural strength. Everything is reduced to essentials; stripped of all superficiality, his paintings stand as challenges to the spirit. Their contemplation reveals us to ourselves. In this they may be called truly Zen.

Sesshu worked in three styles: formal, informal, and **Haboku** (splashed ink). The *Winter Landscape* is in his formal style, while the *Landscape* is in the Haboku style that he developed in later years (fig. 25.7). It is a masterpiece of spontaneity, a distillation of years of experience and technical mastery. Sesshu established monochrome painting in a completely Japanese style. His reverence for ink and paper and the cooperation of artist and medium are clearly evident in this painting, which preserves so vividly the integrity of subject, medium, and artist.

The impetus given by Sesshu to monochrome ink painting as a Japanese form of expression was carried on by Kano Motonobu (1476–1599), who expanded the

range of subject matter and, more important, modified the ink style of painting by adding colors and turning it to decorative uses (fig. 25.8). The tendency to stylize and to make patterns, with emphasis upon the two-dimensional flat surface of the paper, with little recession in depth, are all characteristics that were carried further by painters of succeeding generations. Motonobu's non-religious style formed the basis for the Kano school of painting, which continued to enjoy the patronage of the shoguns through the Momoyama (1573–1615) and Tokugawa periods (1615–1868).

Homes of the Shoguns

For his retirement Ashikaga Yoshimitsu had a large villa constructed in the northern hills of Kyoto. It was situated on a large pond and consisted of several buildings for various purposes. It was known as the Kitayama Villa, but sadly it was destroyed in later centuries, except for a single detached building that the retired shogun used as a retreat. This pavilion was of wood in three stories. The first floor was utilitarian, while the second provided space for entertainment of small groups or individuals. The third floor was a Zen meditation hall.

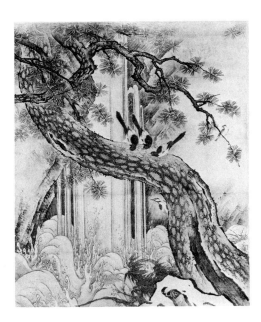

Figure 25.8 *Birds and Waterfall*, by Kano Motonobu. Ink and color on paper. Originally mounted on sliding door. Ashikaga (first half sixteenth century). H. 5'10''. Daisen-in, Daitoku-ji, Kyoto. Photo: Sakamoto.

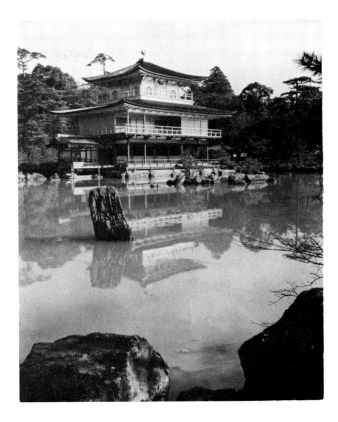

Figure 25.9 Kinkaku, Golden Pavilion, of the villa built by Ashikaga Yoshimitsu in 1398. Totally destroyed by fire in 1950. Rebuilt 1956. Wood. Two upper floors gilded. H. about 35'. Photo: Borromeo, Frederico, Milan.

After his death Yoshimitsu's villa was turned into a Zen temple, the Jisho-ji. The retreat was called the Golden Pavilion (Kinkaku-ji) because the two upper stories were covered with gold leaf. Tragically this only remaining building of Yoshimitsu's palace was burned in 1950 but, thanks to complete measurements and photographs, it was rebuilt so that it presents an excellent image of the original (fig. 25.9).

The garden of the Golden Pavilion, with its large pond, had precedents in the Heian gardens of Japan and of Tang China and in the concept of the Buddhist paradise scenes of the four Dhyani Buddhas (colorplate 8). The gold leaf of the two upper stories of the pavilion symbolized spiritual light or radiance. But gold leaf was traditionally reserved for sculpture and painting on the interior of the Golden Hall of a temple; it was not used on the exterior walls of buildings. Is it used here as a reminder that what is within is visible from without?

Could this also refer to the idea that, in his retirement, the shogun has passed on to his transcendent state to function as the guardian of the northern direction, where he sits above his pond in meditation? The paradise Buddhas, it is remembered, are Dhyani, that is, meditation Buddhas. The very act of Yoshimitsu's retirement shows another side of his character. It was not common for shoguns to retire, but by this time it had become common for the emperor to do so and to continue ruling through his son. In all this there may have

been a sly suggestion of the shogun's role as being equal to the emperor. If the emperor noted the shogun's retirement or its implication, there was little he could have done about it; Yoshimitsu had the might.

The eighth Ashikaga shogun, Ashikaga Yoshimasa, built his retirement villa in the eastern hills of Heian (Kyoto). One of its pavilions, known today as the Ginkaku-ji (Silver Pavilion), compares to the Golden Pavilion and seems to have been built in emulation of it (fig. 25.10). It has only two stories but is, otherwise, quite similar, even to the phoenix on the roof; probably a reference to the Byodo-in at Uji and to the Fujiwara family, who were responsible for that temple (fig. 24.5a). The phoenix had been the symbol of Chinese empresses, and it was adopted by the Japanese imperial family just as it had also adopted the dragon, symbol of the emperor. Since several of the Fujiwara daughters had been married to Japanese emperors, it had been used at the Byodo-in to indicate the imperial connection. It has been used by the Ashikagas in somewhat the same manner but without any real prerogative. The same intent seems to have prevailed in the

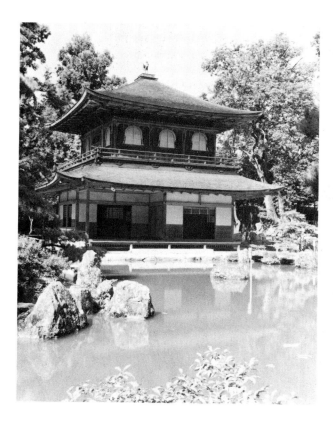

Figure 25.10 The Ginkaku (Silver Pavilion). Wood. Ashikaga period. Built ca. A.D. 1484 by Ashikaga Yoshimasa as a part of his retirement villa in the Higashiyama (eastern hills) district of Kyoto. H. 24'. © Kodansha Images/The Image Bank.

phoenix symbolism in both the Golden and the Silver pavilions, in the use of the phoenix, but birds on the roof have symbolized domestic happiness in China since the Han dynasty in China and certainly would have been known also to the Japanese.

Shinden Style

These large Ashikaga family villas were based on the type of domestic architecture that had developed in the Heian period. It is called Shinden (sleeping room) style. In the Heian period, the custom of building separate buildings to handle the various familial functions developed. The home of Fujiwara no Tamemitsu of the tenth century shows the kinds of multiple buildings in the Shinden style (fig. 25.11) and how the great arms of the projecting corridors and pavilions reflect the plan of the Byodo-in (fig. 24.5*b*). This whole development probably owes a great deal to Tang Chinese temple plans as seen in the wall paintings at Dunhuang (colorplate 8) with the square central building flanked by extending wings. See also figure 26.19 for a painting

fragment of such a villa of the thirteenth century. These examples all give some idea of what the Ashikaga villas probably looked like.

The New Shoin Style

A building type not found earlier but preserved at the Ginkaku-ji has some elements of a new residential style. It has a small square room with a built-in low table along the north wall and shelves for scrolls and a small cupboard for storage. Shoji screens above the table may be slid back to view the garden. This style became popular in the succeeding Momoyama and Edo periods and continues to be the basis of traditional architecture today. The room described is called a Shoin, that is, "book room," or library, and so the style is known as the Shoin style. The building in which the Shoin is located is called the Togu-do (fig. 25.12). It had a prayer and meditation room as well as a room where Yoshimasa was served tea by the curator of his art collection (primarily Chinese paintings and ceramics). Thus began the famous tea "ceremony," which has continued to the present day. The Togu-do is beautifully situated on a small promontory overlooking the garden, providing seclusion and, if desired, solitude. The Shinden mansion organizational plan is still inherent in the Japanese home, where the group activities take place in the central core while the more private activities and those requiring quiet are physically removed to the periphery, in so far as possible.

SUMMARY

The transfer of military power from the control of the emperor into the hands of the shogun and the establishment of the military headquarters at Kamakura caused a deep rift within the Japanese way of life. The court retained its elegant and refined aesthetic life and its stately rituals, but without power it began to become self-centered. The military, on the other hand, possessed the power but no aesthetic tradition.

The need to reorganize and reintegrate life after the battles that left Yoritomo victorious meant that the great temples at Nara had to be restored and required that architecture and sculpture of the Nara period be repaired or matched with newly made replacements. Unkei and his family of sculptors not only undertook and completed the task of restoration, they also developed a new and even more vigorously realistic style. This was based on that of the Nara but went beyond it in the intensity of emotional expression.

Painting, too, was imbued with a new and active sense of realism. The horizontal scroll format was favored for historical subjects, which included battle

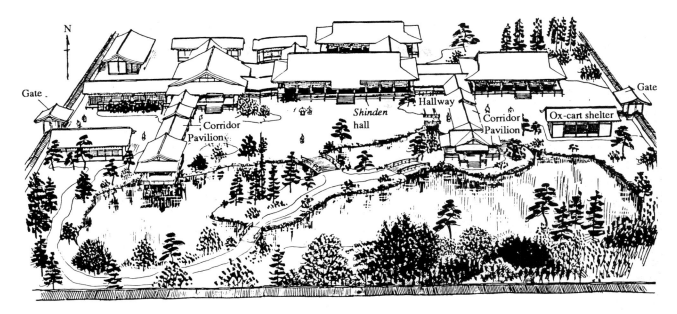

Plan

Figure 25.11 The Shinden (sleeping room) style. Reconstruction of the Hoju-ji, originally the mansion of Fujiwara no Tamemitsu (942–92). The pavilions at the ends of the wings extending south to the pond are indicative of the pavilions of the villas of Ashikaga Yoshimitsu and of Ashikaga Yoshimasa, known today as the Kinkaku-ji and the Ginkaku-ji, respectively. Source: From Kazuo Nishi and Kazuo Hozumi, *What Is Japanese Architecture?*, 2d edition. Copyright © 1986 Kodansha International, Tokyo, Japan.

scenes, episodes from the histories of temples, and famous religious leaders. The Kamakura style stressed bold swift strokes of black ink to indicate the most expressive pose of figure, with a few economically placed strokes to catch the most evocative facial expression. Bright colors and black ink against an often plain background emphasized the active involvement of the figures.

The succeeding Ashikaga period witnessed the relocation from Kamakura back to Kyoto on the part of the military dictators. Zen Buddhism, combined with hard times resulting from continual political upheaval, became a powerful factor in the aesthetic life of the times. The Japanese learned to live with hardship and to manage with few consumer goods; but the result was a triumph of the aesthetic spirit. Many of the qualities

that we think of as being so distinctively Japanese were developed during this period. Understatement, natural materials, low-keyed color, all counterpointed by a striking accent of some kind, are characteristics. These qualities are as typical of Japanese food as of architecture; they are the result of necessity in impoverished times. Even the Golden Pavilion, built by the third Ashikaga shogun, was more a surprising accent of the garden that surrounded it than a display of sumptuous extravagance. It impresses by contrast, almost by shock, emphasizing the very elements of the natural setting in which it is placed.

Ashikaga painters were influenced by the Southern Song painters whose works had been brought to Japan by Zen monks or by the newly reopened trade with China. Sesshu and Shubun admired the Chinese painters, especially those of the Chan sect.

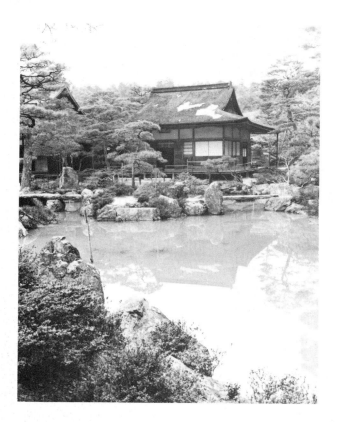

Figure 25.12 The Togu-do, private prayer hall of the Higashiyama Villa. Wood (A.D. 1484). H. 16′. © Kodansha Images/The Image Bank.

The Kano school modified the style of Sesshu by stressing the two-dimensional character of painting, thus resulting in a more decorative and secular style. The Kano family became the official painters to the military and remained so through the Momoyama and Tokugawa periods.

GLOSSARY

E-Makimono Painted hand scrolls. (p. 229)

Haboku Japanese style of splashed ink painting. (p. 232)

Monochrome ink paintings Ink paintings done in a single hue. (p. 231)

Sabi Timeworn; mellowed by use; preference for old rather than new. (p. 231)

Samurai Warriors of premodern Japan. (p. 228)

Shibui Bitter, but refreshing; astringent. (p. 231)

Shogun Military dictator of premodern Japan, 1185–1573. (p. 228)

Wabi Honest integrity, poverty without impoverishment. (p. 231)

Zen A Buddhist sect stressing meditation and rigorous self-discipline introduced during the Kamakura period, 1185–1333. (p. 229)

26
.

THE MOMOYAMA (1573–1615) AND
EDO/TOKUGAWA (1600–1867) PERIODS

MOMOYAMA: A PATTERN FOR THE AGE

In 1573 Oda Nobunaga abolished the Ashikaga shogunate by expelling the last shogun from Kyoto. He broke the political power of the Buddhists by destroying monasteries and killing monks. His successor, Toyotomi Hideyoshi (1536–98), unified the great families (**Daimyo,** "Great Names") and succeeded in 1590 in bringing all Japan under one rule after 250 years of disunity.

Hideyoshi feared Europeans, especially the Spanish and the Portuguese, who were seeking trade and conversions to Christianity. In 1549 the Jesuit missionary St. Francis Xavier arrived and by 1586 almost 200,000 Japanese had converted to Christianity. In 1587 Hideyoshi expelled the Jesuits. While the powerful families, or Daimyo, allied themselves with Hideyoshi, they maintained their autonomy and probably a certain fear that Hideyoshi or his successors might confiscate their provinces, as he had already done to landowners of smaller amounts of property.

Castles

As a reaction to these events, the Daimyo built bigger and better castles. In plan, these new fortress-palaces were arranged in a series of three **maru** (circle). The inner circle (*Hon maru*) was the most secure, at the heart of the compound. It contained the watchtower

(**donjon**) complex on its massive stone base, with storehouses and walls (fig. 26.1*a*). The two outer circles comprised the living quarters and offices of the Daimyo in peaceful times. Walls and moats prevented enemy intrusion, like European castles.

At Himeji, west of Kyoto, while on campaign, Hideyoshi had seen one of the earliest (ca. 1580) of these castles and liked it (fig. 26.1*b*). He gave it, along with his second daughter, to Ikeda Terumasa in marriage to strengthen his alliance. The castle watchtower was enlarged from three to five stories in seven floors (ca. 1609). It is connected to smaller towers and other sections by two storied corridors roofed with tiles. The living quarters are no longer intact, but they were probably as elegant and refined as the *Hon maru* is sturdy (fig. 26.2).

The sudden spate of castle building caused a flurry of artistic activity among painters and craftspersons. One of the great Momoyama painters was Kano Eitoku (1543–90), the grandson of Kano Motonobu (chapter 25). Eitoku transformed the Kano style from the monochrome, atmospheric style to the large, flat, bold-patterned style using color and gold leaf. His *Cypress Tree,* now mounted as a folding screen, was originally painted on four *fusuma* (sliding doors) across one end of a room (fig. 26.3). The scale, like that of most Momoyama Kano architectural paintings, is very large. The *Cypress Tree* is life-size. The screen is six feet high and sixteen feet wide.

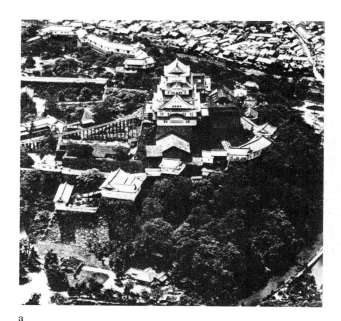

a

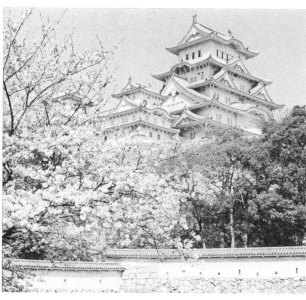

b

Figure 26.1 *a.* Himeji Castle. Himeji, Hyogo Prefecture. Completed 1609.

b. Himeji Castle, main keep (Donjon).

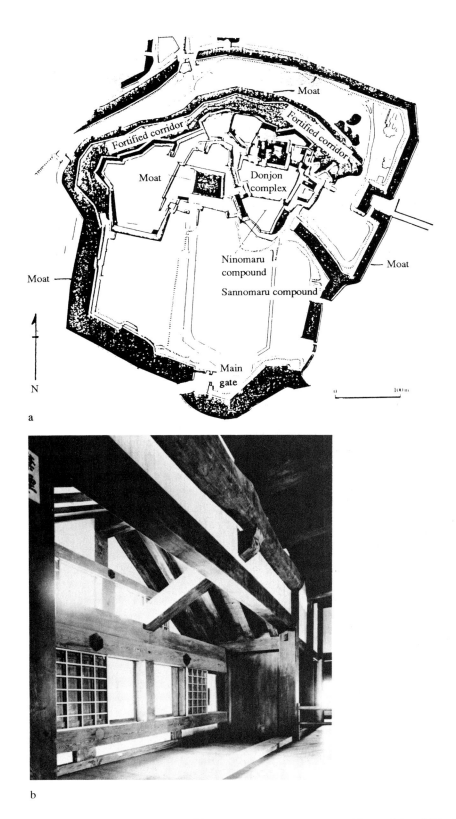

a

b

Figure 26.2 *a*. Himeji Castle. Ground plan. Source: From Kiyoshi Hirai, *Feudal Architecture of Japan*. Copyright © 1973 Weatherhill, Inc., New York, NY. Reprinted by permission. *b*. Himeji Castle, main keep (Donjon), interior detail. Courtesy of Elemond, Milano.

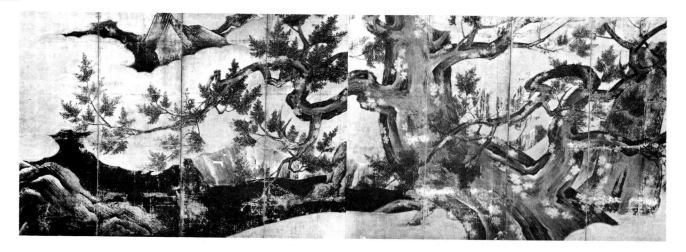

Figure 26.3 *Cypress Tree,* by Kano Eitoku (1543–90). Eightfold screen. Ink and color with gold leaf on paper. Momoyama period. H. 6', W. 16'. Tokyo National Museum.

TOKUGAWA: ISOLATION AND STABILITY

The picture of the Daimyo enclosed in a fortress to keep out the rest of the world is also the picture of Japan during the two and a half centuries after the death of Hideyoshi, in 1598. His successors, the Tokugawas, closed Japan to foreigners and it was not reopened until the late nineteenth century. During the Tokugawa period Japan isolated herself and thus gained peaceful stability.

The lower and middle classes, particularly the merchants, rose rapidly to positions of importance, thus increasing the market for art products. Foreign imports ceased, at least in theory, although some smuggling did occur, particularly of Chinese porcelain. Japanese artists and artisans found ready employment in producing the necessities and luxuries of life. The grandiose opulence of the Momoyama continued unbroken into the Tokugawa, but it came to be looked upon as "official"; quite a different style prevailed in the unofficial private sphere of life. While the public life of a Daimyo was one of magnificent and often overstated pomp, his private life and that of his family was the reverse; understatement was the keynote. Restrained simplicity was a preferred way of life with which the Japanese aristocracy had become familiar, and they retained it. Their primordial desire to be close to nature and to be surrounded by harmony between nature and humans as expressed in ancient Shinto had come into a prominence it had not enjoyed since before the introduction of Buddhism.

THE TEA CULT

The antithesis of the fortified castle is the teahouse, which was developed in the Momoyama period. Tea drinking had been introduced from China with Zen (Chan) Buddhism (chapter 15). At first tea was used only as a stimulant to keep the novice monks awake during long temple services or meditation. It became popular with the Ashikaga shogun, Yoshimasa, whose caretaker of his art collection met with him to drink tea and discuss the merits of paintings and ceramics in the garden of the Silver Pavilion, Yoshimasa's retirement villa (fig. 25.10). The small building called the Togu-do, where they met, was a combination of meditation hall and library (fig. 25.12). It has the distinction of being the first secular residential building to contain a library and to have incorporated the Zen practice of tea drinking. Both library and tea had previously been temple-bound.

The art curator responsible for this transfer from temple to villa was Murata Juko (1422–1502). The utensils Juko used were, naturally, those teabowls, flower containers, and incense burners of Chinese make in the shogun's collection, such objects for tea preparation and drinking as had come to Japan from China along with Zen. Tea drinking also became popular with Oda Nobunaga and, when Hideyoshi succeeded him, he inherited the services of the most famous tea master of them all, Sen no Rikyu.

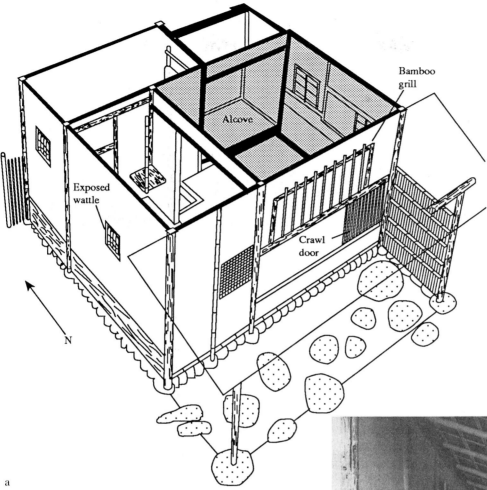

a

Figure 26.4 *a.* Axonometric drawing of Tai-an teahouse. Source:
From Kazuo Nishi and Kazuo Hozumi, *What Is Japanese Architecture?*,
2d edition. Copyright © 1986 Kodansha International, Tokyo, Japan.

The Teahouse

Rikyu designed a retreat for Hideyoshi; a place where
he could get away from daily stress, from the larger-
than-life public image his office demanded, from the
superhuman scale of audience halls and battlefields,
from the symbols of the shogun, and from the visual
dynamics of sliding doors and walls and folding screens
all covered with huge-patterned hawks and trees, tigers
and bamboo, pheasants and flowers in brilliant colors
against gold backgrounds. Sen no Rikyu's Tai-an tea-
house, only four and a half **tatami** (mat), or about nine
by nine feet, must have seemed like a snug harbor, safe
from the storms of state (fig. 26.4). This tiny edifice
was probably built in Rikyu's own garden, perhaps in
1582, and later moved to the Myoki-an, a nearby
Buddhist temple, where it resides today. Only about

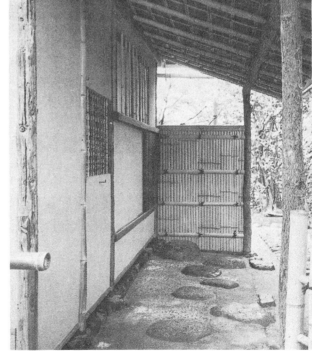

b

b. Tai-an, teahouse entry way, by Sen no Rikyu, 1582. Crawl door is
dark sliding panel to the left of the bamboo screen, above the stone step.

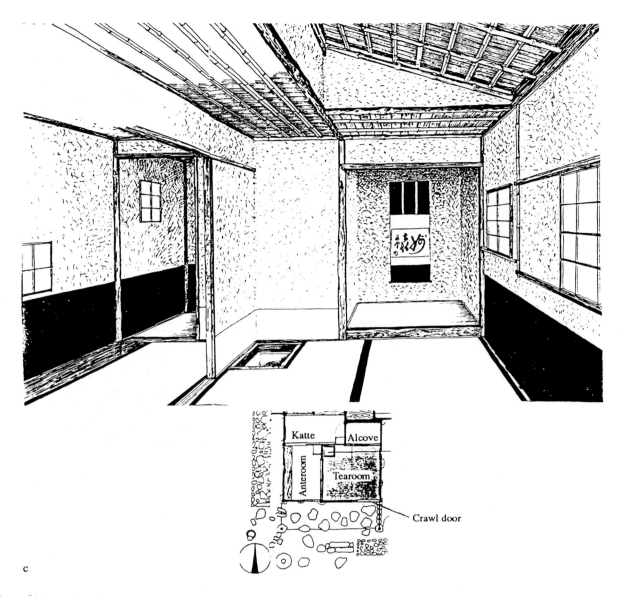

c

Figure 26.4 continued

c. Tai-an teahouse of Myok-an Temple, and Tai-an teahouse plan.

Source: From Kazuo Nishi and Kazuo Hozumi, *What Is Japanese Architecture?*, 2d edition. Copyright © 1986 Kodansha International, Tokyo, Japan.

two-thirds of this structure was used by Rikyu as the place for drinking tea with Hideyoshi—a six-by-six-foot square with a recessed alcove. The remaining space was partitioned off and used for storage and preparation.

Entry to the Tai-an was from the garden through a tiny door so small that the visitor entered kneeling, a gesture meant to inspire humility and to suggest rebirth. One corner of the room contained the **toko-no-ma,** an alcove of space set apart and reserved for the display of a painting or calligraphy scroll along with a floral arrangement, all according to season. The toko-no-ma in the Tai-an is supported on its left side by a rustic unfinished post called the heart post (fig. 25.5).

This is the support that ties the house to the earth through its symbolic axis. The concept is very old in Shinto shrines and is carried over into domestic architecture. It reveals a very Japanese trait: the preservation of a reminder of the humble and reverent relationship between the people and their physical environment. This trait is also shown by the teahouse's placement in a garden. It is this return to the natural that is at the heart of the tea ceremony. And it is implicit in the minimal characteristics of all aspects of tea.

The deliberate blocking out of all but this tiny cell of space, of all sense of outside time—the deliberate

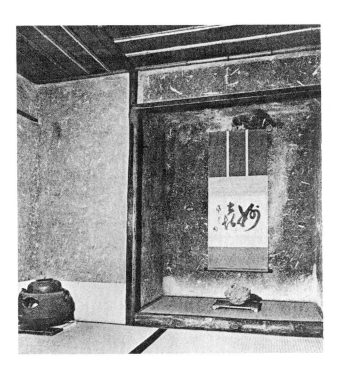

Figure 26.5 Tai-an tearoom, Myoki-an, Kyoto. Toko-no-ma alcove on *right;* charcoal stove and water kettle on *left.* Momoyama period.

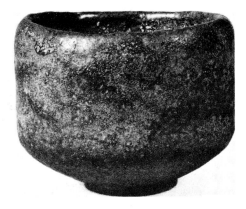

Figure 26.6 Teabowl named "Iris," by Chojiro. Raku ware. Momoyama period.

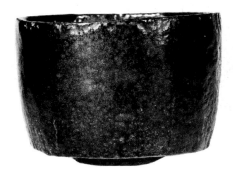

Figure 26.7 Teabowl by Honnami Koetsu (d. 1637). Coarse brown earthware; green-brown glaze. Momoyama-Tokugawa periods. H. 3⁷⁄₁₆". Freer Gallery of Art, Washington, D.C.

obliteration of all distractions—permits the mind to focus on the minimal elements of the simple ceremony of heating the water and whisking the boiling water into the powdered tea. It also encourages the deeper examination of the other utensils—the small jar that holds the powdered tea, the water kettle, the tea scoop for measuring the tea powder, even the wooden water dipper, made especially for each tea ceremony.

The leisurely enjoyment of tea and its accoutrements was, under the tutelage of Rikyu, an exercise of *wabi,* the aesthetic that emphasized the humble integrity of the natural, which arose from the difficult period of civil wars during the Ashikaga period (chapter 25). Rikyu departed from the Ashikaga tradition of using imported Chinese teabowls and other utensils and proclaimed simplicity and understatement as the spirit of tea. This aesthetic favored the subdued colors of the traditional unglazed Japanese wares. Chojiro (1516–92), the son of a Korean tile maker, made simple, low-fired teabowls for Rikyu. The bowl in figure 26.6, called "Iris," was made by hand.

Raku Pottery

The kind of ware produced by Chojiro came to be known as raku (happiness), after a gold seal with that character was presented by Hideyoshi to Chojiro's son, Jokei, in admiration of the ware. The raku line of pot-

ters descending from Chojiro is now in its fourteenth generation, and raku ware is still being produced in Kyoto. It is recorded that "Iris" was used by Sen no Rikyu at a tea ceremony in 1587.

One of the most famous, perhaps the most greatly admired, was Honnami Koetsu (1568–1637), whose bowls display the solid strength and integrity so revered by the practitioners of tea (fig. 26.7). It may seem odd that a bowl can express virtue, but to the Japanese it is precisely this quality that has made Koetsu's products so highly prized. There is in all this a strong Zen flavor, and it is clear that when the tea cult brought tea out of the monastery and into the shogunal villa, it brought Zen concepts and aesthetics as well.

Raku potters did not use the potter's wheel. The potter began with a round ball of clay, into which he pushed both thumbs and continued to push in successive stages downward and outward, turning and compressing between the hands and fingers until arriving

at a more or less cylindrical shape with a more or less straight lip that sloped slightly inward. The base was then trimmed to form a round foot for support. A simple glaze was applied, and firing was at a medium range for only two or three hours. Then, when the bowl glowed all the way through it was taken out of the kiln with long iron tongs and put into a container of leaves, moss, or other vegetable material and left covered to produce a reduction phase. The color is black, suffused with rusts and purples and browns in a mottled pattern of great richness. The entire effect is more like an organic object formed by nature than an object mechanically produced. This is the essence of the tea cult and of much of Japanese aesthetic character.

Porcelain Appears

Many kilns had produced pottery throughout Japan, but it was not until the return of Hideyoshi from an abortive attempt to conquer Korea in 1592 that porcelain began to be made in Japan. Korean potters were brought to Japan, where they set up kilns to create the underglaze blue and white porcelain to which the Chinese had introduced them. Chinese Ming three-colored enameled wares were imitated, and by the Tokugawa period fine pieces were being made in **Kakiemon ware.**

Although inspired by Chinese precedents, Kakiemon ware is identified by a greater freedom of design. Birds and flowers in overglaze enamels of red, green, yellow, and blue were painted in purely Japanese style. Asymmetrical compositions, unlimited by the compartmental registers so characteristic of the Ming style, flow across the entire vessel (compare fig. 26.8 and fig. 18.3). Ware of this type was first made in the early seventeenth century. The well-known "Imari" ware made at Arita in northern Kyushu and exported to Europe from the port of Imari in the eighteenth century was derived from this type. Arita kilns produced several styles of porcelain decorated with underglaze blue and overglaze enamels. Imari ware is distinguished from Kakiemon by the use of underglaze blue in addition to the enamels. The style differs distinctly; whereas Kakiemon is reminiscent of scroll paintings, Imari has the overall designs of brocaded textiles, even to the use of gold enamel.

The two traditions, pottery and porcelain, continued just as did the two aspects, public and private, of Japanese life and taste. Porcelain tended to be in the official or public realm and was widely exported, while pottery was preferred to express a deeper private preference. Kilns were built to produce ceramics for both tastes.

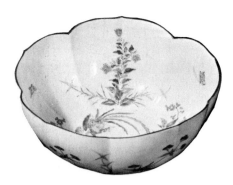

Figure 26.8 Bowl, in bell-flower shape, by Kakiemon V (1660–91). Tokugawa period. H. 3⁵⁄₁₆″. Stanford University Museum, gift in honor of Mrs. Philip N. Lilienthal, Jr.

PAINTING: THE SOTATSU-KORIN SCHOOL

While the Kano family of painters continued throughout the Tokugawa period to maintain their position as decorators and screen painters, several other schools of painting also developed. One of these was the Sotatsu-Korin school in Kyoto. Nonomura Sotatsu (d. 1643) often collaborated with his friend, Honnami Koetsu in the production of poetry scrolls, in which Sotatsu decorated paper and Koetsu did the calligraphy (fig. 26.9). Sotatsu was probably influenced by Koetsu in his emphasis upon the natural. In painting this meant using the brush in its most natural manner: flowing line or puddled color.

Nonomura Sotatsu

Sotatsu ran a shop in northeastern Kyoto, not far from the Imperial Palace, which specialized in fans and decorative writing papers. The conservative nature of the court had preserved the culture of the Heian period almost intact since the twelfth century, when its power had been wrenched away by the shogunal system of the Kamakura period (chapter 25). Sotatsu's style and technique appealed to the courtly taste. His themes were taken largely from Yamato-e (Japanese painting) traditions and the literary sources of the Heian. His revival of old motifs, often done in a shorthand manner in which only a small motif drawn from a famous story stood for the whole, intensified the poignancy of the original to which Sotatsu's work referred.

Sotatsu and Koetsu seem to have worked so closely together that a Japanese art historian was inspired to suggest that they were but differing names for the same person. They developed a highly expressive and at the same time free and easygoing style. They seem to have been at ease with their materials because of their thorough understanding of them and their vast creative

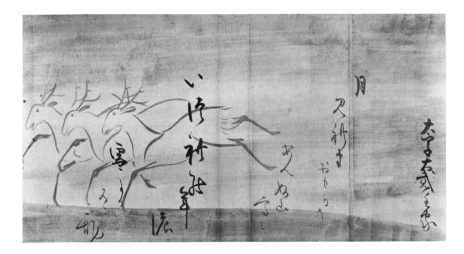

Figure 26.9 Deer scroll. Painting by Sotatsu; calligraphy by Koetsu. Ink and gold and silver on paper. Momoyama-Tokugawa periods.

H. 13⅜''; full length 34'2½''. Seattle Art Museum, Mrs. Donald E. Frederick.

skills in working with a wide range of techniques. Sotatsu probably made paper and designed fans as well as painting decorative patterns on both. Koetsu may have been more concerned with designing lacquer ware boxes for holding writing paper and smaller ones for incense. In addition, Koetsu was Japan's greatest calligrapher and raku potter. That these creative giants should have lived in the same age is remarkable, but that they should have been friends (and perhaps even related through marriage) is an indication of the rich mix of the aesthetic spirit of the Momoyama and Early Edo Age.

Sotatsu's pair of *Waves at Matsushima* screens depict the jutting rocks of the Matsushima (Pine Islands) in northeastern Japan and the pines and the rolling waves of wild waters breaking against the shore (colorplate 17 and fig. 26.10). The rocks are evident; the waves are clear. The pines are stylized as simplifications of the old knarled and stunted trees one sees on such islands. The dramatically simplified upper one-third of the screens is difficult to interpret. It is neither in the same scale nor seen from the same point of view as the lower section. In fact, the only unified view in the entire scheme is the right half of the right screen, where the rocks, pines, and waves are seen more or less as they might look in nature.

As the eye moves from here to the left (the normal movement in China and Japan), the specific visual meaning becomes more and more difficult to determine. Behind the second island (left side of right screen) a broad horizontal band of gold leaf is to be seen. It is divided into two horizontal arms continued into the next five panels of the left screen. This nine-panel shape of gold is defined on its bottom by a straight horizontal

edge and, if that were all, it would be easily readable as a cloud, such as those seen in Late Heian paintings. Whatever hopes the viewer may have had for the charming island at the right end of the right screen as promising a more or less natural view of Matsushima, are dashed like the waves against those rocks by this totally flat, unmitigated abstract shape on the left end.

As if to emphasize the stern unrealism of this shape, Sotatsu has outlined the upper edge of the lower right arm in the fourth and fifth panels of the right screen with a wide band of black, giving it the emphatic statement of three-dimensional depth, as though it had been cut from a flat board. This totally unreal treatment is echoed in the last three panels of the entire ensemble by the strange "floating" island shape in the lower left. This shape is bounded by the same heavy black, but the contours of this rock are modulated both in width and in dark-light. The rough vigor of these contours strongly suggest rough rocks, but the area within these heavy lines lacks any further suggestion of color or texture. The same enigmatic wide black line is seen to drift across panels three, four, and five of the left screen with no further clarification of the function of any of these three areas of black outlining.

Across the upper part of the first four panels of the left screen, six or seven wonderfully designed pines are distributed along the golden arm, which, at this point, seems to be readable as a sandy spit of land jutting into the sea. The waves are brilliantly arranged into an overall but non-repeating pattern of gold and tan. It is at once clear that this pair of screens is a remarkably beautiful, even stunning, work of art. The firmly Japanese character, with little or no reference to Chinese styles, is a hallmark of the Sotatsu-Korin group of painters.

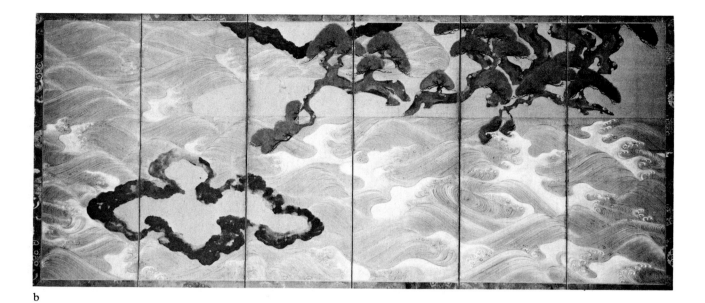

b

The creative invention of the far view on the right panel and the close view on the left is characteristic of the free-wheeling mind of Sotatsu and is seen again in his successors Ogata Korin and his brother Ogata Kenzan. The strikingly contrasted coloring of the islands on the right screen comes from the blotchy technique developed by Sotatsu called **tarashikomi** (puddled ink) in which a very wet application of watercolor is applied and other colors and/or ink are dropped onto the watery paper to intermix, spread, and flow together. The kami of the paper, water, and pigments are permitted to make the effect without any control by the artist—a purely Japanese concept based on the reverence for spirits of the media. This technique produces dried edges, which together with the patterning of the puddled ink/color, emphasize the flatness of the surface of the painting.

A comparison between these Sotatsu screens and Song Chinese landscapes confirms the distinction between completely Chinese and completely Japanese landscape painting (figs. 16.2–16.4). Yamato-e painting is of purely Japanese subjects painted in wholly Japanese style, which we have seen in the Heiji Monogatari (fig. 25.4). In the Heiji Monogatari there is no painting of the ground. We assume its presence from the manner in which the buildings, people, and animals are distributed across the paper. Shading and atmospheric mistiness are minimal, and this helps to emphasize the flatness of the paper and to abstract the subject from the everyday real time/space and to put it into the timeless and spaceless sphere of art. The artist has taken the real events as raw material but has redesigned them so they have become clearer, more expressive, and more

thrillingly beautiful than in real life. The painting re-creates the subject, it does not imitate it; but in its recreation the vividness of the real experience has been intensified and vivified so that the aesthetic experience touches us more deeply than the actual un-recreated experience may have.

This is why societies so value their great artists. In the process, the everyday fact of the actual is transformed into an aesthetic experience that can lift us above the fact to the timeless truth. This experience can imbue the work of art with an aesthetic significance in ways that could never have occurred in the actual event/time/place.

To return to Sotatsu and his Matsushima screens, observe that there are at least three points of view presented to us by the artist. There is the more or less natural view at the beginning (right end), the combination of natural and unreal in the middle (the second island and cloud of screen number one and the cloud/beach with pines), and the almost "unreadable" treatment of the last island at the left end of the whole composition. What does it all mean? A possible answer might center on the various aspects of the scene *known* to Sotatsu as well as what was *seen* by him. Then, reading from right to left one sees first the redesigned but recognizably "normal" view of rocks, pines, and waves. Then begins the greater abstraction by which the cloud becomes "solid" and then turns into a beach with pines. These pines are seen in a closeup view. This further breaks apart any factual unity the viewer may have expected to find, but it also tells us much more about these islands than a simple faraway view could possibly provide. We have a real sense of being among these

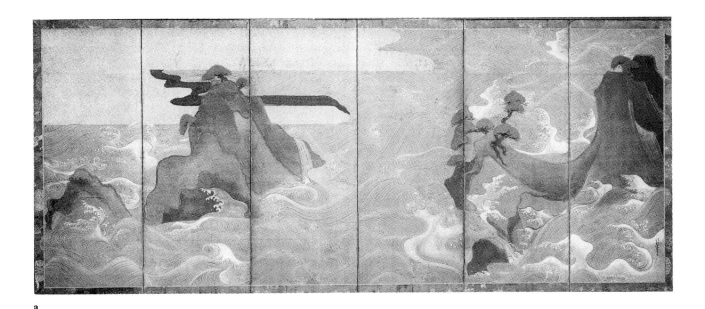

a

Figure 26.10 *Waves at Matsushima,* by Nonomura Sotatsu. Pair of screens. *a.* Right screen; *b.* left screen. Ink, color, and gold leaf on paper. Early Edo period. H. 59⅞″, W. 11′7″. Courtesy of the Freer Gallery of Art, Smithsonian Institution Washington, D.C. Accession 06. 231 *b.* H. 59⅞″, W. 140³⁄₁₆″. Accession 06. 232.

strangely beautiful trees; we are on shore with them. Thus we gain a greatly more majestic and, at the same time, intimate view of this island group. The lower left "floating" island is still enigmatic, but it is just possible that it may be meant to be an aerial view or plan without detail. The floating character of that shape arises from the fact that the waves behind it seem to take no notice of it at all and roll along as though it floats above them.

Whatever the explanation for the dramatic juxtapositions in this painting, their effect is to emphasize the flatness of the screens. This is reinforced by the treatment of the waves. Although they appear to be seen individually at eye level, as a group they give the impression of being seen from above because there is no sense of diminution of size as they go from front to back into distance. In fact, distance is nullified. Everything stays parallel to the picture plane, and the lack of a horizon line reinforces this effect.

In short, it does appear that Sotatsu was not an artist concerned with the illusion of visual imitation, rather, he was a highly original personality whose primary concern was with the wedding of subject and surface without ever permitting the former to nullify the latter. His interest in pattern and surface made great art of decoration. His artistic descendants, Korin, Hoitsu, and later followers, all shared this strong sense of the validity of surface, brilliant color, and themes drawn from Japanese literature and tradition.

Sotatsu's gods of wind and thunder screens draw upon a theme already established in the Buddhist iconography of Japan (fig. 26.11). In his screens these gods look pretty much as they had in Kamakura period narrative hand scrolls, but Sotatsu has radically altered their scale; what had been a figure two or three inches high became two to three feet high. He has also isolated them from their narrative and visual context and placed them against a plain gold background. Gold leaf was always associated with Buddhist art in Japan. Any viewer would have recognized it as a clue to the religious nature of the subject. In fact, in Kyoto, any viewer would have recognized these two particular figures as the same wind and thunder deities they could see any day at a local Kamakura period temple where they were to be found, in life-size sculptural form, as members of the twenty-eight guardians of the Bodhisattva Kannon in his Thousand Armed manifestation. They would have recognized them by their iconographical attributes, the wind bag and the thunder drums as well as their fierce expressions and poses. The iconography of these figures goes back to India (as might be expected), where figures with similar attributes are known from at least the tenth century. Sotatsu has simply lifted them intact. His creativity lay not in his subjects so much as in his treatment of them.

Here, not only the greatly increased scale, but also the bold and vivacious manner in which they are composed contribute to their novelty. Each deity is placed

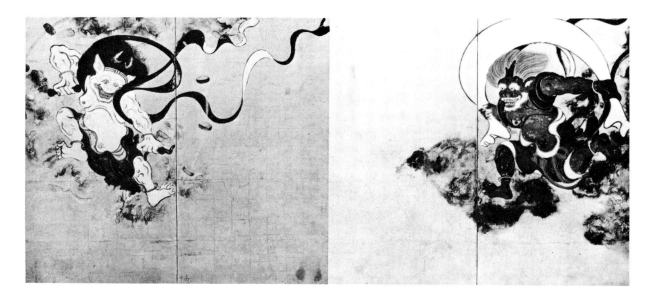

Figure 26.11 *Gods of Wind and Thunder,* by Nonomura Sotatsu. Pair of twofold screens. Colors and gold leaf on paper. Edo period (mid-seventeenth century). H. 5′11¾″. Kennin-ji, Kyoto.

on the outermost panel, leaving the central pair virtually empty. This provides a great sense of space, which suggests a powerful potential for the figures. This power is accented by the movement of the viewer's eye as the pair of screens are "read," right to left. The sudden reversal of the leftward movement when the eye strikes the white thunder god, who is turning sharply back toward us, causing his limbs to arrange themselves along a strong diagonal axis running from the upper left to the lower right-hand corner, gives a strong sense of conflict and dramatic climax of movement. The bold brushwork, strong colors, in red, green, white, browns, and blacks, against the brilliant gold-leafed background, and strongly muddled ink and color (*tarashikomi*) of the clouds all come together in a new and vivid presentation of an age-old theme. The artists of the Sotatsu-Korin school may be thought of very accurately as revitalizers of the Yamato-e tradition, and Sotatsu was their leader.

Ogata Korin

Ogata Korin (1658–1716) was the son of a wealthy textile merchant whose family shop was near Sotatsu's fan shop. It is probable that works by Sotatsu were handed down in Korin's family or were owned by families known to him. Korin's father provided cloth for the empress and probably to the rising socialites of Kyoto as well. Korin was a popular member of Kyoto society and had access to many of the best homes and their art collections.

Korin, like Sotatsu, was a town painter, that is, he did not belong to the official Kano or Tosa families, although he had studied as a boy with one of the Kyoto Kano painters. He only took up painting as a vocation when the family business went into bankruptcy. Korin's painting style was influenced by his admiration of the paintings of Sotatsu. He especially liked the puddled ink (*tarashikomi*) technique. This was precisely the kind of effect Chinese and Japanese painters had abhorred for generations. But the Sotatsu school made a virtue of it and achieved striking results (figs. 26.9 and 26.10).

This fresh approach to color was an indication that Sotatsu and the painters who followed in his tradition were aligned with the Yamato-e school typified by the Genji Monogatari (colorplate 15) and the Heiji Monogatari (fig. 25.4) rather than the Chinese styles as seen in the Early Kano tradition (fig. 25.12) and the Sesshu style of the Ashikaga period (figs. 25.10 and 25.11).

Korin was an exemplar of the nostalgia for the splendid days of the courtly Heian Age of grace and elegance. Sotatsu before him had looked to the past for his themes, and Korin looked back to Sotatsu. Perhaps the realization that the admired past could not be regained led to the awareness that life is indeed fleeting, that nothing lasts, and that the sense of regret led to the heightened appreciation for life and time. This new concept was defined as *ukiyo,* "the floating world." Seasonal moods and enjoyments were its themes.

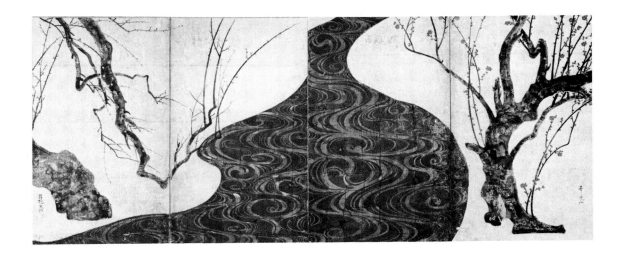

Figure 26.12 *Red and White Plum Blossoms,* by Ogata Korin. Pair of twofold screens. Ink and color with gold and silver leaf on paper. Edo period. MOA: Museum of Art, Atami, Japan.

Korin's paintings reveal a remarkable amalgam of abstraction, arising from the simplification of silhouette and emphasis upon two-dimensionality, combined with a very careful observation of natural detail. The pair of red and white plum blossom screens is considered one of Korin's masterpieces (fig. 26.12). The colors—the indigo of the waves, and the blues and greens of the tree trunks heightened by the spritely red and white blossoms all against the gold leaf—make a very rich and pleasing harmony. The puddled color admirably suggests the rough texture of the bark as well as the blotchy lichen growing upon it.

The highly stylized pattern of the stream bisecting the composition provides the abstract counterpoint to the simplified but realistic trees. This combination of intimately observed natural detail side by side with geometric abstraction is characteristic of the school, and Korin is one of its greatest masters.

Ogata Kenzan

Ogata Korin's brother, Ogata Kenzan was a potter and a painter who shared the spirit of the Sotatsu school in looking to the past for inspiration, but the ceramic past he admired was Chinese, not Japanese. He took as models of styles Chinese wares from the Song dynasty to the Ming. The incense burner is stylistically derived from two sources (fig. 26.13). The form of the square-stepped terrace surmounted by a lion holding a ball under its left paw is to be found in thirteenth-century

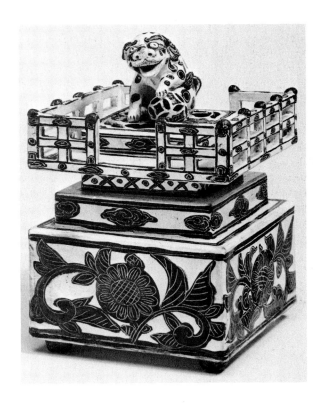

Figure 26.13 Incense burner, by Ogata Kenzan. Kenzan ware. Edo period (signed and dated 1715). H. 8″. Private collection.

Celadon, (Lonquan) wares of the Korean Koryu dynasty. While Kenzan has used that form, he has derived the decorative style as well as its technique from the black-and-white carved slip method of the Song Cizhou kilns (chapter 16).

It is clear that Kenzan knew the Chinese ceramic tradition. He was also familiar with Chinese literature, as his incense burner attests. On the back of the base there is a poem praising the lion and its majesty by a Tang dynasty Chinese poet. In China and Japan the lion was known primarily through its association with Buddhism (chapter 3). A comparison of the two figures is striking: Kenzan's lion is far from the majestic beast spoken of in the poem and depicted on the Ashokan capital. It is almost "zany" by comparison. This quality, sometimes described as "awkward," is seen in other ceramics and in some paintings by Kenzan. The railing harks back to the type found at Sanchi (figs. 3.2 and 3.3) but with later Chinese and Japanese descendants (fig. 24.2).

Kenzan's pottery techniques were varied and innovative. He had learned the raku method from Koetsu's grandson, Koho, and the secrets of enameling from Ninsei. Koetsu, Ninsei, and Kenzan are Japan's three greatest potters. Kenzan's pieces were highly prized. At first Korin helped by painting designs on Kenzan's bowls and trays. But the ceramic trade was risky, and he was never able to be without worry over financial matters. Like Korin, he had become a professional artist because of his family's diminishing fortunes. Both the brothers were prominent in Kyoto, even though Kenzan was as reticent and reclusive as Korin was expansive and gregarious. Kenzan was more concerned with perfecting his art than with finding and repeating production formulas for easy sales. Both Korin and Kenzan were friends of Prince Nijo, who was more like Kenzan in personality. The latter shared Kenzan's Zen practice and interest in aesthetics and were frequently together.

The design for a teabowl may have been made to guide the glaze painters in Kenzan's studio (fig. 26.14). The mottled green of the pine needles suggests a copper glaze would have been used along with an iron one for the browns of the pine trunk. The curved vertical strokes of the needle masses and trunks would have been added in gold lacquer after the glazes were fired.

Kenzan added a whole new category to the ceramic history of Japan, and Kenzan ware continues to be made to the present day. The pine teabowl painting gives us a glimpse of Kenzan's lightness of touch and blithe creativity. The painting as painting and as a design for colored glazes conveys a vivid sense of Kenzan's attitude. The bowl is casually (but not rigidly) symmetrical. The design is brushed on wet with a strongly puddled color effect both in the light and dark

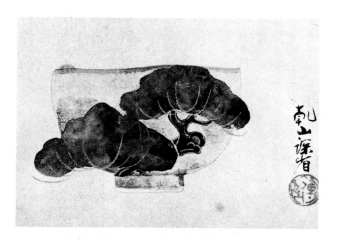

Figure 26.14 Pine as design for teabowl, by Ogata Kenzan. Color on paper. Edo period. H. 5¼″; W. 7¼″.

and yellow-green to blue-green variations, as well as in the light rust to dark brown glaze of the trunk. Similar effects are quite possible in enamels and appear in actual Kenzan ceramics.

The whole painting, seemingly a hurried sketch, combines an elegant sensitivity to the mechanically produced, but far from mechanical looking, bowl shape, which is just asymmetrical enough to seem "alive." This is a bowl very different from that of Chojiro (fig. 26.6) or Koetsu (fig. 26.7). The unique personalities and aesthetic preferences of each potter have been expressed so completely and profoundly that, as the Japanese experts maintain, a bowl may communicate the artists' being as surely as a painting may.

Sakai Hoitsu

Sakai Hoitsu (1761–1828), the eldest son of the lord of Himeji Castle, gave up his inheritance to pursue a career in painting. He was trained both by masters of the Kano family and the Tosa family but was most attracted by and influenced by the works of Sotatsu and Korin, which he could study in his father's collections as well as in those of family friends in the Osaka/Kyoto region.

A remarkable and charming example of Hoitsu's artistic lineage is seen in his pair of twofold screens entitled *Summer Rain and Autumn Wind* (fig. 26.15). The format of each pair is square like the Sotatsu screens (fig. 26.11). The subjects are also similar: in the first case, the gods of thunder (that is, rain) and of wind, and in the Hoitsu screens, their corollaries. It is easy to see that Hoitsu has really painted the same themes that Sotatsu has presented as deities but now they are depicted as natural forces.

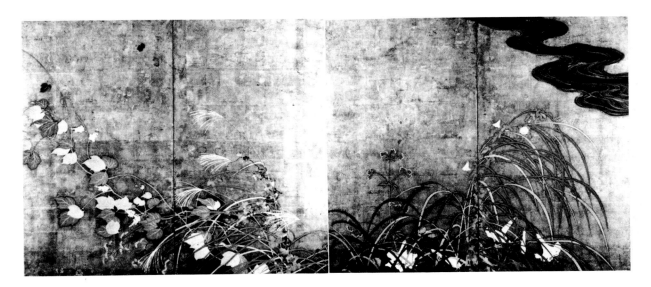

Figure 26.15 *Summer Rain and Autumn Wind*, by Sakai Hoitsu (1779–1828). Pair of twofold screens. Color and silver leaf on paper. Edo period. H. 61″. National Commission for the Protection of Cultural Properties, Tokyo.

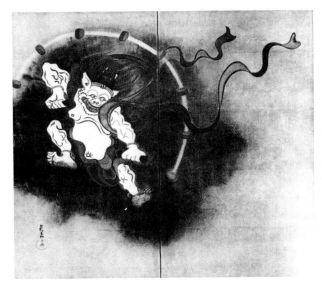
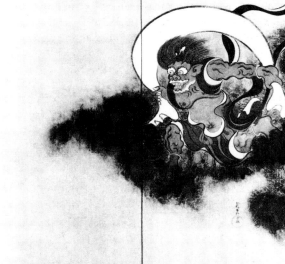

Figure 26.16 *Wind and Thunder Gods,* copy of Sotatsu's screen (fig. 26.11), by Ogata Korin. Edo period. H. 61″. National Commission for the Protection of Cultural Properties, Tokyo.

Even though he has changed the presentation, there is no question that these Hoitsu screens are reverently within the Sotatsu-Korin tradition he so admired. Just as Korin had copied the Sotatsu wind and thunder gods (fig. 26.16) Hoitsu has adopted Korin's theme. As if to convince us of this act of homage he even painted his wind and rain subjects on the backs of the Korin screens he owned at the time! And he maintained the identifications by painting the autumn wind on the back of

Korin's wind god and the summer rain on the back of Korin's thunder god. In such an act of aesthetic homage it would be improper to transpose the subjects. Korin's wind god must be backed by Hoitsu's summer rain. When one sees the Korin (as also the Sotatsu screens), the right screen is the wind god and the left is thunder (fig. 26.11). But Hoitsu has reversed them, beginning with the rain (thunder) on the right and wind on the

left. This was unavoidable in maintaining the icono-
graphic correlation between Korin's and Hoitsu's sub-
jects. And it emphasizes his iconographic intent. It
should be noted that the Korin screens, like those of
Sotatsu, have gold-leaf backgrounds that would have
inevitably suggested Buddhist temple religious tradi-
tion. Hoitsu used silver leaf for his backgrounds, as
though to say that this was not a religious painting.

NAGASAKI: CHINESE AND EUROPEAN INFLUENCES

In 1639 Hidetada, the son of Tokugawa Ieyasu, ex-
pelled the Portuguese. In 1640, when a new trade mis-
sion arrived, he had them all executed. He was
determined to prevent contact with the outside world,
because he feared such contacts would introduce con-
version not only to Western religion but to Western cul-
ture as well. Confucianism was the officially supported
philosophy, and, although Chinese in origin, it had been
accepted as the basis of government reform as early as
the Nara period (chapter 23).

The capital at Edo (now Tokyo) maintained its en-
closed and secure codes and modes of life. But on the
island of Kyushu, in the port city of Nagasaki, to which
the Dutch and English as well as the Chinese traders
were restricted, artistic events were developing that
would eventually prove that the rulers' fears were cor-
rect.

Nagasaki was the only place foreign traders were
permitted to live. The Japanese were fascinated with
these people, their customs, and their culture. The result
was the development of schools of foreign styles of art
as well as of foreign sciences. It was the tiny seed from
which the transformation of Japan from a closed nation
to a world power would grow.

The influence of painting from Ming and Qing dy-
nasties came to Nagasaki with a few painters who vis-
ited the city in the early eighteenth century. They
brought with them Chinese block-printed painting
manuals, showing how to paint in the manner of Chinese
upper-class educated painters. This style, with its close
ties to Confucian ideals of the cultivated individual,
appealed to the middle-class Japanese painters and their
patrons who, like them, aspired to an upper-class *bun-
jinga* status. Although there was no literati, or scholar,
class in Japan there were many scholars, particularly
of the Confucian classics, and the newly revived Con-
fucian ideals supported the pursuit of the ethical and
intellectual life.

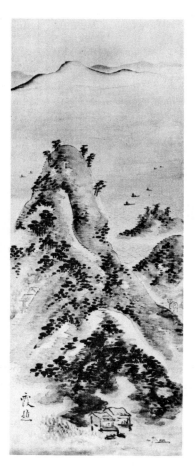

Figure 26.17 A true view of Kojma Bay, by Ike Taiga (1723–76).
Hanging scroll. Ink and color on silk. H. 39¼".

Ike Taiga

Among the young painters who were drawn to the
Chinese life-style and the new painting style was Ike
Taiga (1723–76). Taiga had been a town painter pro-
ducing works in one or another Japanese styles or, more
often, in a combination of several, including the Tosa,
Kano, and Sotatsu-Korin, before he came under the
spell of the new style. This style, which eventually had
many practitioners in Japan, was called **Nanga**
(southern painting), referring to its Chinese sources.
Taiga did not start it but he brought it to its highest
perfection (fig. 26.17). Taiga loved the mountains,
where he spent his life. Although his style is based on
Chinese models, his paintings are typically Japanese,

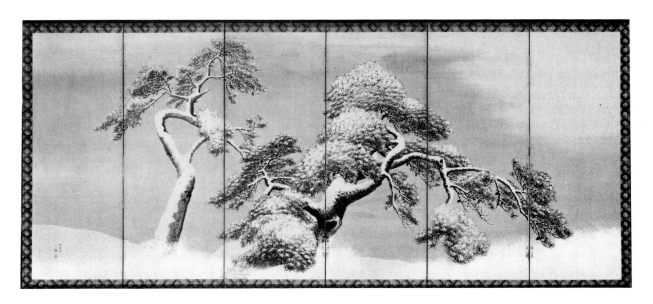

Figure 26.18 *Pine Trees in Snow,* by Maruyama Okyo (1733–95). Screen. Color and gold leaf on paper. Edo period (second half of eighteenth century). H. 4′ 11″; W. 11′ 5¾″. Mitsuibunko. Tokyo, Japan.

with their strong simplifications and abstract two-dimensional aspects of composition deliberately emphasizing the surface plane at the expense of any atmospheric illusionism. It is this quality that most distinguishes Chinese from Japanese painting. The ancient concern for the spirit of the material, the kami, of paper brush and media, prevent the violation of surface merely to gain the trick of an illusory depth that does not really exist. It is this same quality that is so clear in the Sotatsu-Korin tradition and is at the heart of all Yamato-e.

Maruyama Okyo

In the eighteenth century Maruyama Okyo (1733–95) began his career in the Kano style but became intrigued with Western scientific observation and perspective through his contact with book engravings. He developed a style that combined the compositional scale of Kano with the precision of detail akin to that of Sakai Hoitsu. But the difference of taste and aesthetic preferences are clearly visible in the comparison between the works of these two painters, proving again that an artist's style is not merely the result of influences.

The pine trees in snow screens have a gold-leaf background applied to the paper (fig. 26.18). Without the gold, the trees would appear almost photographic in their realism, but the combination of realistic detail and the juxtapositional abstraction forecast something of the kind of character that was to reemerge after a period of adjustment to foreign styles as a distinctively Japanese trait of the last half of the twentieth century.

RESIDENTIAL ARCHITECTURE (HEIAN THROUGH TOKUGAWA PERIODS)

The Heian period (794–1185) saw the development of the style of grand residential architecture called the **Shinden** (sleeping hall) style, because the rooms for sleeping were placed in a large hall at the center of a complex of buildings. The main building faced south, and from it corridors connected other buildings to it. The usual plan was an upside-down U-shape. The sleeping hall formed the bottom, and corridors connecting other rooms and pavilions formed the arms, which pointed south toward a large pond with an island with two or three bridges (fig. 25.11). Both the Kinkaku-ji (fig. 25.9) and the Ginkaku-ji (fig. 25.10) are the pavilions at the edges of the garden ponds of the large Shinden-style retirement villas of their respective shoguns. The organization of the plan was more or less symmetrical but not rigidly so, and the arrangement of buildings was accommodated to the natural terrain.

These Shinden-style residences sometimes covered a full city block and were surrounded by walls. The principal gate was in the east wall with a second in the west. They were owned only by the wealthiest families.

A section of a Kamakura scroll painting shows us how they must have looked (fig. 26.19). The mats that covered the floors were not the thick, soft, and spongy tatami used today in Japanese homes. They were simple grass mats woven in one thin layer. The modern tatami came into use in the Momoyama period.

Shoin Style

By the Momoyama period, a new style had arisen, and it was to remain the standard for aristocratic homes. The U-shaped plan was abandoned in favor of a staggered one. The separate buildings were connected by covered corridors, and the floor level was elevated above the ground. Floors were covered by the tatami still used in residences, and these tatami were the modular unit upon which the proportions of the entire building scheme were based. Rooms are still referred to not by square feet but by number of tatami: a six tatami room would be roughly nine by twelve feet, since the tatami size is about three by six feet.

The reception (living) room of a **Shoin** home has a toko-no-ma and a built-in recess with shelves for books and a low writing desk. The translucent panels called **shoji,** made of white paper, stretch over light wooden frames. These frames fit into a slotted track so that they may be moved back and forth to permit a great variation of light to enter. In addition, most of the interior walls are also sliding opaque paper panels and may be pulled back to open up two adjoining rooms or, in hot summer weather, removed entirely to permit the cooling breezes to blow through the entire house. The high roofs, almost half the height of a Shoin residence, act as insulators to keep the heat out in summer and to keep it in during winter. The only supplement to heat from sunlight were small *hibachi,* portable charcoal burners, and multiple layers of clothing.

Traditionally, the Japanese have not had beds. Thick and soft comforters are placed directly upon the tatami, which itself is springy but firm, at night and taken away and stored during the day. At mealtime a low table was provided. Chairs, like beds, were unknown in Japan until the nineteenth century. The result is that the standard point of view for residential architecture is close to floor level, and this tends to emphasize the horizontal rather than the vertical. Traditional Japanese homes were always one story.

Nijo Castle

In contrast to the fortified *donjon* of the *Hon maru* of the Himeji castle, all that remains of Nijo Castle in Kyoto are the five major buildings and three or four minor ones of the *Nino maru.* The donjon of the *Hon maru* was destroyed by lightning. The castle was built

Figure 26.19 Shinden style villa of Heian style. Detail from a landscape screen. Colors on silk (thirteenth century). Owned by the Jingo-ji, Kyoto. Showing large Shinden hall with corridor wings extending toward pond in south connecting to islands by bridges.

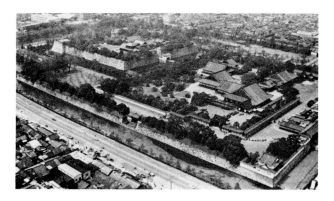

Figure 26.20 Aerial view of Nijo Castle: *upper left,* Hon maru. Compound, with donjon foundation visible at extreme left; *lower right,* Nino maru Compound; *extreme lower right,* eastern main gate to the castle. Kyoto.

in 1602–3 by Tokugawa Ieyasu, but the remaining buildings of the second circle (*Nino maru*) are thought to have been renovated by Tokugawa Iemitsu in 1624–25 for the visit of Emperor Gomizunoo in 1626. Except for the replacement of the original cedar bark roof with ceramic tile, the large-scale buildings are in remarkable condition (fig. 26.20).

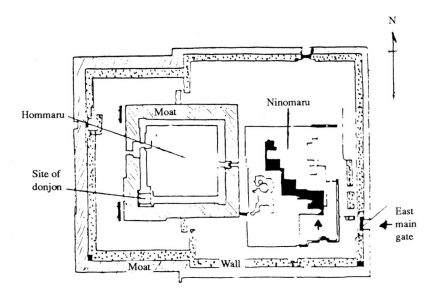

Figure 26.21 Nijo Castle. Plan. Source: From Kazuo Nishi and Kazuo Hozumi, *What Is Japanese Architecture?*, 2d edition. Copyright © 1986 Kodansha International, Tokyo, Japan.

The entrance is in the southeast corner of the compound. The first four buildings are staggered northward and westward in a stepped plan (fig. 26.21). They are separated according to specific function: the first is the room for the samurai guards. It is decorated with painted panels of tigers in a bamboo grove. The next room to the left is the greeting room for guests, where their gifts to the shogun were accepted and registered. The third building was the large hall of public audience, with gold leaf and brightly colored life-size pine trees and hawks in Kano style (colorplate 18). The fourth building was a smaller hall of private audience, with similar decor substituting pheasants for hawks. The ceilings of all the rooms are elaborately **coved** and **coffered** and painted in brilliant brocade-like patterns. The last major building, directly north of the hall of private audience, was the living quarters of the shogun. Compared to the other buildings, with their dazzling decor, this building is low key. The sliding panels are primarily painted in monochrome ink landscape scenes—a welcome relief from the public halls.

The kitchens and other domestic buildings are located directly north behind the first building of the group. The whole of the remaining compound is given over to ponds and gardens. The Nijo Castle residence is the most complete and best preserved of any in Japan.

Since Ieyasu moved his capital to Kyoto in 1603, Nijo was retained only for shogunal visits, but in April of 1603, he held a grand audience in the hall of public audience to celebrate his having had the title of shogun

Figure 26.22 Nijo Castle, Kyoto. Looking north. Buildings, *right to left*, reception hall, waiting room, public audience hall, private audience hall. Private living quarters are behind the private audience hall, *left.*

officially bestowed upon him by the emperor only a few weeks earlier, although in function he had held the post for several years. It was not, however, until the famous battle of Sekigahara in 1600 that he had finally united the entire nation under his rule.

Sukiya Style

The formal Shoin style of residential architecture combined with tea architecture gradually begot a style known as **Sukiya.** This style emphasizes refined architectural delights rather than outward display as in the Shoin style. It is relaxed and simple and reflects a great

deal of the character of the tea ceremony architecture, which had been based upon the type of peasant hut or farmhouse that traced its ancestry back to the beginning of Japanese culture.

Sukiya architecture owes nothing to China. It is purely Japanese in the lightness of its construction, flexibility of spatial usage, and complete orientation to its setting. Outside corridors and verandas connect the various sections of the residence, and these may be protected by the translucent sliding shoji panels. In bad weather both the Shoin and Sukiya styles are protected by shutters.

The Sukiya residence par excellence is the Katsura Detached Palace in southwestern Kyoto (fig. 26.23). It was built between 1515 and 1520 for Prince Toshihito (1579–1629) on land given to him by Toyotomi Hideyoshi, who had adopted the prince because Hideyoshi had no son of his own. When, a few years later, a son was born to him, Hideyoshi established a new family name for the prince, who then became Hachijo-no-miya Toshihito. That the warlord could adopt a son of the emperor and then fob him off with a few acres and a new name indicates the supreme power of the military over the imperial line.

The residence stands on fourteen acres near the Katsura River, a part of which was diverted to run through its garden. There are three major Shoin sections made up of five to six rooms each. As in the Shoin style, tatami cover all the floors but the veranda, which runs along the south and east sides and is polished wood. The posts are slender and square, and the roofs of bark thatch have expansive eaves to cover and protect the verandas and the lower sections of the building from sun and rain. The proportions, based on the tatami, are elegant, and the sections of the building as it recedes from east to west (right to left in the photograph) are seen to be on different ground levels although, of course, the floor level inside is constant. A comparison of the Old Shoin, the first section to be built, on the right, with the Middle Shoin, to its left, succeeded by the music room (only the eave of which shows beyond the Middle Shoin) and the New Shoin at the far left in the photo, reveals the strong similarity but also the subtle differences between these buildings. Like a fugue they are contained within a total unity, but they contain almost limitless variations on the theme of white base, dark posts, paneled shoji, and roof lines. The interior shares these qualities. The sliding panels that divide the rooms are completely plain except for a small pattern of light blue or tan flocked leaf pattern in low contrast. The toko-no-ma in the first two Shoin are equally simple, but in the New Shoin it is decorated with monochrome ink landscape painting. The bookcases and

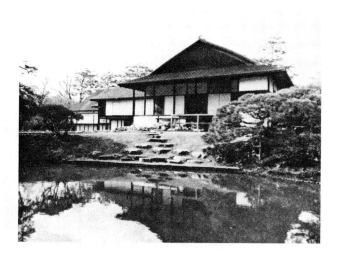

Figure 26.23 Southeastern exposure of Shoin complex: *left to right,* New Shoin, Middle Shoin, Old Shoin. Katsura Imperial Villa.

writing tables are also plain in the first two sections, but in the third they are complex and made of many different kinds of woods. This section and the music room were built for the visit of the retired emperor Gomizunoo about 1660.

The entire compound was conceived as a retreat. In fact in the family diary it is referred to simply as the Katsura "teahouse." It was not a home in the usual sense of the word, and it certainly was not a palace. Perhaps the family saw its function more clearly. There are five teahouses scattered around the eastern and southern perimeter of the garden, so deftly hidden by foliage as to be unnoticeable except in close proximity. They have lovely names such as "Pavilion of the Lute in the Pines" and "Hut of Smiling Thoughts." These teahouses were probably used in rotation according to the season as horticultural delights came into view during the year.

The wooden platform seen at the right of the stone walk in figure 26.23 is the base of the "Moon Viewing Platform." It is seen from inside the second room of the Old Shoin in fig. 26.24. It is covered with bamboo and was the focus of moon viewing parties, particularly in August, when the full moon rose early over the eastern section of the pond. Depending upon the weather, the shoji seen at either side could be partially open as here or removed all together. This location must have seen the most elegant and refined performances of poetry, music, and dance in Kyoto in the Edo period. And one can only imagine the mood of the guests as they watched the moon, the budding iris, the coloring maple; all passing phenomena of life as ephemeral as tea—the "floating world (Ukiyo)."

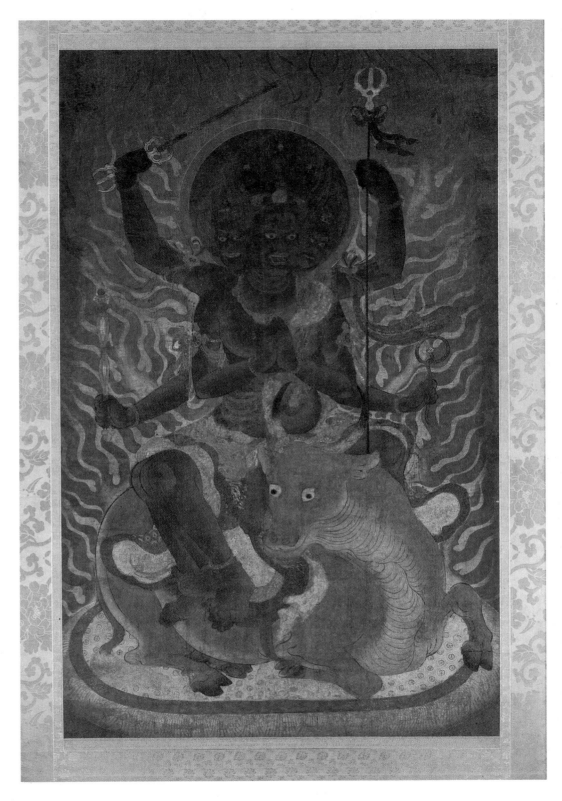

Colorplate 14 Dai-Itoku Myo-o, Enlightened King of the West.
Pigments and gold on silk. H. 76″. Museum of Fine Arts, Boston. Gift
of Wm. Sturgis Bigelow in memory of Okakura Kakuzo.

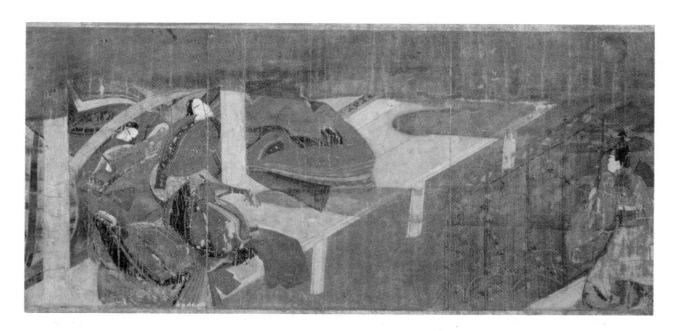

Colorplate 15 Genji Monogatari Emaki (Tale of Genji Picture Scroll). Chapter 45: Hashihime. Kashiwagi's son, Kaoru, spies on Genji's nieces as they play music in the moonlight. Ink and opaque watercolor on paper. Late Heian period. H. 8½″. Tokugawa Art Museum.

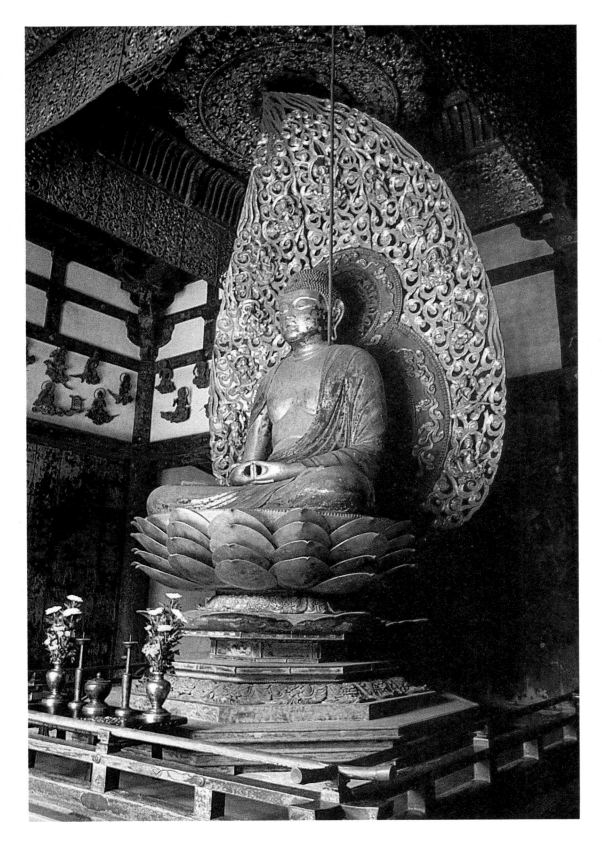

Colorplate 16 *Amida Buddha*, by Jocho. Wood lacquered and gilt.
Late Heian (mid 11th century). H. figure only, 9′3″. Photo: author.

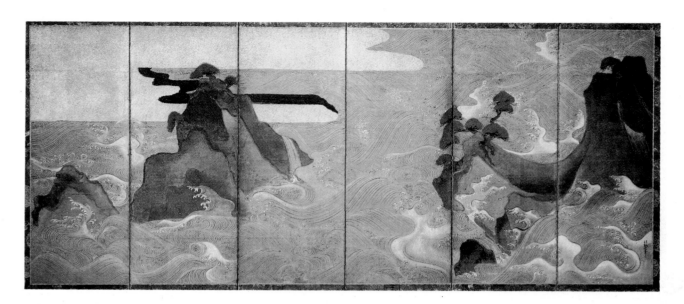

Colorplate 17 *Waves at Matsushima*. Pair of screens, right half, by
Nonomura Sotatsu. Early Edo period. Ink, color, and gold leaf on paper.
H. 5'4"; W. 11'7". Courtesy of the Freer Gallery of Art, Smithsonian
Institution, Washington, D.C. 06.232.

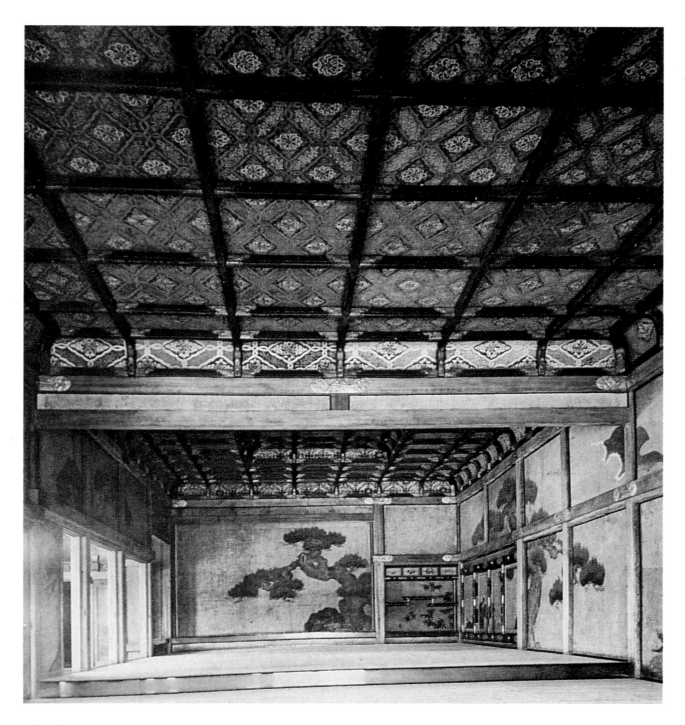

Colorplate 18 Ohiroma (audience hall), Nijo Castle, Kyoto (1626).

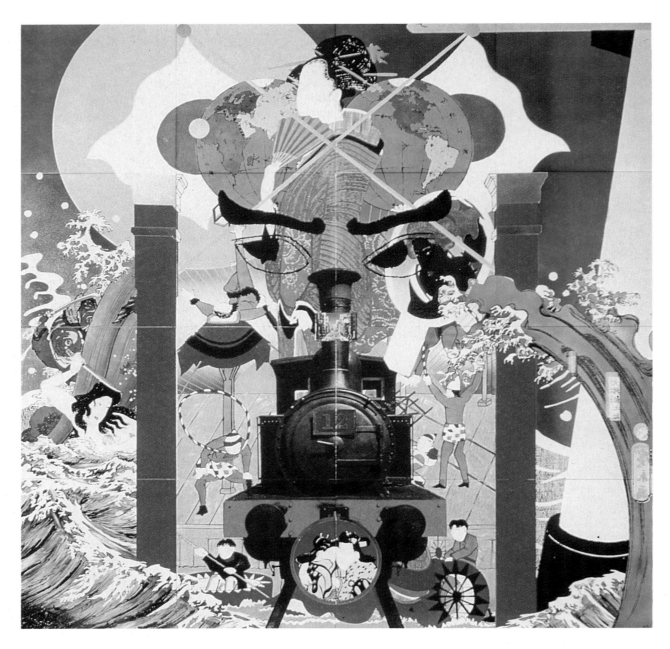

Colorplate 19 *Edo to Meiji*, by Tadanori Yoko-o. Silk-screened
glazes on ceramic tile (1986). H. 96″. By Tadanori Yokoo. Collection of
the artist.

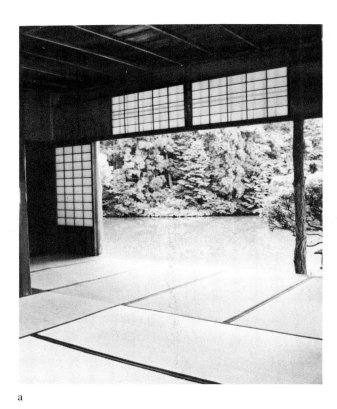

a

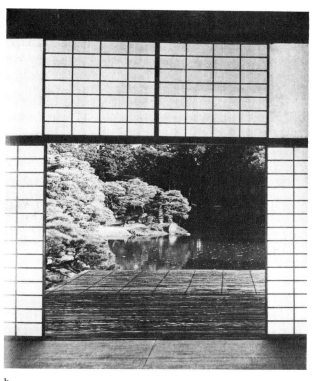

b

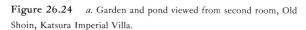

Figure 26.24 *a.* Garden and pond viewed from second room, Old Shoin, Katsura Imperial Villa.

b. View of garden and moon-viewing platform from Old Shoin. Katsura Detached Palace. © Kodansha Images/The Image Bank.

PRINTMAKING: SCENES OF THE FLOATING WORLD (UKIYO-E)

Another aspect of the floating world was the art of wood-block prints. The technique of color wood-block printing was developed in China during the Ming dynasty. But printing in black with color added by hand had a long history before then. One of the first uses for block printing, both in China and Japan, was the multiplication of the image of the Buddha and bodhisattvas. These small, inexpensive images could be obtained for presentation to temples in petition or as souvenirs. Buddhist temples in Japan still stamp the small pilgrimage booklets with their temple seals to attest the visit.

By the mid-seventeenth century the blockprint repertoire had risen to include many kinds of everyday activities as well as historical and erotic subjects. The practice of hand painting in simple colors changed around the mid-eighteenth century and shifted to multicolored prints. This meant that rather than cutting a single block it was necessary to cut a separate block for most of the colors.

It must be understood that the block-printing business was a commercial enterprise carried on by publishers who engaged painters to create designs and block cutters and printers to reproduce them. The designs (the subjects of which were often suggested by the publishers, for whom the painters, carvers, and printers worked) were painted by the artist-designer in black ink on thin paper. These were then pasted face-down upon the smooth woodblock, which had first been painted white to give the design maximum visibility during the cutting process, when all of the white would be cut away leaving only the design, which now appeared in black, against the raw wood background. Several prints in black were made from this key block and sent to the artist, who then indicated the colors to appear in each area of the design. More blocks were cut reserving only the area of one color on each block, cutting the background away.

When all the blocks for the colors were ready to be printed, they were painted with water mixed with a little paste and the dampened paper was laid down and

vigorously rubbed. This pressure plus the dampness of the paper lifted the color from each block in turn until the sequence was completed. Thus the production was a cooperative effort involving artist, publisher, carvers, and printers. The finished prints were sold by the publishers, who financed the issue and who stood most to profit from a successful run. Suzuki Harunobu (ca. 1724–70) is credited with the growth and popularity of multi-color printing.

The Kabuki theatre was a natural subject for prints. Not only could patrons collect prints of their idols, but the performances could benefit from the adulation and excitement and advertising that such prints generated among the Edo populace.

The print of the actor on stage depicts the great Kabuki actor Danjuro V (fig. 26.25). Actors, like painters and ceramists, formed dynasties. Danjuro I was a celebrated actor of the early eighteenth century who founded the Ichikawa line of Kabuki actors. Danjuro V, whose real name was Ebizo, is shown here in one of his most popular roles in December of 1796. Though restricted to less than six colors, the impact of the design is so striking that the abstract elements of the composition convey a strong sense of the elaborate staging and costuming as well as the energetic dramatic acting that comprises the Kabuki theatre.

Kitagawa Utamaru is probably the best known of the print designers who specialized in prints of female beauty. The print in figure 26.26 is from a series called "Selected Love Poems," which portrays women variously affected by love and longing. Utamaru's prints are exceptionally refined in their relationships: the strikingly designed patterns of hair and hairpins, the positioning of the hand, the turn of the head to reveal the nape of the neck (considered erotically attractive) in conjunction with the patterns of robes, all set against a background of crushed mica, which gives a rich but simple foil to the deep blacks and muted browns and rusts of the superbly elegant presentation. Much of the appeal of Utamaru's works lies in their large scale. His women are seen close up, heightening their visual drama and fleeting expression.

Katsushika Hokusai (1760–1849) was an artist of prolific talents. He was interested in the new scientific introductions from the west and, in art, in the European one-point perspective system, which he used in many of his prints. Hokusai studied all the Japanese and Chinese styles of painting and habitually sketched from direct observation of the natural world as well. Even his sketchbooks were made into prints and published. They indicate an amazing catalogue of human activities in which the figures are reduced to a minimal number of brushstrokes, like individual characters of Japanese writing.

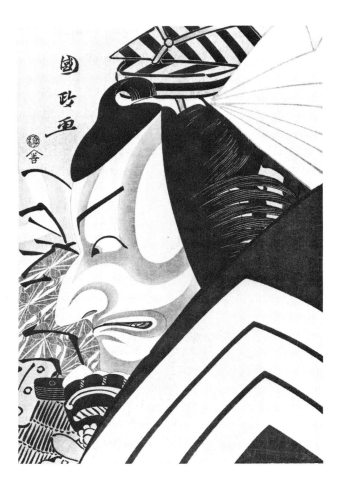

Figure 26.25 *Actor Danjuro V* in costume. Block print on paper. Designed by Utagawa Kunimasa (1773–1810). The James Michener Collection. The Honolulu Academy of Arts.

Hokusai's mature working life spanned a period of more than sixty years, and his output was prodigious. He illustrated over two hundred books, including novels, guidebooks, greeting cards, and erotic albums. But his best-known prints are those that were published in series, consisting of five to twenty or thirty prints, each dealing with the same visual theme. Over 140 such series are known, comprising almost a thousand separate prints, such as "Fish and Shellfish," "Eight Views of Lake Biwa," "Eight Fashionable Views of the Eastern Capital" (Tokyo), "The Fifty-three Stations of the Tokaido" (the highway connecting Kyoto and Tokyo), and "Thirty-six Views of Mount Fuji" seen from various vistas (fig. 26.27).

When Japanese prints came to Europe in the late nineteenth century, they were greatly admired by several of the impressionist and Post-Impressionist painters, including Manet, Monet, Degas, and Whistler. Hokusai's *Great Wave,* as it was called in Europe,

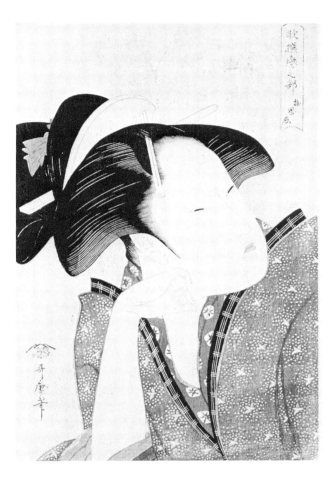

Figure 26.26 *Matron in Love,* by Utamaru. Wood-block print (late 1780s). Musée Guimet, Paris.

became the best loved of all. The two-dimensional treatment of the composition, playing actively against the strongly suggested three-dimensional implications of the subject, fascinated those painters who were experimenting with the same elements of nature and painting.

Both Van Gogh and Whistler made near copies of Japanese prints and show strong influences of them in much of their work. The *Great Wave* is said to have been the inspiration for Claude Debussy's musical composition "La Mer."

The involvement of the viewer in the print, as though we are experiencing what the men in the boats are experiencing, is achieved by the huge roller-coaster ride our eyes take as they slide downward from the right side of the print and up through the minor crest to leap into space with the foam at the crest of the great wave. A comparison of the figures in this print with those in the donkey train in the Fan Kuan painting of the Northern Song (fig. 16.2) may reveal insights into the different feelings of the artists, their cultures, and their times. Consider what they communicate to us and how they do it.

SUMMARY

The Momoyama period was the age of castle building in Japan. Japanese culture returned to its own past for inspiration. The Kano school maintained its favor with the military and its style became bold and resplendent. Sliding doors and screens were often painted with life-size or larger images of trees, flowers, and animals. The monochrome style of the Ashikaga period continued, and gradually a distinction arose between the two styles. By the time of the Tokugawa regime it had become customary to employ the bold patterned colors and gold style in public areas of military residences, while the subdued, smaller-scaled monochrome style was preferred for the private dwelling chambers.

The tea ceremony, inspired by the monastic practice of tea drinking, had been adopted by the eighth Ashikaga shogun, and his successors enjoyed the cult under various renowned tea masters. The tea cult preserved much of the aesthetic flavor that had developed during the Ashikaga. Simplicity and humility were keynotes, and old and discarded vessels were often pressed into its service to insure that the air of humble integrity should be maintained. Gradually tea masters had their own designs made by local kilns, and some of the master potters also designed bowls for the ceremony.

Porcelain clay was discovered in Kyushu in the seventeenth century, and the kilns set up there began by imitating the Chinese porcelains of the Ming dynasty, with underglaze blue or overglaze enamel designs. The porcelain factories have continued to produce excellent wares to the present time.

In the Edo period town painters emerged as a group distinct from the traditional Kano school or the Yamato-e painters. The Sotatsu-Korin "school" is the most important, and they had a powerful effect on subsequent Japanese painting. The forerunner was Sotatsu, who, with Koetsu, shared a unique but completely Japanese aesthetic. Later on, in the Edo period, Korin and his brother Kenzan and, still later, Sakai Hoitsu all shared the same colorful and decorative attitude and style. Sotatsu, Korin, and Hoitsu were painters, while Koetsu and Kenzan produced pottery and, in the case of Koetsu, lacquer wares as well.

The Momoyama and Edo periods saw the first European ships to reach Japan seeking trade alliances. Both Hideyoshi and the Tokugawas distrusted and feared these people, believing they would undermine the Japanese system, and so they were restricted to the port of Nagasaki in the western island of Kyushu. To this same port came some Chinese painters in the Edo period, and it was there that several young Japanese painters encountered foreign painting for the first time. The Chinese style (Nanga) and the Western style

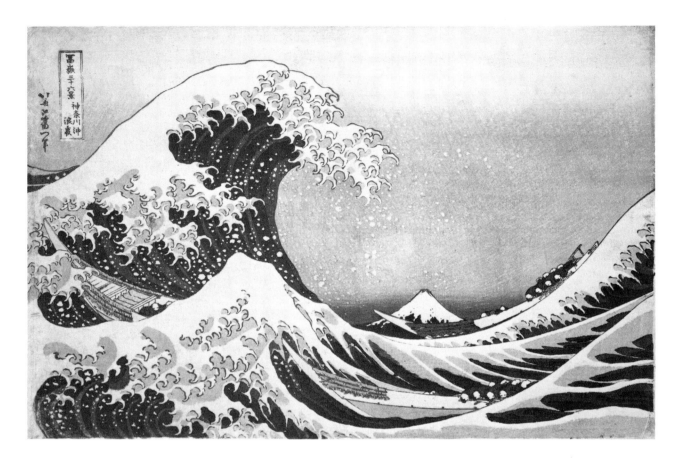

Figure 26.27 *The Great Wave,* by Katsushika Hokusai (1760–1849). One of the thirty-six views of Mount Fuji. Wood-block print. Edo period. W. 14¾″. Spaulding Collection. Courtesy, Museum of Fine Arts, Boston. Acc. 21.6765.

(Yoga) were soon absorbed into the Japanese repertoire as manners of Japanese painting.

The residential architecture of the Muromachi and Momoyama periods had continued the Shinden style of the Heian period, with its emphasis upon separate buildings and directional orientation. But, in Momoyama, the new Shoin style came into being for official residences of military leaders. In Tokugawa/Edo it was appropriated for the wealthy classes as well. Nijo Castle in Kyoto is the finest extant example.

The Sukiya style is best seen in the Katsura Villa. It derives its elegantly understated simplicity from the teahouse style, based in turn on peasant buildings. Here it combines these qualities with those of Shoin architecture, especially in plan and in the special way the buildings are related to the setting. The Toko-no-ma is to be found in both the Shoin and in the Sukiya style but not in the Shinden style.

The temporary aspect of these styles parallels the Ukiyo attitude: the reverence for the fleeting, the floating world. This was a philosophic aesthetic attitude that developed in the Edo period, particularly in

the capital of Edo (Tokyo). It focused on the transient, the ephemeral, and the evanescent aspects of life, which, like a beautiful flower, enchant partly because they cannot be held beyond their brief moment. Such aspects of life included all temporal and temporary phenomena: the passing of the seasons, the waxing and waning of the moon, even the fleeting up-to-the-minuteness of fashions and especially the performing arts of music, dance, and the Kabuki theater.

Ukiyo-e, Pictures of the Floating World, depicted in painting and in wood-block prints the many subjects of the genre. Instead of the profound, sometimes eternal character of earlier paintings, the Ukiyo-e took scenes of picnicking, scenes of daily life in and around Tokyo, Mt. Fuji seen from many different places around Japan, various neighborhoods, etc. But the most sought-after subjects were the prints of Kabuki actors in famous roles or of famous actors in well-known plays. The Ukiyo-e cult became a craze in the late eighteenth and early nineteenth century. Before it died it produced some amazingly dramatic prints, which, both in genre and in formal organization, were to have an effect upon modern painting in Europe.

GLOSSARY

Bunjinga Japanese form of Chinese wenrenhua ("Literati Painting").

Daimyo Great Names; Japan's great families. (p. 238)

Donjon Main keep of a Japanese castle. (p. 238)

Kakiemon ware Red picture ware. Fine white porcelain with enamel designs made at Arita beginning in the seventeenth century. (p. 244)

Maru Circle; divisions of castle compounds as first, second, and third circles of defense. (p. 238)

Nanga Southern painting. Chinese-style paintings made by Japanese. (p. 252)

Shinden Sleeping room; domestic style of architecture developed in the Heian period. (p. 253)

Shoin Book room; domestic style of architecture developed during the Momoyama period in which one room of the home was devoted to a library. (p. 254)

Shoji Sliding panels with wood framework covered with translucent white paper. (p. 254)

Sukiya Elegant dwelling place; domestic style of architecture that combines the refinement of the Shoin and the rusticity of the tea architecture tradition. (p. 255)

Tarashikomi Puddled color effects achieved by touching a brush loaded with ink and/or colors to an already wet surface, producing mixed color variations. (p. 246)

Tatami Woven grass mats stuffed with straw; about three by six feet and three to four inches thick used as floor coverings. (p. 241)

Toko-no-ma Place of the mat. An alcove for display of seasonal flower arrangements and/or paintings/calligraphy. (p. 242)

27
· · · · ·

MODERN ART IN JAPAN
The Meiji (1868–1912), Taisho (1912–26),
and Showa (1926–88) Periods

In 1854 Japan opened doors to the world that had been closed for two hundred years. The arrival of Commodore Perry, with demands for trade, resulted in the Japanese ports being opened to American trade, and the Dutch, English, French, and Russians demanded and received equal trading privileges. This opening to Western trade and the subsequent proclamation of Emperor Meiji brought to Japan a knowledge of Western cultures. Within two generations Japan turned its orientation from China to Europe.

In 1868 the last Tokugawa shogun was forced to return the military power that had been snatched away by Minamoto Yoritomo more than 650 years before (chapter 25). The emperor Meiji, who received the control of Japan's military forces, was only fifteen years old. The ceremony took place in the audience hall at Nijo Castle in Kyoto (fig. 26.22). This site was chosen because the shogun Tokugawa Ieyasu had held an audience there to celebrate his final conquest of all of the outlying districts of Japan in 1603 (chapter 26), and all of unified Japan was now coming back under the protection of the emperor.

The new emperor declared a deep determination to open friendly relations with other countries. The old city of Edo was renamed Tokyo and became the capital. From this city Emperor Meiji and his son and grandson, the Taisho and Showa emperors, continued to rule Japan. His great-grandson, the present emperor, Akihito, ascended the throne in 1990.

ARCHITECTURE

Western Influence

During the Meiji period (1868–1912) a reversal of the Edo governmental attitude occurred; within a generation everything Western was seen to be good. Japanese ladies even took to hoop skirts and gentlemen to top hats and tails. Electricity and railroads were introduced and along with them buildings in Western style. Engineers, technologists, and architects, as well as artists, came from Europe and America to work and teach. Suddenly traditional Japanese architecture was left alone in the home. Public buildings donned stone dress decorated with Greek columns and French windows.

Katayama Tokuma (1853–1917) was the imperial household architect who produced the most spectacular Western-style buildings. The Akasaka Detached Palace in Tokyo is perhaps his most ambitious plan (fig. 27.1). It was inspired by the Palace of Versailles but has echoes of many other phases of European architectural style. The building is simply not Japanese in conceptions, materials, or decor inside or outside. The long tradition of Chinese/Korean wood construction of pillars, beams, brackets, and tiles was abandoned in the Meiji period for new materials and foreign styles.

The Meiji opening of Japan to Westernization led not only to the adoption of Western styles and techniques but also to courses in the history of architecture, beginning in 1887 at Tokyo University. Gradually a reappraisal of tradition occurred, and a new desire to blend the Japanese with Western styles and engineering techniques arose.

Inspired by the Viennese secessionist group of artists and by German expressionism, in 1920 Yamada Mamora and Horiguchi Sutemi organized a Japanese secession group of architects. Architects Maekawa Kunio and Yoshizaka Takamasa went to Paris to study with the great new architect Le Corbusier, where they learned his steel and concrete techniques and box-like spatial organization.

The Imperial Hotel in Tokyo, designed by the young American Frank Lloyd Wright, had just been completed when the catastrophic 1923 earthquake struck the city, leveling most other large buildings.

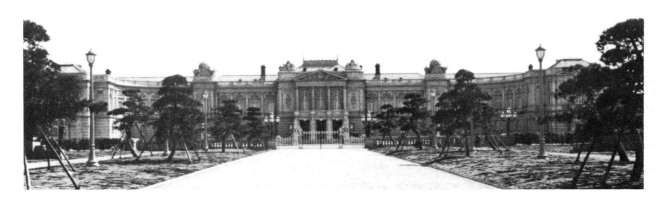

Figure 27.1 Akasaka Detached Palace, Tokyo, by Katayama Tokuma (1853–1917). Meiji period (completed 1909). © Kodansha Images/The Image Bank.

Wright had used reinforced concrete supported on piling, and the Imperial Hotel suffered no major damage. In rebuilding Tokyo, both the materials and techniques of the hotel were carefully studied and adopted with the cooperation and encouragement of Mr. Wright.

The confluence of rethinking modernism in Japanese architecture and the influence of Wright's techniques and materials led to a period in which the ancient pillar and beam system of wood architecture was imitated in reinforced concrete. Gradually, a generation of younger architects turned from this imitation of past styles in modern materials and techniques to consider the possibilities of stylistic potential inherent in these materials and techniques themselves.

After the destruction of most of Tokyo in World War II, a new integration of the traditional qualities, rather than the mere style, of Japanese residential architecture emerged as characteristics of buildings whose purposes were not residential or constructed of the traditional wood and thatch. The qualities so cherished in Japan's past—lightness and flexibility of spatial units, fluidity of movement, modular repetition of the fundamental unit, plus the strong integration of the building (the house) with surrounding nature (the garden)—emerged in large commercial and public buildings, but the *style* is so different from that of the Katsura Detached Palace, for example, as to make it difficult sometimes to see the more fundamental architectural qualities, that is, to separate the visual from the functional aspects of the buildings.

Public Architecture

The Kamakura Museum of Modern Art (1952), designed by Sakakura Junzo (b. 1904), is recognizably influenced by the French architect, Le Corbusier, with whom Junzo studied in Paris (fig. 27.2). It is built of steel faced with white marble and glass, but it also has a strong reminiscence of the Katsura Detached Palace. Both are supported above the ground level on slender posts, although the materials are different. Both have vertical and horizontal modular divisions of the surfaces. Both have wide horizontal spaces from which the exterior garden may be viewed by those within. One great difference between them, however, is the roof. Katsura has the typical heavy roof with widely overhanging eaves (to prevent rain from splashing against the wood of the supports and rotting them), but the museum has no visible roof at all. A comparison of figure 26.23 with the Kamakura Museum building may reveal other similarities and differences.

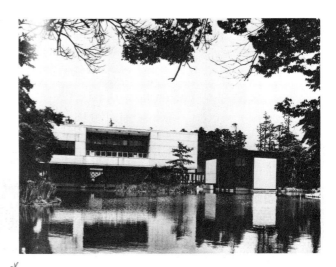

Figure 27.2 Museum of Modern Art, Kamakura, by Sakakura Junzo (1952). Courtesy of Elemond, Milano.

Maekawa Kunio (b. 1905) also studied with Le Corbusier from 1928 to 1930, and in 1935 he established his own office in Tokyo. Maekawa insisted on developing technology and engineering as the only firm basis for the modernization of Japanese architecture. His best-known apprentice is Tange Kenzo (b. 1913). Tange began teaching at Tokyo University in 1946 immediately after World War II. He won a competition for his first important work, the Peace Hall at Hiroshima, begun in 1949 and finished in 1956. Since his early years he has been a visionary in the avant-garde of architectural technology. He has won many prizes and has executed projects in over twenty countries worldwide. He has developed his own dramatically daring style based on pre-stressed concrete and steel.

One of Tange's most striking concepts is that of the indoor stadiums for the Tokyo Olympics in 1964 (fig. 27.3). The roofs are suspended from huge steel cables, which provide interior spaces entirely free of any supporting pillars and ideal for viewing sports events. In the swimming stadium, two concrete towers suspend two eleven-inch steel cables between them (fig. 27.4, left side). Smaller cables run downward and outward, supporting the tent-shaped roof that shelters the swimming pools and fifteen thousand seats for spectators. The same construction supports the roof of the building on the opposite side, but here the simple main cable descends from its concrete tower in a spiral, covering a circular space with four thousand seats.

Tange used the same concept of pre-stressed reinforced concrete supported by steel cables in his beautiful and innovative St. Mary's Cathedral in Tokyo

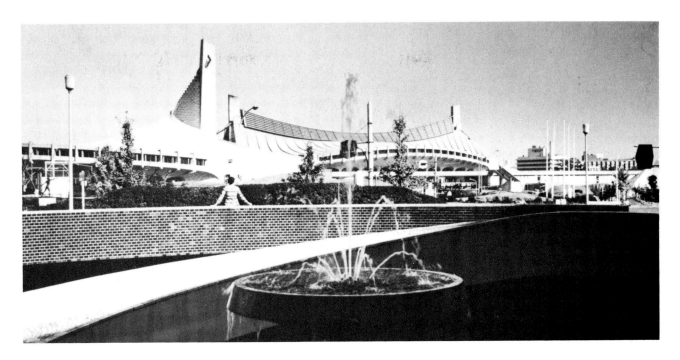

Figure 27.3 National indoor stadiums for the 1964 Olympics, Tokyo, by Tange Kenzo. Steel and reinforced concrete (completed 1964). © Kodansha Images/The Image Bank.

(1965) (fig. 27.5). This building may seem ultra-modern and totally non-Japanese, but the roots of its architectural form go very far back into Japanese history. It is derived from the traditional heavy thatched roofs of Shinto shrines and traditional dwellings (fig. 21.8). This style has continued more or less complete and to the present day. It has been amalgamated with the Chinese-style hipped and gabled roofs of Buddhist temple architecture (figs. 22.2 and 22.4, for example) to produce the kind of roof seen in the last rebuilding of the Izumo Taisha, a Shinto shrine on the north coast of Japan, which was given a bark thatched roof with downward curve of the type under discussion in the Edo period (fig. 27.6). Tange's 1960 plan for Tokyo's expansion across Tokyo Bay, to be supported by pilings, incorporated vertical skyscrapers and low, large rectangular parks that were to be roofed with colossal versions of the Izumo roof done in reinforced concrete (figs. 27.7 and 27.8). The open spaces where the slopes of the roofs ought to meet at the ridge have been left separated for light just as in the Olympic Swimming Stadium (fig. 27.4). The St. Mary's Cathedral roof is made by setting one roof of the Tokyo plan type down over another at a ninety degree angle so that they form a cross in plan (fig. 27.9).

Domestic Architecture

Japanese domestic architecture of the modern era was slower to react to foreign influences than public and commercial architecture, for the simple reason that the traditional Shinden and Sukiya styles had been so thoroughly in tune with Japanese family and aesthetic life. Even today the Sukiya style is preferred but sometimes with daring innovations inspired by the West. The first of these came just after World War II, when it became common for wealthy Japanese families to have a "Western room" with furnishings like those in America.

The more permanent materials of steel and concrete, plus glass windows, have been used by such architects as Yoshida Isoya (1894–1974). Amenities not available to older Japan, such as electric lighting and central heating, are often added to these "new Sukiya" homes. The residence in figure 27.10 combines concrete and glass with wood and retains a strong sense of the fluidity, simplicity, and clean lines of the past. Yoshida traveled in Europe and America after graduation from Tokyo University and observed and studied Western architectural styles firsthand. He specialized in domestic architecture and in very elegant restaurants.

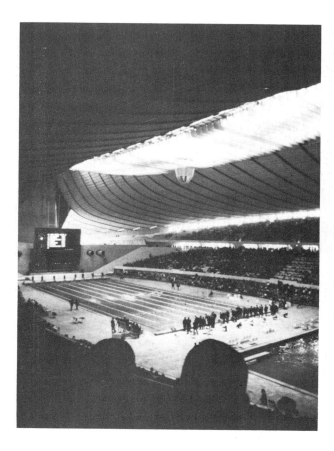

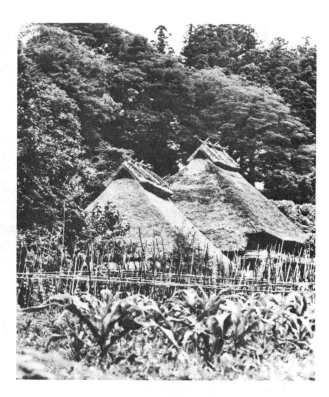

Figure 27.5 Houses in Yubuin village, Oita Prefecture, northeastern Kyushu folk architecture. Date unknown: probably nineteenth century.

Figure 27.4 National indoor stadiums for 1964 Olympics, Tokyo, by Tange Kenzo. Interior of Swimming Stadium. Steel and reinforced concrete (completed 1964). © Kodansha Images/The Image Bank.

The Shinwa Bank by Shirai Seiichi (1905–83) is, of course, a commercial and not a domestic building, but it is included in this section because the architect was noted for his great sensitivity to materials and forms and the overall humane character of his public buildings (fig. 27.11). Like Yoshida Isoya, he visited Europe as a young man, became entranced with Gothic architecture, and was self-taught. His work is credited with a spiritual quality, and he became a greatly revered mentor among his peers.

The Shinwa Bank was built in three phases, and while the style and even the materials change from one section to another, the overall unity of the building arises not from harmonies but from counterpoints. With deep sensitivity to juxtapositions so characteristic of Japanese art, this building creates a sense of excitement and visual resonance between its three phases often lacking in buildings that follow a single style throughout.

Ando Tadao (b. 1941) is also a self-taught architect. His severe style owes much to the international style of the Bauhaus. The strict clarity and simplicity of form, based upon a spatial module, or box, 17.5 feet by 15.5 feet used in the residential complex seen in figure 27.12 may seem to stop just short of monotony. But the design is greatly modified (and counterpointed) by its setting among tree-covered hills and by the large picture windows.

Architecture is free from iconography and representation and is thus able more easily to adapt new techniques and forms. In the last century Japanese architecture has evolved from age-old traditions into widely varied and highly inventive new forms while preserving the standards of quality, if not the styles, of its predecessors. New solutions to functional needs have been invented, and Japanese architecture of the present age shares with the best of architecture of this period

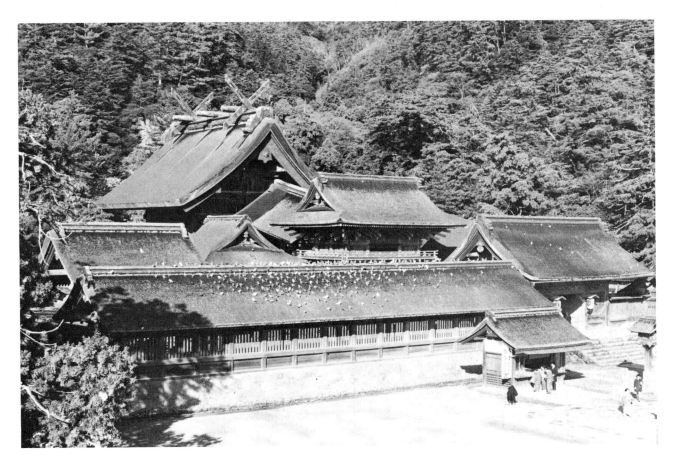

Figure 27.6 Izumo Taisha. Main shrine. Wood, cedar bark thatch.
H. 80'. Originally built in the eighth century. Last rebuilt in eighteenth
century. © Shashinka Photo Library.

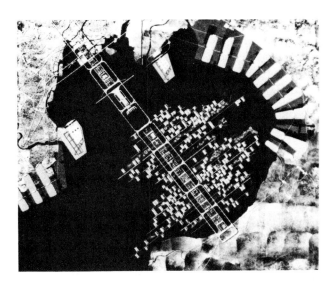

Figure 27.7 Model of Tange Kenzo's plan for Tokyo expansion
across Tokyo Bay (1960).

Figure 27.8 Plan for Tokyo, detail, by Tange Kenzo (1960).
Courtesy of Elemond, Milano.

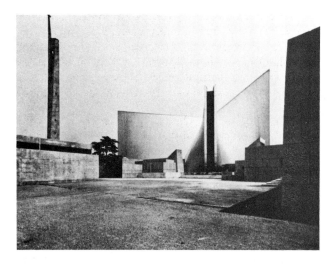

Figure 27.9 St. Mary's Cathedral, Tokyo, by Tange Kenzo (1965). Courtesy of Elemond, Milano.

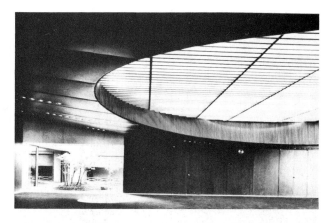

Figure 27.11 Shinwa Bank, Sasebo City, Kyushu. Interior view of Lecture Hall, by Shirai Seiichi. Steel and reinforced concrete (completed 1975).

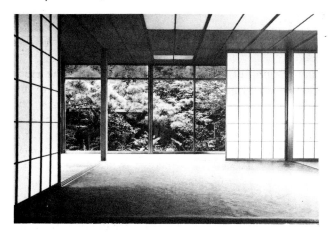

Figure 27.10 Kitamura residence, Kyoto, by Yoshida Isoya. Reinforced concrete and wood (1963). Note ceiling lighting, translucent inner sliding wall panels, exterior glass panels, and woven carpet.

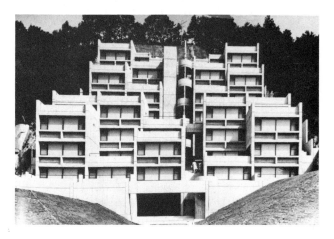

Figure 27.12 Residential complex, Kobe, by Ando Tadao. Reinforced concrete (1983).

in other countries a new emphasis upon function rather than style as the inspiration for new buildings. This attitude produces a unity that promises to produce a new international style of real significance in the near future.

PAINTING

Japanese-Style Painting (Yamato-e)

Before looking at new developments in painting in the modern period it will be helpful to consider late Yamato-e painters who continued to paint in the old manner. The spirit and glee of a Sotatsu or a Korin are not evident in the works of Meiji and Showa painters. The tradition had entered a period of formulaic repetition. Here are two of the better ones.

Yamaguchi Hoshun (b. 1893) attended the Tokyo School of Fine Arts to study Western-style painting. He then switched to the study of Japanese-style painting—Yamato-e— at the same school. His *Nachi Shrine* painting was awarded the Imperial Art Academy Prize in 1926 (fig. 27.13). He was elected a member of the Art Academy of Japan in 1950 and was awarded the order of culture in 1965.

Yamaguchi was trained by the leading Yamato-e painter of the period, Matsuoka Eikyu. Yamaguchi's Nachi painting recalls the Kamakura period painting of the same subject (fig. 25.5). In Yamaguchi's presentation the Kumano Shinto shrines at the base of the waterfall compete for our attention, so it is clear that the painter was concerned with the ensemble, while

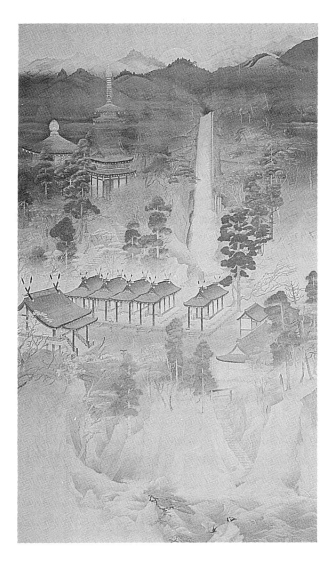

Figure 27.13 The Nachi Shrine of Kumano, by Yamaguchi Hoshun. Colors on paper (1926). H. 8′. Imperial Household Agency, Tokyo.

the Kamakura painter seems to have been only interested in the waterfall (although it is probable that the thirteenth-century painting has been trimmed at the bottom so that only a roof of a building remains).

The monumental character of the waterfall is conveyed by the way in which it fills up the space. The mountain and waterfall have been revered as Kami since the fourth century and, from the Heian period onward, the Shinto Kami and Buddhist Buddhas and bodhisattvas were increasingly purported to be identical. As a result, all Shinto deities were seen to be but manifestations of Buddhist ones, and Buddhist temples had often been built within the grounds of Shinto shrines. On the left of this painting is such a Buddhist enclave, complete with pagoda rising above the trees in the background.

In the Yamaguchi painting the middle distance mountains are painted in deep blues, a possible reflection of the Chinese blue and green style (fig. 14.7 and colorplate 11). The sculptures of lions flanking the doorway to each shrine go all the way back to India, where they were symbols of the royalty of the Buddha (fig. 3.15).

It is interesting and helpful to compare both the Yamaguchi Hoshun and the Kamakura paintings with the Fan Kuan (fig. 16.2). Consider, for example, the sense of atmospheric depth; the function of the waterfall in each and the evidence of human habitation, as well as the sense of actuality. What does each painting convey in terms of an actual experience of the place represented? Of its spirituality?

The painting called *Fire Dance,* by Hayami Gyoshu (1894–1935), is a fine example of Yamato-e (fig. 27.14). Its black background, brilliant red flames, and white moths produce a strong visual impact. Edges are all-important. There is no background, and linear eye-catching rhythms attract our attention. This painting is evidently inspired by the stylized flames of the Kamakura painters. These lack the force of the flames in the burning of the Sanjo Palace section of the Heiji Monogatari (fig. 25.4) because their edges tend to run too parallel and rather meandering by comparison, but Hayami's painting reflects the Kamakura interest. Not only were flames found in scrolls of historic events, but many more depictions of them were shown in the scenes of the various kinds of Buddhist hells, in which every kind of torment of the lost souls was shown.

Hayami may have had such scrolls in mind when he chose as his subject the moths. By nature they are attracted to the flames, and they are flying to their destruction in the same way that people who follow their own unpurified nature are flying to their own destruction in one of the many hells prepared for them in the Buddhist lore. Hayami shows his true Yamato-e spirit in harking back to the Kamakura style that was perpetuated by the Tosa line of painters.

The Yamato-e of the modern period seems bland compared to the great creative masters like Sotatsu, Korin, and Hoitsu of Edo (chapter 26). And certainly when compared to the Kamakura Japanese-style painting they seem vapid and without any real significance. There is a conservative aspect in these later followers that verges on the timid, and it was this quality perhaps as much as matters of style that made artists thankful for the official opening of Japan to foreign technological and cultural influences.

One of the unfortunate consequences of the Meiji push for Westernization was the separation of Shintoism from Buddhism. Shinto is the oldest form of Japanese religion and it was inseparably fused to the

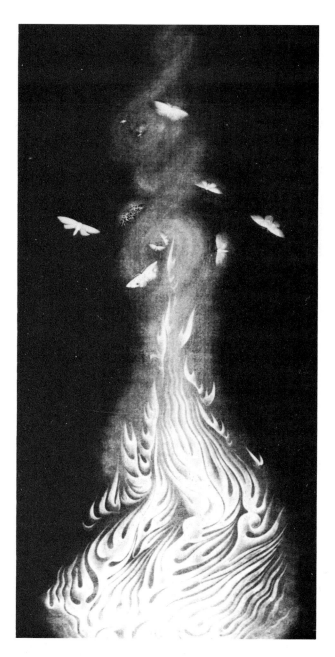

Figure 27.14 *Fire Dance,* by Hayami Gyoshu (1894–1935). Colors on silk (1925). H. 47¾".

imperial family (chapter 21). An irrational wave of destruction caused many Buddhist establishments to be destroyed along with their paintings, sculptures, books, and ritual objects. If it had not been for the arrival of an American professor, Ernest F. Fenollosa, along with William S. Bigelow from Boston, much more would have been damaged. Fenollosa convinced the Japanese government to protect its art treasures and, as though to show the great value of these cultural treasures, Dr.

Bigelow bought a great many objects, which are now in the Museum of Fine Arts in Boston, where Fenollosa became the director of the Oriental Department in 1891.

Western-Style Painting (Yoga)

The new development heralding the general Meiji shift to acceptance of Western cultural modes was the introduction of the technique of oil painting by Charles Wirgman (1832–91), a British newspaper correspondent. A handful of painters studied in Europe and America in the last quarter of the nineteenth century, and in 1888 the Meiji Bijutsu-Kai (Meiji Art Society) was established by Asai Chu—who had studied with the Italian Antonio Fontanesi (1818–82), who had come to Japan in 1876— and Kawamura Kiyo-o. Subsequently several other art schools were set up for the purpose of teaching Western-style painting, including the Hakuba-Kai (White Horse Society) group of painters, who specialized in outdoor painting following the *plein air* painters of the Barbizon school of France.

The first of Fontanesi's students to go to Europe to study was Yamamoto Hosui (1850–1906). He had been a Nanga painter in Kyoto and went to France after studying with Fontanesi for a year. In France he was accepted as a student by Leon Jerome. His painting of a *European Lady* is said to be a portrait of the daughter of Theophile Gautier, the famous poet and authoress (fig. 27.15).

Yamamoto was responsible for encouraging Kuroda Seiki, whom he had met as a young law student in Paris, to undertake a career in painting. It was Yamamoto's Tokyo studio that later became the studio of Kuroda and the center of the *plein air* school.

New groups were formed as knowledge of other movements in European, primarily French, painting reached Japan. These groups, like the Nanga painters before them, immersed themselves, insofar as they could, in the culture, language, and literature of the West as well as in the new painting styles in an effort at a kind of total osmotic absorption. All of these early developments may seem, in retrospect, to be more imitative than creative, although most reached a respectable level of accomplishment and contributed in their own ways to modern art in Japan.

Japanese artists wholeheartedly plunged into European ways. Painters adopted oil and canvas, a mode totally foreign to their tradition. Nude oil painting appeared, together with that old standby the still-life study. Light falling on objects and defining their volumes was a new idea in Japanese painting. The impressionist use of color to simulate light in atmosphere was revolutionary.

Figure 27.15 *European Lady,* by Yamamoto Hosui (1850–1906). Oil (1882). H. 16″.

These schools of painting, particularly the *plein air* White Horse Society led by Kuroda Seiki, who had studied with Raphael Collin and painted in Paris for ten years, became deeply influential. *Morning Toilette* was painted in Kuroda's last years in France and exhibited at the National Society of Fine Arts (fig. 27.16). But a few months later it caused a sensation when it was shown in Japan, where nudity was not acceptable for public display. What the Tokugawa rulers had feared had come about: the loosening of the fixed and rigid social system, which had subordinated the individual's feelings to the group, through contacts with Western philosophies, religions, and customs. The vigorous feudal system that bound each person to the family at the expense of individuality was disappearing. Painting in the outdoor light and colors of the modified manner of Collin and Kuroda introduced the complementary color system, which provided the vastly increased means for emotional intensity.

Figure 27.16 *Morning Toilette,* by Kuroda Seiki. Oil (1893).

Kojima Torajiro (1881–1929) was one of the earliest Japanese painters to practice the methods of the French Impressionists. He had studied in France and in Belgium, but by the end of the century the general excitement about Western painting was losing its momentum. Even the White Horse Society, which had been the major group, had dissipated its energies.

In 1907, a series of exhibitions sponsored by the Ministry of Education after the manner of the French *salon* were initiated in Tokyo. These exhibitions have been held each fall since then. They included Japanese-style and foreign-style paintings and sculpture. The rage for oil painting had all but eclipsed that of watercolor

Figure 27.17 *Woman with Shoes,* by Yamashita Shintaro (1882–1969). Oil (1908). H. 2′3″.

in the Western manner. One of the outstanding water-colorists who exhibited at these fall shows in the early years was Yoshida Hiroshi, who later turned to woodblock printing.

In 1910 Yamashita Shintaro (1881–1969) showed *Woman with Shoes* (fig. 27.17). It was painted in 1908 while he was studying in France, where he became interested in the paintings of Velasquez and Renoir. This painting, with its soft and blurry brushstrokes and its complementary hues, especially the scheme of blues and orange, is strongly reminiscent of Renoir. Yamashita's paintings and those of Fujishima Takeji gave Western-style painting a new lease in Japan.

These annual exhibitions, however, became more and more official and institutionalized, and the vital breath was being stifled by the judges' narrow views of acceptability and the artists' tendency to cater to them. Finally, in opposition to the fall exhibitions, a circle of younger painters formed a group, and it was these new painters, who wished to encourage new styles of expression, that gave rise to the new direction in Western-style art in Japan. Kishida Ryusei (1891–1929) experimented with many European styles, including those of the Fauves and Albrecht Durer and Jan Van Eyck, but finally returned to the traditional

Japanese styles and techniques, as did many others during the Taisho period.

Yorozu Tetsugoro (1885–1927) was an eclectic painter whose intellectual attitude led him into studies of a great many aesthetic problems. He was among the earliest Japanese painters to take up cubism and to be interested in African masks. Finally he retired in 1919 and took up the traditional Nanga style of painting.

The Japanese public received the new experiments in Post-Impressionist, Fauve, and Cubist art with no more positive response than these styles had found in France, where they originated. The whole episode of Western-style painting in Japan could be explained by that old cliché that says the Japanese are great imitators; and a glance at these Meiji-Taisho paintings certainly proves it. But it proves two profound truths of much greater importance. First, the Japanese painters did not merely imitate—they *learned*—the European styles. Many learned them in Europe from European teachers (or, as in the beginning, from Europeans in Japan). And, of even greater importance, the best among them came to realize, early or late, that, admirable as these styles were, they were not really for them.

When tradition was no longer viable for the younger generation, they rebelled and turned to Europe. They then became the older generation, but in so doing, many marked a path out of the dilemma whether to follow a lifeless tradition or to turn to foreign styles or, finally, to blaze new trails out of the dilemma and return home.

Art Prints—Hanga

When some of these Japanese artists went to study in Europe, they found that European painters were attracted to Ukiyo-e prints. Furthermore, they found that European print makers made and printed their own blocks. The Japanese of the Meiji period did not take the Ukiyo-e prints of the Edo very seriously. For one thing, they were out of fashion, and all things European were in. Ukiyo-e was so passé that it is said at least one shipper of Japanese ceramics packed his dishes in surplus unsold prints and that is how they originally got to Europe!

When the Japanese student-painters realized the attraction these Ukiyo-e prints had for Europeans, they began to reconsider them. At home primary attraction of these prints had not been as "art" but as informative pictures—the distinction being the difference between *what* is shown and *how* it is shown. These prints were sought by Edo collectors because of their subject matter, not their formal visual qualities (figs. 26.25, 26.26, and 26.27). European artists saw them in the reverse manner: they did not care at all what they represented, it was *how* they represented it that was important. That

is, it was the formal aspects of composition, pattern, and color, regardless of the subject, that held them spellbound.

When students returned to Japan, they began to start a new age of the Japanese print. Their work had no hint of the Ukiyo-e. It was more infused with the formalism of the painting styles they had learned abroad. They made their own blocks, did their own printing, and called their new method, **hanga**— "block picture"—or perhaps more smoothly translated simply as "print" because the term included all kinds of printing methods.

Early Hanga

The art print form owed its invention to a small group of artists, mainly Yamamoto Kanae, who founded a group that experimented with making their own prints and published a small magazine devoted to the subject in 1907. Yamamoto spent four years in Paris working and studying. He organized the first exhibition of the Art Print Association in Tokyo in 1919. It included prints by the Englishman Bernard Leach, who was a potter who became involved by Hamada Shoji and Yanage Soetsu, the leaders of the movement, in revising the handmade pottery industry in Japan. This led to the revival of all Japanese handicrafts, which, in the early twentieth century, had been overpowered by the Industrial Revolution. This revolution had so turned Japanese taste that people preferred a factory-produced plate because it was mechanical and gave no evidence of having been made by people, to one that carried evidence of having been made by hand.

Yoshida Hiroshi (1876–1950) went to Europe to study painting at age twenty-nine. His particular enthusiasms were for the Impressionist and Post-Impressionist painters of France. He was a man of cosmopolitan interests and curiosity and had been a member of the Pacific Painting Society, successor to the Meiji Art Society. His primary medium became watercolor applied in the Western manner. In his adult life he continued to travel to Europe, America, and to many parts of Asia and did watercolor sketches on the site of many famous views, including architecture, and designed exquisite block prints from them upon return home (fig. 27.18). Later in life his wife and children also took up print making with great success and had exhibitions in Europe and America, as well as in Japan.

Yoshida combined the Western interest in both abstraction and light and atmosphere in his prints. There is a fascinating dynamic between depth and surface; between illusion and abstraction; between the flat line of the Japanese wood-block tradition (fig. 26.27) and

Figure 27.18 Kailasa Temple, Ellora (Shown b). Wood-block print on paper (1931). H. 14¹¹/₁₆″. Courtesy of the Arthur M. Sackler Gallery, Smithsonian Institution, Washington, D.C. Acc. S1986.S71.

the light and atmosphere of Impressionism. It is the same paradox that baffled and fascinated Paul Cezanne (1839–1906). Although Yoshida's solution is very different from that of the French painter, they both wished to preserve their works from the illusionism of depth that would destroy the integrity of the surface.

A comparison between the Yoshida print and a photograph of the same subject indicates these qualities (fig. 6.10). While the photograph shows us the great spatial depth of the subject and its powerful three-dimensionality, Yoshida has actually diminished the sense of spatial depth without diminishing the implication of it. He preserves the integrity of the surface of the paper in this way. The outlining of all the major forms and the restriction of the dark to light range both help to emphasize the flatness of the organizational scheme. The colors, too, are restricted to blue violets, cocoa brown, gray blues, and ivory, with tiny touches of red in the turbans. The colors are flat, as though

painted in broad watercolor washes. We are reminded that Yoshida was trained in Western watercolor techniques as well as in the complementary color system of the French impressionists.

Onchi Koshiro (1891–1955) was the son of a highly conservative member of the court of Emperor Meiji. Koshiro grew up surrounded by princes, with whom he attended school in the palace, where they studied with his father. He received, thereby, as strictly traditional and intense an education as was available. Onchi had yearned to be an artist, but his father wanted him to be a doctor. However, when his three older siblings all died within a space of two years, while Koshiro was in the pre-med program at a German middle school in Tokyo, his father gave in and let him enter the art academy at seventeen. He was an artistically rebellious student and was asked to leave after three years. He had abandoned oils for block printing, among other heretical aesthetic activities.

European Influence

Onchi was inspired by Yamamoto in his new field, but he was influenced more by the Europeans, especially Wassily Kandinski and Edvard Munch. He was one of the early creative print makers and one of the very earliest to work in non-objective, non-representational art (fig. 27.19). He experimented with new techniques and materials, adding string, paper, leaves, etc., and invented a new printing method something like the *frottage* method of Europe. The principle was that instead of cutting woodblocks, he assembled the elements of his composition on waxed paper, having applied ink to each section of cardboard, string, etc., and then laid the printing paper face-down upon it. When pressure was applied, the paper picked up the ink. The results look more like monoprints, where the subject is painted upon a smooth surface and the paper applied directly, producing a one-of-a-kind print.

Munakata Shiko (1903–78) was a strong figure in the Showa period. His prints are at the opposite pole from the elegance of his predecessors of the Edo period. Rather than graceful line and a rich range of color, Munakata's prints employ awkward, primitive, and often disturbing designs printed only in black on white paper (although he sometimes used one or two colors on the reverse side of the paper). But they are intensely compelling. His work had no parallels in his generation. He rejected foreign influences and said he did not want to broaden his outlook by studying other artists' works. He wanted simply to go deeper and deeper into his medium and his themes, which were Buddhist.

Munakata was a devout Zen Buddhist and often did series of prints around a Buddhist subject, such as his *Ten Disciples* (1939). It has been said that he, more

Figure 27.19 Abstraction (My Own Dead Face), by Onchi Koshiro (1891–1955). Printed on paper. Showa period. H. 11″.

than any other Japanese artist, synthesized modern and traditional attitudes. This is because his prints are reminiscent of the small prints of the Buddha and bodhisattvas, which are still available to pilgrims to Buddhist temples, and which have a long history going back at least to the Heian period, and perhaps earlier in China and India at Bodhgaya, where they may have been printed on leaves or cloth. Such small souvenir prints were often simple, crude, and provincial, but Munakata believed they might be the only true block prints because they were produced without any self-consciousness.

Munakata himself remained a provincial—a simple man who never acquired the veneer of urbanization. He came from Aomori, the northernmost prefecture of the large island of Honshu. He worked very rapidly, with large chisels, one flat and one with a round edge, and omitted any fine detail. Munakata said it was not he who guided his chisels but that he merely opened the gate so that the essential truth might flow in. He also said when the self does not control the work, meaning must. Munakata's *Wind God* (fig. 27.20) certainly is a change in style from the same subject by Sotatsu (fig. 26.11). Does it seem ordinary in comparison to the earlier version? Sotatsu's has the wind contained in his large bag; Munakata's does not hold such a bag. Does

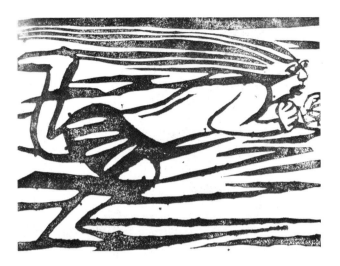

Figure 27.20 *Wind God,* by Munakata Shiko (1903–78). Wood-block print on paper (1937).

it seem that Munakata's wind god is affected by the wind as anyone is? Is there, perhaps, a parallel between Munakata's ideas on art and his presentation of the wind god?

World War II wrenched the fabric of Japanese cultural history. The old Japan may be said to have died with the secularization of the emperor. From being the son of heaven, who traced his lineage from the sun goddess, he was declared an ordinary man without divine qualifications.

The generation after Hiroshima had a profoundly difficult time believing in anything if they could no longer believe in their emperor. Traditional values were questioned. Shinto, because it had been incorporated into the militarist nationalism, was downgraded, as Buddhism had been in the Edo period. In view of the diminished consensus regarding a national mythology or religious inconography, and in keeping with the idea that mass production is better—or at least typical of our time—Japanese painters have, for the most part, taken up the international style and have changed from painting to printmaking.

During the occupation of Japan, a ready-made market arose among the occupation forces and increasing numbers of foreign visitors. Both the tradition and its techniques had been uprooted and in its place a new form totally suited to the Japanese arose.

It is perhaps related to the resurrected postwar Japanese economy that the art of painting has given way to the art of mass production. Even ceramic designs are no longer hand painted as they were before the war. After the war they were applied by a decal process, but now they are more apt to be done by laser technology.

The new printmaking was not fully in force until the 1950s. Some of the artists turned from oil painting after the war, when both space to work and materials were at a premium or unavailable because Belgian linen and English and Italian pigments were entirely obtainable. It is a tribute to the spirit of the artists that they did not give up creativity; they simply turned to a new medium, which required less room than a painter's studio and native pigments and ink. Wood for the blocks could be scrounged, and tools for cutting them could be improvised. When hard woodblocks could not be obtained the printers turned to plywood. This gave them a larger size, which had not been possible in hardwoods.

After the war the young visual artists found a great treasure of new technologies coming to them from the West—new colors, new plastics, both liquid and solid, and old European print techniques. All, from silk screen to mezzotint, were avidly absorbed and utilized.

From the West also came new and exciting conceptual modes. Surrealism particularly had a noticeable impact on the visual as on the literary arts. Its surprising, dreamlike juxtapositions of seemingly unrelated images created whole new fields of aesthetic experience that tapped into the subconscious sources of symbolic imagery, which seems always to have resided at deeper levels of personality than the imagery of iconographic religion.

An early print artist who owed his fame to the foreign visitors after the war is Saito Kyoshi (b. 1907). His subjects are the simple country life or the nooks and crannies of famous temples and celebrated views, which usually are left quite unseen by those who visit them. He has also done strikingly simplified abstractions of subjects as varied as prehistoric *Haniwa* and twentieth-century Catholic nuns. Saito's color is subdued and natural—dull moss greens, rock grays, and rust browns combined with black and tan or white. His work is appreciated for its uncanny ability to evoke in the viewer a kindred feeling for his subjects as much as for their simple and handsome impact. They evoke also the older and simpler Japan, with its quiet, tucked away retreats. *House in Aizu* is an old farmhouse with the huge thatched roof of a kind seen in figure 27.5 (fig. 27.21).

Returning Japanese students brought new knowledge of Western printing techniques. Lithography, etching, and mezzotint all entered the field, along with silk-screen printing, a process derived from textile printing. New photo print techniques were all tried, singly and combined, in an explosion of ingenuity.

The most fundamental element of a print is the paper. When canvas and oil paints were scarce or nonexistent, paper was available. Japan had produced the

Figure 27.21 *House in Aizu,* by Saito Kyoshi (b. 1907). Wood-block print. H. 18".

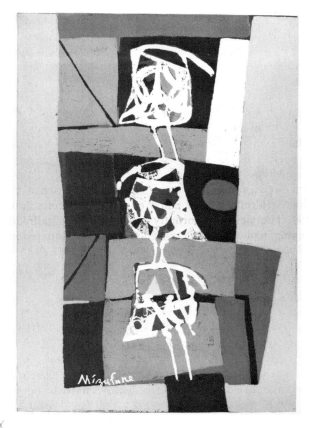

Figure 27.22 *"Poet's Gate,"* by Mizufune Rokushi (b. 1912). Wood-block print, (1960). H. 26⅛". Courtesy of Arthur M. Sackler Gallery, Smithsonian Institution, Washington, D.C. s1988.41.

finest of papers for centuries. Recall that Honami Koetsu ran a shop specializing in papers and fans. Just as China had produced the finest and most varied kinds of silk, so Japan specialized in paper. Out of the Japanese respect for Kami (or just good husbandry of natural resources), reforestation was practiced and a continuous supply of tree pulp was available. The printing papers are absorbent, soft, and receptive to the blocks, which leave a depression upon its surface. The combination of the soft, snow-white paper and the precisely cut edges of the block is, in itself, an exciting sensory experience to those who appreciate wood-block prints.

Mizufune Rokushi (b. 1912) is a sculptor who took up printmaking following the war and has become famous for his powerful prints, in which he uses strong contrasts of dark and light as well as color. His subject matter is more suggestive than descriptive (fig. 27.22). He omits shading but provides a fine textural relationship between one flat shape and another by not cutting the background wood totally smooth but leaving small bits in each block so that the total effect reminds one of light-colored paint applied rather opaquely to a dark background. It produces a strikingly handsome effect and creates a subtle resonance between the sections of the total print. It provides a deeply satisfying series for prolonged visual contemplation. Mizufune's prints have extemely high visual impact, and without this resonance, the viewer would lose interest. The balance between impact and the holding power of the subtler elements produces enjoyment on the order of music.

An example of combined techniques of the printing and ceramic arts is the printed tile mural. In a 1986 exhibition, "Tokyo: Form and Spirit"—initiated by the Walker Art Center in Minneapolis and Japan House Gallery in New York—four Japanese architects, and six designers were asked to deal with Tokyo as the cre-

ative hub of Japan over the past four hundred years. In the exhibition, whose theme was the Tokyo way of life and its continuity through change, the plan of the gallery space was that of an abstracted "street" in which seven chronological phases of Tokyo life are evoked in the visitor. The intent was to convey through visual imagery the particular cosmopolitan essence of Tokyo. Since the Tokugawa shoguns required half of the Daimyo and their retainees to serve at any one time in Tokyo, and, since they came from all regions of Japan, it was inevitable that this gave Tokyo life a rich intermix of customs, attitudes, and aesthetic preferences not found elsewhere.

The subtleties of the Kyoto court or of the Zen mind were not to be found in Tokyo. This was a samurai and merchant society. The Edo block prints would have horrified the Kyoto aristocracy. The floating world of Tokyo was a reflection of the uncertainty of life, which, therefore, was to be enjoyed while it lasted.

To capture, distill, and express the quality and characteristics of each of the seven ages of Tokyo, Tadanori Yoko-o produced a series of ceramic tile murals

suggesting Tokyo, past, present and future (where Godzilla threatens to eat it!). The designs were drawn by him and the colors indicated. Then they were turned over to the Otsuka Ohmi Ceramic Company, where glazes were applied by silk-screen printing on tiles. This whole process of design by artist and preparation and printing by craftspersons, with final approval by artist but overall supervision by the production company, is familiar to us from the Ukiyo-e print process of eighteenth-century Edo.

In the ceramic mural entitled *Edo to Meiji* Yoko-o expresses the confrontations of Edo Japan by the Meiji reformations and Westernization (colorplate 19). The viewer is abruptly confronted by a railroad engine in photographic rendition flanked by square red pillars of classical Western derivation. Scenes from a Meiji circus print form a background between the pillars. To the right and left a reference to Hokusai's ocean waves is seen with a mythological battle between a maiden and a fish warrior. Over all is the world in two halves and two flags of Japan against the golden sun. The largest-scale elements are a faceless standing female figure and the eyes and eyebrows only of a Kabuki theater actor. The entire melange is richly visual and evocative of the subject. It does not move us in the way a Rembrandt painting might, but it is typical of the power of juxtaposition, visual pun, and reminiscence. These are qualities that seem inherent in Japanese art of the Edo and modern periods.

The last mural in the series deals with the near future. It starts with Godzilla attacking Tokyo and ends with the Buddha Amida rising over the burned ruins like a new sun. In reference to this mural, the artist has said that the city, like humans, goes through birth, life, death, and resurrection, over and over. This is very similar to the Hindu concept of cosmic time and cycles.

SCULPTURE IN THE MODERN PERIOD

Just as European painters were invited to teach in Japan, so the government invited an Italian, Vincenzo Ragusa (1841–1927), to teach sculpture. However, after six years Ragusa returned to Italy because there were not enough interested students. One reason may have been that the Edo government repression of Buddhism had destroyed the major purpose for sculpture. The sculptors turned to making ivory carvings and dolls for export. But outside the religious milieu there had not been a motivation for sculpture since the Buddhist culture had arrived in the Asuka period (chapter 22) and introduced cremation, destroying the need for Haniwa sculptures of the Kofun period (chapter 21).

It is only after the Meiji period that architecture and sculpture have been tolerated as "arts" in Japan.

And it has been largely due to acquaintance with the standards and values of Europe and America that this has come about. Nevertheless, some of Ragusa's students, notably Okuma Ujihiro (1856–1934) and Takamura Koun (1852–1934), produced academic works in the nineteenth-century European manner, including some public monuments to famous historical figures.

Just as the Western style painters had journeyed to Europe, so also did the sculptors make their own artistic pilgrimages. The Western sculptor whose works most affected Japan in this period was Auguste Rodin (1840–1917), and the two Japanese sculptors most influenced by him were Ogiwara Morie (1879–1910) and Takamura Kotaro (1883–1956). Both worked in bronze, and every element of their figural sculptures follows Rodin; subjects, style, and technique reflect the French sculptor but do not contribute anything beyond, and, saddest of all, they do not let any of their Japanese makers' own being show through. They only confirm what the traditionalists of the time would have said— it is a craft, not an art.

The Western-style architects and painters had reflected dissatisfaction with native forms and studied forms of the West with great diligence. But it was not until after the war that they were able to find their own reality and develop their own creativity. So it was with sculpture. The great Europeans of the late 1920s and early 1930s were also studied. Henry Moore, Calder, and Brancusi all had their imitators, but a few figures have emerged who may be considered by history to have been great sculptors of the second half of the twentieth century.

Probably the best-known contemporary Japanese sculptor is Nagare Masayuki (b. 1923) (fig. 27.23). He was influenced early by Brancusi, and the simplicity of Brancusi's forms is perhaps remembered in Nagare's works, but, where Brancusi demands purity of geometric forms, Nagare has a master's ability to juxtapose that geometry with organic nuance and suggestion. This gives his pieces a breathtaking sense of discovery—as of one finding, at last, the mysterious purity of the forces at work in the organic world—underlying all organic life but present in a special kind of vivid intensity in this particular work.

The reverence for particular stones as habitations for spirits is one of the oldest elements known of the inhabitants of prehistoric Japan. This reverence has remained vigorous throughout its long history. When one asks a Japanese how one *knows* that a particular stone is indeed the resting place or marking place of the presence of a spirit of nature, the answer is, "One just knows." So with Nagare. One just knows. Somehow, certainly beyond mere craft, the artist is able to reveal the soul of the stone—its Kami. Is it by mere whim that he has called this piece *Returning*?

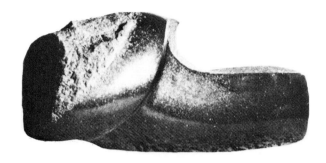

Figure 27.23 *Returning,* by Nagare Masayuki. Black marble. Showa period.

SUMMARY

The Meiji policy of modernization led to the importation of Western concepts, institutions, and arts. Western teachers were hired to teach, and many young students traveled to Europe and America. The sequence of architectural styles was like that in modern India, except for the very important fact that the Japanese government encouraged students to study in Europe, whereas in India the government merely hired European architects to build their most important buildings—to design "Indian" architecture. One result was that Le Corbusier, who had designed Chandigarh in India, was the actual teacher of several of the young Japanese students in Paris. The British India imported their architect, but the Japanese imported knowledge. Thus, today some of the world's leading architects are Japanese, while Indian architecture is just now making the transition into valid modern forms.

Painting in Japan during the modern period has, in general, followed the same pattern of the other arts and of those of India and China. Modernism has been equated with Westernism. But, whereas the Indian cultural system had been badly affected by the British occupation, and the Chinese system by the devastation of the Communist revolution, Japan was spared both foreign domination and internal conflict. Added to this happy circumstance was the eager enthusiasm with which the artists and intellectuals greeted the proclamation of the emperor Meiji.

Although the traditional styles, the Kano and the Yamato-e, continued, some painters yearned for a more expressive manner. They found it in the work of visiting European painters, who became the first teachers of the Western style in Japan. This style probably suited the interest in the floating world idea of timelessness as well. But, although some creditable work was done in the impressionist and Post-Impressionist styles, it became clear that neither the oil medium nor the subject matter of foreign painting were quite valid for the Japanese.

Many turned to other media and to other subject matter. World War II served to break both the connections with Europe and the oil painting style. Many artists turned instead to wood-block printing due to unavailability of oil paints. Much of the very best work since the war has been done by those who turned to the old medium but who used it in new and creative ways, producing some of the most striking visual art of the twentieth century.

GLOSSARY

Hanga Block picture, that is, block print. (p. 273)
Plein air French for "full air," that is, open air, referring to the nineteenth-century French school of oil painting whose members painted out of doors, in the open air. (p. 270)
Salon French for "hall" or "drawing room," connoting an event or meeting held there on a periodic basis. In modern art it refers to the exhibitions of groups of painters held, usually, on an annual basis. (p. 271)

SELECTED BIBLIOGRAPHY

Boyd, A. *Chinese Architecture and Town Planning 1500 B.C.–A.D. 1911*. Chicago: University of Chicago Press, 1962.

Bussagli, M. *Oriental Architecture/1 India, Indonesia, Indochina*. New York: Electa/Rizzoli, 1981.

Bussgali, M. *Oriental Architecture/2 China, Korea, Japan*. New York: Electa/Rizzoli, 1981.

Cahill, J. *Chinese Painting*. Geneva: Skira; distributor New York: Crown, 1972.

Chang, K. C. *The Archaeology of Ancient China*. New Haven and London: Yale University Press, 1963.

Cohen, J. L. *The New Chinese Painting 1949–1986*. New York: Harry N. Abrams, 1987.

Edwardes, M. *Great Buildings of the World, Indian Temples and Palaces*. London, New York: Paul Hamlyn, 1969.

Egami, N. *The Beginnings of Japanese Art*. New York, Tokyo: Weatherhill/Heibonsha, 1973.

Fong, W., ed. *The Great Bronze Age of China: An Exhibition from the People's Republic of China*. New York: Metropolitan Museum of Art, 1980.

Frankel, L., ed. *Festival of India in the United States 1985–1986*. Exhibition Catalog. Foreword by Pupul Jayakar, Chairman, Indian Advisory Committee. New York: Harry N. Abrams, 1985.

Freer Gallery of Art, Washington, D.C. *The Freer Gallery of Art*. 2 vols. Vol. 1: *China;* Vol. 2: *Japan*. Tokyo: Kodansha, 1971.

Freer Gallery of Art. *Masterpieces of Chinese and Japanese Art: Freer Gallery of Art Handbook*, Washington, D.C., 1976.

Harada, M. *Meiji Western Painting*. New York, Tokyo: Weatherhill, 1968.

Ienaga, S. *Painting in the Yamato Style*. Trans. John M. Shields. New York, Tokyo: Weatherhill/Heibonsha, 1973.

Kidder, J. E. *Early Japanese Art*, Princeton: Van Nostrand, 1964.

Lane, R. *Images from the Floating World. The Japanese Print*. New York: Dorset Press, 1978.

Lee, S. E. *A History of Far Eastern Art*, 4th ed. New York: Harry N. Abrams, 1982.

Lim, L. (coordinator). *Contemporary Chinese Painting*. An Exhibition from The People's Republic of China. Chinese Cultural Center of San Francisco, in cooperation with the Chinese Artists Association of the People's Republic of China, 1983.

Masuda, T. *Living Architecture: Japanese*. New York: Grosset and Dunlap, 1970.

Medley, M. *The Chinese Potter*. New York: Charles Scribner, 1976.

Michener, J. A. *The Modern Japanese Print. An Appreciation.* Rutland, Tokyo: Charles E. Tuttle, 1968.

Mizuno, H. *Edo Paintings: Sotatsu and Korin.* New York, Tokyo: Weatherhill/Heibonsha, 1965.

Munsterberg, H. *The Art of Modern Japan from the Meiji Restoration to the Meiji Centennial 1868–1968.* New York: Hacker Art Books, 1978.

Nakamura, T. *Contemporary Japanese-style Painting.* New York, Tokyo: Weatherhill/Heibonsha, 1973.

Nishi, K., and K. Hozumi. *What Is Japanese Architecture?* Tokyo, Palo Alto: Kodansha International/Harper Row, New York, 1985.

Okawa, N. *Edo Architecture: Katsura and Nikko.* New York, Tokyo: Weatherhill/Heibonsha, 1975.

Paine, R. T., and A. C. Soper. *The Art and Architecture of Japan,* rev. ed. New York: Penguin, 1974.

Pirazzoli-T'severstevens, M. *Living Architecture: Chinese.* New York: Grosset and Dunlap, 1971.

Ramachandra Rao, P. R. *Modern Indian Painting.* Madras: Rachana, n.d.

Rawson, J. *Ancient China: Art and Archaeology.* New York: Harper & Row, 1980.

Ross, M. *Beyond Metabolism: The New Japanese Architecture.* New York, Toronto: Architectural Record Books, McGraw-Hill, 1978.

Rowland, B. *The Wall Paintings of India, Central Asia and Ceylon.* Boston: Merrymount Press, 1938.

Rowland, B. *The Art and Architecture of India.* Baltimore: Penguin, 1967.

Seckel, D. *Emakimono, The Art of the Japanese Painted Handscroll.* New York: Pantheon, 1959.

Sickman, L., and A. C. Soper. *The Art and Architecture of China,* 3d ed. Baltimore: Penguin, 1968.

Sihare, L. P. *Selected Expressionistic Paintings from the Collection of the National Gallery of Modern Art.* New Delhi: New Delhi National Gallery of Art, 1975.

Sihare, L. P. *Selected Surrealist Paintings from the Collection of the National Gallery of Modern Art.* New Delhi: New Delhi National Gallery of Art, 1977.

Statler, O. *Modern Japanese Prints, An Art Reborn.* Rutland, Tokyo: Charles E. Tuttle, 1959.

Sullivan, M. *The Arts of China,* 3d ed. Berkeley: University of California Press, 1984.

Swann, P. *A Concise History of Japanese Art.* New York, Tokyo: Kodansha, 1979.

Tillotson, G. H. R. *The Tradition of Indian Architecture, Continuity, Controversy and Change Since 1850.* New Haven, London: Yale University Press, 1989.

Valenstein, S. G. *A Handbook of Chinese Ceramics.* New York: Metropolitan Museum of Art, 1975.

Volwahsen, A. *Living Architecture: Indian.* New York: Grosset and Dunlap, 1969.

Watanabe, Y. *Shinto Art: Ise and Izumo Taisha.* Trans. R. Ricketts. New York, Tokyo: Weatherhill/Heibonsha, 1974.

Welch, S. C. *India, Art and Culture 1300–1900.* The Metropolitan Museum of Art. New York: Holt, Rinehart & Winston, © 1985, by the Metropolitan Museum of Art, New York.

Zimmer, H. R. *The Art of Indian Asia.* 2 vols. Ed. Joseph Campbell. New York: Pantheon, 1955.

INDEX